Masterworks of American Art
from the
Munson-Williams-Proctor Institute

Contributors

Philip Rhys Adams
Fred B. Adelson
Leon A. Arkus
Elizabeth Stevenson Armandroff
Dore Ashton
Linda Ayres
Mary Black
Richard J. Boyle
Kathleen M. Burnside
Warder H. Cadbury
Mary Schmidt Campbell
Bruce W. Chambers
Nicolai Cikovsky, Jr.
Carol Clark
Sarah Clark-Langager
Marilyn Cohen
Wayne Craven
Rainer Crone
Elizabeth de Veer
Mary Sweeney Ellett
Rowland Elzea
Monroe H. Fabian
Betsy Fahlman
Linda S. Ferber
Harry F. Gaugh
William H. Gerdts
Mona Hadler
Barbara Haskell
Robert C. Hobbs
William Innes Homer
Anthony F. Janson
Mitchell D. Kahan
Franklin Kelly
Nancy B. Ketchiff
Martha Kingsbury
John R. Lane

Susan C. Larsen
Ileana B. Leavens
Gail Levin
Susan Lubowsky
Patricia C.F. Mandel
Chad Mandeles
Nancy Miller
Francis M. Naumann
Edward J. Nygren
Francis V. O'Connor
Judith Hansen O'Toole
Gwendolyn Owens
Ellwood C. Parry III
Bennard B. Perlman
Ronald G. Pisano
Stephen Polcari
Jeanne Chenault Porter
Kenneth W. Prescott
Harry Rand
Eliza E. Rathbone
Sheldon Reich
Richard Rubenfeld
John R. Sawyer
Paul D. Schweizer
Linda Crocker Simmons
David M. Sokol
William S. Talbot
David Tatham
Ellen Wiley Todd
Carol Troyen
William H. Truettner
Richard J. Wattenmaker
Ila Weiss
John Wilmerding
Judith Wolfe
Robert G. Workman

Masterworks of American Art

FROM THE

Munson-Williams-Proctor Institute

Edited by
PAUL D. SCHWEIZER
Director of the Museum and Chief Curator

Assisted by
SARAH CLARK-LANGAGER

and
JOHN R. SAWYER
Curator of Twentieth-Century Art

Harry N. Abrams, Inc., Publishers, New York

Project Director: Margaret L. Kaplan
Coordinating editor: Nora Beeson
Designer: Michael Hentges

All color photography by Gale Farley, except for Church, Hassam, and Kline by
Ray Albright; Burchfield and Shinn by Munson-Williams-Proctor Institute; and
Warhol by Christie's. Contents page photograph by Ezra Stoller © ESTO.

Research and publication of *Masterworks of American Art from the Munson-
Williams-Proctor Institute* has been funded by a grant from The Luce Fund for
Scholarship in American Art, a program of The Henry Luce Foundation, Inc.
Additional funding was provided by the Members' Program Fund of the
Munson-Williams-Proctor Institute.

Library of Congress
Cataloging-in-Publication Data

Masterworks of American art from the Munson-Williams-Proctor Institute /
edited by Paul D. Schweizer; assisted by Sarah Clark-Langager and John
Sawyer.

 p. cm.
 Bibliography: p.
 Includes index.
 ISBN 0-8109-1535-9
 1. Painting, American—Catalogs. 2. Painting—New York—Utica
—Catalogs. 3. Munson-Williams-Proctor Institute—Catalogs.
I. Schweizer, Paul D. II. Clark-Langager, Sarah A., 1943–
III. Sawyer, John. IV. Munson-Williams-Proctor Institute.
ND205.M315 1989
759.13'074'01476—dc19 88-22298

Contents

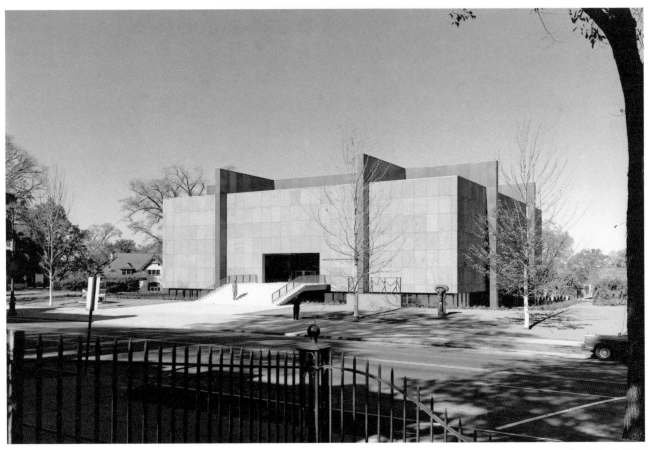

The museum building, designed by Philip Johnson, when it was first opened in the fall of 1960.

Foreword

THIS CATALOG, which analyzes one hundred of the most important American pictures acquired by the Museum of Art, Munson-Williams-Proctor Institute over the past fifty years, is the first of what is hoped will be a series of similar publications devoted to other important facets of the permanent collection. After selecting the works to be included, it was decided to invite outside scholars to write the majority of the essays, using whatever methodological approach seemed appropriate for the task at hand. In choosing these individuals an effort was made to secure the help of both recognized authorities who have published seminal studies of the artists in question, as well as younger scholars whose work on a particular artist promised to make an important contribution. Naturally, I am deeply grateful to the seventy-one authors, whose essays are published here, for the substantial addition they have made to our knowledge about a group of pictures that spans more than 250 years of American art history.

The works in this catalog do not necessarily represent the full extent of the museum's holdings of any of the artists included. In fifteen instances (Avery, Bolotowsky, Cole, Earl, Fisher, Gifford, Hartley, Inman, E. Johnson, Kuniyoshi, Matteson, Partridge, Raphaelle Peale, Prendergast, and Rothko), there is at least one other noteworthy painting in the museum's permanent collection. In other cases, the number of additional works ranges from several (Baziotes, Brook, Crawford, Cropsey, Davis, Dove, Graves, Kuhn, Lawson, Marin, Marsh, Pollock, Shinn, Tobey, Tomlin, and Whittredge), to many (Davies, Burchfield, Palmer, and Stamos). Moreover, while we felt that this catalog should be limited to only one hundred works, a number of other pictures by Blakelock, Bloch, Dzubas, Elliott, Heade, Hofmann, Jarvis, Kantor, Levi, Mount, Rembrandt Peale, Rubens Peale, Pereira, Price, Speicher, Vickrey, Walkowitz, Whistler, and others, which might otherwise have been included, were by necessity omitted. All of these will be included in a forthcoming handbook being prepared by the museum's staff, which will provide in one convenient source a listing of the museum's entire permanent collection of works of various civilizations, centuries, and media.

For the opportunity to publish this catalog, I am deeply grateful to Robert E. Armstrong, Vice President and Executive Director, and to Mary Jane Hickey, Program Officer of The Henry Luce Foundation, Inc. At Harry N. Abrams, Inc., the initial interest that Margaret L. Kaplan, Senior Vice President and Executive Editor, expressed in this catalog, and the sage advice she and her staff provided during its production have been invaluable. I am also grateful to Nora Beeson for her deftly applied editorial assistance and to Michael Hentges who designed this publication with a keen sensitivity to the relationship between its images and texts. At the Munson-Williams-Proctor Institute, Paul J. Farinella, President, has followed its progress with great interest. Also at the museum, valuable contributions have been made at various stages by Sarah Clark-Langager, John R. Sawyer, Marianne Corrou, Patricia Serafini, and Gale Farley. Additional assistance was given by the staff of the Institute's library, and by the reference staffs at the libraries at Hamilton College, Colgate University, Syracuse University, and the Utica Public Library.

PAUL D. SCHWEIZER
Director and Chief Curator

A History of the Collection

WHEN HENRY TUCKERMAN PUBLISHED HIS *Book of the Artists* in 1867, several citizens of the thriving central New York State city of Utica found their names listed with people who had assembled noteworthy art collections in other cities from Boston to Washington, D.C.[1] Among Tuckerman's list of Utica collectors, the names of James Watson Williams and Helen Elizabeth Munson Williams were not included, but the reasons for this are clear. By this time they were living in an Italianate-styled house (later called Fountain Elms), which they designed with the architect William L. Woollett, Jr.,[2] and decorated with examples of the latest New York furniture[3] and possibly as well with ancestral portraits by Ralph Earl, John Trumbull, and Ezra Ames. By 1867 James and Helen Williams had also commissioned works by the portraitists Henry Darby and Frederick R. Spencer, and the sculptors Erastus Dow Palmer and John Moffitt.[4] However, the important paintings by Frederic Church, Sanford R. Gifford, David Johnson, William T. Richards, and others that eventually formed the basis of the Munson-Williams-Proctor Institute's collection of American paintings were acquired by Mrs. Williams following the death of her husband in 1873. This fact, as well as James Williams's repugnance for notoriety, may explain why the art collection that Mr. and Mrs. Williams began to assemble in the 1860s escaped Tuckerman's notice.

At least three of the paintings Mrs. Williams acquired after her husband's death were purchased from the annual exhibitions mounted by the Utica Art Association, which in the decades following the Civil War, like comparable organizations in Buffalo, Rochester, and Troy,[5] played an important role in developing a taste for the fine arts among the citizens of upstate New York, as well as providing opportunities for artists to exhibit and sell their works outside the major urban areas.

At the 1878 Utica exhibition, Mrs. Williams purchased David Johnson's *Brook Study at Warwick* for one thousand dollars.[6] In a letter about this painting Johnson noted that it depicted a brook "that rises in the mountain two miles west of Warwick, Orange Co. and empties into the Wawa-yan-da which flows through Warwick." Describing his plein air working method, he noted: "I placed my easel there and went to work earnestly to find out how Dame Nature made things, divesting myself of all thoughts of picture or Studio effects."[7]

At the next exhibition of the Utica Art Association in 1879, Mrs. Williams purchased five paintings, the two most important being Sanford R. Gifford's recently com-pleted *Galleries of the Stelvio—Lake Como* and Frederic Church's *Sunset*.[8] With a purchase price of two thousand dollars, Church's painting was one of the two most expensive works in the exhibition. While this price was reported by the New York City press, the invoice that the Association sent to Helen Williams indicated that she may actually have purchased this work for five hundred dollars less than this amount.[9]

During the 1880s Mrs. Williams continued to acquire paintings; however, she ceased patronizing the Utica Art Association. As her two daughters Rachel and Maria grew older, the three women began to travel more, providing her with numerous opportunities to see and purchase paintings elsewhere.[10] On returning to Utica from one such trip in 1889, she and her daughters took a suite in a local hotel for the remainder of the winter. The proprietor was Thomas Proctor, and two years later he and Maria were married. Three years after that Thomas's younger half-brother Frederick married Maria's older sister Rachel.

Of the two Proctor brothers, Thomas was the greater antiquarian. He had some interest in paintings, particularly historical and contemporary portraits and pictures of military subjects, but his greatest collecting enthusiasms were rare books and bookplates, historical prints, coins and medals, letters and autographs, as well as watches and timepieces.[11] Frederick assembled a collection of antique watches as well,[12] and like his brother had an interest in holography, as is evident in the letter he received from the painter George H. Boughton. Frederick may have wanted Boughton's signature because he owned the artist's painting, the *Puritan Maiden*. He may have mentioned this in a letter he sent to the painter, for in his reply Boughton noted diplomatically: "I think I remember the Puritan girl you have of mine (done some years ago)."[13]

Because of a large inheritance that Rachel and Maria received from their mother, which was enhanced by their own wise investments, as well as by Thomas's and Frederick's successful business ventures, the four Proctors amassed substantial fortunes. Neither couple had any children, and the problem of how they should ultimately dispose of their money, which loomed more insistently with Rachel's death in 1915, prompted them to formulate a plan whereby the bulk of their estate would benefit the people of central New York State. This took tangible form in 1919 when they founded the Munson-Williams-Proctor Institute, which today offers arts-related programs under three separately directed departments: a school of art, a performing arts division, and a museum.[14] These

three divisions began evolving after the death in 1935 of Maria Proctor, the last surviving founder. At that time the Trustees designated that the Thomas Proctor house be used for the Institute's "Cultural Program," which included among its offerings recitals and lectures on music. Next door, the Frederick Proctor house (Fountain Elms) was maintained as a house museum with the Proctors' paintings, prints, and decorative furnishings serving as the nucleus of a permanent collection. The two carriage houses behind these homes were renovated for use as an art school.

Until the end of World War II no significant additions were made to the museum's painting collection. Earlier, the Trustees considered initiating an acquisitions program,[15] but it was only with the arrival of Harris K. Prior, who assumed the duties of director of the museum early in 1947, that an effort was begun to expand the collection of paintings left by the Proctors. Prior began by patronizing the art school's visiting artist program, which was designed to bring to Utica prominent contemporary artists to lecture and run workshops. The first artist of the 1947–48 season was Philip Guston. As head of the Department of Painting at Washington University in St. Louis, Guston had received a Guggenheim Fellowship in the spring of 1947 that enabled him to spend a year away from his classroom duties to concentrate on his art. Nonetheless, he accepted an invitation to be a guest artist for the better part of November of 1947, during which time an exhibition of his paintings was held simultaneously in the Institute's school of art and museum.[16]

In a memorandum Prior reminded the Institute's executive vice president, Thomas B. Rudd, that a commitment had been made to purchase a work from each visiting artist. The Guston painting that Prior wanted was *The Performers,* a work that had been independently chosen as well by William C. Palmer, the director of the school of art, and by Prior's assistant, Joseph S. Trovato, who in subsequent years organized many of the museum's most important exhibitions. In his note to Rudd, Prior did not restrain his enthusiasm for this work, and he pointed out the role that it could play in the future growth of the collection. "This is a really important painting, one which in the long run may appear to be the cornerstone of our collection of contemporary American art."[17] Despite his admiration for this painting, Prior was not able to convince the Trustees to acquire it, and it was subsequently purchased by the Metropolitan Museum of Art.

The Guston painting that the museum ultimately purchased, *Porch No. 2,* was probably seen by Prior at the Whitney Museum of American Art's annual in the winter of 1947–48. Guston's dealer, Alan D. Gruskin of the Midtown Galleries in New York, wrote to Prior in early March of 1948 that this painting could be sent to Utica on approval and that "if you can come to a decision on this picture now" he would deduct eight hundred dollars from its price.[18] The painting was shipped to Utica and, in a letter to Prior, Gruskin noted: "I hope it remains with you. But, if it does, I am sure it will be borrowed frequently . . . and, of course, we should want to borrow it back for our one-man show next season. Phil was looking at it the other day and said he thought that he had gone further in *Porch No. 2* than in anything else he had painted."[19] In late March the painting was purchased for two thousand dollars, which was five hundred more than Guston had asked for *The Performers.* When this acquisition was announced in the Institute's *Bulletin,* it was noted that the artist's "free and imaginative use of rich and glowing color makes this perhaps one of Guston's finest paintings."[20] And with the acquisition of this work, which was bought within a year of being painted, the museum renewed the practice begun by its founders of collecting the works of living American artists.

Several months after the Guston purchase, an exhibition of the mid-nineteenth-century genre painter Tompkins H. Matteson took place near Utica in the small village of Sherburne, as a tribute to one of that village's most illustrious residents.[21] Having recently mounted an exhibition at the Institute entitled Arts of Early Utica, Prior went to Sherburne and became interested in several of the paintings he saw. As a result, in April of 1949 he purchased Matteson's *Hop Picking.* In a letter to Robert H. Palmiter, a local dealer from whom the work was acquired and who had been a moving force in the Sherburne exhibition, Prior articulated the principle that has guided the museum in the acquisition of paintings by regional artists:

I hope we can continue to find significant works by artists who were born or lived in this region. I should like eventually to have a good collection of this type of work. However, we are not embarking on a policy of buying everything which comes in this category, but only works of considerable quality, since we are after all an Art Museum rather than an Historical Museum.[22]

When considering the purchase of Raphaelle Peale's *Still Life with Steak* several years later, Prior had another opportunity to discuss the issue of quality. He was initially concerned about the painting's rather unusual subject matter and its seemingly too obvious signature. After being assured of its authenticity by Charles Coleman Sellers,[23] an authority on the Peale family of painters, Prior purchased the work. In a letter that Edith Halpert of the Downtown Gallery in New York wrote to Prior confirming the sale of the painting from her gallery to the Institute, she summarized the principle of connoisseurship that appears to have sustained Prior's interest in the painting. Halpert noted: "I appreciate no end your point of

view that quality is the determining factor in all painting. Attributions and reattributions have gone on over hundreds of years, but the specific painting never changes in character."[24]

Prior's interest in quality was also shared by Edward W. Root, a pioneering and discriminating collector of twentieth-century American art, who lived in the village of Clinton, just south of Utica.[25] Because of a similar interest in contemporary painting, the two men became close friends. In the fall of 1949 the Trustees of the Institute invited Root to serve as a consultant on the matter of acquisitions. It is clear from the letter that Prior wrote to Root on November 17, 1949, that he was a strong proponent of this appointment, and that he valued and trusted Root's judgment:

I am writing to say how happy I am that you have accepted the invitation of our Board to be Consultant in Art for the Institute. I have considered you in just that capacity for a long time, I am afraid, but now I shall feel freer to call upon you for advice and assistance.

There are a few things which you may wish to help out with during this winter in New York. First, I am hoping to acquire some good examples of contemporary painting and sculpture for the Institute's collection this year. Up to now I have hardly had sufficient time to give to such a weighty matter. In May I want to have here an invited exhibition of works which we shall definitely consider for purchase. During the winter you and I could be working on the selection of things for this show. When they are all here and hung, we shall have a good opportunity to make our selections carefully and go over them with the Board. We shall probably spend nearly $5000 at that time, and I want to make it go a long way.

Of course, during the year there may be things we would want to purchase which would require immediate action, and we can take these things up as they arise. However, as we approach the time of the exhibition, I think dealers would be willing to hold a work until we have had time to consider it in May.

Another way in which you may wish to help is to follow the auctions as far as it is convenient for you, and actually to bid for us when I cannot get to New York. I shall want to talk with you about these things when I see you.[26]

Two days later Root wrote to Prior from his apartment on 63rd Street in Manhattan where it was his custom to stay during the winter months. Judging from the questions he had it would appear that Root was not taking his consultantship lightly:

Thank you very much for your kind letter of the 17th. Please do get in touch with me when you come to New York. We could lunch somewhere and you could tell me what you have in mind.

As for me, I shall have several questions to ask—for instance, has the Institute formulated a policy as regards purchases? Has it put down in black and white its aims, the kind of art objects which it thinks would serve these aims, and the categories to which it thinks purchases should be limited because of lack of funds or the expectation of future gifts? A little information along these lines would be a great help.

If you get down this coming week you will see some excellent contemporary shows—Tobey, Tam and Pollock amongst others—so come if you possibly can.[27]

Shortly after receiving this letter Prior went to New York City to talk to Root in more detail about their mutual aspirations for the collection. Subsequently, both he and Root systematically compiled lists of the names of painters who they believed should be represented in the Institute's collection. In the November 27, 1949 letter he sent to Prior on this matter, Root divided the names of the artists who interested him into four groups, using quality and availability from New York galleries as the determining factors. Root's comment that certain artists are "adequately represented in my own collection"—implying that Prior could best spend the museum's acquisition funds on other names—suggests that he, like the Institute's founders, was thinking about giving his art collection as a resource for Central New York:

The work of the following artists is: (1) adequately represented in the Institute's collection—Burchfield, Guston; (2) adequately represented in my own collection—Dove, Hopper, Burchfield, Kantor, Kuniyoshi, Tobey, Stamos; (3) represented by fine but minor works in my own collection—Marin, Demuth, Sheeler, S. Davis, Watkins, Baziotes, Graves, Pollock; (4) not represented in either collection—Hartley, Maurer, Sloan, O'Keeffe, Weber, Knaths, Shahn, Pereira, Wyeth.

You could probably find on the market fine examples of Marin, Sheeler, Baziotes, Pollock, O'Keeffe, Weber, Knaths, and Pereira, but you would probably have to wait and act promptly when occasion offered in order to acquire [a] major work by Demuth, Davis, Watkins, Hartley, Maurer, Sloan, Shahn or Wyeth.[28]

In February of 1950 Prior responded by sending Root a list of the artists he would like to see represented in the museum's collection. In compiling his plan for the future growth of the collection, Prior divided his list into the following seven categories: American sculptors, "foreign sculptors," European painters of the twentieth century, contemporary "expatriates," "artists outside of the New York area," nineteenth- and early twentieth-century

American painters, and "suggested additions to Mr. Root's list." In the penultimate category Prior listed the names Copley, Allston, Peale, Morse, Mount, Homer, Ryder, Eakins, Inness, Twachtman, Prendergast, Luks, Davies, Bellows, and Glackens. In the twentieth-century American painting category, Prior's additions to Root's list included the names Brook, Crawford, Levine, Heliker, Marsh, Bishop, Miller, and Sepeshy.[29] In his letter to Root, Prior explained why he added several of these names:

I know that Bill [Palmer] feels that we need to include some works which will represent the period in between the older and younger men on your list, work characteristic of the depression years, for example, and the decade of the 'twenties, say Reginald Marsh or Isabel Bishop, or Kenneth Hayes Miller. A top work by Alexander Brook might also cover a type not now included. Should we try to represent the middle west group, say by a Thomas Hart Benton?[30]

Issues tangential to the question of which artists should be acquired for the collection were also discussed. For example, Root recommended regularly setting aside funds that over time would enable the museum to purchase earlier American masterworks. He also mentioned his reservations about acquiring contemporary works from the museum's loan exhibitions, or buying works primarily as teaching aids for the Institute's art teachers:

First, as regards the annual allocation of money by the trustees for the purpose of making purchases. It seems to me that if the Institute is eventually to buy important examples of earlier American art it would be advisable for it to begin now to put money by for this purpose. In other words it seems to me that money should for several years be appropriated and allowed to accumulate so that the Institute will have something to work with when the time comes.

Second, as regards the purchase of contemporary works of art out of loan exhibitions. After considerable reflection I have become doubtful about the desirability of spending the bulk of the annual appropriation in this manner. Some of it should be, of course, spent in this way but not the greater part of it. Here are my reasons:

(1) I don't think such a method of purchases is necessary in order to get exhibitions from dealers.

(2) I don't think such a method will in the long run provide the Institute with as good works of art as buying directly whenever opportunity offers.

(3) In purchasing works of art I believe in fait accompli. I had rather have the public tell the trustees how bad it thinks purchases are than have it try to tell them what not to purchase. No doubt this is a remote

possibility, but it has happened. I know that there must be another side to all this and I hope that you will before too long expound it to me.

Third, as regards purchasing works of art for teaching purposes. This seems to me to require very careful consideration. Provided purchases for teaching purposes were not made primarily from the technician's point of view it would be all right, but it is very difficult to live up to this sort of provision. The tendency will always be to buy a particular sculpture or painting because it exemplifies some specific aspect of execution or design which some particular teacher is interested in and is trying to explain in class.[31]

After arriving at a consensus regarding which American painters they believed were important for the permanent collection, Prior and Root set about buying examples of their work. From the spring loan exhibition that Root helped Prior organize in 1950, pictures by Isabel Bishop, William Glackens, George Luks, and Georgia O'Keeffe were purchased. New paintings by Charles Sheeler and Jack Levine were acquired in 1951 and 1952 respectively, and after the death in 1952 of Kenneth Hayes Miller the museum bought *The Morning Paper* from the artist's daughter. The display at the Metropolitan Museum of Art in 1953 of Root's Mark Rothko painting, *Abstraction No. 2*, of 1947 (along with 133 other works from his collection)—the first such private collection of twentieth-century paintings to enjoy such a distinction[32]—provided the impetus for the museum purchasing in the same year the artist's recently painted *Number 18*. Similarly, Ilya Bolotowsky's *Diamond Shape*, Stuart Davis's *Eggbeater No. 2*, Jackson Pollock's dramatic fifteen-foot canvas *Number 2, 1949*, and Bradley Walker Tomlin's *Number 10* were acquired to complement paintings by those artists that were owned by Root. Two painters whose works Prior admired, George Inness and Arthur B. Davies, were also added to the collection.

One artist Root did not collect was Milton Avery and, therefore, the gift around this time by Mr. and Mrs. Roy R. Neuberger of the artist's *Pink Tablecloth* was a particularly welcome addition to the collection. Works by other artists who were not on either Root's or Prior's lists were added as well. Gilbert Stuart's portrait of General Peter Gansevoort was an important purchase in view of the role this sitter played in the early history of the upper Mohawk Valley. Everett Shinn attracted attention because of his role as a member of The Eight. An important painting by Morgan Russell was another appropriate addition to the group of early twentieth-century American paintings being assembled. And in keeping with the practice established earlier with the acquisition of paintings by Guston and Rothko, the museum purchased Franz Kline's *The*

Bridge, no doubt with Root's concurrence, a year after it was painted.

Shortly after the purchase of the Kline, Philip Johnson was selected by the Trustees to design a new art museum,[33] which was to be erected next to Fountain Elms on the site occupied by the Thomas Proctor house. Some time before this, the administrators of St. Luke's Hospital in New York City decided to sell the original version of Thomas Cole's four-part allegorical series, *The Voyage of Life,* which had been given to the hospital years earlier. In the fall of 1955 Prior received a letter from William Sturgis of St. Luke's inquiring if the Institute would be interested in purchasing them. "We have been asking $20,000 for the set, and if they are of interest to your museum, we would be glad to negotiate with you."[34] Less than a week later Prior replied that he was "very much interested in these paintings for they would add tremendously to our collection of American 19th century art."[35] He consulted with Root, as well as Lloyd Goodrich, a noted scholar of American art, and after personally examining the paintings in Manhattan was even more enthusiastic about the prospect of buying them, for they were in even better condition than he had dared to hope. In a memorandum he sent to William C. Murray, the newly elected president of the Institute, Prior pointed out that Sturgis "seemed to be personally interested in having these paintings come here." In describing the series' subject matter, he noted: "The allegory is, to be sure, a little bit 'corny,' but it is in the spirit of the times." For Prior, who had not included Cole's name on his list of potential acquisitions, the most redeeming feature of the four paintings was their landscape passages, which he described to Murray as "very dramatic and beautiful."[36] After obtaining the Trustees' approval to negotiate for their purchase, Prior contacted the hospital and asked if they would reduce the price by one thousand dollars, which was half the amount that the conservators Sheldon and Caroline Keck had estimated it would cost to clean them.[37] The hospital accepted Prior's proposal and by late November of 1955 the Kecks began work on the paintings, which were unveiled in Utica the following spring and quickly became one of the museum's most popular acquisitions.

In early December of 1956 Edward Root died and in his bequest to the Institute left over two hundred twentieth-century American paintings. Suddenly, the Munson-Williams-Proctor Institute was a major repository of art from this era. Included in this catalog are paintings by the following artists that came from the Root bequest: William Baziotes, Alexander Brook, Charles Burchfield, Willem de Kooning, Preston Dickinson, Arthur Dove, Arshile Gorky, Morris Graves, Edward Hopper, Yasuo Kuniyoshi, Reginald Marsh, Maurice Prendergast, Raphael Soyer, Theodoros Stamos, and Mark Tobey. Ac-

tually, however, the impact of Root's taste and vision on the Institute's collection is even more profound than this, for one-third of the paintings included in this catalog are by artists whose works he and Prior had sought to acquire.

Shortly before Root's death, Prior announced his intention to resign his post at the museum to assume the directorship of the American Federation of Arts in New York City. However, he continued to work as a consultant during the months before and for some time after his successor, Richard B.K. McLanathan, assumed his duties in November of 1957. From his new post in Manhattan, Prior, like Root before him, was able to scour the galleries and recommend paintings that might be of interest. For example, in a letter sent to Murray in the spring of 1957, Prior suggested that the museum consider purchasing Albert P. Ryder's *The Barnyard,* which was for sale for ten thousand dollars at the Hirschl and Adler Galleries. Mindful of the numerous fake Ryders that plagued the art market, he noted to Murray: "I checked with Lloyd Goodrich, the best authority on Ryder, and he verified the authenticity of the painting and the fact that it is a good example of Ryder's work and that the price is quite fair."[38] Among the other paintings Prior mentioned to Murray was what he described as a major William M. Harnett. In May of 1957 the Trustees followed Prior's suggestion and purchased the Ryder. The Harnett also interested them, however, so the following month they purchased this painting as well at a cost that was about what they had paid for Cole's *The Voyage of Life* less than two years earlier. Shortly thereafter, William M. Chase's *Memories* was acquired, which helped to fill one of the serious gaps in the collection for the period between the Civil War and the early twentieth century. Then in September of 1957 the Trustees purchased Walt Kuhn's *Camp Cook.* In 1949 this painting had attracted attention when it was shown at the museum. At that time Prior wrote to the dealer who owned it: "There is considerable interest on the part of my Board in the Walt Kuhn. . . . They are floored by the price, to be quite frank, but would consider, I think something around $2500 to $3000 if it should be available at that figure. . . . we consider it just about the best painting in the exhibition."[39] Regretfully, the work was not acquired. Eight years later when the Trustees finally did decide to purchase *Camp Cook,* it cost over twice the amount that Kuhn's dealer had asked when the painting was first considered.

Shortly after taking up his responsibilities at the museum, McLanathan saw at the Childs Gallery in Boston the masterful portrait of Thomas Aston Coffin that John S. Copley painted as a young artist. His excitement about the prospect of acquiring such a noteworthy example of one of America's leading eighteenth-century painters is apparent in the memorandum he wrote to Murray on this matter, in which he explained that the portrait was a "well

known, in fact famous, and universally admired example of his work, as well as being a particularly attractive painting from every point of view."[40] It had been loaned by a direct descendant of the sitter to the Worcester Art Museum for many years and would probably have been purchased by that institution if they did not already own several fine Copleys.[41] So, early in 1958 the museum purchased it, and for a number of years the painting enjoyed the distinction of being one of the earliest eighteenth-century American portraits in the collection. Other works acquired at this time included Childe Hassam's view of Long Island, an early landscape by John H. Twachtman, Robert Henri's *Dutch Soldier,* and Ernest Lawson's *Washington Bridge,* which was purchased from Mrs. Edward Root. Shortly after the ground-breaking ceremonies for the Institute's new museum building in May of 1958, paintings by John Sloan and Ben Shahn were acquired. Then, early in 1959, McLanathan purchased another work from Mrs. Root, Robert Motherwell's early black-and-white painting, *The Tomb of Captain Ahab.*

With the construction of the Johnson building, a decision was made to renovate and refurbish Fountain Elms as a Victorian house museum. To this end a number of paintings were acquired in 1960 which were deemed suitable for the period settings that were being assembled by McLanathan. Jasper F. Cropsey's *Castle by a Lake* was purchased from the Vose Galleries in Boston for this purpose, as was the imaginary landscape by Joshua Shaw. Another painting, William E. West's *A Domestic Affliction,* was purchased by McLanathan from a Boston dealer who described it as "very appropriate for a Victorian house"; however, it was never installed in Fountain Elms, possibly because its large size was inappropriate for the scale of the rooms there.

In the fall of 1960 Philip Johnson's museum building opened with great fanfare and critical acclaim. In the years just before and immediately following this, the anticipation and excitement that the new building generated enabled the museum to acquire a number of eighteenth- and nineteenth-century paintings from local families. In 1958, for example, William T. Ranney's large historical genre painting, *Recruiting for the Continental Army,* was given by T. Proctor Eldred of Utica. Four years later a rare and beautiful eighteenth-century American landscape by William Winstanley was purchased from the descendant of an old upstate New York family. Eastman Johnson's *The Chimney Corner* was acquired from Edmund G. Munson of Utica—a relative of the founders of the Munson-Williams-Proctor Institute—having been purchased by one of Mr. Munson's forebears at the 1878 exhibition of the Utica Art Association.[42] Alexander Wyant's large and dramatic *Rocky Ledge, Adirondacks* was purchased from the same private collection in Albany that the museum

acquired Alvan Fisher's *Eclipse, with Race Track.* Finally, in the field of portraiture, the likeness of Gerrit Symonse Veeder, attributed to Nehemiah Partridge, which passed down in the Veeder family of the Mohawk River Valley area, was acquired in 1965, supplanting the Copley as one of the museum's earliest American portraits.

An important acquisition in the field of nineteenth-century genre painting occurred about a year after Edward H. Dwight assumed the directorship of the museum in the summer of 1962. He learned from William F. Davidson at M. Knoedler & Co. in New York City that Quidor's *Antony Van Corlear Brought Into the Presence of Peter Stuyvesant* was available for sale. Since 1912 this painting had been owned by The Brook, a small Manhattan men's club that boasted an art collection assembled under the guidance of the art collector Thomas B. Clarke.[43] Dwight was keenly interested in this painting and, after satisfying himself that it was in sound physical condition, negotiated with Davidson over its price, which was eventually set at $22,500.[44] In December of 1963 the Trustees approved Dwight's recommendation, and shortly thereafter he undertook to organize an exhibition of Quidor's paintings. Dwight's motive in acquiring this picture is clear in the introduction he wrote for the catalog for this show, where he described Quidor as "one of America's rarest, most inventive, and least-known artists."[45]

Over the years the museum has continued to seek still-life paintings that would complement the other paintings of this genre in the collection by Peale, Harnett, and others. In 1961 an unusually large work by John F. Peto was offered to the museum but was turned down.[46] Four years later the painting was with M. Knoedler & Co. and was still for sale. Dwight took an interest in it and wrote to Alfred V. Frankenstein, an authority on Peto, for his opinion of the painting. He replied that it was part of a series of paintings Peto made depicting paraphernalia related to fishing: "It is one of the several versions of this subject Peto painted; it is also the largest of the series and, in my opinion, the best. I found it, covered with 40 years of dust, standing against a wall in Peto's house in Island Heights when I made my visit there in 1947."[47] Shortly after acquiring this still life Dwight purchased Worthington Whittredge's *Peaches* from the Kennedy Galleries in New York. He had a long-standing interest in this painter and, following the pattern of the Quidor purchase, subsequently undertook to organize an exhibition of this artist's work.

In 1968 Mr. and Mrs. Ferdinand Davis donated Edwin Dickinson's *Bible Reading Aboard the Tegetthoff* to the museum. Around this same time Dwight purchased paintings by James G. Clonney and Arthur F. Tait, as well as a rare oil painting by John J. Audubon that the dealer Peter Tillou of Litchfield, Connecticut, discovered at an estate

sale in England. In 1972 a new picture by Romare Bearden was purchased a year after his one-man exhibition at the Museum of Modern Art, and Ferdinand Richardt's view of a waterfall near Utica was added to the collection as well. The following year paintings by David Gilmour Blythe and Willard L. Metcalf were acquired with funds from the Charles E. Merrill Trust. In 1975 Dwight purchased an early painting by Clyfford Still with funds provided by the Katzenbach Foundation. During these years, Dwight was acquiring works by artists, some of whom were on the Root and Prior lists. Among these were the paintings by Charles Demuth and Marsden Hartley, as well as Ralston Crawford, an artist whose work Dwight particularly admired.

Dwight had an interest in the art of the Peale family throughout his career, and it is fitting that one of the last paintings he purchased for the collection was James Peale's *Still Life: Apples, Grapes, Pear.* Dwight had known this work at least as early as 1969 and corresponded with the family that owned it.[48] Between 1975 and 1977 it was consigned to M. Knoedler & Co. for one hundred thousand dollars, where it was admired by Dwight, but who felt that the price was too high.[49] The next year he received a letter from Peter H. Davidson asking if he would be interested in purchasing it from the descendants of the former owner at "a more reasonable price."[50] Dwight replied that he was "definitely interested,"[51] and set about making arrangements to have the picture examined by a conservator insofar as its wooden support had split at some point and been badly repaired. Technical examination showed the work to be in basically good condition, so Dwight consulted with the Institute's new president, Paul J. Farinella, and sought the Trustees' approval at their June 1978 meeting to purchase it for seventy-five thousand dollars. Upon approving Dwight's recommendation, the Trustees determined that the picture should be dedicated to William C. Murray who, from 1949 until his retirement in 1977, had served the Institute in various capacities when its collection of American pictures grew to become one of the most distinguished in the nation.

Shortly after the appointment of Paul D. Schweizer as director of the museum in 1980, the acquisition policy was reviewed and a commitment made to continue building on the strengths of the collection as they had previously been established in the areas of both historical and modern American painting. Hence, during the 1980s a number of nineteenth-century American works were acquired. The first was Edward Moran's turbulent *Shipwreck,* an early painting by this artist that reveals his fascination with maritime themes. Shortly thereafter Severin Roesen's *Still Life with Fruit and Champagne* was purchased at auction, providing a chronological and thematic bridge between the museum's collection of early still-life paintings by

various members of the Peale family and later nineteenth-century works by Harnett, Peto, Whittredge, and others. In 1983 Henry Inman's long-lost *Trout Fishing in Sullivan County, New York* was acquired at a price that exceeded what had hitherto been spent on any other American painting in the collection. Francis A. Silva's *Sunrise: Marine View* was purchased two years later. Finally, in 1986, the museum acquired Asher B. Durand's *Woodland Path,* an intimate picture dating from the period of some of this painter's most important works.

The twentieth-century collection was enhanced in 1982 when Mr. and Mrs. Edmund Munson and Mr. and Mrs. Watson Lowery donated a splendid early watercolor by John Marin to the Institute, while Mrs. James Lowery gave John Kane's *Morewood Heights.* Another gift to the collection was made in the summer of 1987 when the painter William C. Palmer donated *Washington Square, New York,* a picture he described as one of his most important works.[52] Another painting dating from this period, Joe Jones's *Portrait of the Artist's Father,* purchased in 1983, and Man Ray's *Hills* acquired three years later, further enhanced the museum's holdings in the areas of early avant-garde and Depression-era art. Works by Frank Stella and Malcolm Morley have extended the range of the contemporary collection. Strong advocacy by Sarah Clark-Langager, former curator of twentieth-century art, helped to bring Susan Rothenberg's *Untitled (Night Head)* and David True's *Void of Course* to the collection shortly after each was painted. In 1983 Helen Frankenthaler's early color field painting, *Two Moons,* was acquired at auction, and two years later Andy Warhol's *Big Electric Chair* came in the same fashion, just shortly before his unexpected death.

PAUL D. SCHWEIZER
Director and Chief Curator

JOHN R. SAWYER
Curator of Twentieth-Century Art

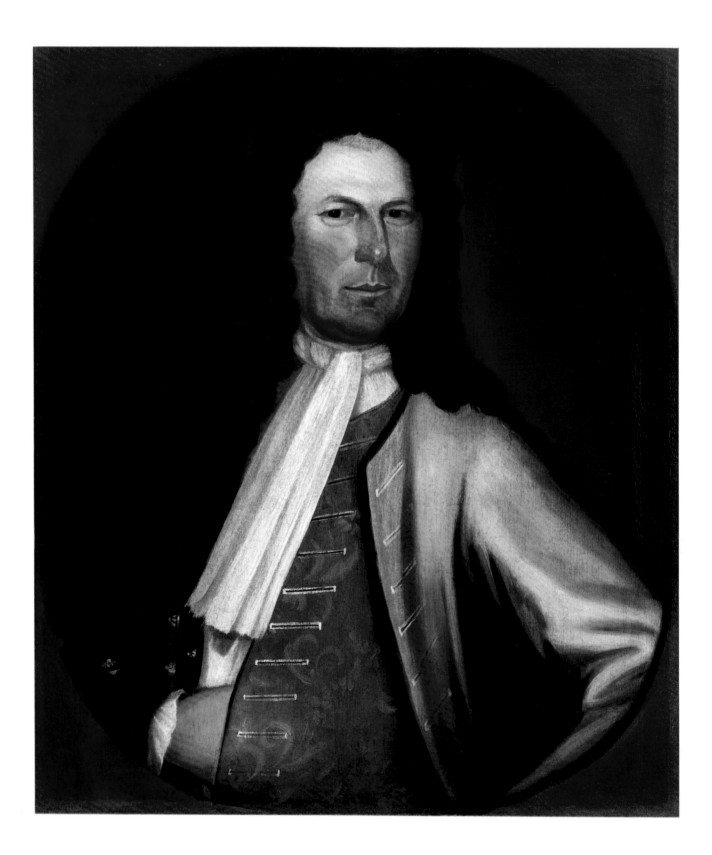

🦆 1

ATTRIBUTED TO NEHEMIAH PARTRIDGE (1683–c. 1730)

Gerrit Symonse Veeder

THE SUBJECT OF THIS EARLY eighteenth-century portrait of a handsome middle-aged man in a blue jacket and brocade waistcoat is Gerrit Veeder, a land and mill owner in Schenectady, New York. An 1886 history of the county also lists him as a carpenter.[1] In his 1690 marriage to Tryntje Otten he obtained additional land in the heart of the town at the corner of Union and Church streets.[2] Like many marriages along the upper Hudson, this one early proved fruitful, and the couple's first child, a son, was born less than three months after the wedding ceremony.

The Veeders's next door neighbors were Caleb and Anna Beck, who kept a tavern and store in the palisaded town on the Mohawk River. Caleb Beck was born in Portsmouth, New Hampshire, and it appears likely that the limner Nehemiah Partridge, born in the same town at about the same time, came to his Schenectady subjects through acquaintance with this New Hampshire-born mariner. There is at least one reference to Veeder in Caleb Beck's account book, as in the early winter of 1718 Beck charged Gerrit Simonson Veeder for 1 gill of rum purchased "for his son Daniel."[3]

Portraits of the Becks are, along with this subject, among the more than sixty portraits from wide-ranging locations in the colonies once attributed to an anonymous Aetatis Suae limner. In 1980, after a generation's search by contemporary art historians, portraits of members of the Wendell family of Albany—three out of more than twenty-five paintings having inscriptions written in one distinctive hand and consistent in style with the large group of likenesses—were identified as Partridge's work. In a May 13, 1718, entry in his day book, Evert Wendell recorded—in Dutch—that "Nehemiah Peartridge De Schilder [painter]" had promised to paint portraits of the family and pay ten pounds in exchange for a horse. One of the witnesses to the agreement was Samuel Van Vechten, later a sitter to the same painter. Thus Partridge, who began his career in Boston, and who early in 1718 had

identified himself as a limner in an apprenticeship agreement in New York City, was established as the artist of a group of paintings that had hitherto been described as having been painted in the distinctive Aetatis Suae manner.[4]

The portrait of Veeder is painted in the economical style that Partridge often employed for quick effect, especially in less sophisticated towns or in other areas where he had already established his reputation by his initial use of a more painstaking and elaborate technique. The paintings in the former style often had Indian red grounds—as in this case—which is visible in facial shadows and at the edges of large areas of colors laid over the base layer.

Many details of Veeder's facial features and costume echo those in other men's portraits attributed to Partridge, the most evocative being the relation between this portrait and the 1721 likeness of Captain Christopher Christophers of New London, Connecticut (bearing an inscription at the upper right in Partridge's hand),[5] and the portrait of Captain Ebenezer Coffin of Nantucket (Bayou Bend Collection, Houston), the painter's cousin, who was probably painted when he was in Boston in 1714, at a time when Partridge was beginning to advertise his skills as a limner in the *Boston News Letter*.

MARY BLACK

🦆 c. 1720
Oil on canvas, 30¼ × 26¼"
Museum purchase 65.29

JOHN SINGLETON COPLEY (1738–1815)

Thomas Aston Coffin

THIS PORTRAIT REPRESENTS Thomas Aston Coffin (1754–1810) as a little boy, well before he had started his distinguished career in the British colonial service, and it was painted when the young artist was at a most significant point in the early development of his career. The subject was born in Boston, the son of a merchant, William Coffin, Jr., and Mary Aston Coffin. He was graduated from Harvard College in 1772. His father was a Loyalist, and when the British evacuated Boston in 1776, Thomas accompanied him to Halifax. Young Coffin then became secretary to Sir Guy Carleton, Governor of Lower Canada, and eventually he was appointed Commissary to the British army in North America. He was with the English troops when they evacuated New York in 1783. Once more in Lower Canada in 1804, he was named Secretary and Comptroller of Accounts, and soon thereafter became Sir Thomas Aston Coffin, Baronet.

Copley's portrait shows young Master Thomas wearing a blue satin coat over an ivory-colored petticoat; up to around the age of eight children were dressed about the same, whether boys or girls.[1] To avoid any confusion about the gender, a plumed hat, definitely of masculine attire, is placed at the right side of the picture. The subject holds some cherries in his right hand, perhaps intending to feed them to his two pet pigeons that are tethered on a pink ribbon. A shuttlecock and battledore are seen at the lower left, instruments of a game (which prefigured badminton) that was then very popular in England and the English colonies. The other details of the picture—the enormous plant in the foreground, the blossoming morning-glory vine in the upper right, and the landscape with a stream winding through woods, with a mountain range on the horizon—may have been taken from an English mezzotint engraving, for it is known that Copley often drew upon such sources in his work of the 1750s.[2] It is typical of colonial painting that the background appears more like a backdrop, for, in contrast to the well-rounded and richly modeled objects of the foreground, everything beyond the figure seems generalized and flattened into a single scenic plane; typical, too, is the lack of integration between the foreground and background—the little boy stands in front of the landscape rather than being integrated with it.

Nevertheless, this is perhaps the most successful portrait of a child painted in the American colonies up to this time, for previous artists, such as John Smibert, Robert Feke, and Joseph Badger, had difficulty in capturing in convincing manner the special joys and beauties of childhood. Copley, however, became a master at doing so, as demonstrated in a double portrait also painted in 1758, representing young Mary and Elizabeth Royall, and of course his celebrated portrait of Henry Pelham, better known as Boy with a Squirrel of 1765 (both, Museum of Fine Arts, Boston). In both of these pictures the subjects are shown with their favorite pets, a motif that had come into colonial American portraiture early in the eighteenth century.

Copley was only nineteen or twenty years old when he painted the Thomas Aston Coffin, a fact that underscores the prodigy of his innate genius. He had no formal instruction, but of course had studied such work as he could see by former and contemporary New England artists such as Smibert, Feke, Badger, and Joseph Blackburn, the latter a fashionable painter from London who had arrived in Boston in 1753. Young Copley learned much from Blackburn's art in the mid-1750s, for it carried with it the current Georgian mannerisms then in vogue in London studios. But in 1758, with portraits such as the Thomas Aston Coffin, Copley clearly shows signs of surpassing the English master, who, thereafter, would not be able to meet the competition of the young native-born artist and within a few years was driven to seek patronage elsewhere; that is, after about 1758–60, portrait painting in New England is clearly dominated by one man, John Singleton Copley, and the Munson-Williams-Proctor Institute Museum of Art's portrait marks the beginning of his dominance.

WAYNE CRAVEN

ह~ 1758
Oil on canvas, 50 × 40"
Museum purchase 58.1

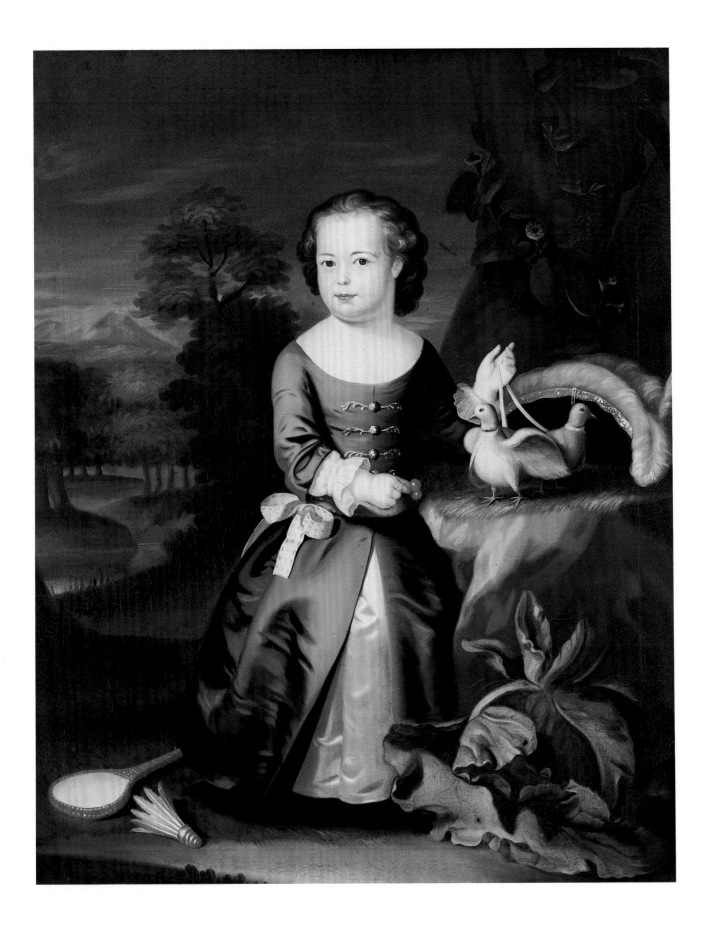

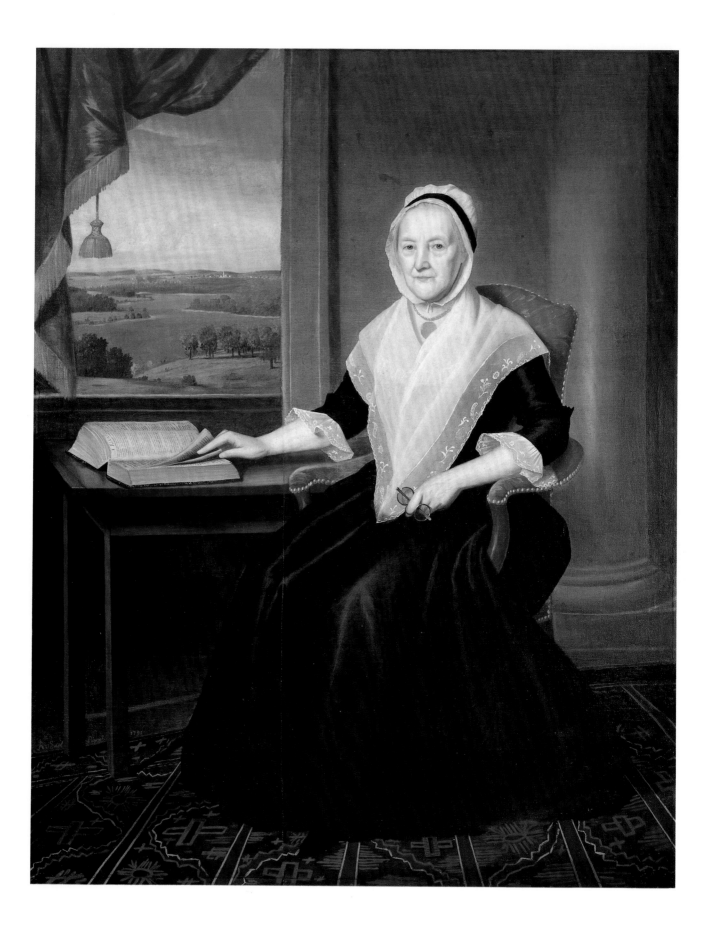

❧ 3

RALPH EARL (1751–1801)

Mrs. John Watson

BETHIA TYLER (1708–92) was born in Wallingford, Connecticut, and on April 30, 1730, she married John Watson. She was the mother of five daughters and six sons, who in time assumed prominent roles in the affairs of the colony, the state, and the nation. By the time of her death in 1792 she could have recorded the names of fifty-two grandchildren in the family Bible, possibly the one shown in her portrait. She lived much of her married life in Litchfield, and her grave is in a little retired cemetery just southwest of nearby Bantam Lake. Earl's portrait of Bethia Tyler Watson descended through the family to her great-grandson, James Watson Williams (who married Helen Elizabeth Munson) of Utica, New York, and then to his daughters, Rachel Williams, who became the wife of Frederick T. Proctor, and Maria Watson Williams, who married Thomas R. Proctor; bequests from these families established the Munson-Williams-Proctor Institute in 1919, and the *Mrs. John Watson* was given to the Institute through the estate of Frederick T. Proctor.

Ralph Earl was the foremost portraitist of the Connecticut Valley School when he painted the full-length image of Mrs. Watson in 1791. Earl was born in Worcester County, Massachusetts, but first appears as an artist in the New Haven, Connecticut, area around 1775.[1] Among his earliest works is the well-known portrait of Roger Sherman of c. 1775 (Yale University Art Gallery), which possesses a stark, austere quality that was well matched to his colonial American subject. Many of the stylistic features found in the *Sherman* were so firmly implanted in Earl's manner and in the aesthetic taste of his Connecticut Valley patrons that they endured even his several years of training in England.

Earl's Loyalist sympathies forced him to flee the colonies in 1778, when he went to England where he eventually entered the London studio of Benjamin West.[2] After John S. Copley arrived in London in 1776, he had completely changed his style to the fluid, painterly, airy, pastel-hued manner of the leading portraitists of the English School—Reynolds, Gainsborough, and Romney. But Earl, who spent seven years in England, resisted the techniques of the London masters, although, as Wilmerding put it, "his manner of painting evolved gradually out of its early stiffness and rugged simplicity into a more colorful and decorative style."[3]

So Earl became a better painter during his English sojourn, but his style did not change fundamentally; after he returned to his native land in 1785, his American patrons encouraged retention of what was essentially a pre-Revolutionary War colonial style. He spent a few years in New York City, but by the late 1780s he was back home taking likenesses in Connecticut where "his elegance and provincialism [created] an exact expression both of the limitations and the strength of Connecticut's rural culture," as Edgar P. Richardson so aptly phrased it.[4]

Earl's *Mrs. John Watson* of 1791, painted in Litchfield, is bracketed by two of his best-known works—the *Elijah Boardman* of 1789 (Metropolitan Museum of Art), and the *Mr. and Mrs. Oliver Ellsworth* of 1792 (Wadsworth Atheneum)—and it shares with them a linear, decorative style as well as a marvelous character study in the face. Mrs. Watson is shown sitting in a chair at a table upon which rests a Bible, open to the First Book of Kings; she holds her spectacles in her left hand while the right toys with the pages of the book. The scene suggests that we have come upon the subject during one of her usual readings, and she has paused to take note of our presence. Her dress, like the design of the table and the chair, is of a slightly old-fashioned style for 1791, but it indicates a propensity to cling to time-honored values, just as Mrs. Watson would approve of the retardataire style with which her portrait was painted. Earl's decorative flair is seen in the richly patterned rug, and his special talent for landscape is manifested in the lovely view out the window which shows Bantam Lake with the white-spired village of Litchfield in the distance. Two years after Earl painted the *Mrs. Watson,* Gilbert Stuart returned to America, bringing with him a fashionable British style, which, in most areas, at last displaced the lingering colonial style; but not so in the Connecticut Valley, where Earl and his successors long continued to find appreciative patronage for their brand of portraiture.

WAYNE CRAVEN

❧ 1791
Oil on canvas, 68¹/₄ × 54³/₈″
Proctor Collection PC.42

୫⤴ 4

GILBERT STUART (1755–1828)
General Peter Gansevoort

SCION OF AN OLD DUTCH FAMILY living in Albany, Peter Gansevoort served as a line officer in the Revolution from 1775 to 1781. The highlight of his military career was a three-week successful defense of an American fort at what is now Rome, New York. Ever after, especially in his own family, he was venerated as "the Hero of Fort Stanwix." After leaving the army he returned to Albany, where he managed family businesses of lumbering and brewing while maintaining military status by an affiliation with the New York Militia. On October 8, 1793, he was commissioned a major-general. It may well have been this event that prompted him to go to New York to be painted by Gilbert Stuart.

The artist was newly arrived in New York in 1793 after spending eighteen years in England and Ireland absorbing and polishing all the fine points of the art of painting fashionable portraiture. Back home in America, he thus had no competitor in the production of stylish and elegant portraits, and his work was immediately in demand. He stayed in New York for only one year before moving on to the seat of the federal government in Philadelphia, but in that one year he painted a number of handsome portraits of local sitters. In painting Gansevoort, Stuart used his usual format for a bust-length portrait. The head and body form a triangle set slightly off center. The dark sky serves to increase the luminosity of the powdered hair, pleasant face, and the light-toned elements of the sitter's dress. The gold shoulder epaulette, the buttons of the uniform coat, and the breast badge of the Society of the Cincinnati are painted with a bravura haziness, which adds decorative interest to the portrait, but which does not provide undue distraction from the importance of the blue-eyed gaze of the sitter.

Peter Gansevoort obviously wished to nurture his reputation as a military hero and Stuart did not disappoint him. Within the sitter's family until well into the present century the portrait had almost the status of a saintly relic.

Peter's grandson, the author Herman Melville, apparently had a copy painted for himself by Joseph A. Ames.[1] This painted copy is lost, but Melville's own, overly romantic, verbal copy survives in his novel, *Pierre*. The young hero of the novel is given a departed military grandfather, a character based upon Melville's own grandfather, Peter Gansevoort, and the household owns a portrait of him, which Melville describes as "a glorious gospel framed and hung upon the wall, and declaring to all people, as from the Mount, that man is a noble, godlike being, full of choicest juices; made up of strength and beauty."[2]

Newton Arvin, a biographer of Melville, made the irreverent observation that the portrait shows "the countenance of a Dutch brewer refined and ennobled."[3] A perceptive observation, but also one that is a testament to Gilbert Stuart's ability to flatter his sitter. Knowing of the penchant to flatter, one small detail of the portrait becomes even more surprising: on the sitter's right cheek, just next to his nose, Stuart has indicated a lump, or wen. We can only surmise that it must have been even more prominent than he painted it and an important detail of the face that even the artist's abilities could not make go away.

MONROE H. FABIAN

୫⤴ c. 1794
Oil on canvas, 30 1/8 × 25"
Museum purchase 54.88

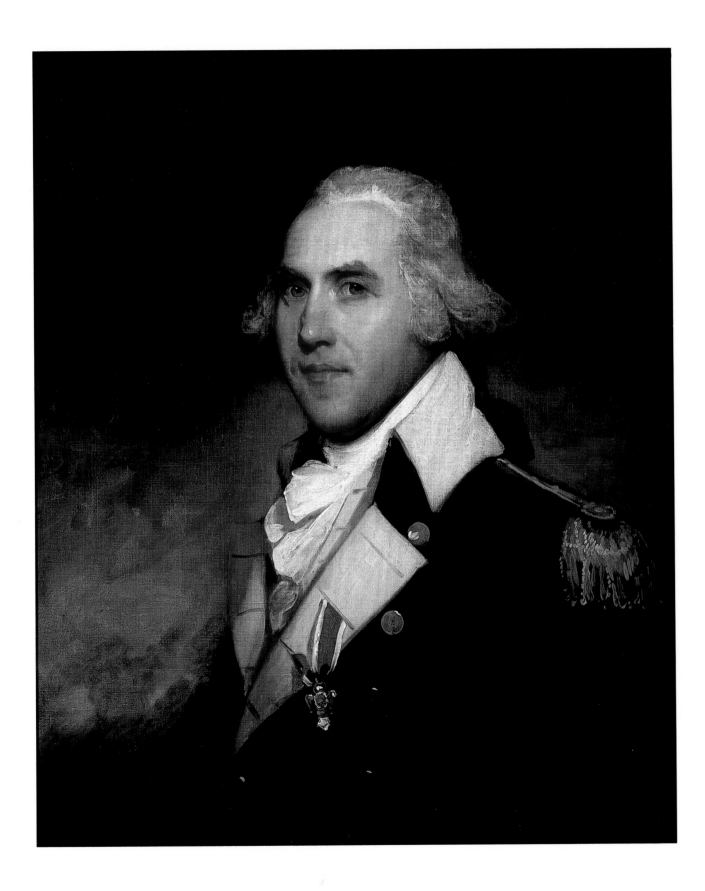

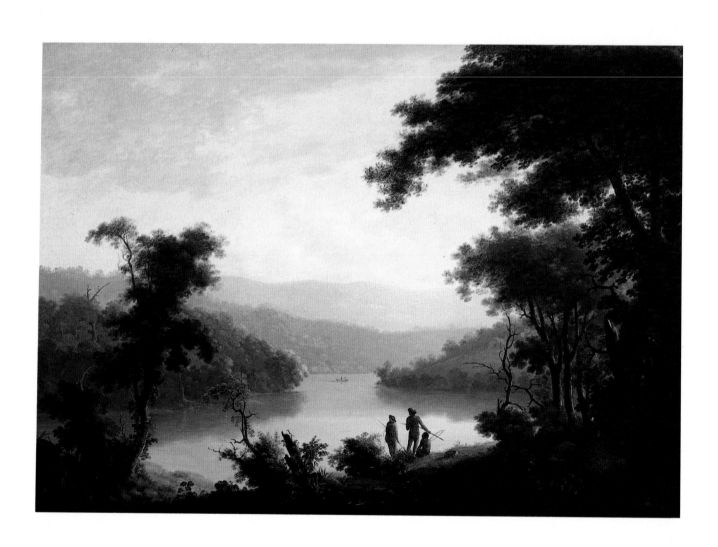

WILLIAM WINSTANLEY (1775–1806)
Meeting of the Waters

MEETING OF THE WATERS is one of only four major landscapes that can positively be ascribed to William Winstanley, an English artist whose career in America was limited to the last decade of the eighteenth century and the opening years of the nineteenth.[1] According to William Dunlap, Winstanley was a well-educated young man of good family who came to America in the early 1790s on business involving the Episcopal Church.[2] In 1795, the date of this work, he exhibited in New York a panorama of London, the first of its kind in America. By 1806 he was back in England, where he sent a group of American landscapes to the recently established British institution.

The little that is known of Winstanley's life and work revolves primarily around his association with George Washington. In April 1793 he was in Philadelphia, then the center of government, when Washington purchased from the artist two views of the Hudson—*Morning* and *Evening*—now at Mount Vernon. Two other landscapes were acquired by the President, who wrote a letter of introduction for the young artist, in September 1793, to the Commissioners of the District of Columbia. He referred to Winstanley as "a celebrated Landskip Painter" who intended to take a view of the Federal City. Washington further commented that he had suggested to Winstanley subjects in the vicinity, such as the Great and Little Falls of the Potomac, and the passage of that river through the Blue Ridge Mountains.[3]

Winstanley's visit to the future capital in late 1793 or early 1794[4] may have been the genesis of this painting, which has been known as *The Meeting of the Potomac and the Shenandoah Rivers at Harper's Ferry* since it was acquired by the Munson-Williams-Proctor Institute Museum of Art in 1963. The junction of these two rivers was renowned. Thomas Jefferson in *Notes on Virginia*, first published in 1784, had described the site as "one of the most stupendous scenes in nature" and worth a voyage across the Atlantic.[5] Jefferson's encomium may strike the present visitor to Harper's Ferry, as it did some of his contemporaries, as hyperbolic, but the union of the two rivers as they "rush together against the mountain, rend it asunder, and pass off to the sea" was and is dramatic. However, even if inspired by the actual merging of these two rivers, *Meeting of the Waters,* like the artist's two views of the Hudson, is not a faithful depiction of a specific locale, but rather a poetic evocation. Winstanley would have been aware of the distinction then made between a topographical or imitative view and an imaginative or creative landscape. And this painting, with its air of idyllic tranquility, was clearly conceived as a work of imagination.

Bathed in a diffused yellow light, *Meeting of the Waters* exudes a sense of repose. It is, in effect, an essay on the beautiful as defined by Edmund Burke in the mid-eighteenth century.[6] Delicate tints of greens and blues invest the scene with a clarity and freshness appropriate to the wilderness setting. The hushed stillness is almost palpable. The viewer of the painting moves gradually back into pictorial space, taking in, as do the fishermen on the shore, the picturesque beauty of the spot.

It is also a classical landscape. The balanced composition, framed by foliage, and the crystalline atmospheric effects ultimately derive from Claude Lorrain and Gaspard Dughet, Franco-Italian painters of the seventeenth century who had a far-reaching influence on the development of landscape.[7] Winstanley would have had many opportunities to see in England works by these artists, but strong echoes of their style were also present in the paintings of such contemporaries, or predecessors, as George Lambert, Richard Wilson, and Thomas Gainsborough. Yet it is not to British followers of Claude and Gaspard that Winstanley turned for a model, but to the popular French painter Claude-Joseph Vernet.[8] Like Vernet, Winstanley populates his landscape with graceful figures that add to the delicacy of the scene and contribute to its poetic tone. For *Meeting of the Waters,* despite its possible source of inspiration, does not offer a real view of the American wilderness, but rather a vision of a Virgilian idyll that transcends time and place. As such, it is a surprisingly sophisticated and artistically precocious painting for America at the end of the eighteenth century.

EDWARD J. NYGREN

&~ 6

RAPHAELLE PEALE (1774–1825)
Still Life with Steak

STILL LIFE WITH STEAK by Raphaelle Peale is one of that artist's most typical, and at the same time most unusual, pictures. Raphaelle, the oldest of the painter-sons of Philadelphia's artistic doyen, Charles Willson Peale, was also the most supremely gifted of his generation. Unfortunately, those gifts were in inverse proportion to their aesthetic appreciation by the connoisseurs of his time, which included critics, collectors, his fellow artists and his father, and very probably himself; that is, Raphaelle was, in general, a quite mediocre portrait painter, a first-rate miniaturist, and a brilliant still-life painter at a time when still life was deemed the least worthy of all the original forms and themes of artistry.[1]

This is not to say that Peale's still-life paintings were not admired by the critics of the early nineteenth century in Philadelphia, where Peale painted, nor that the leading patrons of art did not acquire his work; quite the contrary.[2] But the critics would always qualify their admiration by demeaning the genre itself, and the collectors would pay paltry sums for even the finest of his pictures. Charles Willson Peale, too, in his letters to Raphaelle and to other members of the family would commend Raphaelle as unexcelled in this special line of artistry, but would express concern that he improve himself in portraiture.[3]

Raphaelle Peale was the founder of the American still-life painting tradition as well as its finest practitioner, at least during his lifetime and arguably in the whole history of the art form in this country. While Raphaelle must have painted still lifes as early as 1795, when a group of eight of them were shown in the first public art exhibition held in this country, at the Columbianum in Philadelphia, almost all of his located works in this genre date from the decade of 1813 to 1822. This corresponds generally to the availability of public exhibition for such works, since, after the abortive single show held by the short-lived Columbianum, temporary exhibitions where artists might exhibit their work for sale did not start up again in Philadelphia until annual shows began to be held at the Pennsylvania Academy of the Fine Arts in 1811. While Raphaelle may well have painted still lifes during the almost two decades between the Columbianum show of 1795 and the first examples he exhibited at the Academy in 1812, it is likely that these years were primarily devoted to oil portraits, miniatures, and silhouettes, which would have been commissioned before they were created; still-life painting was generally speculative and necessitated an exhibition outlet.

Raphaelle's still lifes were almost totally pictures of edibles. Fruit painting constitutes the great majority of the approximately fifty-five located examples, as do also the projected 125–150 that one speculates he may have created. The objects in these pictures correspond to the aesthetics of contemporary Neoclassicism: he emphasizes solid, sculptural form, often reduced to near-perfect geometric shapes—spherical peaches, oval grapes, cleanly sliced watermelons, and the like. The fruit itself, too, seems in perfect shape, seldom displaying age or imperfection. The forms are laid out on a shallow surface, referred to as a "tabletop," but not precisely defined as such and possibly a shelf, or a board, of neutral tone. This "support" is not allowed to distract the viewer's attention from the primary objects, nor is the neutral background of a plain wall, animated only by a changing gradation of light and dark. The edibles themselves are arranged parallel to the picture plane and are usually centered on the support, the composition close-ended, with no forms protruding beyond the right and left edges of the composition. Occasionally, as in the present work, an element of the composition might overhang the "tabletop," but this small acknowledgment to the tradition of trompe l'oeil, or deceptive realism, is generally underplayed; formal concerns rather than trickery and illusionism are Peale's main motivations.

But while *Still Life with Steak* is, aesthetically, a classic example of Raphaelle's mastery at its finest, the subject matter is among his most unusual. Fruit paintings were viewed as decorative, suitable for hanging in a dining room or a parlor; vegetable and meat pictures constituted "kitchen" still lifes, and in their very nature were far less saleable, however beautifully rendered, and thus far less often painted. Other vegetable paintings by Raphaelle are known, though not many, but this is the only picture of meat known by him, and, in fact, 1817 would seem to be the last year that he painted kitchen pictures of any sort. The picture was probably completed in the winter of 1816–17, for he tended, as most painters, to publicly exhibit his most recent work; the present example was first shown at the Peale Museum in Philadelphia, in March 1817, when a local newspaper announced on March 4 that a "still life Piece, representing a fillet of Veal and Vegetables—Painting by Mr. Raphael [sic] Peale"[4] was on view there. Subsequently it was shown later that spring at the annual exhibition of the Pennsylvania Academy, but it still appears not to have sold, for it was shown again at the Academy, posthumously, in 1829.[5] For all the beauty of the rendering of its form, for all its abstract majesty, wherein Raphaelle endowed objects so utterly inelegant

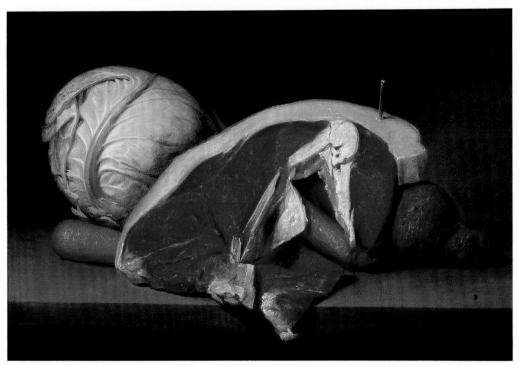

and mundane with formal grandeur and chromatic symphony, it did not have the necessary decorative appeal.

In Raphaelle Peale's oeuvre, the picture is unusual in another way, beyond its subject matter. In most of his still lifes, his choice of objects is dictated, as here, by their availability, but they are organized to conform to formal preoccupations; that is, they are chosen and arranged generally according to abstract concerns. Peaches and grapes may "go well" together, but they are not inevitable companions. In the other example of his work in the collection of the Munson-Williams-Proctor Institute Museum of Art, *Still Life with Celery and Wine,* celery makes little "sense" combined with yellow apples. But here, the beef, along with the cabbage, carrots, and a turnip, suggests a stew, a hearty, enjoyable meal, made certainly of only the finest ingredients, which logically combine together in daily eating. And it may be that the logicality of Raphaelle's choice of objects seemed to lack, therefore, his usual formal artistic selection and intention, qualities demanded of a "true" work of art.

Certainly, such a subject was exceedingly unusual, even unique, in early nineteenth-century Philadelphia or, for that matter, in this country. The presentation of a meal, per se, was a noted feature in many of the still lifes of the great eighteenth-century French master Jean-Baptiste Chardin, but Chardin's still lifes were not to be seen in Philadelphia at the time, nor would their lack of Neoclassic purity and austerity necessarily have appealed to the Philadelphia painter. More evocative would have been the work of the great Spanish seventeenth-century painter Juan Sánchez Cotan, several of whose paintings were shown at the Pennsylvania Academy in the following year, 1818, and were most probably brought to this country by Joseph Bonaparte around 1815; Raphaelle could conceivably have seen them even before they were shown publicly at the Academy. The aesthetic of Cotan is close to that of Peale's; moreover, both of the examples of Cotan's work, shown at the Academy in 1818, included vegetables that correspond with the two examples painted by Raphaelle in 1818 and now in the Munson-Williams-Proctor Institute Museum of Art—Cotan's now unlocated *Still Life—Celery, Birds, Lemons, Etc.,* and his *Still Life—Quince, Cabbage, Melon, Etc.* (San Diego Museum of Art). The pairing of these two works, which were most likely installed in 1816 in Point Breeze, the estate that Bonaparte purchased near Bordentown, New Jersey, not far from Philadelphia, and the two vegetable still lifes containing, respectively, celery and a cabbage, which Peale painted early the following year, seems more than coincidental.[6] Despite the honorable and historic lineage that such works by the Spanish master may have established, Peale was not to return to the vegetable theme again, and it appears extremely seldom even in subsequent American still-life painting. The theme of meat (except for the separate dead-game tradition) was even more rare, though it had previously appeared in Philadelphia at the Columbianum show of 1795 in the *Ribs of Raw Beef,* exhibited by Dr. John Foulke, an amateur artist and one of the organizers of the Columbianum. The theme resurfaces, perhaps most notably, in Henry Smith Mount's *Beef and Dead Game* of 1831 (Suffolk Museum & Carriage House, Stony Brook, New York), which seems more in the tradition of sign painting out of which Mount came than the fine arts heritage of still-life painting established by Raphaelle Peale.[7]

WILLIAM H. GERDTS

Probably 1816–17
Oil on wood, 13³/₈ × 19¹/₂"
Museum purchase 53.215

Alvan Fisher (1792–1863)
Eclipse, with Race Track

Alvan Fisher combines portraiture and landscape in *Eclipse, with Race Track* to create a sporting picture that is one of his most successful images dealing with the American Turf. Paintings of celebrated thoroughbreds had been popular in England since the mid-eighteenth century, but were unknown in the United States before a group of racehorse portraits was commissioned in 1822 by Charles Henry Hall (1781–1852), the New York agriculturist and breeder.[1] Fisher was the first American artist to paint domestic thoroughbreds for patrons such as Hall, who had become as fond of racing as their British counterparts.[2] Though he portrayed Duroc, Sir Archy, Virginian, and Sir Charles, American Eclipse was unquestionably the most famous stallion "excelling all the racers of the day, in the three great essentials of *speed, stoutness,* or *lastingness,* and *ability to carry weight.*"[3]

Foaled on May 25, 1814, at Dosoris on Long Island, American Eclipse was sired by Duroc out of Miller's Damsel.[4] Four years later he was regarded to be "the best three-mile horse of the day."[5] At maturity, American Eclipse was "a sorrel horse, with a star, the near hind foot white, said to be fifteen hands three inches in height, but in fact measures, by the standard, only fifteen hands and two inches. He possesses great power and substance, being well spread and full made throughout his whole frame."[6] On March 15, 1819, Eclipse was sold by Nathaniel Coles, the breeder, to Cornelius W. Van Ranst, who owned the racehorse during his most illustrious days.[7] For the next two consecutive seasons, the thoroughbred stood to mares on Long Island.[8] Soon after he resumed competitive racing in October 1821, Eclipse's national reputation was firmly established with several spectacular four-mile wins that culminated in the spring of 1823.[9] He was the first horse to be retired to stud and then to return successfully to the track.

On May 27, 1823, at the Union Course on Long Island, American Eclipse realized his greatest victory, a twenty-thousand dollar challenge match against Sir Henry, the colt representing Southern interests. By 1830 the editor of the *American Turf Register* could proclaim: "No race ever run in the United States has attracted so much notice, or had as much influence as that, in promoting attention to the breeding of horses and to the sports of the turf."[10] From as far away as the Boston suburbs, where he maintained a studio, Fisher informed his patron, "I wish very much to be present at the races."[11] He may have been among the "upwards of sixty thousand spectators" to attend the event.[12] Since Eclipse had lost the first of the three heats, Cornelius Van Ranst declared, "He appears always to rise with the occasion. He has now proved himself, beyond all cavil, to be a horse of speed and bottom unequalled in this country."[13] Despite subsequent offers of larger purses, Eclipse did not race again; his undefeated record was maintained for posterity. He became one of the most familiar names in American thoroughbred history.

To capitalize on the horse's popularity, Fisher painted many versions of Eclipse's portrait.[14] Though *Eclipse, with Race Track* is undated, the canvas closely resembles others that he executed in 1822 and 1823. Because the artist had hoped that Charles H. Hall would introduce his work to fellow racing enthusiasts, he notified him, "You thot [sic] it probable that I might dispose of some portraits of 'Eclipse' should I paint them. I have completed four pictures of him in a superior style."[15] *Eclipse, with Race Track* may be one of the "superior" works mentioned by Fisher. Its well-rendered landscape is not just a backdrop but frames the subject and provides narrative enrichment to the image. The painting with owner, jockey, and groom is more ambitious than those that depict only a single attending figure. Above all, the composition recalls the thoroughbred portraits, which illustrated the British Turf of the eighteenth century, by George Stubbs. It is, however, difficult to determine how familiar Fisher may have been with these oils before he traveled abroad in 1825. The artist possibly had access to engravings based on Stubbs's pictures. The similarity is conceivably more than mere coincidence and may account for the English character of Fisher's work.

Like the *portrait d'apparat,* in which a sitter's profession is suggested by both the accessories and surroundings, the subject of *Eclipse, with Race Track* is presented as an equine celebrity of muscular strength. Slightly angled from a profile view and facing right, American Eclipse stands brightly lit in the foreground, dominating the left side of the composition. The stance reveals his powerful front legs. Because the horizon is low, the contour of the thoroughbred's well-formed neck and back with plaited mane is prominently seen against a cloud-filled yet peaceful sky. He is firmly held by his owner, a literal reference to their relationship. Placed between Van Ranst and the racehorse, Samuel Purdy is seen holding a saddle and wearing the vibrant red racing silks that are the owner's colors. He is the jockey who rode Eclipse to many victories. At the far right, a groom is folding the animal's blanket.

Fisher has chosen the moment before the race begins. The horse is perfectly groomed, and Van Ranst is formally

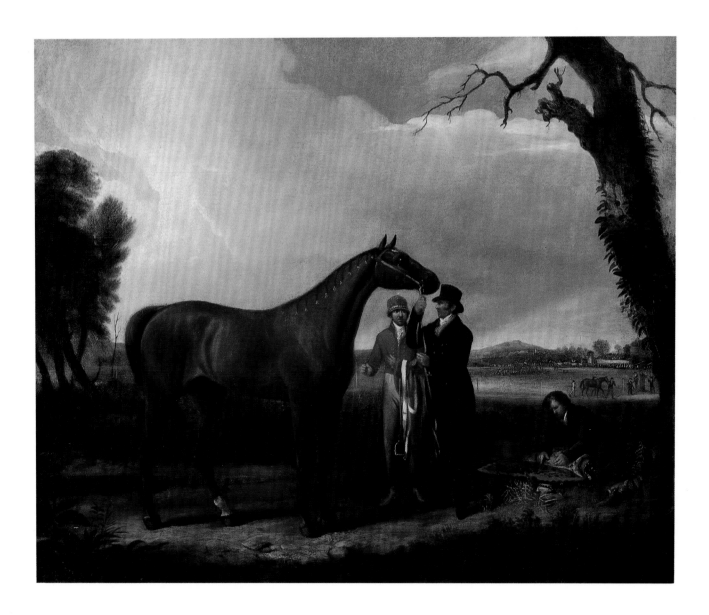

dressed. Any tension has been subdued; the thoroughbred and his attendants demonstrate full confidence. The painting is an image of composure, underscored by the picturesque landscape setting. It appears that Eclipse will be led to the track visible in the distance.[16] A crowd waits there for the contest to commence, while another horse is being led around the course for the benefit of the bettors. The implied narrative connects the foreground and background scenes, which might otherwise seem a bit disjointed.

When Hall loaned his thoroughbred portraits by Fisher to the early exhibitions of the National Academy of Design, an important aspect of the artist's career was brought to public attention. In 1827 a critic in the weekly *New-York Mirror* wrote: "Mr. F. bids fair to become a first-rate animal painter."[17] Although Fisher had introduced formal portraits of American racehorses to this country, his enthusiasm for native scenery caused him to forsake these sporting subjects in favor of landscape painting.

FRED B. ADELSON

Probably 1822 or 1823
Oil on canvas, 24 × 30″
Museum purchase 64.149

8

JAMES PEALE (1749–1831)
Still Life: Apples, Grapes, Pear

DEPICTING LATE-SUMMER FRUIT lying in and about a ceramic bowl on a simple table, this serene composition by James Peale is one of the artist's finest still-life paintings. Although not signed or dated, it may be attributed to his work of 1822–25 when compared with signed and dated works of the same subject.[1] The attribution is further supported by the provenance: the painting was inherited by James Peale's great-grandson, Clifford Peale, who sold it in 1939 to a New York dealer, who in turn sold it to the private collector from whom the Munson-Williams-Proctor Institute purchased it in 1978.[2]

It was the numerous Peale family of painters who introduced still life to American art.[3] By 1821 James Peale, then in his seventies, had given up painting miniature portraits, for which he is today best known, and had turned almost exclusively to still life and landscape. The traditional conclusion, however, that this change to a larger painting format was caused by failing eyesight may need revision. The meticulous surface detail of the fruit in this painting and certain others of the period indicates that the artist's vision was, in fact, capable of delicate close-up work.

More pertinent, still life was to give a new dimension to James Peale's work. His long experience in portrait painting, both life-sized and miniature, brought maturity and depth of meaning to a class of subject matter that even his older brother and teacher, Charles Willson Peale, student of Benjamin West and founder of the painting clan, regarded as merely decorative. His nephew, Raphaelle Peale, eldest son of Charles to survive infancy, had made still life his specialty and no doubt stimulated James to the new effort. Both had shown still life a few years earlier in the 1795 Columbianum exhibition in Philadelphia.[4] But in Raphaelle's still-life paintings the fruit and vegetable subjects were generalized, and the emphasis was on the aesthetic impact of both the composition and the ideal.

In the Utica still life, James Peale approached the subject as he would a group portrait. Each fruit is painted as an individual with its special merits and blemishes. Each of the five prominent apples has its own shape, color, and profile. One apple in the foreground—perhaps the equivalent of the grandparent in a family portrait—has begun to

decay and yet is painted with such sensitivity that it is as much an image of beauty as are the bunches of green and purple grapes in their youthful, relaxed postures. This variety is maintained throughout the picture—in the distinctions of the grape leaves, for example, and the dignity of the single standing pear on the left. The elegant decorated ceramic bowl, indicating the taste and station of its owner, provides the group with a special identity in the same way that a piece of fine furniture does in a portrait.

Peale's delight in color, already apparent in his miniature and life-sized portraits, was given the possibility of full play in his still-life works. In the Utica painting the profusion of fruit allows him a symphony of strong yellows, reds, oranges, greens, and blues that move across the panel and are reflected everywhere within the composition. Light entering from the left illuminates the assemblage and accentuates the shapes, which are also faintly lit in the right background. This Peale-type illumination[5] allows for a greater concentration on line and texture. The combinations of elements—the shallow space, the spatial clarity, and the silhouetted forms—are characteristically Neoclassical (the prevailing taste in the first decades of the nineteenth century) and can also be seen in Peale's portraits of the same period.

Far from being merely decorative, the Munson-Williams-Proctor Institute Museum of Art's still life represents James Peale at his most significant as an artist of maturity and penetration, as well as an inspired colorist who emerged at the beginning stages of the influential Neoclassical movement in American art.

LINDA CROCKER SIMMONS

c. 1822–25
Oil on wood, 18 3/16 × 26 3/8"
Museum purchase in memory of William C. Murray 78.45

JOHN JAMES AUDUBON (1785–1851)

Two Cats Fighting

UPON HIS ARRIVAL in Edinburgh in late October of 1826, John James Audubon was quickly lionized by Scottish society. In a letter to his wife begun on December 21, he wrote: "My situation in Edinburgh borders almost on the miraculous . . . I am positively looked on by all the Professors & many of the principal persons here as a very extraordinary man. . . ."[1] For the citizens of Edinburgh the novelty of having a genuine American woodsman in their midst must certainly have contributed to his popularity; however, Audubon's colorful background would not have been enough to sustain the public's interest were it not for the noteworthy exhibition of his drawings, which took place at this time in the rooms of the Royal Institution.

Encouraged by his notoriety, Audubon sought to broaden the range of his artistic output by improving his skill at oil painting in order to provide himself with funds to finance *The Birds of America*.[2] In the letter of December 21 to his wife Audubon noted: "Since here I have painted 2 pictures in oil now in the Exhibition—One contains II Turkies with a landscape—the other is my Otter in a Trap. My success in Oil painting is truly wonderful—I am called an astonishing artist. . . ."[3] Unmentioned in this letter was his painting of two cats, a pencil sketch for which appears at the bottom of a page of the artist's journal dated December 5, 1826.[4] Ten days later, Audubon wrote again in his journal of his plans to begin a painting of this subject and of the assistance he received from his agent and friend. "Mr. Lizars has been extremely kind [about] procuring cats for a picture that I will begin tomorrow."[5] On December 16 he noted how he overcame the difficulties of placing his subjects in a life-like composition: "My canvas was ready and the cats Mr. Daniel Lizars had sent me were ready to be killed! I asked the son of Mrs. Dickie to help

me. We hung the poor animals in two minutes each and I put them up in fighting attitudes ready for painting when daylight would come."[6] Two days later he noted: "My painting, of the cats fighting like two devils for a dead squirrel, I finished at 3 o'clock, having been ten hours at it."[7]

In view of the dead models that Audubon used for this picture, it is understandable why he spent no more than two days painting this work. And in posing his subjects, Audubon more than likely used the same wiring techniques that proved useful in his ornithological studies. As in those works, however, he was not too adept at blending his subject into a credible space. In executing the Utica painting his major effort went into delineating the color and texture of the fur of the two cats and the dead squirrel, whereas the moonlit sky, the flying tufts of hair, and the drops of blood in the foreground have all been painted quite rapidly, imparting a quality of spontaneity that is in keeping with the subject of the picture.

PAUL D. SCHWEIZER

ဒၜ 1826
Oil on canvas, 28 × 36¼″
Museum purchase 70.66

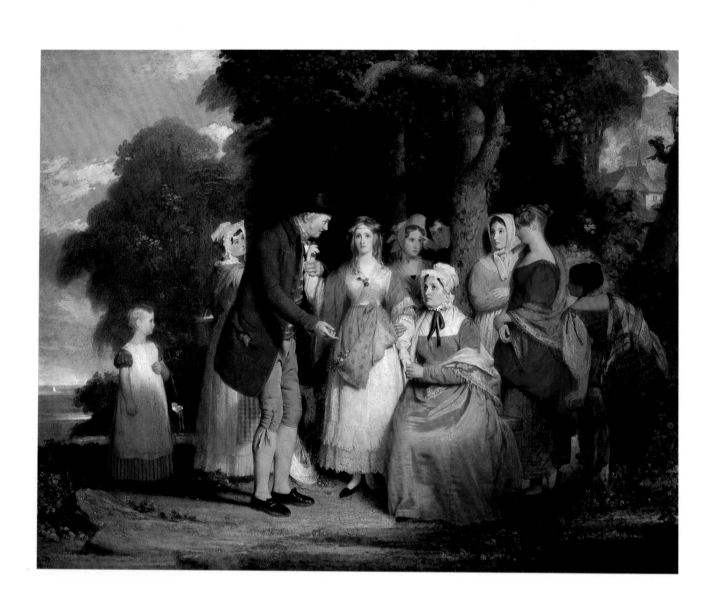

10

WILLIAM E. WEST (1788–1857)
A Domestic Affliction (Annette de l'Arbre)

HENRY TUCKERMAN'S ACCOUNT of William E. West's career assigns considerable importance to a painting he described as "Annette de l'Arbre."[1] Because an engraving was made after it by Joseph Andrews in London around 1835,[2] West's composition was well known; however, the actual painting, which was in the hands of a Boston family for more than one hundred years, was relatively unknown until it was acquired in 1960 by the Munson-Williams-Proctor Institute Museum of Art.

The picture's origins can be traced to late 1829 when both West and Washington Irving were in England. For several years before this, West had exhibited mostly portraits at the Royal Academy's annual exhibitions, but Irving persuaded him to paint works inspired by his stories, and during the two seasons they were together West only exhibited paintings based on Irving's tales.

For the 1830 Academy exhibition the artist painted a work derived from Irving's *Sketch Book* (1820) entitled *The Pride of the Village,* which is lost. Following the success of this picture, West illustrated another of Irving's stories for the 1831 exhibition. He titled the work *A Domestic Affliction* after the story "Annette Delarbre" in *Bracebridge Hall* (1822). When the work was shown at the Academy, it was accompanied by a short passage intended to explain the scene represented.[3]

In the center of the painting stands Annette, the belle of the village of Pont l'Évêque in Normandy, being comforted by a physician and the widowed mother of Eugene, who is Annette's lover. Her coquettishness caused him to run away to sea, and the sad rumor that he drowned in a storm afflicted her mind. In due course Eugene does return, but there is concern that her frail constitution cannot sustain the shock of seeing him, so their happy reunion is deferred for a while.

In West's painting Annette is depicted standing near the seashore surrounded by her friends, while Eugene stares longingly at her from behind a tree where he is hiding, a strangely comical detail that has no source in Irving's story. At one point in the tale, Annette is described as standing on the edge of a hill looking out to sea for her lover's returning ship; however, this passage does not men-tion the group of friends who surround her in West's painting, nor does it mention the bridal wreath she is wearing on her head. Both of these details as well as the sympathetic support that Annette is receiving from Eugene's mother, and the attention she is getting from the village doctor, who is shown measuring her pulse, were compressed into the composition from different parts of Irving's story. The resultant massing of figures assumes a distinctly theatrical aspect that may be indebted in a general way to some production West saw on the English stage.

Despite, or perhaps because of, the liberties West took with Irving's text, the painting was well received when it was shown at the Royal Academy. Charles Leslie recounted in a letter to William Dunlap that its "pathos and natural expression . . . attracted the admiration of Mr. Stothard and Mr. Rogers, two men whose good opinion is well worth having."[4] The consequence of Samuel Rogers's admiration of the picture was noted by Henry Tuckerman: "The appreciation of the bard of memory drew general attention to the picture."[5] News of West's triumph even attracted attention at the National Academy of Design in New York where he was designated an Honorary Member although up to 1832 he had shown only one work. Many years later West recalled how this picture helped him to establish his career as a portraitist in England: "That picture procured me my introduction to the English nobility."[6]

PAUL D. SCHWEIZER

1831
Oil on canvas, 44³/₈ × 56¹/₈"
Museum purchase 60.328

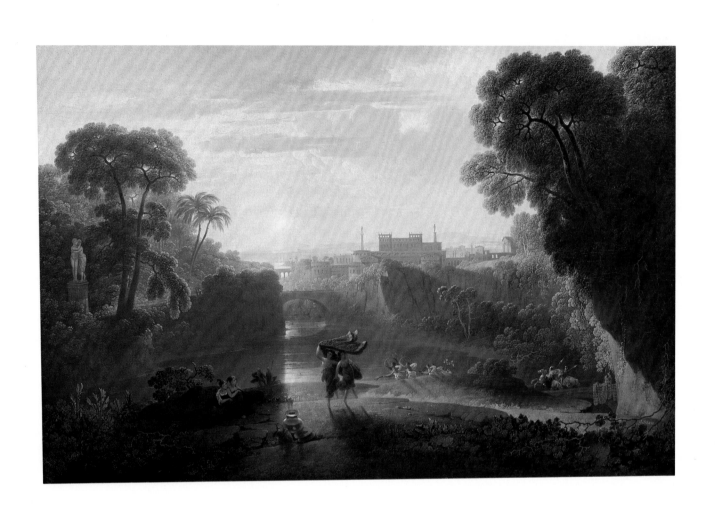

❧ 11

JOSHUA SHAW (1776–1860)
Dido and Aeneas Going to the Hunt

JOSHUA SHAW, PAINTER OF LANDSCAPES that often included exotic themes, was born in Lincolnshire, England, and as a youth was apprenticed to a sign painter. Largely self-taught, he had moved to Bath by 1802, and he began exhibiting his work at the Royal Academy in London. Sir Joshua Reynolds had died only a few years before, but the legacy of his *Discourses*—which advocated, among other things, that landscape should be ennobled by some scene from literature or history—lived on in the art of the aged Benjamin West. Shaw may well have seen such works by West as the *Telemachus and Calypso* of 1806 (Corcoran Gallery of Art),[1] a scene taken from Homer's *Odyssey* which depicts the meeting between Odysseus's son and the beautiful queen of the island upon which the Homeric heroes had become shipwrecked—a situation similar to the setting of Shaw's Utica picture. Scenes from the *Aeneid,* specifically of the Dido myth, had long been popular, and one of Sir Joshua's rare ventures into history painting was his *Death of Dido* of 1781 (Buckingham Palace).[2] In Shaw's own day, however, the artist who most frequently explored the visual potential of the subject was J. M. W. Turner, whose series representing the events at ancient Carthage—executed between about 1811 and 1817, the very years before Shaw left England for America—was influenced by the great seventeenth-century French painter Claude Lorrain. Turner transmitted to Shaw the Claudian idea of an idyllic landscape enveloped in the sun's golden glow.[3]

Shaw arrived in the United States in 1817 and settled in Philadelphia where he became an active member of the art scene. Along with Thomas Birch, he established landscape painting in America several years before the rise of the Hudson River School in New York. In 1819 and 1820 he worked on a series that was engraved and published, titled *Picturesque Views of American Scenery.*[4] But Shaw never forgot the type of landscape painting he had learned in England—one enriched by literary themes and rendered in the style of the Grand Manner, and that was quite different from his simple views of American scenery.

Shaw's *Dido and Aeneas Going to the Hunt* takes its subject from Virgil's *Aeneid.*[5] After the fall of Troy, Aeneas, his son Ascanius, and their men are shipwrecked at Carthage (the great city seen in the middle distance of Shaw's picture), which had been built by Queen Dido. At dawn one day Dido and Aeneas, bearing spears, ride out on a hunt; they are seen on horseback in the lower right, preceded by other members of the hunting party who sound great animal-headed trumpets. In the center two Maenads dance as a couple of shepherdesses look on, while a still life of gold utensils and a wine-filled glass attests to the wealth of this ancient land. At the left center a statue represents Cupid and Psyche, an image of the sensual love that is in store for Dido, for the clouds gathering in the upper right will soon bring a storm that forces her and Aeneas to take refuge in a cave, where their passion is consummated. Aeneas, however, eventually deserts Dido and the disconsolate queen throws herself upon a burning pyre.[6]

Shaw exhibited his *Dido and Aeneas* extensively, at the Boston Athenaeum (1831), the Pennsylvania Academy of the Fine Arts (1832), and the National Academy of Design (1835), and he frequently painted subjects in a similar vein.[7] But his American patrons tended to prefer straightforward views of real American scenery, and few of them shared Shaw's idyllic visions of landscapes in the Claudian mode.

WAYNE CRAVEN

❧ c. 1831
Oil on canvas, 26¹/₈ × 38¹/₂"
Museum purchase 60.197

JOHN QUIDOR (1801–81)

Antony Van Corlear Brought Into the Presence of Peter Stuyvesant

MANY NINETEENTH-CENTURY American artists attempted at least one painting based on a literary source, but John Quidor was unique in devoting his entire professional career to this genre. His subjects were drawn, almost exclusively, from American literature, with most based on the writings of our most popular early author, Washington Irving. His short stories and biographies supplied Quidor (and others) with a variety of subjects, but the source that inspired the largest number of paintings was the author's satirical Diedrich Knickerbocker's *History of New-York*.[1]

The Utica painting represents the moment in Irving's history when Van Corlear responds to the newly appointed governor's interrogation by "sounding his own trumpet," capturing the spirit of Irving's original, while substantially enriching and embellishing his presentation.[2] The other people, the howling dog, the painting on the rear wall, and other inanimate objects each serve a purpose, whether to underscore the basic storyline, to enrich the viewer's appreciation of the moment in relation to the larger history, or to present Quidor's own feelings toward his subject. Underscoring the moment and the impact of Van Corlear's music are the dancing figures, the wistful woman held in check by the guard, and the howling dog. The young woman, at the same time, personifies all the Dutch and Yankee women who, in different points in the history, are attracted to the trumpeter.

Other parts of the painting that provide historical continuity include the painting-within-a-painting on the rear wall and the relief carving over the door lintel. The former includes a boating party, stepped-gabled houses, and a figure hanging by the waist from a beam. This is a reference to Stuyvesant's predecessor, William the Testy, and the form of punishment he meted out for minor infractions of New Amsterdam's laws.[3] Juxtaposed to the form of punishment described in the small painting and reflecting the present regime rather than the past are what appear to be whips, the more effective tools of punishment used by Stuyvesant. The lintel relief also seems to make an historical allusion, both to Stuyvesant's furnishing his counsellors with long pipes in order to divert them from the cares of government, as described in the history, and to St. Nicholas, the patron saint of the city, prefiguring the end of Dutch control that occurred when the governor surrendered to the British.[4] Placing this scene over the head of Stuyvesant is Quidor's idea and combines the issue of the larger historical framework with that of the artist's own inventions and intent. Other examples of Quidor's inventiveness include the contemptuous guard, the urchins outside the door, and the proliferation of phallic objects used to represent both a pun on the governor's name and Irving's suggestive references to Van Corlear's prowess with his "trumpet."[5]

The entire composition is charged with an energy that enhances the pull-push composition that Quidor adapted from Dutch seventeenth-century prototypes. The boldness of his colors, the painterly quality, and the brilliant highlights conceal the pencil drawings beneath the paint, as well as the changes that infrared photography has revealed to us.[6] The most important figures are brought forward and modeled with light, as well as color, and the secondary figures are darker and recede into space. Forms are repeated and the whole composition is unified by the tubular forms of the guns, sword, and trumpet.

Quidor has taken a moment from Irving's satirical, yet benevolent and dispassionate, account and transformed it into a richly painted and many-faceted summation of both the Dutch era of American history and a deeply personal Rabelaisian view of mankind. No mere illustration of a literary subject, the painting has a style and a content that is the fullest expression of inspired artistic creativity.

DAVID M. SOKOL

ॐ 1839
Oil on canvas, 27³/8 × 34¹/16"
Museum purchase 63.110

⛤ 13

THOMAS COLE (1801–48)

The Voyage of Life: Childhood

EARLY IN MARCH OF 1839, Thomas Cole was commissioned by the prominent New York banker and philanthropist Samuel Ward, Sr., to paint an allegorical series of four paintings entitled *The Voyage of Life,* the subject of which he had conceived in the fall of 1836.[1] Cole began work with great enthusiasm on the first of the series, named *Childhood,* in September of 1839, using as his guide a number of preliminary pencil drawings and oil sketches. Despite the unexpected death of his patron several months later, he continued working on this picture until early 1840 when it was in large measure completed.

In contrast to the numerous figures and the exotic mise-en-scène that he used in his earlier set of allegorical paintings, *The Course of Empire* (New-York Historical Society),[2] Cole had the good sense to realize that for a commission that would be executed on four canvases, which were to be about the same size as the largest canvas of his earlier series, the project would be less tedious if he selected a subject requiring fewer figures. His great achievement in *The Voyage of Life* was his synthesis of three related ideas: that life is a pilgrimage; that a person's life can be divided into a number of distinctly identifiable stages; and that the course of a person's life can be metaphorically compared to a journey on a river that winds its way through the landscape of time.[3] Cole invented a pictorial program that combined these three universal, but potentially complicated themes in simple terms, one that did not require as many figures as were included in *The Course of Empire.* Moreover, by keeping those that were required relatively small, Cole capitalized on his skills as a landscape artist while simultaneously avoiding his shortcomings as a figure painter.[4]

Judging from a small ink drawing and a preparatory oil sketch that he made for *Childhood* (both Albany Institute of History and Art), Cole appears to have had a definite idea, when he first began planning *The Voyage of Life,* what *Childhood* should look like.[5] Of all four pictures in the series, his painting of *Childhood* is closest to the original idea suggested in these two preliminary works.

In the finished painting, Cole's infant voyager begins his journey on the river of life under the watchful eye of a guardian angel, who holds the tiller of a gilded boat that is adorned with angels and an hourglass. Cole suggested the optimism and joy of this stage of life by painting this scene in the warm and promising light of morning, and by the gesture of the child whose arms reach up to embrace an Edenic land adorned with a vast array of flowers simultaneously in bloom.

After all four paintings were completed and turned over to Samuel Ward's heirs, Cole began to fret about their fate. Ward's descendants appear to have lost interest in the pictures, but they were unwilling to let Cole buy them back so that he could exhibit them for the benefit of his reputation. As a result, when Cole was in Rome during the winter of 1841–42, he boldly decided to paint a second full-sized set (National Gallery of Art). The several changes he made in the design of the replica version of *Childhood* are best understood as representing his feelings about how he could improve upon the original composition. In the Washington version of *Childhood* there is a greater expanse of landscape at the right, which enabled him to show the river winding off to the horizon. He also raised the horizontal plane of the river and repositioned the gilded boat deeper in the picture and further to the left, thereby anchoring it more securely in midstream, rather than in the foreground, as it appears in the Ward composition.

PAUL D. SCHWEIZER

⛤ 1839–40
Oil on canvas, 52 × 78″
Museum purchase 55.105

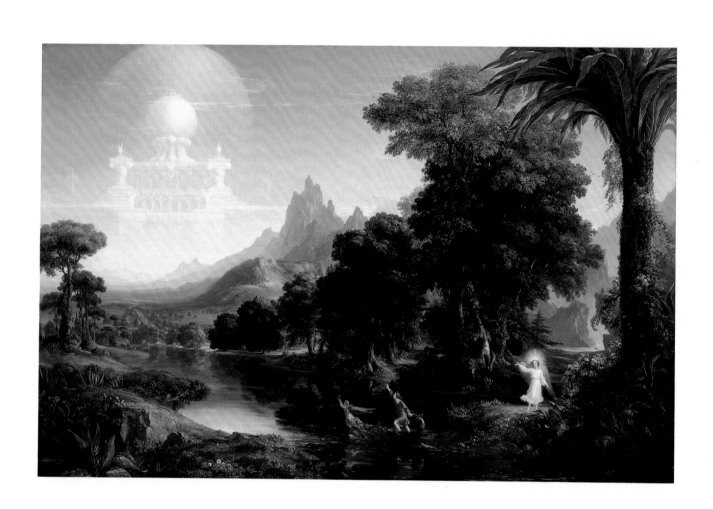

Thomas Cole (1801–48)
The Voyage of Life: Youth

EARLY IN 1840 Cole began work on *Youth,* the second picture in his four-part allegorical series *The Voyage of Life.* His preliminary oil sketch for this painting (Albany Institute of History and Art) shows that Cole originally intended to have the river flow from left to right, the same general direction as it flows in *Childhood.*[1] At some point before he began painting the final version of *Youth,* however, he changed his mind and decided to show the river flowing in the opposite direction. When questioned about this, Cole replied that it was dictated by "pictorial necessity." What he meant was that this change enabled him to avoid the problem that the series would appear monotonous if both pictures showed the river and boats heading in the same direction. In response to the charge that this change violated the internal consistency of the first two pictures, Cole explained that "there are many windings in the stream of life" and that the alternating direction of the stream in *Childhood* and *Youth* is the pictorial equivalent of the "changeable tenor of our mortal existence."[2]

Another reason Cole may have been willing to make this alteration involves the practical matter of how the completed series, which requires around forty feet of wall space, was to be installed in Samuel Ward's private picture gallery.[3] It is clear from the efforts Cole took in planning the original installation of *The Course of Empire* (New-York Historical Society)[4] that he was deeply interested in such matters; if, as it seems likely, there was no single wall in Ward's gallery long enough to accommodate four elaborately framed six-foot-wide pictures, Cole recognized before painting *Youth* that he should modify his original plan so that the series would be a success even if it were necessary to display it as two pairs of pictures on separate walls.[5]

To achieve this, Cole designed *Youth* so that the course of the river (upward and to the left) formally complements the flow of the river in *Childhood* (downward and to the right). Moreover, in *Youth,* the gesture of the guardian angel, as well as those of the youth and the angel holding an hourglass at the bow of the boat, all point in the same direction as the river flows and help to draw attention to Cole's architectural vision which—being much more fantastic than the shallow-domed building appearing in the

Albany sketch—defies stylistic categorization: its spherical dome and lancet arcades are reminiscent of Hindu architecture, which Cole could have studied in the illustrated travel accounts and architectural treatises available to him in libraries, such as the extensive one assembled by his patron, the architect Ithiel Town.[6]

Movement toward the background of the picture is also established by the line of trees on the right riverbank, whose crowns create a strong diagonal leading to the point where the river makes an abrupt turn to the right and a trail begins winding over the hills into the distance. The large beech in the right foreground, which towers over the voyager and his guardian angel, is the only tree whose top disrupts the regularity of this diagonal line of trees. When examined in raking light, the raised paint surface that describes this tree suggests that it was painted on top of what Cole at one point may have regarded as a finished paint surface. By adding this beech Cole was able to soften the rigid geometry that he had inadvertently established with this line of trees. Assuming this to be the case, it would help to explain the statement Cole made to his wife several years later that the trees in this picture gave him difficulty.[7] When he painted his full-sized replica of this work in Rome early in 1842 (National Gallery of Art), Cole took pains to introduce more variation into the crowns of this receding line of trees and to anchor the roots of the largest beech more plausibly in the side of the riverbank.

PAUL D. SCHWEIZER

ॐ 1840
Oil on canvas, 52½ × 78½"
Museum purchase 55.106

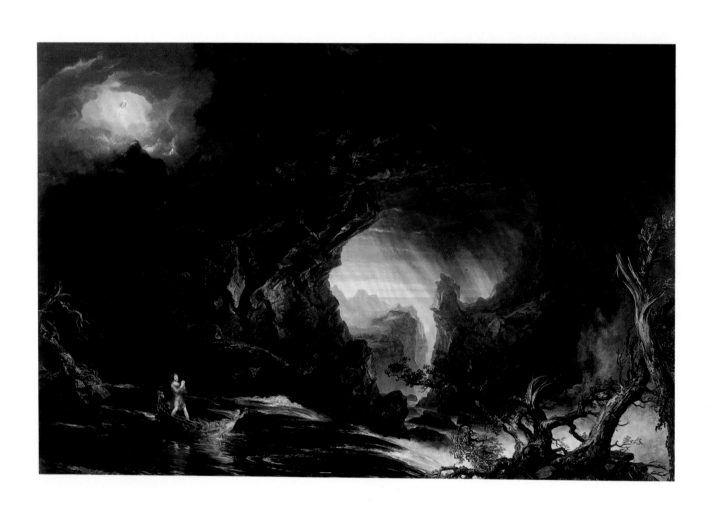

☙ 15

Thomas Cole (1801–48)
The Voyage of Life: Manhood

Cole painted *Manhood,* the third picture of his allegorical series *The Voyage of Life,* during the summer and fall of 1840, at a time when he was having considerable difficulty getting permission from Samuel Ward's children and from the administrator of Ward's estate to exhibit the soon-to-be-completed series in New York City before turning them over to his former patron's family.

In view of the differences between the finished painting of *Manhood* and his preliminary oil sketch (Albany Institute of History and Art)[1]—which looks more like a coast scene than a river view—it would appear that his plan for this stage of the series satisfied him less than the other three Albany oil sketches. Part of a description written by Cole for this stage of the commission, "the rapid river foams over broken rocks,"[2] indicates from the time he first conceived the series that he fully intended to continue the motif of the river in *Manhood,* but that it took him some time to decide how this idea should be translated into paint. At some point while he was working on the large version of *Youth,* however, he must have resolved the basic idea for the next picture for he included in the right background of the second picture a hint of the rapids that would form an essential feature of *Manhood.* And just as Cole incorporated in the second painting a view of the third picture's impending rapids, so also did he give some hint of the ultimate goal of the voyager's journey in *Manhood* by including a view of the broad ocean, which forms a principal feature of the design of *Old Age.*

The bright light of midday, which Cole painted as the natural equivalent of adolescent hope in *Youth,* was replaced in *Manhood* with the clouds of middle age. As the voyager stands stiffly in a rudderless boat, his plight is observed from the sky by the guardian angel and by three ghosts whom Cole identified in his published gloss on the series as the demons of Suicide, Intemperance, and Murder. Cole also notes that the "upward and imploring look of the voyager, shows his dependence on a Superior Power, and *that* faith saves him from the destruction that seems inevitable."[3] The religious awakening that the voyager experiences is the dramatic and emotional turning point of the series, as well as the precondition for the salvation depicted in the fourth picture.[4]

It would appear that even after Cole completed Ward's full-sized version he was not entirely satisfied with its appearance. In Rome during the winter of 1841–42, after he decided to paint the series again, it was this composition that he executed first and in the process made more changes than he would in any of the other pictures in the replica set (National Gallery of Art). The most important alteration, and the one that significantly improved the overall design, involved reducing the massiveness of the wall of rocks that towers over the voyager. This enabled Cole to depict a larger expanse of the distant sea as well as a more luminous sunset. He also painted an entirely different tree at the right and, as with the second version of *Childhood,* repositioned the voyager's boat. In the replica it is further back in the picture and seemingly closer to the beginning of the rapids. He also altered the appearance of the voyager by giving him a heavier beard and by changing his stance in the boat so that one bent leg is supported by a bundle of worldly goods, which are missing when the boat glides out into the open sea in *Old Age.*

Paul D. Schweizer

☙ 1840
Oil on canvas, 52 × 78"
Museum purchase 55.107

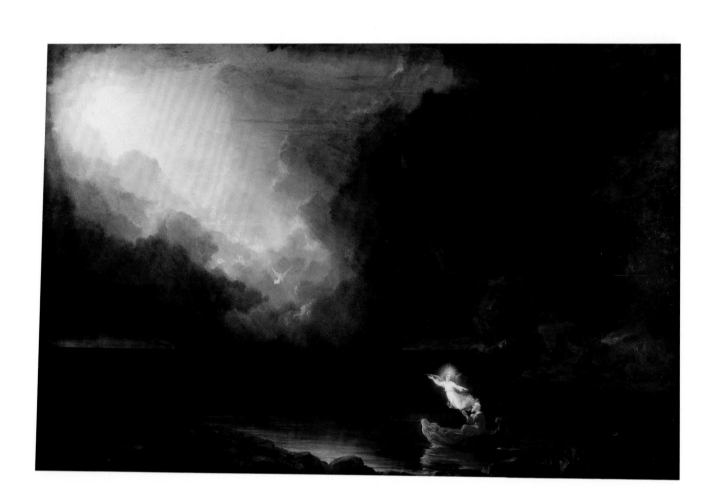

16

THOMAS COLE (1801–48)
The Voyage of Life: Old Age

COLE'S PAPERS DO NOT INDICATE when he began *Old Age,* the fourth and last picture of his allegorical series *The Voyage of Life.* By November 18, 1840, however, the picture must have been fairly well completed, for by then he had shipped the series from his studio in Catskill to New York City, where the paintings were hung in the National Academy of Design's well-illuminated galleries so that he could paint whatever final adjustments the four pictures needed.[1]

Like his oil sketch for *Youth,* the preliminary design for *Old Age* (Albany Institute of History and Art) reveals that Cole originally intended the course of the river in this picture to flow from left to right.[2] When it came time to execute the Utica picture, however, Cole followed the pattern he had established with the second canvas by reversing the design so that the series formed two compositionally complementary pairs.

While the relative absence of landscape elements in the finished version of *Old Age* might seem to be the result of Cole's exhaustion as he neared the end of a year-long campaign to paint four large pictures, the Albany sketch for this canvas indicates that, from the time he first began planning Ward's commission, he regarded the bare and forlorn landscape, which is the principal feature of this stage of the series, as an appropriate natural equivalent to the closing years of life.

Having survived the rapids of *Manhood,* Cole's voyager is shown emerging from the river of life into the ocean that was first seen in the background of the third picture. In the sky at the upper left, the clouds have parted, allowing a burst of heavenly light to shine down on the aged voyager. While the apocalyptic skies that appear in the paintings and prints of the English artist John Martin may have been a source of inspiration for the sky in this picture, Cole was probably influenced as well by Rembrandt's etching *The Angel Appearing to the Shepherds,* an impression of which captured his attention at the British Museum during his first trip to London.[3]

For the first time in the series, Cole has shown the voyager facing his guardian angel. With one hand, the angel makes a gesture of benediction, similar to the one that appeared in *Childhood,* and with the other hand points to the host of angels descending from the sky. In what may be an attempt to underscore the voyager's imminent passage to immortal life,[4] Cole painted the voyager's boat without the angel and hourglass at the bow. When he painted this boat again in his second full-sized version (National Gallery of Art), Cole repeated this detail and, additionally, omitted the volute at the boat's stern. He also made changes in the arrangement of the rocks in the picture's fore- and middle grounds, and repositioned the voyager's right hand so that instead of touching his chest with his fingers, as it appears in the Utica picture, the palm of his hand is turned outward toward the heavenly light.

PAUL D. SCHWEIZER

1840
Oil on canvas, 51¾ × 78¼"
Museum purchase 55.108

45

🦢 17

HENRY INMAN (1801–46)
Trout Fishing in Sullivan County, New York

I remember going round your exhibition of the National Academy at Clinton Hall in New York, and seeing a fine landscape, I asked, "Who painted this?" The answer was, "Inman." Then I came to a beautiful group of figures—"Ah, this is very clever—let us see whose this is." I looked at my catalogue,—"Inman." Then some Indians caught my eye—catalogue again—"Inman." A little further on, and I exclaimed, "By George, here is the finest miniature I have seen for many a day!" It was a lady in black, "Who is this miniature painter?" "Inman." His large portraits I was acquainted with, but this variety of style took me altogether by surprise.[1]

THOMAS SULLY'S DESCRIPTION of his reaction to the work of his New York colleague, Henry Inman, is probably the most quoted evaluation of Inman's career made during his lifetime or afterward. Sully, as supreme in Philadelphia portraiture as Inman was in New York, here focuses on Inman's extreme versatility—extremely unusual at a time when painters tended to specialize in a single genre or at least achieved their primary success in one or another theme. Enjoying far greater longevity and being equally productive, Sully had a much greater oeuvre than Inman; Sully, too, explored a variety of subjects, but he never garnered the acclaim for such variety in his work.

Despite such a reputation, however, Inman was primarily a painter of life-size oil portraits. Despite the occasional masterwork by such of his colleagues as Samuel F.B. Morse, who provided New York's City Hall with his great full-length likeness of the Marquis de Lafayette in 1825–26, Inman was New York's finest portrait painter between c. 1825 and his early death at the beginning of 1846. Inman's career as a miniaturist was pretty well confined to his beginning years in the 1820s; and his excursions into landscape, genre, and literary paintings were few and sporadic, most of the better known of these being painted in the later years of his life, although Sully's reminiscence must be from the early 1830s, after the Academy moved to Clinton Hall in 1831. I have dealt elsewhere with Inman's genre paintings, which, though few in number, garnered a good deal of notice due to their reproduction in the popular gift books of the period.[2] Inman's interest and accomplishment in landscape painting are also attested to in several of his literary and genre pictures, most notably his now unlocated *Lake of the Dismal Swamp* and his 1845 *Dismissal from School on an October Afternoon* (Museum of Fine Arts, Boston).

"Pure" landscape paintings by him—that is, pictures in which the enjoyment of Nature for its own sake rather than as an appropriate setting for figural activity is the primary motivation—are exceedingly rare; among the best known were several he painted on his only trip abroad, when he visited England, in 1844–45, and painted the scenery at Rydal Mount, the home of William Wordsworth, as well as a fine portrait of the great poet. The present example, *Trout Fishing in Sullivan County, New York,* was probably the most acclaimed in its time and is also the most autobiographical, since Inman was almost as well known for his piscatorial enthusiasm as he was for his artistry. The format of the painting suggests the work of his contemporary, Thomas Doughty, who often placed a small fisherman within an otherwise tranquil wilderness setting, which emphasized Nature's grandeur. Doughty's figures, however, may be merely contemplative or may actually be fishing, but they function primarily as surrogates for the viewer. In Inman's painting the figures are not only more actively engaged in several aspects of the sport, but they are quite specifically defined and may even be identifiable. In June of 1841, Inman spent time fishing in Sullivan County with his close friend and fellow sportsman Richard T. Fosdick. Since the present work was painted the previous winter, it most probably documents a similar fishing trip made the previous year when Fosdick and Inman are known to have fished together. The boy seated on the bank by the principal fisherman appears to be about twelve years old and may represent Inman's son, the future painter John O'Brien Inman, born in 1828.[3]

By and large, Inman's picture was well received when it was exhibited at the sixteenth annual exhibition of the National Academy of Design, which opened on May 3, 1841, although several critics deemed the palette "too green," a not uncommon criticism of his work. Again, his versatility was noted and confirmed, for the present landscape was accompanied by both portraits and the first of his series of mature genre pictures of the 1840s, his Dickensian *The Newsboy* (Addison Gallery of American Art).[4] The picture appeared at the third Boston Artists' Association exhibition in 1844, again in New York at the Inman Memorial Exhibition held at the rooms of the American Art-Union in February of 1846, and at the annual exhibition of the Pennsylvania Academy of the Fine Arts in Philadelphia in 1847. In the Memorial Exhibition the picture was again much admired, and the propitious union of the late, lamented artist's primary vocation and avocation was justly noted.[5]

WILLIAM H. GERDTS

🦢 1840–41
Oil on canvas, 25 1/8 × 30"
Museum purchase 83.14

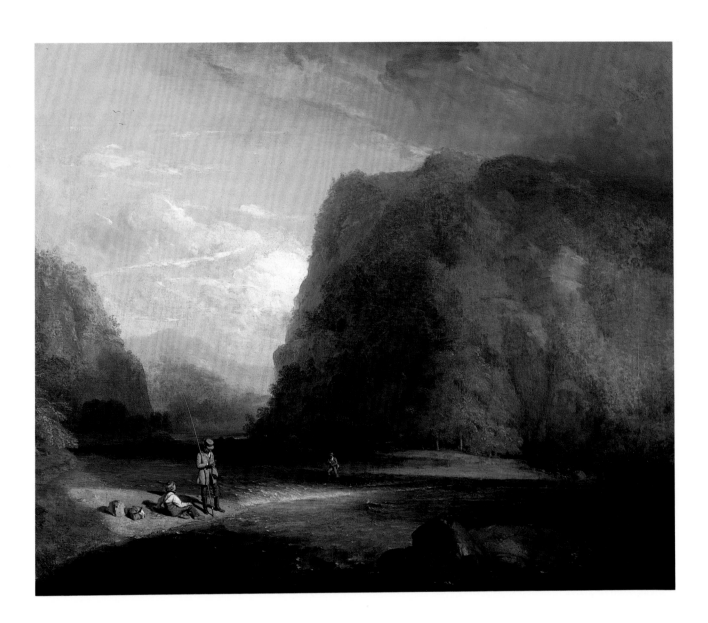

Asher B. Durand (1796–1886)

Woodland Path

Asher B. Durand had been America's most eminent engraver before his inclination toward painting caused him to give up the burin for the brush in 1834, when he was nearly forty years old. After concentrating on portraiture in the late 1830s, he went to Europe for a brief visit, and by about 1841 he committed himself to landscape painting, doing so with the encouragement of his good friend, Thomas Cole, and his patron, Luman Reed. Cole had already turned to fantasy landscapes that were didactic tableaux in history and morality for which most American patrons did not really care, and Frederic Church had not yet become the dominating force he was after about 1855; during the decade following 1845, Durand was the most popular member of the so-called Hudson River School of American landscapists. It was early in this period that he painted the picture the Munson-Williams-Proctor Institute Museum of Art now owns—*Woodland Path*, which is related to his famous *Beeches* of 1845 (Metropolitan Museum of Art) and his celebrated *Kindred Spirits* of 1849 (New York Public Library).[1]

Durand, under the influence of Cole, had tried his hand at idealized, historiated landscapes, converting American scenes into classical allegories or medieval reveries, but he soon rejected this type as foreign to him as an artist and to the taste of his patrons. Instead, Durand took the American wilderness and domesticated rural scene as his themes. He painted innumerable secluded woodland nooks, in which no human presence is to be found; majestic old trees assumed the starring roles, as in *Woodland Path*. Durand once wrote: "The true province of landscape art is the representation of the work of God in the visible creation, independent of man, or not dependent upon human action."[2] The fervor with which a contemporary critic might respond to his visions is evident in Henry Tuckerman's comments: "There is great individuality in Durand's trees. This is a very desirable characteristic for an artist who deals with American scenery. No country boasts more glorious sylvan monarchs ... [and] each genus presents novel specimens eminently worthy of accurate portraiture."[3]

The *Woodland Path* was probably executed as a sketch, but the term "sketch" needs some clarification in relation to Durand's method of working. He was among the first to paint from nature, on location out of doors, and he frequently painted rather highly finished studies, which would later, back in the studio during the winter months, be combined to produce larger canvases. There are several similar studies of about the same size and date at the New-York Historical Society.[4] While some of their compositional problems may not be resolved, these sketches often possess an intimacy and a spontaneity that are lost in Durand's larger "finished" pictures.

Durand's son, John, has left us a perceptive description of the way his father worked, and it applies well to *Woodland Path*:

My father's practice was, while faithfully painting what he saw, not to paint all that he saw. Finding trees in groups, he selected one that seemed to him, in age, color, or form, to be the most characteristic of its species, or, in other words, the most beautiful. In painting its surroundings, he eliminated all shrubs and other trees which interfered with the impression made by this one. Every outdoor study ... was regarded as a sort of dramatic scene in which a particular tree or aspect of nature may be called the principal figure.[5]

A label on the stretcher indicates that the picture at one time belonged to Charles Lanman, the author and sometime-artist. Durand and Lanman were very close, and the Institute's picture may well have been a gift from the artist to his friend and erstwhile pupil. A painting, also titled *Woodland Path* and of about the same dimensions, was listed in the sale of Lanman's collection in 1915.[6]

Wayne Craven

ॐ c. 1846
Oil on canvas, 21 1/2 × 17 1/4"
Museum purchase 86.62

19

James Goodwyn Clonney (1812–67)

Mexican News

After visiting the United States briefly in 1842, Charles Dickens complained in print that Americans "certainly are not a humourous people, and their temperaments always impressed me as being of a dull and gloomy character," as if unduly "oppressed by the prevailing seriousness and melancholy air of business." As an instant antidote to this and several other flaws he perceived in the national character, Dickens prescribed "a greater encouragement to lightness of heart and gaiety, and a wider cultivation of what is beautiful, without being eminently and directly useful." In short, the novelist concluded, "it would be well, there can be no doubt, for the American people as a whole, if they loved the Real less, and the Ideal somewhat more." But even if this remedy did not take immediately, Dickens still hoped to hear in the future "of there being some other national amusement in the United States, besides newspaper politics."[1]

In light of these John Bullish remarks, it is instructive to learn that James Goodwyn Clonney's *Mexican News* was but one of several entertaining genre pictures of the 1840s in which American males—whose crude public manners, political passions, love of trade, and delight in sharp dealing had filled Dickens with aversion—were carefully, even fondly depicted holding, reading, reacting to, or arguing over newspapers. However, unlike what takes place in Richard C. Woodville's paintings of 1848, *War News from Mexico* (National Academy of Design) and *Politics in an Oyster House* (Walters Art Gallery), or in Clonney's own earlier work in a similar vein, *Politicians in a Country Bar* of 1844 (New York State Historical Association, Cooperstown), the paper in *Mexican News* provokes neither sudden surprise and excitement nor a heated partisan debate.[2] Instead, the stark simplicity of the composition as a whole, the comparatively tight, dry handling of the two figures (who seem to be sitting on the sunny porch of a rustic inn), and the remarkable absence of melodrama or even narrative detail, except for the headline (which is readable upside down), make it clear that the artist was intent on achieving a good-natured, yet unsentimental realism, free of distracting traces of the Ideal.[3]

The faces, gestures, and costumes of the two protagonists in *Mexican News* also prove the point that, even though their creator had been born in Great Britain in the same year as Charles Dickens (who claimed that all Americans seemed alike: "There is scarcely a man who is in anything different from his neighbor"[4]), Clonney contemplated the denizens of the New World from a much closer perspective. As a resident of the New York City area since the early 1830s, working first as a miniaturist and later as a genre painter in the mold of William S. Mount, and then as a naturalized citizen after 1840, Clonney must have developed an insider's eye for distinctive American types. In *Mexican News,* for example, the older, toothless man about to drink from his mocha-ware mug must have been a favorite model because of his somewhat comic features. Wearing similar clothing while sitting on a rock, rather than a Queen Anne chair, he reappears in another Clonney painting of 1847, *The Happy Moment* (Museum of Fine Arts, Boston), where he shows off a fine catch at the end of his fishing line.[5]

The younger man holding the newspaper in *Mexican News* also has the air of an identifiable rural type. His forage cap, his dark jacket worn without a vest, and his buff-colored pants mark him as being more modish and probably more affluent than the older man, though far from a city slicker. The Staffordshire pitcher and small empty glass beside him on the end of a convenient bench suggest that he, too, has had something to drink, but then again he may have been serving his companion from that pitcher more often than himself. Still more importantly, the backward tilt of his Hitchcock chair, a graceless social habit ridiculed in Frances Trollope's scathing report on the *Domestic Manners of the Americans* in 1832, virtually brands him as the unsophisticated—Mrs. Trollope would have said uncouth—product of a new democracy and obviously proud of it.[6]

It must be national pride that shows in both smiling faces in *Mexican News*. Reports from the war zone described one American success after another in 1847—from General Zachary Taylor's victory at Buena Vista in February to the capture of Mexico City in September. Yet there is a key difference between Clonney's characters. In the deferential turn of the younger man's head, clearly visible in the earliest preparatory drawings, the artist created a tension that holds the viewer's interest.[7] The young man appears to be waiting expectantly for the next words, the next humorous aphorism, the next example of Yankee wit, the next bit of crackerbox philosophy to come from the mouth of the older fellow who seems perfectly cast in the popular role of the comic countryman, the American cousin, the Brother Jonathan able to embody the homespun humor and defiant spirit of an entire nation.[8]

Ellwood C. Parry III

1847
Oil on canvas, 26¾ × 21⅞"
Museum purchase 66.73

51

Severin Roesen (active c. 1847–c. 1871)
Still Life with Fruit and Champagne

Severin Roesen chose to sign and date very few of his canvases, a fact that can be interpreted as an indication of the artist's satisfaction with a particular work. Only two canvases from 1853 are recorded, the Munson-Williams-Proctor Institute Museum of Art's *Still Life with Fruit and Champagne* and *Flower Still-life with Bird's Nest* (Jo Ann and Julian Ganz, Jr., Los Angeles).

Both paintings were executed five years after Roesen's arrival in New York City, where he, like many other German artists, had fled to escape the political turmoil of mid-century Germany. Roesen came to this country at a time when the Dutch still-life tradition was becoming popular in New York through exhibitions of the work of artists such as Johann Wilhelm Preyer. Following his arrival, Roesen's paintings appeared regularly in the exhibitions organized by the American Art-Union, a contemporary indicator of the popularity of the artist.

While *Still Life with Fruit and Champagne* contains motifs from his first known paintings, it is one of Roesen's earliest New York pictures to exhibit both stylistic and thematic elements characteristic of his mature period in Williamsport, Pennsylvania, c. 1860–72. These include the use of a horizontal format and the arrangement of two dark, marble tiers extending from the right side of the canvas and ending just before the left side.

The white epergne appeared in Roesen's work as early as 1850 but with an unornamented stem; in the Utica painting Roesen decorated the pedestal with carved cabbage roses and morning glories, whimsically alluding to their living counterparts in his floral compositions. Another painting, dated 1851 (The White House, Washington), includes an open-work basket, which would become a standard motif in Roesen's fruit still lifes, sometimes filled with peaches as in the Utica example, and at other times containing an assortment of fruits.

Roesen's first dated work, a floral still life of 1848 (Corcoran Gallery of Art), depicts a profusion of flowers composed around a gentle *s* curve. His later work is more robust and compact, while at the same time more stable and frontal. As in the Utica painting, the objects are lined up along the picture plane with more emphasis on shape and color, and less interplay between foreground and background. Here a unifying diagonal, which also serves to enliven the composition, is created by the wonderfully elegant line of the grapevine, which runs from the upper right to the lower left of the painting.

It is certain that Roesen did not work directly from life; too many of his themes reappear throughout his career of twenty-four years, while few new motifs are introduced. In the Utica painting, Roesen's willingness consciously to alter nature to enhance his composition is apparent in the cluster of purple grapes at the lower center, which appear as if they have sprouted from a vine of white grapes.

Evidence of Roesen's early training as a painter on enamel can be seen in this picture's precise execution, polished surface, and glowing color—characteristics that are all reminiscent of that decorative medium. The rendering of detail on such a large scale is remarkable as is the effort to evoke textures and qualities specific to each element in the composition. The lemon rind, for example, is realistically pockmarked and rigid, while the thin, luminescent membranes of each grape look strained and ready to burst with juice.

At the same time, however, Roesen's close observation of the structure of strawberries results in a schematic presentation resembling tiny, unappetizing pinecones. The flourishes of the vine tendrils and the ubiquitous dew drops seem somewhat contrived, but certainly add to the sensory delight of the picture.

This dichotomy is typical of Roesen's work, causing some critics to feel that he successfully imitates nature, while others feel that his work is artificial. In actuality, he epitomizes what Barbara Novak has described as the American ability to be creationist and evolutionary[1] by romantically celebrating the mystical side of nature while simultaneously subjecting it to close botanical scrutiny.

Judith Hansen O'Toole

ॐ 1853
Oil on canvas, 30 × 44"
Museum purchase 82.53

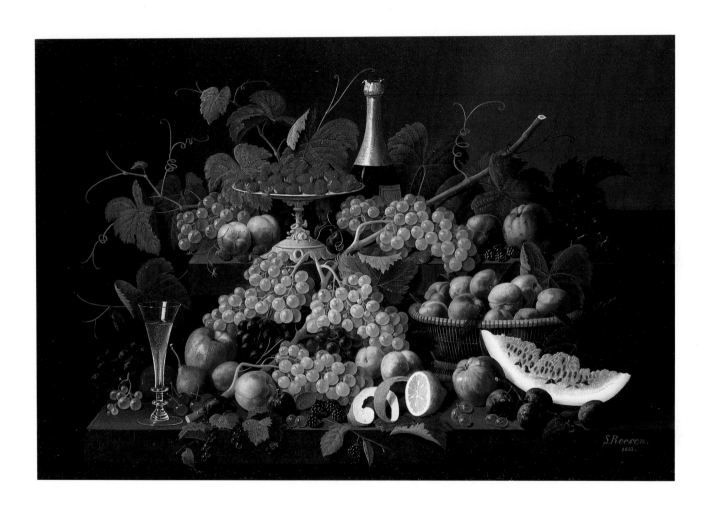

JASPER FRANCIS CROPSEY (1823–1900)

Castle by a Lake

AMERICA HAD NO CASTLES. Its unique past was to be seen in vast untouched wilderness, firsthand evidence of a natural history long vanished from the Old World. American writers such as William Cullen Bryant and Ralph Waldo Emerson, and painters such as Thomas Cole extolled the moral message to be found in primeval nature. Jasper Francis Cropsey followed such admonitions and drew carefully after nature, but he was also one of the American artists who were strongly attracted to ruins, castles, and other European monuments to human history.

During and after his first journey abroad as a young artist, from 1847 to 1849, Cropsey sketched and painted castles as well as landscapes in Italy, Scotland, and England.[1] Trained first as an architect, the painter was usually faithful to the appearance of such actual historical monuments as the citadel at Naples,[2] Doune Castle[3] in the Trossach Mountains of Scotland, and Kenilworth Castle.[4]

While nature, carefully studied, was a core concern of mid-century American painters, the landscape as drama and allegory had substantial public appeal. In addition to keenly observed American views Cropsey also painted, in the 1850s, some dramatic interpretations of both American and European subjects. Contact with the Old Masters in Europe and the contemporary English anecdotal history painters stimulated Cropsey and other American painters; and the writings of Sir Walter Scott made events set in feudal times especially popular.

In the Utica painting of 1855 a fortified castle is set in the midst of a sunny landscape. It is one of several European subjects painted just before the artist's second trip abroad, from 1856 to 1863, many of which appeared in an April 1856 auction sale held in his studio.[5] It does not appear to resemble any known fortress, but we are persuaded of its actuality by the detailed naturalism of its landscape setting. A brush fluent in the vocabulary of placid water, springy plants, ancient shadowed trees, and grazing deer convinces us of the setting's reality. No matter that the castle is a bit fanciful in design and somewhat insubstantially modeled, the fluttering banners and figures atop the walls welcome a party returning on horseback and transport us to a feudal time and place. The effect of a view into another era is made even more strongly by the oval format, a shape not common for Cropsey.

In 1851 he had painted *Spirit of War* (National Gallery of Art), in which, under a lurid sky, a huge medieval castle looms darkly atop a rocky outcropping while knights in armor ride out to avenge the sack of a smoldering village.[6] In *Hawking Party in the Time of Queen Elizabeth* of 1853 (private collection), a festive hunting party rides from woods into a clearing beneath a castle whose walls and towers are made massive by strong light and shadow.[7] Cropsey evoked the violence and the pageantry in dramatic images of a distant historic period. He was criticized by some for excessive detail to the detriment of general coherence and harmony, but such historical compositions were nonetheless well regarded by those who esteemed moral didacticism.

In *Castle by a Lake,* however, Cropsey avoids the overt melodrama, which can be distracting in some of his histories. He transports us back to an earlier age, not with an image of dramatic heroism or picturesque pageantry, but one of everyday reality made convincing by its close attention to nature.

WILLIAM S. TALBOT

౭ 1855
Oil on canvas, 25 1/2 × 34 1/2″ (square)
Museum purchase 60.195

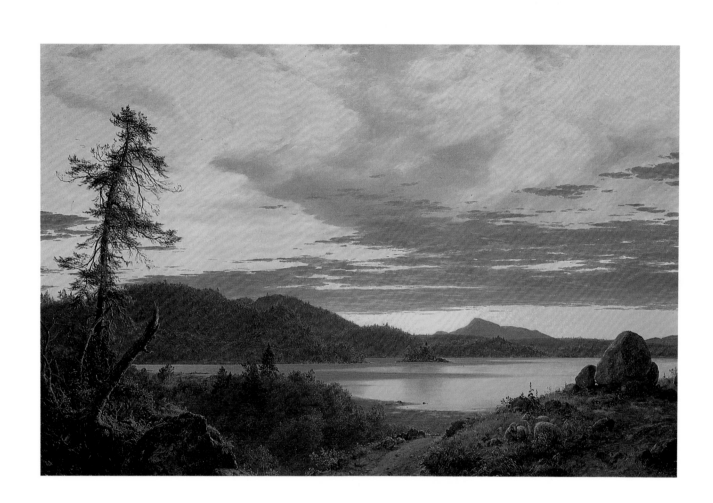

22

FREDERIC EDWIN CHURCH (1826–1900)

Sunset

FREDERIC EDWIN CHURCH, as his contemporaries knew very well, had "an eye for a sunset."[1] From the earliest days of his career in the mid-1840s until the final years at his hilltop home, Olana, he constantly drew and sketched the twilight sky. Like his contemporary Henry David Thoreau, whose *Journal* abounds with evocative descriptions of sunrises and sunsets, Church never tired of nature's daily pageant of light and color.

Hundreds of Church's drawings and oil sketches survive in the collections of Olana and the Cooper-Hewitt Museum, but in relatively few cases can we closely follow his progress from an initial pencil sketch, to a more elaborate oil study, to a finished painting. *Sunset* offers just such an opportunity. In a drawing inscribed "Mt Desert/Sep-1854/2ᵈ Twilight," Church recorded, with a few rapid pencil strokes, a view just north of Bar Harbor, looking westward across Hull's Cove.[2] The scene includes low hills and a pair of sailboats at anchor, but the artist focused primarily on recording the rapidly changing hues of the sky. Color notations, with phrases such as "superb brilliant blue" and "brilliant splendid orange," cover the sheet, providing guidance when Church later painted an oil sketch of the scene.[3] The small, intensely colored oil sketch is a faithful transcription of the initial study, retaining the basic configurations of land and sky, but bringing to life the colors only described in the drawing.

After completing the Mount Desert oil study, Church put it aside and did not take it up again until 1856.[4] And, when he did, as the basis for *Sunset,* he reused the twilight effect, but transformed the landscape into an inland lake scene, removing all indications of the coast and introducing glacial rocks, a rugged spruce, and a dramatic mountain in the distance. We do not know just when in 1856 Church created *Sunset,* but it was probably in the fall, after he and his friend, the writer Theodore Winthrop, had returned from a summer excursion to the interior of Maine.[5] The object of their journey, as Winthrop noted, was "to be somewhere near the heart of New England's

wildest wilderness," and their goal was "Katahdin—the distinctest mountain to be found on this side of the continent. . . ."[6] Church had visited the area before and had painted a major oil, *Mount Katahdin* (Yale University Art Gallery) in 1853. In that painting, however, Church's youthful optimism transformed the rugged wilderness of the region into a pastoral landscape complete with the props of incipient civilization. *Sunset* presents a very different world, bringing the viewer to the farthest reaches (symbolized by the rugged dirt path) of man's penetration into the primeval American landscape.

Church's interest in portraying the American wilderness intensified during the late 1850s, and *Sunset* is a key picture in the sequence of images leading to his masterpiece of 1860, *Twilight in the Wilderness* (Cleveland Museum of Art). Like the latter, *Sunset* is an eloquent expression of two essential ingredients in the national identity—American space and American light. It is "a landscape of vigorous simplicity,"[7] to use Winthrop's words, but one which nevertheless denies the viewer easy passage into the distance. Unlike Church's earlier paintings, with their coherent flow of one zone of the landscape to the next, *Sunset* is deliberately challenging. The lake and heavily forested hills block terrestrial progress, and the viewer looks instinctively to the sky, where the ranks of receding clouds lead a headlong rush to the distant, Katahdin-like peak. We are thus at once made aware both of the vastness of American space through light and atmosphere and of its dense impenetrability through the physical realities of earthly nature.[8]

FRANKLIN KELLY

1856
Oil on canvas, 24 × 36″
Proctor Collection PC.21

57

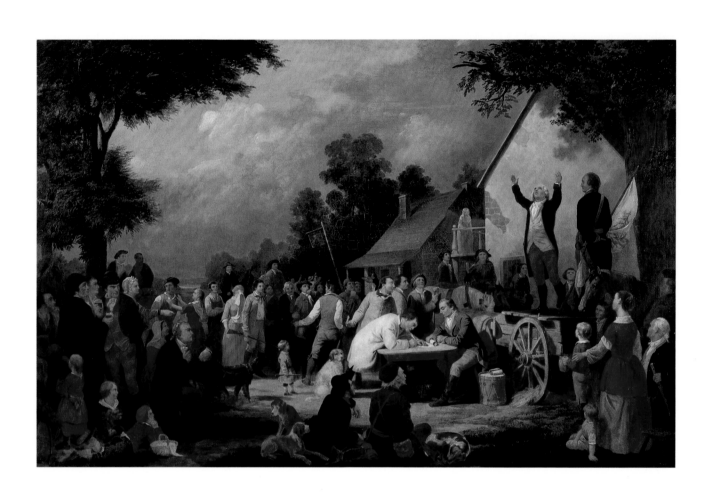

﹌ 23

William T. Ranney (1813–57, with Charles F. Blauvelt, 1824–1900)

Recruiting for the Continental Army

William T. Ranney is known for three types of genre paintings: frontier life, duck-hunting along the eastern seaboard, and the Revolutionary War. This last category, perhaps the least known aspect of Ranney's work, includes at least nine paintings created over a period of twelve years, beginning in 1845.[1] Several factors influenced Ranney's choice of subject matter at this time. The American Art-Union, then in its heyday, provided exhibition space for genre and historical paintings and encouraged artists to depict native subjects. The mid-nineteenth century, especially the late 1840s, saw a renewed interest in historical events, specifically those of the Revolutionary War.[2] This patriotism was brought about in part by the Mexican War, a conflict precipitated by the granting of statehood to Texas, in whose war for independence Ranney had fought in the previous decade.

Just as the U.S. Army relied on short-term volunteer enlistments during the 1846–48 crisis,[3] so did the Continental Army during the Revolution. The plea for volunteers is the subject of Ranney's *Recruiting for the Continental Army,* which, like the majority of his Revolutionary War pictures, focuses on nonheroic incidents rather than battle scenes.

In its coloration and crowded composition, Ranney's painting recalls George Caleb Bingham's election series created in the 1850s. Bingham's village scenes, peopled with American "types" and depicting vignettes of daily life, were exhibited in the East and drew widespread attention. The Utica picture seems especially indebted to Bingham's *County Election* of 1851–52 (St. Louis Art Museum) and the print after it by John Sartain (1854). In both Bingham's and Ranney's paintings the main action occurs to the composition's right, near major architectural elements, which include an inn with a sign out front. In Ranney's painting, the sign depicts a crowned head symbolizing royalty and it is being pulled down by a group of Patriots.

The crowd is arranged in a semicircular composition, with the central position occupied by the man joining the army. The pool of light falling on the middle group draws our eyes to this important part of the narrative. However, other dramatic moments are being enacted in each section of the painting. A white-haired patriot, standing on a farm wagon with a soldier, exhorts others to join. As men too old to fight remain seated, a group of young men carrying rifles forms a line to enlist, while their wives weep and bid them farewell.[4] Even a small child comes forward with his small rifle. Two men to the left—perhaps Loyalists—drink from their tankards, apparently unpersuaded by the oratory.

Begun late in his career when the artist was ill with consumption, the painting remained unfinished at his death and was one of the works auctioned in December 1858 for the benefit of Ranney's family.[5] An inscription on the barrel at lower left indicates that the work was completed in 1859 by Charles F. Blauvelt, a New York portraitist and genre painter who, like Ranney, had exhibited frequently at the National Academy of Design and the American Art-Union.[6]

Linda Ayres

﹌ c. 1857–59
Oil on canvas, 53³/₄ × 82¹/₄″
Gift of T. Proctor Eldred 58.284

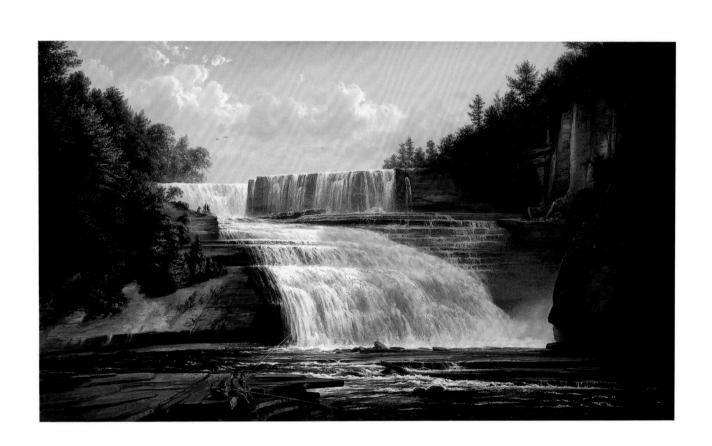

24

FERDINAND RICHARDT (1819–95)

Trenton High Falls

TRENTON HIGH FALLS was the grandest of the series of six different cataracts and cascades over which, in the course of two miles, West Canada Creek once descended on its way from the Adirondacks to the Mohawk River. Located about a dozen miles north of Utica, New York, Trenton Falls became a tourist attraction with the opening of the Erie Canal to that city in the mid-1820s. Accessible first by carriage and then by rail, it remained for more than half a century a high point of the standard scenic tour that followed the Canal across upstate New York and culminated at Niagara Falls.[1] The construction of a dam early in the twentieth century flooded three of the six falls and stopped the free flow of water over the others, including High Falls.

The complex configuration of High Falls, which Richardt has depicted with reasonable accuracy, made it a popular subject for artists. At the upper level, water falls from vertical ledges whose main faces, set at opposed angles, reflect light differently. At the lower level, yet on a different axis, the creek cascades majestically down colossal limestone steps to a mist-clouded pool. The surrounding forest presses in to the edges of the gorge, reinforcing the sense of unfettered nature inherent in the fast-moving stream. A group of fashionably dressed tourists, who survey the spectacle from a ledge left of center, and a more simply garbed man and children, who fish in the quieter water of the foreground, "civilize" this wilderness. Richardt widened the gorge and reduced the scale of the figures in relation to their setting to heighten the grandeur of the scene, a common enough practice among landscape painters of his generation. Following their conventions, Richardt used dark, irregularly shaped forms— trees and shadowed rocks—to frame a bright center of interest, in this case the dazzlingly brilliant light reflecting from the sheet of water that cascades into the pool.

The figures perched on the ledge may represent guests from the Trenton Falls Hotel, a high-toned summer hostelry whose property included all of the falls and the nearby forest. The proprietors of the hotel encouraged artists to record the area's scenery.[2] Between the 1820s and the

1870s many did so, including Albert Bierstadt, DeWitt Clinton Boutelle, Thomas Doughty, Asher B. Durand, Thomas Hicks, and George Inness, occasionally from the top of the falls but more often from the general vantage point of Richardt's painting. Other artists might also have been moved to paint the scene had they seen High Falls as Richardt shows it, resplendently flowing, but in most summers West Canada Creek was for long periods reduced to a mere trickle except in heavy rains.

Richardt's painting seems to express the excited sense of awe and admiration with which most American artists of his generation approached the natural wonders of a land where, as Thomas Cole observed in his *Essay on American Scenery* (1836), "all nature is new to art." To Richardt, who had come to the United States only three years before painting High Falls, American nature was new indeed. Like many of his fellow artists, he treats this scene worshipfully, as if wild nature were a sacred thing; but the distant party of tourists, who have ambled down from the hotel, are a premonition of the great shift in American thinking about the natural world that by the 1850s was already underway, a shift in which a pantheistic concept of Nature as God would give way to the more prosaic idea of Nature as playground.

DAVID TATHAM

1858
Oil on canvas, 35³/₄ × 62³/₁₆″
Unknown gift 72.53

25

DAVID GILMOUR BLYTHE (1815–65)

Wash Day

DAVID GILMOUR BLYTHE grew up in East Liverpool, Ohio, and began his career as a self-taught itinerant portrait painter. In the mid-1850s he settled in Pittsburgh, Pennsylvania, where he found a vast reservoir of social ailments that he could draw upon for satirical genre subjects. Influenced by seventeenth-century Dutch and Flemish genre painting as well as by the English caricature tradition of Hogarth, Rowlandson, and Cruikshank, Blythe was as quick to burlesque the intemperances of the poor as he was to lampoon the pretensions of local politicians. His Protestant eye tended to equate the untidiness and corruption of the city with basic flaws in the moral universe. Yet on occasion, as in *Wash Day,* his paintings convey more a sense of pathos than of condemnation.[1]

In a cramped courtyard barren of all graces save sunlight, a woman and a small boy are attempting to do the laundry. Lifting her skirts above her knees, the woman stands in a wooden tub kneading the wash with her feet, while the boy rinses the clothes in a horse trough. The bright blues and reds of the garments—including several hung out to dry on nails on the back wall—contrast sharply with the overall drabness of the yard, its deep shadows, and the darkened rooms beyond. A canary perches incongruously in a cage that hangs from a beam in the upper right corner.

Several of these motifs surface in other Blythe paintings—the cluttered "basement" setting, the urchin, and the water pump—all symbols of the disarray of urban life. More unusual is the image of a woman performing chores with her feet, which also appears in Blythe's *Kraut Making* (North Carolina Museum of Art). Although portrayals of women engaged in domestic tasks are rare in pre-Civil War American genre painting (and almost nonexistent in the later nineteenth century), Tompkins H. Matteson, Francis W. Edmonds, and, particularly, Lilly Martin Spencer explore the subject in the 1850s, usually with positive if humorous sentiments and always with the woman working with her hands. Blythe's reference to older, European peasant work habits is deliberate; the bathetic rudeness of the as-yet-unassimilated immigrant is one of his pet social peeves.[2]

The caged bird has other connotations. While pet birds appear with some frequency in eighteenth- and nineteenth-century European and American portraiture and genre painting, by the early 1850s, in the works of the British Pre-Raphaelites, the caged bird had come to represent the captive soul, imprisoned (as was its human female companion) in domestic servitude. Blythe, who was an avid borrower from the art of his contemporaries, almost certainly knew this symbolic reference, if only from popular prints or illustrations in periodicals.[3]

The Utica picture's Baltimore provenance suggests that it was painted in 1858 or 1859 when, based on exhibition records and the provenance of other of the artist's paintings, Blythe was working in Baltimore and Philadelphia. Its stylistic qualities—the treacly handling, rich notes of color, and mastery of chiaroscuro—also support this dating, when Blythe had reached maturity as a genre painter but before he turned to political satire, his preoccupation during the Civil War.[4]

BRUCE W. CHAMBERS

Probably 1858 or 1859
Oil on canvas, 17³/₈ × 13¹/₄"
Purchased with funds from the Charles E. Merrill Trust 73.113

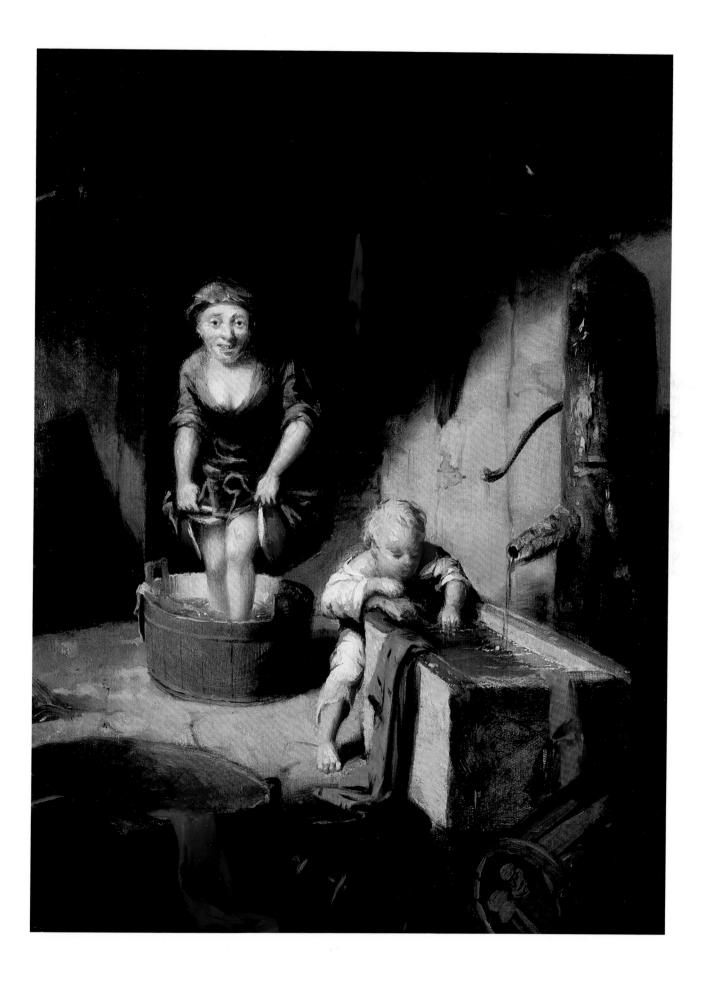

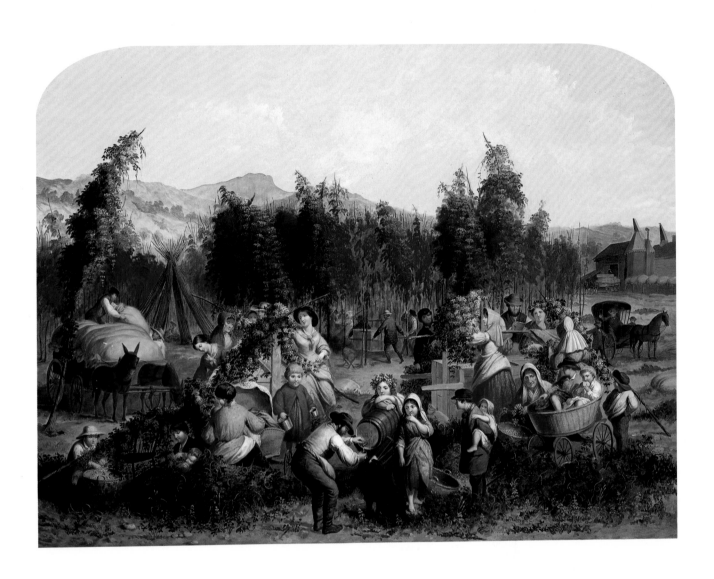

TOMPKINS H. MATTESON (1813–84)

Hop Picking

IN HIS DISCUSSION of Tompkins H. Matteson's art, Henry Tuckerman wrote that the "national and rustic subjects, drawn by this pioneer *genre* painter, indicate the average taste of the people." One of the pictures by this central New York State artist that presumably reflects this taste is a work Tuckerman called the "Hop Yard."[1] A recently discovered reference in the *Waterville Times* provides information regarding the circumstances surrounding its creation. "Mr. T.H. Matteson, artist, of Sherburne, is at present occupying the rooms of A. Taylor in the Putnam Block, where he has on exhibition a splendid painting representing a scene in Hop Picking, which . . . was painted for Mortimer Conger, from sketches made in Conger & Sons Hopyard by Mr. Matteson."[2]

During the middle decades of the nineteenth century, the cultivation of hops was one of central New York State's most important agricultural activities; this fact would not have been lost on Matteson insofar as his home in Sherburne, New York, was strategically located in the center of the state's hop farming region. As shown in the Utica painting, hops grow on vines that are supported by poles buried in the ground. After the hop flowers matured in the fall, farmers hired numerous men, women, and children to quickly cut the vines, pick the blossoms, and dry them in specially constructed kilns.

Set against a background that exaggerates the height of the hills of the region around Waterville, New York, the scene has more than thirty figures. Despite shortcomings in drawing and scale, his figures depict the various tasks and social merriments associated with the annual hop harvest.[3] At least two of the figure groups in the painting derive from a sketchbook that Matteson may have used in Mortimer Conger's hop yard.[4] *Hop Picking* is somewhat larger in size than most of his paintings, and Matteson has adopted a technique that enabled him to quickly paint the dense middleground of poled vines by laying down broad areas of green pigment on top of which the leaves of the hop vines were painted with fluid tints and shades of the same color. The vines and foliage in the foreground also appear to have been painted quite rapidly, with the result that there is very little botanical accuracy in this part of the painting, suggesting Matteson's almost deliberate rejection of the esthetics of the American Pre-Raphaelites, which were then on the ascendancy in American taste.[5]

Although painted during the dark days of the Civil War, Matteson's harvest scene embodies none of the sinister connotations that inform Winslow Homer's 1867 painting, *The Veteran in a New Field* (Metropolitan Museum of Art).[6] The audience that saw a smaller variant of Matteson's painting called *Hop-Pickers* (Arkansas Art Center), when it was exhibited at the Utica Art Association's 1867 exhibition, would have found comfort in its powerful affirmation of nature's bounty, its idealization of the relationship between the laborer and the property owner, as well as its espousal of the value and usefulness of cooperative effort and hard work.[7]

PAUL D. SCHWEIZER

℥ 1862
Oil on canvas, 38 1/2 × 50 3/4"
Museum purchase 49.11

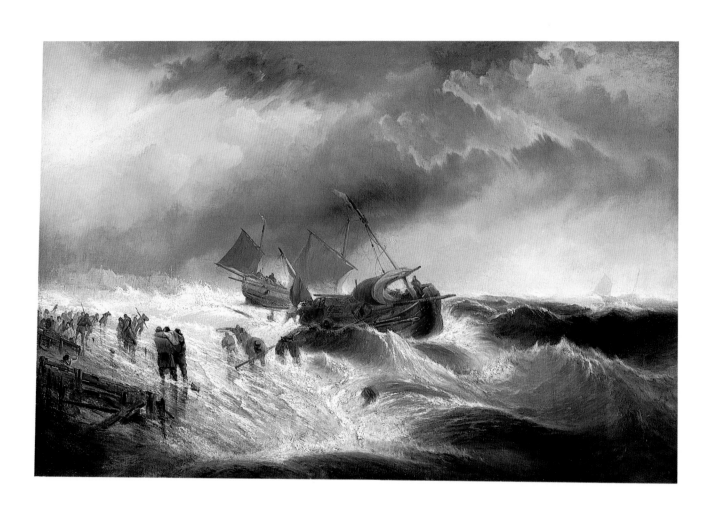

Edward Moran (1829–1901)
Shipwreck

At the time of his death in 1901 Edward Moran was eulogized as one of the most prominent marine painters of his generation. The author Hugh W. Coleman noted, for example, that "as a painter of the sea in its many moods and phases, Edward Moran, it is commonly admitted, had no superior in America."[1] However, in spite of the widespread acclaim that he received in conservative art circles at the turn of the century, Moran's reputation fell into obscurity shortly thereafter. In part, this decline can be blamed on the collapse of the academic tradition, but even in the early twentieth-century writings of America's more conservative critics his work received little attention.[2] Today, while it is difficult to justify the unqualified praise that he received from figures such as Coleman, the contribution Moran made to the history of nineteenth-century American marine painting has been generally overlooked.

He began his career in Philadelphia in the mid-1850s, when the production of clipper ships was at its height in the United States, and Isambard K. Brunel launched his famous steamship, the *Great Eastern,* in England. During these years Edward helped to launch the artistic careers of two of his younger brothers, Thomas and Peter, as well as at least two other Philadelphia marine painters, Frank D. Briscoe and George E. Essig.

In his early years in Philadelphia, Moran admired Turner's marine paintings, and his work entitled *The Shipwreck* of c. 1858 (Philadelphia Museum of Art) is clearly indebted—probably through an intermediary source—to Turner's *Wreck of a Transport Ship* (Fundação Calouste Gulbenkian, Lisbon).[3] Taking his cue from that painting, Moran composed a picture that showed the sea triumphing over man and his works, compelling the viewer to meditate on the fragility of human existence.

Also during these years, Turner's *The Harbors of England* was published with a commentary prepared by John Ruskin. Whatever knowledge Moran had at that time of Turner's marine paintings would have been augmented by Ruskin's descriptive prose, as well as by his discussion of Turner's fascination with shipwrecks and drowning sailors, and his wildly romantic depictions of a heaving sea.[4] Moran's knowledge of contemporary English painting would also have been enhanced by the important exhibition of paintings by Turner, Clarkson Stanfield, Ruskin, the Pre-Raphaelites, and others that toured New York, Boston, and Philadelphia in 1857 and 1858.[5]

Sometime early in 1861, Edward and his brother Thomas traveled to England to study the paintings, watercolors, and sketches by Turner that were displayed in London at the South Kensington Museum and the National Gallery. Later that year Edward followed Turner's footsteps on a sketching tour of the channel coast. This sojourn had a beneficial effect on Moran's productivity, for after returning to Philadelphia he made an impressive account of himself by displaying at least seventeen works in the 1862 annual exhibition at the Pennsylvania Academy of the Fine Arts.[6]

One of the pictures he displayed that year was a work entitled *Coast Scene near New Brunswick,* owned at the time by the important Philadelphia collector Harrison Earl. Because the title of the Utica painting seems to have been given to the work around 1981 when it was on the art market, it is possible that it is the painting originally owned by Earl.[7] In the background at the left, tall pilings protect the fishing village from the pounding surf, suggesting that this painting might depict a scene somewhere in the Bay of Fundy. Moran first traveled to the Canadian maritimes in the late 1850s, and, although no pencil or oil sketches from this trip have been discovered, the experience provided material for a number of paintings he executed over the next years.

Paul D. Schweizer

ARTHUR FITZWILLIAM TAIT (1819–1905)
Mink Trapping in Northern New York

THIS PAINTING WAS FIRST EXHIBITED at the National Academy of Design in Manhattan in the spring of 1862, a time when the country's mood was depressed by the bloodshed and destruction of the Civil War. Perhaps it was chosen for this honor in part because such an anecdotal scene of rural life suggested happier places and times, thus offering a welcome lift to the nation's morale.

The English-born artist had spent much of the previous decade in the Adirondacks painting game birds and animals with increasing success.[1] Unfortunately the identity of the two woodsmen portrayed is not known, but Tait's records noted that the canvas was "very carefully finished" and had been carried away from his studio that winter in a sleigh by his good patron, the restauranteur John C. Force, for the handsome sum of one hundred seventy-five dollars.

The painting soon came to the attention of the firm of Currier & Ives, which, in order to capitalize on the wartime market for colorful pictures, was already at work publishing a dozen large lithographs of Tait's hunting and fishing scenes. Perhaps to avoid copyright problems, Tait painted the picture again, but with the figures reversed, to oblige the "printmakers to the American people."

The traditional deadfall trap depicted in *Mink Trapping in Northern New York* was made from materials that were readily available to the Adirondack woodsman.[2] In his right hand he holds the dead mink just removed from the trap. The long log he holds in his left hand is held in place by vertical stakes to keep it directly over and parallel to a shorter log on the ground. In order to set the trap, the top pole is supported in the air by a delicate trigger mechanism made up of three notched twigs fitted together in the shape of the number 4 (these twigs appear on the ground in front of the trap). The little pen covered by leaves

behind the logs forces the animal to approach the bait from one direction only. The mink must step between the upper and lower logs to reach the triggered bait, thus causing the heavy top pole to fall and crush its victim against the pole on the ground.

It is doubly fitting that this Adirondack painting now enjoys a permanent home in the nearby Mohawk Valley. For decades trappers used to bring their pelts to Utica and other communities along the river to sell to fur traders. They sometimes stayed in town just long enough to satisfy their thirst and buy supplies before heading back to the north woods.

Furthermore, not far to the west of Utica, the utopian Oneida Community perfected the mass machine production of the world-famous Newhouse steel trap.[3] Within a year after Tait's painting was completed, a quarter of a million of these reliable and economical inventions were produced, suddenly making the rustic deadfall trap all but obsolete.[4] Tait thus documented for posterity this colorful aspect of our American past at a crucial moment.

WARDER H. CADBURY

ॐ 1862
Oil on canvas, 20 1/8 × 30 1/8"
Museum purchase 67.92

EASTMAN JOHNSON (1824–1906)
The Chimney Corner

A GIFTED DRAFTSMAN, the major artistic spokesman for post-Civil War rural America, and a figure of wide acquaintance and influence in New York art circles, Eastman Johnson enjoyed a long, productive, and distinguished career. His talent emerged early in portrait studies done in Lovell, Maine, his birthplace, and progressed rapidly through training in Düsseldorf and Paris. When he returned to this country in 1855, he was as advanced technically as any other artist of his generation, and his work continued to grow in breadth and power through the next three decades.

The Chimney Corner builds on lessons Johnson had learned well by 1863. His grasp of form and contour was assured, his figures possess an inner authority, dominating well-defined, Dutch-like spaces, and his brush moves with a broad energy that heightens contrasts of light, color, and texture. In the case of *The Chimney Corner,* the brushwork almost alone carries the muted physical impact of flesh tones, coarse clothing, and uneven interior surfaces. One senses a lingering touch of Düsseldorf in the somber palette, but more of Thomas Couture, Johnson's French master, in the painterly manipulation of form and deftly mixed highlights.

Johnson's picture of a lone black man seated in a rustic interior probably harks back to scenes he had witnessed in Washington, D.C., shortly after his return from abroad. His first statement in this genre was the well-known *Life in the South* of 1859 (New-York Historical Society), later given the more popular title of *Old Kentucky Home.*[1] The obvious narrative character of that picture became reduced and concentrated in the years following into a number of scenes of black life that indicate the seriousness with which the artist approached his subjects. "No one of our painters has more truly caught and perfectly delineated the American rustic and negro," Henry Tuckerman claimed of Johnson in 1867.[2] Hindsight may give us a slightly different perspective, but one can safely say that Johnson, Winslow Homer, and Thomas Eakins were among the few whose work rose above the stereotypical images of black life that preceded and were produced alongside their own.

The Utica picture is almost identical to a painting in the National Museum of American Art entitled *The Lord is My Shepherd.*[3] According to Tuckerman, *The Chimney Corner* had found its way into the collection of John Taylor Johnston by 1867;[4] the provenance of *The Lord is My Shepherd* is unclear, as is the date the painting first assumed that title. Yet the opening line of the Twenty-third Psalm is probably a more accurate representation of what Johnson ultimately meant the painting to convey—that the sober black man, the essence of humble piety, guaranteed the faith of the nation. It was a belief with direct parallels to earlier images of peasant life, especially those produced in rural Barbizon, in which tradition, hardship, and poverty were regarded as the true test of piety.

Surrounding the lone black man reading his lesson are all the signs of these so-called virtues. The forlorn and neglected setting is drawn from *New England Kitchen* (R. Philip Hanes, Jr., Winston-Salem, North Carolina), an interior by Johnson that must have slightly preceded *The Chimney Corner.*[5] The strong, gnarled hands of the subject attest to a life of toil, his dress and circumstances to enduring poverty. Yet his dignity remains, a factor of his stalwart form and the presence of divine grace—no small comfort during the turbulent years of the Civil War. Only by nourishing such individuals, Johnson seems to be saying, would America truly become a free and independent nation.

WILLIAM H. TRUETTNER

ह➳ 1863
Oil on cardboard, 15½ × 13¼"
Gift by exchange of Edmund G. Munson, Jr., 64.116

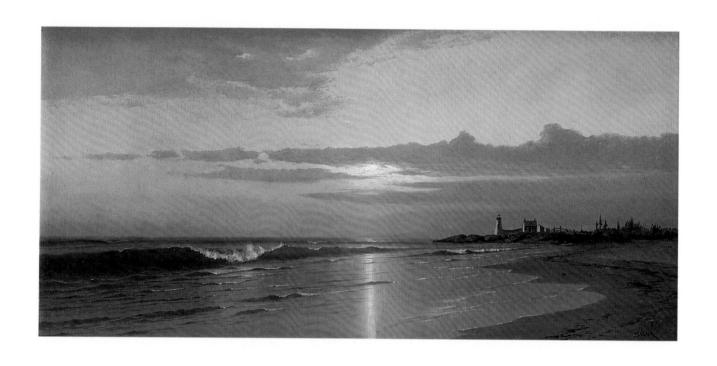

FRANCIS A. SILVA (1835–86)
Sunrise: Marine View

SUNRISE: MARINE VIEW was painted at the beginning of the career of Francis A. Silva and contains the essential characteristics of his art for the rest of his life—a coastal scene smoothly rendered without rich effects of brushwork or impasto, glowing in the warm golden-orange light of a rising or setting sun, serenely calm with a motionless air suggesting a quietude broken only by the soft rolling of waves and the solitude of an isolated lighthouse. To these, at times, may also be added sailboats or other objects appropriate to the traffic of the bay, river, or coast, but always painted in such a way as to suggest a hushed, unhurried world, which served as an antidote to the super-energized, dynamic, industrialized place America had become in the 1870s and early 1880s.[1] Silva's career was brief, spanning little more than a decade and a half, and he never became one of the leading figures in the art world of his day. He arrived too late to share the hour of glory of the so-called Hudson River School, for by 1870 the heyday of Asher B. Durand, John F. Kensett, Frederic Church, and Albert Bierstadt had already passed, and he always disliked the foreign styles that were then being imported into America, strongly criticizing both the Barbizon and Impressionist styles. Instead, he followed in the luminist line of Fitzhugh Lane and Martin Johnson Heade, perpetuating a technique that subordinated itself to a kind of Emersonian, transcendentalist reverence for Nature, always preferring poetic vision to spectacular, swashbuckling brushwork. Silva's work is closest to that of another artist who specialized in marine views, Samuel Colman, his contemporary, whose works were similarly cast aside after the 1880s, only to be rediscovered a hundred years later.[2] Silva's art probably enjoys more attention now than it did in his own lifetime.

Silva was born in New York City, the son of a barber; his grandfather, François Joseph de Lapierre, a Frenchman, painted portraits in Lisbon and Madeira in the early nineteenth century, and Silva's father immigrated from Madeira to New York in 1830. After being apprenticed to a sign painter, young Silva began doing ornamental painting on stagecoaches, fire engines, and any other place where decorative work was required. He seems to have had no formal training, although the National Academy of Design, by the late 1850s, maintained facilities for the study of art. Nevertheless, by 1858 Silva was listed in the New York City directory as "Painter." After serving in the Civil War he set up a studio in New York and exhibited his art for the first time at the National Academy of Design's annual in 1868 with a work titled *Old Wreck at Newport.*

In 1870, about the time the Utica picture was painted, Silva moved his studio to Brooklyn, to a site where he could observe the passing ship traffic; by 1873 his studio was once again in Manhattan, at 650 Broadway.[3] In the early 1870s Silva's work only occasionally attracted the attention of critics and reviewers of exhibitions, but in 1872 he was elected to the newly founded American Watercolor Society and the next year to the Artist Fund Society, suggesting some recognition from his peers. He was one of the first to work seriously in watercolors, which before 1870 had been considered an inferior medium, suitable only for amateurs.

During his career Silva sketched at many coastal areas of the northeastern United States, including Cape Ann, Boston Harbor, Narragansett Bay, Long Island, the mouth of the Hudson River, the New Jersey coast, and the Chesapeake Bay. Sketches made on location were then converted in the studio into larger paintings in oil on canvas. The Jersey coast was long a favorite, and during the last six years of his life he painted its scenes almost exclusively. *Sunrise: Marine View* may, in fact, record an early visit to the coastal area of New Jersey.

WAYNE CRAVEN

ॐ c. 1870
Oil on canvas, 15 × 29⅞″
Museum purchase 85.45

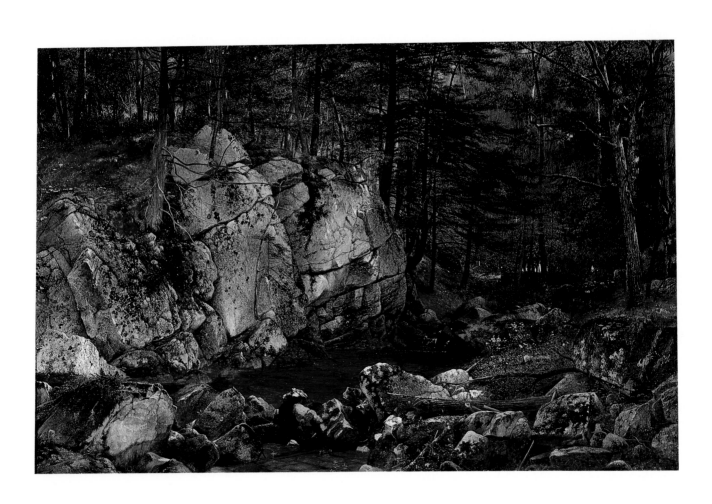

31

DAVID JOHNSON (1827–1908)
Brook Study at Warwick

DAVID JOHNSON WAS INTERESTED in recording nature on canvas rather than celebrating its drama or majesty. Largely self-taught, Johnson took lessons with Jasper F. Cropsey in 1850,[1] and also painted with John F. Kensett and John W. Casilear early in his career.[2] Like these artists and most of the landscape painters of his generation, Johnson traveled to sketch at many of the popular painting locations near the Hudson River and in the White Mountains. In setting up his compositions, he consistently selected views that emphasized the pleasant aspect of the site, not its sublime or mysterious element. Accepted as a member of the National Academy of Design in 1860, he exhibited at the organization's yearly exhibitions and also had works shown at other locations including the Paris Salon of 1877.

Johnson was a careful and methodical draughtsman. His surviving drawings attest to his awareness of morphological differences in natural forms; studies of oaks, elms, maples, and pines show how the artist sought to create detailed renderings of leaf and bark structures, as well as the overall growth pattern of each species. Inland rock formations also fascinated the artist. In a number of paintings, such as *Brook Study at Warwick* or *Forest Rocks* (Cleveland Museum of Art), the rocks are actually the subject rather than incidental elements in the composition. As his career continued, Johnson's painting style was strongly influenced by the tonal European Barbizon landscapes which were popular in France. His paintings from the 1880s and 1890s are an unusual combination of the darker and richer colors of French paintings by Theodore Rousseau and Jean François Millet and the artist's own continued interest in exacting detail.

The Utica picture is a well-documented painting. Exhibited at the Centennial in Philadelphia in 1876, it was also shown in 1878 at the Utica Art Association where it was sold to Mrs. James Watson Williams. In a letter to George W. Adams, President of the Art Association, Johnson stated that this painting was "painted entirely upon the spot and is, as far as I was able to make it so, a literal portrait of the place."[3] He commented further that he was happy to know that the painting would be in a collection that included a painting by the French nineteenth-century artist Jean Baptiste Camille Corot, an artist he admired, "although I see things and put them down diametrically opposite to the great master."[4] In Johnson's earlier landscapes, the exacting attention to detail sometimes gave a certain static or labored quality to the composition, but in *Brook Study at Warwick* the artist had clearly mastered the art of painting precise detail without sacrificing the life of the picture.

According to the artist, the brook at Warwick, in Orange County, New York, was a place often used by "pleasure parties,"[5] but this painting gives the viewer the impression that the subject is removed from the disturbances of civilization. One tree stump at the lower left is the only obvious indication of the alteration of the landscape by man. An astute observer of nature, however, might also note that the trees in this hemlock forest are relatively small, indicating that the land had been cleared in the not too distant past. The soft light and the pleasant green tonalities reinforce the inviting quality of the landscape; nature is presented in its friendly guise as the perfect backdrop for a picnic. In many of Johnson's landscapes with rocks, people are depicted to indicate the scale and confirm the idea that the setting is one which is not foreboding to man. *Brook Study at Warwick* needs nothing else to make it more inviting; the sunlight reflecting on the rocks, the quiet pool, and the warm green of the trees combine to create the effect of a pleasing landscape where visitors are welcome.

GWENDOLYN OWENS

1873
Oil on canvas, 26 × 40"
Proctor Collection PC.62

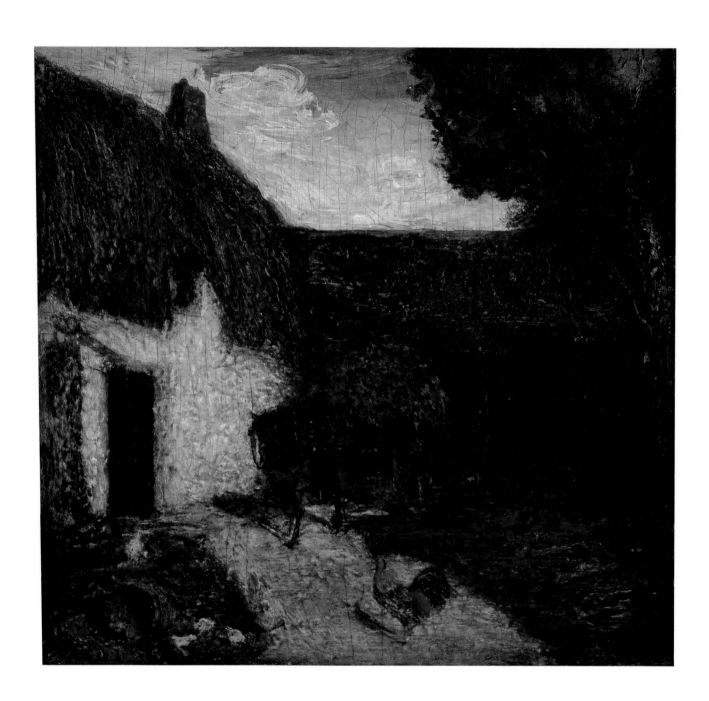

❧ 32

ALBERT PINKHAM RYDER (1847–1917)
The Barnyard

THE BARNYARD by Albert Pinkham Ryder is an excellent example of the artist's early work. One of America's most distinguished painters, Ryder began painting in the tradition of the Barbizon School, following the methods of pastoral painting practiced in France by Corot, Rousseau, and Daubigny. Ryder's panel is much indebted to this tradition in its humble, rural subject matter, complete with thatched cottage, horse and wagon, and roosters in the foreground. The luminous, dark tonalities are reminiscent of the Barbizon tradition as well, with its subdued warm tones of browns and ochers. Recent studies, such as that of Peter Bermingham,[1] have shown that the Barbizon idiom was prevalent in America in the later nineteenth century; and from our vantage point in history, we can see that Ryder's work of the 1870s belongs squarely in that tradition.

There are those who would claim that Ryder was a self-taught genius, oblivious to the major traditions of European art. It pleased certain critics of the 1920s and 1930s to make a case for the home-grown American prodigy; and for some, Ryder fit this mold—or could easily be forced into it. However, recent thinking on this subject takes another view, seeing Ryder as part of an international cosmopolitan tradition, albeit somewhat delayed, in its expression in the United States.

In *The Barnyard,* Ryder turned the Barbizon manner to his own purposes. The work is characteristic of Ryder on a number of counts. For one thing, he simplified his pictorial language into essential planes and masses, eliminating much of the clutter and sentimental trappings so often found in the work of the French Barbizon painters. Moreover, Ryder indulged in that characteristically American practice of flattening his images so that his painting operates as a two-dimensional pattern as much as it does three-dimensionally. Particularly noticeable in this work is Ryder's tendency to treat tangible forms *and* their "background" as equal pictorial weights, balancing one another in an overall compositional pattern. Ryder was to develop and perfect these characteristic traits in subsequent paintings of the 1880s and 1890s, when his compositions were masterfully balanced as two-dimensional entities.

Shortly before Ryder's death in 1917, and for several decades afterward, forgeries of the artist's work frequently appeared on the market, and today museums are still plagued by troublesome works, allegedly by him. *The Barnyard,* however, has an unimpeachable history, something that is always a pleasure to see in the case of Ryder paintings. Records of the work stretch back at least to 1915, the year it was sold at auction from the collection of Ichabod T. Williams of New York.[2] The painting was described fully in the American Art Association catalog, with the note that it was acquired by Williams from the late Daniel Cottier. This history offers an extra measure of security, as Cottier was Ryder's friend and dealer, and any painting from his collection is one that we would expect to be genuine. M. Knoedler was the high bidder, paying fourteen hundred dollars for the work, a respectable price in that era. *The Barnyard* eventually found its way, in 1919, to Duncan Phillips, who bought it for his gallery in Washington. The painting achieved notoriety when it was stolen on its way from Washington to an exhibition at the Century Club, New York. It was hidden from sight until its recovery in 1926. Subsequently, Phillips exchanged this work and another Ryder for *Macbeth and the Witches* (Phillips Collection). Then *The Barnyard* was purchased by Dr. C.J. Robertson, who later sold it to a New York dealer, from whom it was acquired in 1957 by the Munson-Williams-Proctor Institute.

WILLIAM INNES HOMER

❧ c. 1873–76
Oil on wood, 11⁵/₈ × 12¹/₄"
Museum purchase 57.39

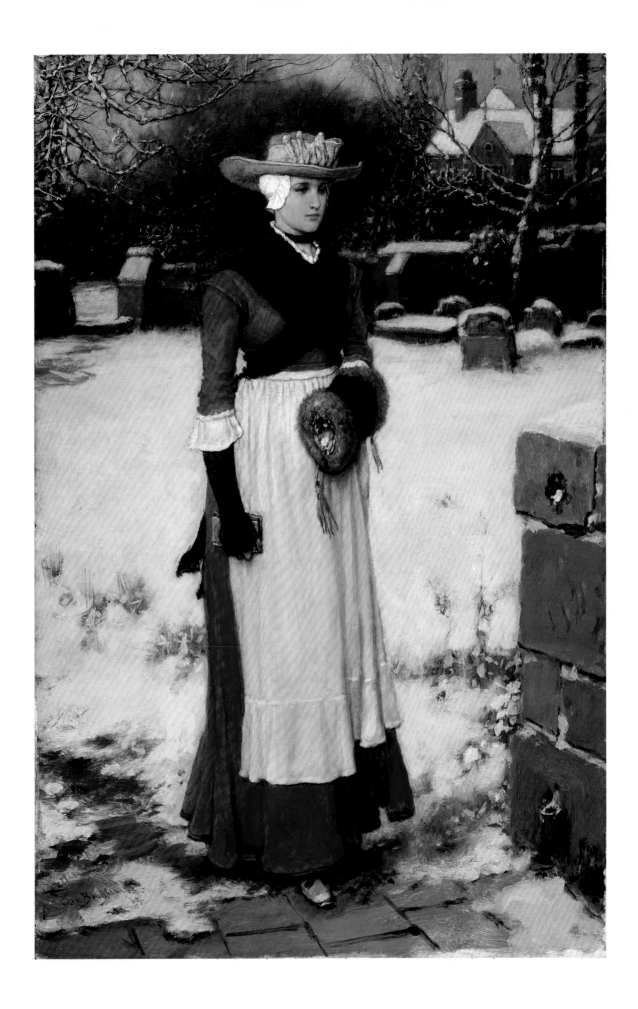

33

GEORGE HENRY BOUGHTON (1833–1905)

Puritan Maiden

HISTORY HELD A POWERFUL GRIP on the popular imagination in America and England in the nineteenth century. Novelists such as Sir Walter Scott and artists such as George Henry Boughton transformed the erudite research of antiquarians and historians into vivid dramas, considering issues that fascinated their audiences. How did people live in earlier times? What real-life dilemmas did they face? How did they resolve them? In this guise, history offered contemporary society, unsettled by the sweeping changes wrought during the nineteenth century, a foil against which it might measure its achievements, question its values, clarify and promote its ideals.

Boughton often recreated scenes from the lives of the Puritans, intrigued, as he told Alfred Baldry, by " 'the sad but picturesque episodes in which they played parts.' "[1] English by birth, Boughton had emigrated with his family to Albany, New York, around 1834. Largely self-trained as a painter, he achieved his first major success with the exhibition and sale of *Winter Twilight* (New York Public Library, on permanent loan to the New-York Historical Society) at the National Academy of Design in 1858. The artist then moved to New York, taking a studio in the Tenth Street Studio Building and attending classes at the National Academy of Design until 1860, when he had saved adequate funds from the sale of his works for travel to Europe. In Paris Boughton studied with Thomas Couture's pupil, Edouard May. Later he traveled to Brittany to work with Edouard Frère. More confident of his mastery of the figure, Boughton set out for New York in 1861, but during a stopover in London he decided to stay and ultimately to make his home there permanently. At the Royal Academy in 1867 Boughton received critical acclaim for his *Early Puritans of New England Going to Worship* (New York Public Library, on permanent loan to the New-York Historical Society). A number of paintings followed this first foray into the realm of the Puritans, some, like his 1879 *Priscilla* (1983, Edward J. Boughton, III, California) and his 1881 *Hester Prynne* (1982, Raydon Gallery, New York), inspired by the literature of Henry Wadsworth Longfellow and Nathaniel Hawthorne. Many of Boughton's Puritan images entered American collections, often with the aid of the painter's friend and supporter, the art dealer Samuel P. Avery. Several were engraved for distribution in the United States. Indeed, Boughton came to be so widely associated with the theme that his nickname as a member of the Tile Club, a New York artists' group, was "The Puritan."[2]

Puritan Maiden of c. 1875 shares the mood of quiet melancholy with which many of the artist's Puritan scenes are imbued. Poised at the edge of a snow-covered cemetery, alone beneath the skeletal branches of ice-coated trees, a young woman approaches a meetinghouse, psalter in hand.[3] She wears a pensive, perhaps sad expression, matching the dark and cheerless day. The only hint of another human presence is to be found in the massive structure looming over the wall at the right. Boughton's palette, restricted to muted gray-blues and ruddy earth tones, contributes to the desolate effect of the scene. The uninviting qualities of the landscape are heightened further by contrast with the youth and beauty of the maiden. Her glowing peach complexion is full of vitality in this otherwise lifeless setting. Arrayed with a variety of decorative accessories—sprightly ribbon-trimmed hat, fur-edged muff, delicately patterned gloves[4]—she presents a sympathetic figure, tempting the viewer to muse about the circumstances of her life. The maiden's erect posture and the determined set of her jaw suggest that she is immune to these bleak surroundings. Is she guided by some inner strength and purpose?

In popular nineteenth-century imagery the Puritans were characterized as people of unswerving conviction and uncommon fortitude—founders of a model community in New England, challengers to royal rule at home. Artists emphasized the Puritans' religious beliefs and their willingness to make personal sacrifices for them. Boughton, for example, intimates that the young subject of *Puritan Maiden* endures a hostile environment sustained by her belief. Artists and their audiences were attracted, it seems, to the very qualities of the Puritans that they believed they themselves lacked. In images such as *Puritan Maiden*, nineteenth-century viewers could look back longingly to a more morally certain era, removed from the confusing flux of modern existence. Boughton's wistful scenes of Puritan life offered particularly compelling glimpses of that simpler time.

ELIZABETH STEVENSON ARMANDROFF

c. 1875
Oil on wood, 21 × 13 7/8"
Proctor Collection PC.9

SANFORD ROBINSON GIFFORD (1823–80)
Galleries of the Stelvio—Lake Como

GIFFORD COMPLETED *Galleries of the Stelvio—Lake Como* in the spring of 1878.[1] On June 22 the New York *Daily Tribune* remarked that its "tone of color . . . would not be recognized as his by those who are not familiar with the range of his work." It also identified the view as "on the side where the Austrian military road has been built along the front of the cliffs which face the lake there." Most likely, the coloristic quality that seemed new or atypical was the strong contrast of bright, warm tans and dark, gray-browns of the receding road, rock, and tunnels that fills about two-thirds of the format. The pink and blue opalescence of distant mountains and their reflection in the lake, glimpsed at the right, and the warm, hazy sky imperceptibly cooling toward azure at the top edge are more typical of Gifford's aerial-luminism.

The concept was actually almost ten years old, and its evolution illustrates the direction taken by Gifford's art during this period. The artist had first encountered the tunnels in 1857 near the Stelvio Pass and merely noted their utilitarian convenience.[2] It was not until August 5, 1868, on the eastern shore of the Italian lake near Varenna and Bellano, that he was struck by the sensuous experience of walking through them—and by their pictorial potential.[3] On two pages of his sketchbook he quickly penciled several horizontal and vertical miniatures of lake and tunnel vistas, including the germinal view through the tunnels with the glimpse of the lake which appealed to his burgeoning interest in pictorial design.[4] He developed the latter as a tonal study, vignetted by a tunnel entrance, and as an oil sketch the next day, further defining and separating shapes tonally, exploring the color contrast of warm foreground and cool distance and beginning to define textures.[5] More of the lake vista is incorporated, as well as such picturesque local figures, culled from the pencil sketches, as a peasant couple gazing at the view and a silhouetted ecclesiastic in a wide-brimmed hat.[6]

Plumbing earlier material, Gifford seized upon the 1868–70 conception for further development, producing the largest version that was announced in the *Tribune,* entered on a "List of Chief Pictures" among the artist's papers, and exhibited at the Utica Art Association in 1879 (where it was purchased on March 7 by Mrs. James Watson Williams). The final image's design impact is strengthened (and the artist-pedestrian's sequential experience suggested) by further darkening and regularizing the natural frame, and tonally unifying and contrasting the large shapes of sunlit road, cliffside, and cavernous shadow. While such descriptive details as castle and villas, woods and meadow, boat and reflections are specified in the haze-veiled distance, the painting's unity is enhanced by integrating distance and foreground in a warm ambience. Added to the cast of local characters is a casually dressed, strolling tourist who is attracted to the view and probably represents the artist himself. Combining the visually tantalizing effects of aerial-luminism with assertive graphic design, the painting realizes the goals of Gifford's last decade, which, in turn, reflect the trend toward aestheticism of the late nineteenth century.

ILA WEISS

ϑ❧ 1878
Oil on canvas, 30^{1}/$_{2}$ × 24^{1}/$_{2}$"
Proctor Collection PC.48

GEORGE INNESS (1825–94)
The Coming Storm

THE TITLE THAT THIS PAINTING now bears, by describing its effect rather than its subject, gracefully and prudently sidesteps the question about which there is considerable confusion—what it depicts. The painting was at one time called *In the Berkshires,*[1] but because of its similarity to a painting now in the collection of the Cleveland Museum entitled *Montclair, New Jersey*[2] it has also been said to represent a New Jersey subject, the Watchung Mountains near Montclair, New Jersey.[3] Inness painted in the Berkshires early in his career, and Montclair was his home for roughly the last twenty years of his life, so neither title is grossly implausible. But in fact the painting represents neither western Massachusetts nor New Jersey but the White Mountains of New Hampshire. There is no mistaking its resemblance to paintings Inness made in 1875 and 1876 of White Mountains subjects in the vicinity of North Conway, such as *Approaching Storm* (Fort Worth Art Museum), *Saco River Valley* (c. 1899, Henry Sampson, New York City), and particularly the great *Saco Ford: Conway Meadows* of 1876 (Mount Holyoke College Art Museum).[4] More specifically, it corresponds closely to a description of a painting of "the gathering of a storm on the lower flanks of Mote [Moat] Mountain":

On [the] side of the valley . . . are collected great masses of cloud and the vapors that precede the mountain storms, which, descending the upper ridges of the mountain, settle down toward the valley below, and wrap its huge shoulders in obscurity and gloom. Frequently by day the farms and orchards that cover its base are bathed in bright sunshine, while the upper regions of the mountain are hidden by dense and dark thunder-clouds, which roll about it in round masses dun as smoke.[5]

To place the Utica painting geographically is at the same time, and more importantly, to locate it artistically. For in belonging among his White Mountains paintings it belongs with some of the finest, the most stirring and beautiful landscapes that Inness—or any other American painter—ever made.

Inness spent the five years from 1870 to 1875 in Europe, chiefly in Italy. He returned to America in February 1875, and by March he had settled in Medfield, Massachusetts (where he lived several years in the early 1860s)

and took a studio in Boston. By late May he was in North Conway, New Hampshire, where, staying in the newly opened Kearsarge House and using an old schoolhouse as his studio, he remained into September. Inness was not the first to discover the pictorial possibilities of the White Mountains—they had long been one of the most popular painting-grounds and natural sites in America—and, in fact, he had never before taken any interest in dramatic mountain scenery. Precisely what awakened that interest in 1875 we do not know. Perhaps he was prepared by experiences of Alpine landscape in Italy, perhaps he hoped to capitalize commercially on the popularity of the White Mountains, or perhaps it was simply because the region had recently been opened to the railroad (which stopped virtually at the door of the Kearsarge House).

But if we do not know the cause of his interest, there is no doubt about its consequences: Inness's summer at North Conway resulted in some of his most impressive paintings, works of majestic conception, dramatic chiaroscuro, and turbulent energy. A writer in *Appleton's Journal* in 1875 described the special mixture in them of description and expression, perception and conception:

Mr. Inness is best known by the strength and richness of his coloring and by strong contrasts of light and shadow. His paintings each represent a sentiment or a passion, "Nature passed through the alembic of humanity," as Emerson says. Yet his pictures are by no means ideal conceptions of Nature, and, were it not that the artistic instinct and the human feeling which dominate them were so much more impressive than their realistic forms, the beholder would suppose that he painted only for the pleasure of reproducing a daguerreotype likeness of natural objects.[6]

NICOLAI CIKOVSKY, JR.

1878
Oil on canvas, 16 × 24"
Museum purchase 54.73

WILLIAM MICHAEL HARNETT (1848–92)
A Study Table

ALTHOUGH HARNETT IS REMEMBERED MOST for his mastery of the trompe l'oeil technique, his use of symbols and symbolic address was by no means negligible. *A Study Table*,[1] for example, while remarkable for its fidelity to the look and feel of the visible world, may well demonstrate Harnett's undying fascination with the theme of *vanitas*.[2] In keeping with a well-established pictorial tradition, certain objects in *A Study Table* may reflect upon the vanity of earthly existence: the old worn books could be read as symbols of learning; the helmet had associations of wealth and power; and the musical instruments and sheet music, the ivory tobacco box, and the tankard could allude to the pleasures of the senses.[3]

At the same time that Harnett captured the fabric of Dutch *vanitas* still lifes, he apparently endeavored to extend the traditional iconographic scheme. The fearsome skull is absent from *A Study Table;* but in its stead is a medieval helmet with empty eyeholes and a grim metallic visage that make up, in effect, a death's head, reflecting the idea of the transience of human life. Likewise, the student lamp in the background, although a lighting device popular in Harnett's time,[4] appears to replace the guttered candlestick and oil lamp that the artist's predecessors had used as symbols of transience. The impression of time and change is emphasized at the left background by the flowers in bud, rather than fully developed. Completing the cycle of growth and decay in nature is a somewhat ominous beetle, shown lurking along the mouthpiece of the flute at the left foreground, which carries dark overtones of winter.[5]

Yet, carefully selected titles that give further meaning to the work may also bespeak the hope of resurrection. Thus the helmet, resting at the apex of the pyramidal composition, is juxtaposed to a large book inscribed "Biblia Sacra," while at the base is Cervantes's "Don Quixote/ Tome IV" and sheet music from François-Adrien Boieldieu's popular opera *La Dame Blanche*.[6] It is hardly surprising that the title of Boieldieu's opera refers to a woman whose ghost, it is believed, lives on in the Castle of Avenal. The idea of life after death is also to be found, significantly enough, at the very beginning of Book IV of *Don Quixote* (Second Part):

It is in vain to expect uniformity in the affairs of this life; the whole seems rather to be in a course of perpetual change. The seasons from year to year run in their appointed circle—spring is succeeded by summer, summer by autumn, and autumn by winter, which is again followed by the season of renovation; and thus they perform their everlasting round. But man's mortal career has no such renewal: from infancy to age it hastens onward to its end, and to the beginning of that state which has neither change nor termination.[7]

If these symbolic allusions are presented in recondite form, they are much enhanced by Harnett's illusionist style. The worn books, the cracked flute, and the dented tankard, which bear witness to the effects of time, are rendered with an irrepressible realism that appeals directly to the viewer. Indeed, Harnett quite deliberately presented an image in which the torn cover of *Don Quixote* and the sheet music for *La Dame Blanche* hang over the table's edge, as if reaching out to us. It is by this kind of illusionist effect, no less than by his use of a broad symbolic language, that Harnett made *A Study Table* a vivid and compelling emblematic statement.

CHAD MANDELES

क़ 1882
Oil on canvas, 39⅞ × 51⅜"
Museum purchase 57.67

ॐ 37

JOHN H. TWACHTMAN (1853–1902)

Landscape

LONGFELLOW CALLED IT "The Queen City of the West," and Baedeker described it as situated on the north bank of the Ohio River, "surrounded by an amphitheater of hills." It was to one of these hilly areas, the suburb of Avondale, that John H. Twachtman and his wife returned when they arrived in Cincinnati early in 1882 after a honeymoon trip to Europe, primarily Holland and Belgium, to wait for the birth of their first child. It was here, or in the nearby countryside, that Twachtman painted *Landscape,* the largest and perhaps most ambitious of the things he did in and around Cincinnati, the town where he was born and raised.

The Utica picture is less directly inspired by Cincinnati, however, than it is by the influence of his training in Munich, where he was taken in 1875 by Frank Duveneck, and which was the first major step in the development of his professional career. Although Twachtman studied at the Royal Academy in Munich, the technique he adopted at that time was principally derived from the German painter Wilhelm Leibl and strongly exemplified by his friend Duveneck. The "Munich Style" is one of great dash and brio, and it was formed through the marriage of the styles of the seventeenth-century painter Frans Hals with the nineteenth-century realist Gustave Courbet. Based on direct observation, Leibl and Duveneck worked directly with a loaded brush, covering the canvas quickly with paint and boldly blocking in the large masses, working from dark to light. Henry James called it "the excitement of adventure and the certitude of repose,"[1] but Twachtman was not at all satisfied. He had not yet found his personal idiom. He had painted in a dark tonal manner since the mid-1870s, but caught a glimpse of something else in the Low Countries, so this stay in Cincinnati was also a period of marking time professionally, of trying to solve painting problems and having difficulty in doing so. "Yesterday I sent you my work," he wrote to his friend J. Alden Weir, "which has little new in addition to what we did in Holland. . . . On some of these," he added, "I worked but I feel that nearly all, at any rate half of them should have more work. . . ."[2] The critics appeared to agree with him; one reviewer wrote in the *New York Times* of February 6, 1882, that, "Twachtman seems to be just where he was two years ago."[3]

Most of the paintings of this period are workmanlike and competent; many are relatively uninspired and all seem to reflect his "painter's block." *Landscape,* however, also reflects something of his independence—the search to find his personal point of view. It has something of Duveneck in it, to be sure, yet it also recalls Courbet and the Barbizon painters in choice of subject and manner of painting; and the greens and grays are additionally reminiscent of Bastien-Lepage, who had a strong influence on many American painters, and whom Twachtman met in Holland. In any case, the technical approach in the Utica picture does suggest an attempt to shed the skin of the Munich School Style. It seems more concerned with light, air, and mood, and despite a certain and not unattractive ambiguity, there is a strong interest in the organization and placement of forms in space. Most of all, however, the thinner, more freely flowing brushwork does seem to lean more in the direction of his studies in France the following year than in his past sojourn in the Bavarian capital. As such, and because of its significant size and stylistic quality, *Landscape* represents an important transition in Twachtman's development and another serious step closer to that personal and modified impressionist style for which he ultimately became famous.

RICHARD J. BOYLE

ॐ 1882
Oil on canvas, 35 × 46"
Museum purchase 58.9

WILLIAM TROST RICHARDS (1833–1905)

Summer Clouds

BY 1854 WILLIAM TROST RICHARDS was active in Philadelphia as a landscape painter, a subject that preoccupied him until the late 1860s when a series of summer sojourns on the northeastern seashore turned his attention to coastal motifs as well. During the 1870s he established himself as a major painter of marine themes in both the oil and watercolor medium. While visual and stylistic parallels link his work to that of his contemporaries such as Francis A. Silva and Alfred T. Bricher, Richards's particular contribution to American marine painting was noted and acknowledged in 1880 by Samuel G.W. Benjamin in his influential survey, *Art in America:*

Still another aspect of our scenery has been reproduced with fidelity by W. T. Richards of Philadelphia. We refer to the long reaches of silvery shore and the sand-dunes which are characteristic of many parts of our Atlantic coast . . . in his beach effects, Mr. Richards maintains an important position; and if slightly mannered, has yet developed a style of subject and treatment which very effectively represents certain distinguishing features of our solemn coasts.[1]

This passage, which aptly described the visual elements of *Summer Clouds,* identified a theme—long flat stretches of sand washed by a procession of rolling breakers under a cloudy but luminous sky—which had long been a favorite of the artist's, inspired by his travels to the beaches of New Jersey beginning about 1870. *Summer Clouds* represents, in fact, what was and for many still is the quintessential Richards marine. On the rectangular canvas of panoramic format, the artist devised a composition that appears to be virtually all water and sky but for a wedge of sand at the right dotted with shells and other beach debris. Waves roll

in from the left, and a line of breakers stretches into the distance meeting the vanishing point of the beach at the extreme right and establishing a dynamic tension as the eye is pulled rapidly along the waves only to be checked by the vertical canvas edge locking into the firm line of the distant horizon. The painting thus consists essentially of two nearly equal zones divided by a razor-sharp horizon firmly containing the restless sea below, while the subtle drama of the sky is played out above by varied cloud forms, which radiate the glowing core of light that unifies the composition. Water and wet sand are active as reflectors of the light from the sky, establishing a harmony of subdued but pervasive light: the "silvery shore" much admired by Benjamin and other nineteenth-century critics and patrons. Early in 1883, Richards received one of his most important commissions from the Corcoran Gallery of Art for the large painting *On the Coast of New Jersey,* which depicts this same favorite theme.[2] *Summer Clouds,* painted that same year, is similar both in composition and treatment, and represents one in the series of smaller canvases surely inspired by the critical success and popularity of the Corcoran commission.[3]

LINDA S. FERBER

ॐ 1883
Oil on canvas, 23 1/8 × 37"
Proctor Collection PC.93

ᘒ 39

ALEXANDER HELWIG WYANT (1836–92)

Rocky Ledge, Adirondacks

ROCKY LEDGE, ADIRONDACKS of c. 1884[1] depicts the
awakening of spring in both its choice of colors and its use
of paint strokes. The overall impression of the canvas is
that of gray tones suggesting the dormancy of winter. The
setting is Keene Valley, New York, where the invalid
Wyant lived with his wife, Arabella, in the early 1880s.[2]
In a geographic area so packed with distinct vistas and
unique mountain profiles, Wyant has gone to considerable
care to select a site that cannot be immediately situated on
a map.[3] Instead, he forces our eye to remain on the picture
surface. There is no distant view and little exploration of
the sky overhead. We, as viewers, are completely sealed
within the wooded ledge before us. The spatial limitation
experienced produces an immediate sense of intimacy and
forces the viewer to be enveloped in the world of the
painting. Once so captured, one's eye becomes aware of the
incredible variety of colors—of ocher, russet, and green—
that Wyant has woven within the overall gray of the paint-
ing. As a true tonalist,[4] Wyant recreates the first warming
of spring with a very delicate light just breaking through
the foliage on the left. In this diffuse light, one spots the
short, quick strokes of yellow marking an early spring
leafing and the smooth, fluid impasto of a newly rushing
stream. Perhaps the most memorable color in this subdued
canvas is the emerald green of moist grasses and mosses.
Little wonder that when Rocky Ledge, Adirondacks was
first exhibited at the Macbeth Gallery in New York City, it
was singled out for its "lovely early spring effect in tender
greens."[5]

Wyant's handling of paint in this Keene Valley painting
anticipates the sketchiness of surface associated with later
American nineteenth-century landscape painters such as
John Henry Twachtman.[6] Like Twachtman, he trans-
lated the dynamics of nature into a painterly effect. "He
[Wyant] is emphatically a painter of wholes, of effects. He
looks for, finds and grasps the specific, essential perma-
nent truths of a scene . . . he interprets the beauty of the
unseen and the lasting."[7] Such was the appreciation of
Wyant in the decade when Rocky Ledge, Adirondacks was
executed, and such it continues to be a century later.

PATRICIA C.F. MANDEL

ᘒ c. 1884
　Oil on canvas, 43¼ × 33½"
　Museum purchase 64.146

WILLIAM MERRITT CHASE (1849–1916)
Memories

COMMENTING ON WHAT HE BELIEVED to be an identifiably American character, William Merritt Chase maintained: "We are a new people in a new country. Watch the crowds along Picadilly or the Champs Élysées—you spot the Americans among them almost as easily as if they wore our flag in their buttonholes. It means that already a new type has appeared, the offspring, as we know, of European stock, but which no longer resembles it."[1] The model Chase portrayed in his painting *Memories* and the manner in which he presented her provide a visual means of understanding this "new type," as well as proof of Chase's dexterity and technical skill as a painter.[2]

Unlike the American expatriate painters John Singer Sargent and James McNeill Whistler, with whom Chase's own paintings have often been justifiably compared, Chase decided to return to America after completing his studies abroad in 1878. Once home, he devoted his efforts to painting American subjects and themes—simple urban and country scenes painted in and nearby his homes in New York City and on Long Island. His models, often family, friends, or students, were generally of the upper middle class, like Chase himself. They were prosperous, yet sensible, and Chase depicted them unselfconsciously enjoying leisure moments, either indoors or in the open air. Described by one contemporary writer as a "human camera," Chase captured in a most candid and spontaneous manner the life of genteel America at the turn of the century.[3] As a consummate painter and one of the prime spokesmen for the aesthetic movement in America, he accomplished his task with obvious grace and ease as evidenced in his painting *Memories.*

The subject for Chase's painting is a young, sensitive, unadorned woman—almost plain when compared to Whistler's ethereal maidens or Sargent's society women. She is more formidable than similar subjects painted by Whistler, and more natural and relaxed in pose when compared to the more formal portraits painted by Sargent, such as his *Lady with the Rose* (Metropolitan Museum of Art). In his painting *Memories* Chase has portrayed an intelligent and well-bred individual who can appreciate the aesthetic value of the artwork she holds in her hand, a connoisseur posed in front of a table strewn with similar works of art. Her expression conveys the deep pleasure she derives from this experience; and the title of the painting, *Memories,* suggests that this experience evokes the remembrance of a similarly pleasurable moment in her life— perhaps a visit to one of the great art museums of Europe, or a visit to a local gallery. By deliberately making the painting suggestive rather than literal, Chase has engaged the viewer to take part in completing the story in his or her own mind.

The image Chase has presented in this work is nostalgic enough to arouse our interest and to evoke a sympathetic response, without being overly sweet or "poetic." The colors he selected and the way in which he used them are equally striking—the palette is limited, but dramatic. Chase contrasted the white of the woman's dress, as well as the prints or drawings on the table and in her hand, against the black background, creating a bold image relieved only by the delicate and lyrical pastel pink of a fan on the table and the golden yellow of what appears to be a shawl also on the tabletop. Foremost in Chase's mind while painting this work was his concern in capturing varying degrees of reflected light—the strong direct light reflected off the objects on the table; the diffused light reflected off the woman's gauzy overskirt; and finally, and most importantly, the backlight illuminating her face and reflected off the print held in her hand.

Painted in 1885 or 1886, *Memories* made its debut in Chase's first one-man exhibition held at the Boston Art Club in the fall of 1886. The show was described as "the sensation of the month in art circles."[4] One critic, responding to the figure studies in the exhibition, maintained in "play of light and shade and contrast, he is unsurpassed." The same critic commended Chase for his "seemingly unconscious or accidental grace of line in female costume and making it play a part in revealing the characteristic lines in the wearer's personality." In summary, he declared that Chase was "emphatically of his day and an interpreter of his day in art."[5] It is likely that *Memories* was one of the works that inspired such favorable and insightful comments; and undoubtedly it was partially responsible for another critic's assessment of this exhibition, "it is upon just such work as this that we can safely base our hopes for art in America."[6]

RONALD G. PISANO

ॐ 1885 or 1886
Oil on canvas, 50½ × 37"
Museum purchase 57.305

JOHN FREDERICK PETO (1854–1907)
Fish House Door with Eel Basket

JOHN FREDERICK PETO is one of America's most original still-life painters, and *Fish House Door with Eel Basket* must rank as one of his most intriguing and important works. While there are numerous precedents in the history of earlier European and American still-life painting for tabletop arrangements, and a few as well for the more demanding illusionary wall compositions, Peto brought fresh imagination and new personal solutions to his handling of these subjects.

First as a student at the Pennsylvania Academy of the Fine Arts in the late 1870s and later as a professional artist in Philadelphia, Peto had ample opportunity to know firsthand the rich tradition of still-life painting in that city. Early in the nineteenth century the Academy's annual art exhibitions included copies after the Spanish and Dutch old masters, and the Peale family took a firm lead in the production of a broad range of tabletop subjects. Succeeding them at mid-century were the prominent names of John F. Francis and Severin Roesen. Peto's own work a generation later acknowledges these predecessors with compositions of fruits and wineglasses, but of far greater interest to him were the commonplace objects of his own domestic or studio surroundings. Not only were they close at hand, but their clutter and casual disarray from everyday use offered him the artistic exploration of unexpected colors, textures, shapes, and contrasts.

Peto became a more self-confident and independent artist during the 1880s, ultimately separating himself physically from Philadelphia by his marriage and move to Island Heights, New Jersey, at the end of the decade. This both allowed and encouraged him to look more introspectively at the immediate world around him: the interior spaces in which he lived and painted, and the nearby landscape of the Toms River shoreline. Correspondingly, his art increasingly concentrated on two central still-life groups. One shows an almost obsessive fascination with books, violins, and painter's palettes, all emblems of creativity, the making of art, and culture's repositories.

A parallel group of works reflects Peto's attention to other pleasures and preoccupations of daily life. Usually in arrangements illusionistically displayed on wallboards or old doors were playing cards, racetrack tickets, beer mugs, pipes and cigarettes—all probably comments on the beliefs and customs held by the local Methodist community.

More personal were those accessories related to Peto's leisure life at the seashore, such as the fishing or sailing excursions on the river he enjoyed with his wife and daughter or visiting relatives. It is this commonplace pleasure that Peto celebrates with the yellow slicker, eel basket, and fishing spear in his "Fish House Door" series.

The general format and scale of these paintings owe a first debt to the famous canvases *After the Hunt* (first version, Amon Carter Museum), done in the mid-1880s by Peto's friend William M. Harnett.[1] The first in the Peto group was a commissioned decoration for the Stag Saloon in Lerado, Ohio, home of his wife's family; that work is believed to have been destroyed, although a record of it survives in old family photographs. In the years following, Peto reworked the design in some half-dozen related variants, all close to life-size. Yet despite the near illusion of scale, texture, and setting in *Fish House Door,* what ultimately compels our attention is the sense of mystery and ambiguity Peto gives to the ordinary.[2]

The Utica painting is not just an image of an old door: the illusion is enhanced by the plane and edges of both canvas and depicted planks being nearly contiguous. Thus all the more evocative are the impenetrable bands of shadow on the left and bottom made by the apparent slight opening of the door inward. As always, in Peto's mature work the source and direction of light are seldom fully explicable or consistent. Unlike other hanging elements, the line holding the eel basket does not cast a complete shadow, and the tiny paper fragments on the door itself are illuminated rather than darkened by the shadow of the basket. What we come to enjoy in Peto's best work is his delight in color harmonies, especially those based on his favorite blue-greens, contrasting textures of nearby objects or surfaces, and the purity of geometric rhythms within an assemblage. All these reveal a mind playing with the basic language of art, here reinforced by the torn fragment of a picture reproduction tacked to the door.[3]

JOHN WILMERDING

🦆 1890s
Oil on canvas, 60¼ × 43″
Museum purchase by exchange 65.15

42

WORTHINGTON WHITTREDGE (1820–1910)

Peaches

THE AFFINITY OF LANDSCAPISTS for still life as a related investigation of nature is peculiar to the nineteenth century. For them, still life was a Sunday excursion undertaken with an obvious pleasure unshared by contemporary portraitists, to whom such details were perhaps too familiar to be enchanting. American landscape painters began executing still lifes as early as the 1820s, but, except for the remarkable flower pieces of Martin Johnson Heade, most are simple fruit arrangements painted between roughly 1855 and 1870.[1] Although distinguished by their freer execution, the fruit pieces by the Hudson River School painters are closely related to the American tradition of intensely observed still lifes culminating in the work of Levi Wells Prentice. They have the same intimate appeal and share a like concern for light and texture.

Worthington Whittredge's first-known still life, *Apple* (Museum of Fine Arts, Boston), dates from 1867, the year of his marriage to Euphemia Foote.[2] Within a year or so he also executed *Autumn Guild* (ex. coll. Douglas Collins, North Falmouth, Massachusetts). Both pictures are similar in style to Jasper Cropsey's *Green Apple* (private collection) of 1865, but are unusual in showing the fruit still on the tree. Bough pictures form a rare subcategory in American art distinct from trompe l'oeil still lifes. Inspired by the writing of John Ruskin, most are nature sketches, although Whittredge's canvases, like Joseph Decker's, are obviously studio products.

Peaches is likewise a bough picture, but was painted considerably later. Unfortunately, the artist rarely dated his work, but the picture can be placed in the mid-1890s on a variety of grounds. Indeed, Edward H. Dwight, the former director of the Munson-Williams-Proctor Institute Museum of Art and a great Whittredge scholar, thought that he could make out the date 1894[3] on the surface, and though this has not been verified, a date about that time is confirmed by other evidence. The canvas actually bears two signatures. The one at the lower left is by Whittredge himself and is typical in form for that decade. The other, running vertically up the tree trunk in the lower center of the picture, was written by his daughter Olive, who inscribed many of his late paintings even when they already bore his signature.[4]

The style of *Peaches* accords well with other works by the artist datable to the middle years of that decade. It must have been done around the same time as the watercolor *Laurel Blossoms in a Blue Vase* (Edward Kesler, Philadelphia) of around 1893–95.[5] The execution has a characteristic freedom, especially in the background. Though there are signs of waning power in the loosest passages, this is a remarkable production for a man in his mid-seventies. The draftsmanship remains firm. Still intact, too, is Whittredge's distinctive sense of color. As seen here, his palette retained its freshness to the end.

ANTHONY F. JANSON

c. 1894
Oil on canvas, 15¹/₂ × 22¹/₄″
Museum purchase 65.28

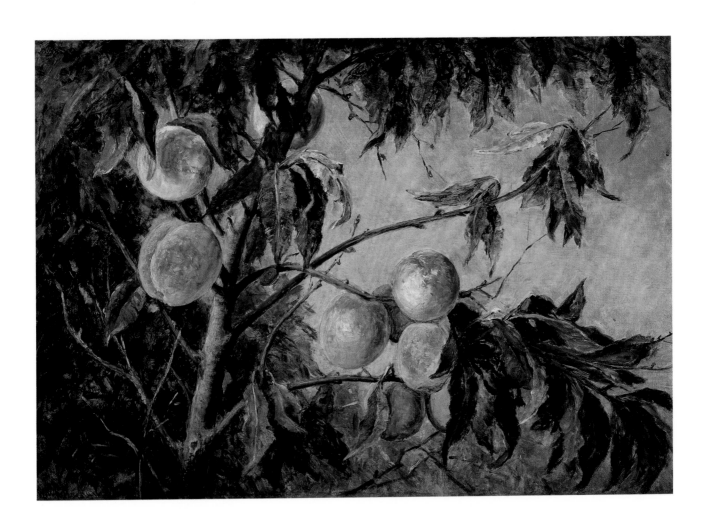

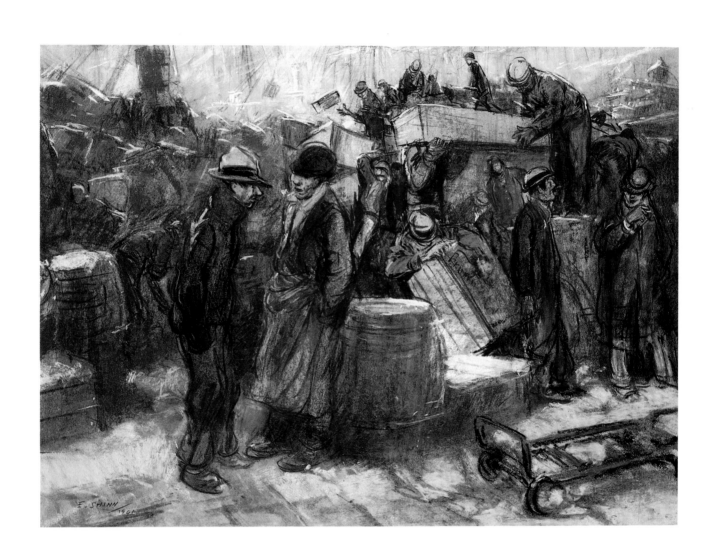

43

Everett Shinn (1873–1953)
The Docks, New York City

The hustle and bustle of stevedores carting crates, the chaos and confusion, the marked contrast between toilers and talkers—all of this brings a sense of immediacy to Everett Shinn's depiction of New York City's docks. The viewer can almost hear the groans and chatter, smell the stench, and feel the cutting cold.

Such a spontaneous composition was made possible because of Shinn's experience during the 1890s as a newspaper artist-reporter, producing on-the-spot sketches of news events in the period before photographs replaced them.

Everett Shinn, like his fellow newspaper artists William Glackens and George Luks, had been assigned to translate into visual terms what the news reporter put into words. The speed required for such art demanded a sponge-like memory, one which would soak up the essence of a scene, retain it, and then allow the image to be squeezed out onto a piece of paper or illustration board. Such a creative approach eliminated the necessity of Shinn's having to sit on a dock one winter's day in 1901.

Just the previous year the artist had executed his first center spread for *Harper's Weekly,* likewise an ambitious crowd scene in pastel. The prize commission had been obtained because the publication's editor, after viewing a selection of Shinn's New York street scenes, asked whether he had a drawing "of the Metropolitan Opera House and Broadway in a snowstorm." "I think I have," the twenty-five-year-old artist responded, knowing full well that he would have to work through the night to create it. The pastel appeared in the magazine on February 17, 1900.[1]

Such slices of life as *The Docks, New York City* were out of step with the times, with the Genteel Tradition and Victorian mores in which even pianos were not referred to as having legs. The Art Establishment sought to avoid representing the seamy side of life, sometimes going so far as to pretend that it did not even exist. Their eyes were cast on upper Fifth Avenue, not the lower East Side, and they viewed it through the warm glow of Luminism or Impressionism, not the somber hues of the realist.

But Shinn, like a Daumier in Manhattan, reveled in recording the virtual pulse of the city. Shying away from depicting either elegant urban vistas or nondescript rural landscapes, he and his friends were soon labeled New York Realists and, years later, the Ashcan School.[2]

One of the ironies of Shinn's early success is that while his subject matter often derived from everyday life, his patrons included the affluent, such as Stanford White, Clyde Fitch, Elsie de Wolfe, and David Belasco. In a one-man show held in 1901, arranged for by White at a Fifth Avenue gallery, Shinn was pleasantly surprised when more than half of the forty pastels on display were sold.[3]

Although numbered among his many achievements are murals for Belasco's Stuyvesant Theater and the Oak Room at the Plaza Hotel, as well as movie sets and book illustrations, Shinn's most poignant artistic statements are his early city scenes in pastel and oil, of which *The Docks, New York City* is a prime example.

Bennard B. Perlman

1901
Pastel on paper, 15 1/2 × 22"
Museum purchase 55.34

WILLIAM GLACKENS (1870–1938)
Under the Trees, Luxembourg Gardens

DURING THE SUMMER of 1906 William Glackens spent three months in France, mainly in Paris, which he had not visited since his eighteen months' stay there in 1895–96. Ira Glackens has described the trip, which was preceded by a visit in Madrid, in his book *William Glackens and The Eight.*[1] He sums up his father's feelings toward things French as follows:

Paris was always my father's favorite city, and France his spiritual home. Everything suited him there, the food, the wine, the people in the streets and public gardens, whom he loved to sketch; the look of restaurants, shops, and cafés; the color of the houses, the signs, the trees, the rivers, the fishermen, the villages, the flow of life. No other country seemed so to invite his pencil and his brush.[2]

Glackens returned to New York in the fall having completed about a half-dozen French canvases, one of which is *Under the Trees, Luxembourg Gardens.*[3] We have abundant evidence of the artist's style at this time because it was an exceptionally productive phase in his creative development. Although Glackens was still deeply engaged in illustration commissions, he was most anxious to devote as much time as possible to painting. Less than a year before, his *Chez Mouquin* (Art Institute of Chicago) had received an Honorable Mention at the Carnegie International Exhibition.[4]

The organization of *Under the Trees, Luxembourg Gardens* consists of a dramatic black tree trunk in the center which, from top to bottom, divides the canvas into two roughly equal zones. Smaller trees are placed on either side and create, by subtly receding into space, an asymmetrical compositional balance. Against this dense verdant screen-like setting, further interspersed with slender willowy tree trunks and branches embedded in the green foliage, is arrayed a band of figures in the foreground. Both seated and standing, these typical Glackens characters are intently engaged in various forms of activity—sewing, talking, and playing—while subsidiary motifs of chairs, both wooden and iron, are placed at angles to the picture plane.[5]

The composition derives fundamentally from Manet's *Music in the Tuileries* of 1862 (National Gallery, London), a painting probably known to Glackens firsthand when it was exhibited at Durand-Ruel's New York gallery in 1895.[6] The Utica picture adopts the same informal vignette-like glimpse of everyday activity, caught the way in which an experienced illustrator such as Glackens was most adept.

The paint handling is spontaneous, gently rugged, and summary rather than highly polished. On the whole, the composition is less formal and premeditated than either *In the Buen Retiro* (private collection), or the Corcoran version of the Utica canvas.[7] Notes of color include the standing uniformed figure of a soldier with red trousers, hat, and epaulette—an eyecatching motif also favored by Glackens's close friend Maurice Prendergast—as well as white dresses, and various shapes and colors of hats. These are enlivened by an occasional touch of blue, beige, pink, or red, all enveloped by the dominant surrounding foil of the green-black park setting.

Glackens expresses vivacity and mastery of gesture, depersonalizing the individual figures by showing most of them from the back or in three-quarter or profile vantage points. Thus he focuses upon the animation of the overall scene rather than particularizing the individual roles of his cast of characters.

Under the Trees, Luxembourg Gardens is a representative example of Glackens's best work of the period. It also exemplifies the approach of the American realist painters, who comprised most of the group subsequently known as The Eight.

RICHARD J. WATTENMAKER

ॐ 1906
Oil on canvas, 19⁵/₈ × 24³/₁₆″
Museum purchase 50.15

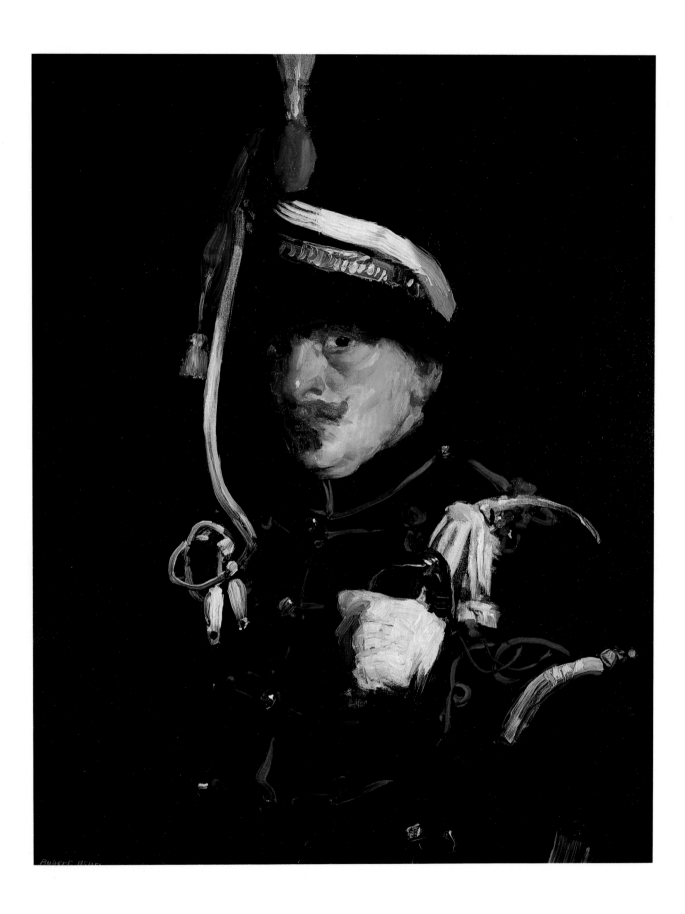

45

Robert Henri (1865–1929)
Dutch Soldier

Robert Henri was the most dynamic teacher of his generation and a champion of progressive causes in American art. In the year *Dutch Soldier* was painted, 1907,[1] the work must have been irritating to critics belonging to the academic tradition. In treating this everyday subject—a member of the Dutch armed forces who peers out at us from a shadowy background—Henri came under the influence of Frans Hals. Henri has applied his paint vigorously, with gusto, as was his habit throughout most of his career. His lack of idealization, his quick strokes of the brush must have seemed threatening to academicians; yet the painting seems relatively tame by contrast to the most radical developments in French art in 1907, the year in which Picasso painted *Les Demoiselles d'Avignon.*

By the time Henri painted *Dutch Soldier,* he had become a master of portraiture. The exploration of human personality had always been one of his great concerns, for he sympathetically identified with his sitters. Henri searched far and wide for "types" from various countries and cultures that would stimulate his feeling for humanity. In this instance, in Haarlem, Holland, he directed his attention toward a full-faced military man, with upturned mustache and goatee. Henri caught the alert glance, the tense gesture of the subject's arm held against the chest, to give us a vivid, vital rendition of this unique human being.

In *Dutch Soldier,* the placement of the head and body in the rectangle of the canvas is perfect from the compositional standpoint; every bit of space is used and the figure does not become lost in its surroundings. Possibly the impact of seeing Old Master paintings in Holland gave Henri the necessary impetus toward firm compositional structure; whatever the reason, his portrait work of the summer of 1907 is among the best of his entire career. His palette remained dark and he capitalized on dramatic contrasts of light and shade. We feel that Henri was most at home with chiaroscuro; his later efforts in full color, while reasonably successful, tended to be garish and even saccharine as a result of using the Maratta system, beginning about 1909.

The painting enjoys a special measure of historical interest. It was exhibited at the celebrated exhibition, *The Eight,* held at the Macbeth Gallery in 1908, a showcase of the controversial art of Henri and his friends. The fact that Henri chose this work, among others, for the show is noteworthy, for he saw it as representative and viewed it as an example of unusually high quality. Not only did the exhibition take place in New York, where it created much interest, it also traveled to various cities in the United States, thus acquainting a wide audience with progressive tendencies in American painting.

William Innes Homer

1907
Oil on canvas, 32⅝ × 26⅛"
Museum purchase 58.8

🐦 46

GEORGE LUKS (1867–1933)
Roundhouse at High Bridge

LUKS'S FAVORITE TOPIC was the city of New York and the people who inhabited its less fashionable districts. *Roundhouse at High Bridge* is one of his few pure cityscapes in oil to show the industrial aspect of New York without the human figure at center stage. In fact, the roundhouse is not the true subject of the painting, but rather the billowing smoke produced by its chimneys and the modulated, industrial sky into which it pours.

Columns of grey-green and white-grey smoke rise in parallel rows, beginning as dense swirls and gradually dissipating to merge with the purple and grey-blue tints of the early-morning sky. The dawn begins as a pink tint behind the roundhouse at the left of the canvas and drifts gradually toward the shadows of the city across the tenuous span of the bridge. A tugboat works its way upstream, its tiny smokestack producing a ribbon of steam to echo the massive emissions of the roundhouse.

The color and tonality of the painting are subdued and impressionistic, with only the dark shape of the buildings on the left providing an anchor. The only bright color is the cheerful red square of a service truck in the lower left, just above Luks's signature. A deeper, reddish light can be seen through the windows. This was typical of Luks's works, which were often completed with shades of a single color—usually an earth tone—over the majority of the canvas and small, brilliant touches of color to accent certain areas.

Luks was fond of comparing himself to the Dutch painter Frans Hals, a master of rich, painterly brushwork. But although Luks obviously worked quickly to produce this painting, he stayed away from the thick impasto, which often characterizes his work, in favor of thin scumblings of paint and transparent washes of color. The only exceptions are the rich swirls made with one heavy daub of paint and one twist of the brush at the point where the smoke is released from the chimney.

In technique and subject the picture is related to Whistler's painting of 1875, *Nocturne in Black and Gold—The Falling Rocket* (Detroit Institute of Arts), which so outraged the English critic John Ruskin. The treatment of both subjects was unconventional for their time by involving the atmospheric effects surrounding a bridge or building rather than a straightforward likeness. Whistler's title betrays his interest in the abstract, while Luks's painting, despite its freedom and unusual composition, is still closely linked to realism as was his philosophy of art in general.

The Utica painting was completed in 1909–10, just shortly after the now famous exhibition of The Eight at the Macbeth Gallery in New York. The group show, held in 1908, was stimulated in part by the rejection of Luks's *Man with Dyed Mustachios* (location unknown) from the 1907 exhibition of the National Academy of Design. Robert Henri's voice on the Academy's jury was the only one raised in support of Luks's painting and when it was not selected, Henri withdrew his own in frustration.

When *Roundhouse at High Bridge* was included in a one-man exhibition at the Kraushaar Gallery in New York in 1914, The Eight were no longer the radicals of the contemporary art scene, having been supplanted by the modernists. James Huneker, an early supporter of the group, gave Luks a favorable review in *Puck*. He recalled having once referred to the artist as "a hand and an eye" and called *Roundhouse at High Bridge* a "most satisfying picture."[1]

JUDITH HANSEN O'TOOLE

🐦 1909–10
Oil on canvas, 30³/₈ × 36¹/₄"
Museum purchase 50.17

ERNEST LAWSON (1873–1939)
Washington Bridge

ON JULY 4, 1842, one of the wonders of American engineering opened to the public. Designed by John Bloomfield Jervis of Oneida County, New York, it was known as High Bridge. Spanning the Harlem River between the Bronx and Manhattan, the bridge and its fifteen tall arches carried not only pedestrian traffic but also the critical pipelines that fed water to Manhattan from the Croton Reservoir system. In 1927 its original design was altered; the five stone arches that carried the bridge across the riverbed were replaced by a single ribbed steel span, leaving a lone granite arch on one bank and a series of nine on the other.

An equally imposing bridge across the Harlem River, just upriver from High Bridge, was completed in 1888. Built by William Hutton, the Washington Bridge had two great steel arches, each in turn spanning the river and the railroad tracks that ran along the east bank. Terminating in three stone arches at one end and four on the other, the Washington Bridge presented a distinctive silhouette which would be emulated in the later reconstruction of High Bridge.[1]

These facts are crucial to distinguishing among Lawson's many Harlem River bridge paintings. Fascinated by modern urban construction, Lawson—no matter how broad his brushwork or impressionistic his surfaces—took great care when it came to essential structural differences. The Utica painting, dating to about 1910 when it was purchased by Edward W. Root, was originally identified as a scene of High Bridge. It is instead a picture of Washington Bridge as seen from a park on the east, or Bronx, side of the river.[2]

The only pure landscape painter among The Eight, Lawson had an enormous stylistic range. It includes lyrical, softly-keyed paintings that resemble the works of Alfred Sisley, tonalist nocturnes influenced both by Whistler and by Julian Alden Weir (Lawson's teacher, with John H. Twachtman, in the 1890s), hot, dry, "expressionist" pictures such as those of Spain from 1916–17, and the scenes of upper Manhattan done in thick layers of brilliant color, applied with a palette knife, which came to be described as having the appearance of "crushed jewels."

The Utica picture falls between several of these stylistic modes. Its thick strokes and rapidity of execution give it an air of being sketched *en plein air,* of being casual, even inattentive to detail. Its late winter palette—reddish browns, tans, and dark blue-greens—achieves balance through subtle placement and emphasis. The structural rhythms of the gazebos in the foreground are echoed in the buildings and bridge abutments on the opposite shore, while the dark band of the river divides the canvas almost equally into "upper" and "lower" halves, emphasizing the painting's flatness. In short, however spontaneous the painting may appear to the viewer, it is tightly controlled, conscious of achieving its effects, which include the precise notation of time of day, of season and, above all, of place. In Lawson's paintings, the permanence of the urban fabric acts as a foil to the inevitable transience of nature.

BRUCE W. CHAMBERS

ह c. 1910
Oil on canvas, 25 × 30¼"
Museum purchase 58.42

JOHN SLOAN (1871–1951)

Scrubwoman, Astor Library

IN THE SPRING OF 1904 John Sloan moved from Philadelphia, where he had worked as a decorative illustrator for the Philadelphia newspapers for twelve years, to New York City, supporting himself and his wife by free-lance book and magazine illustrations. No longer bound by office hours, he was free to devote himself seriously to painting and to observing the rich and varied life of the city for the first time. In the years between 1904 and 1913, when the lessons Sloan learned from the Post-Impressionist paintings he saw in the Armory Show radically changed the philosophy and subject matter of his work, Sloan produced a body of paintings, drawings, and graphics, which express the profound joy he received from observing life around him. Sloan's friend and mentor, Robert Henri, had recommended that Sloan and his fellow Philadelphians, George Luks, William Glackens, and Everett Shinn, paint subjects from real life because expression of the vitality of life was, in Henri's estimation, the true aim of art. Because the life these artists painted was not that of the upper and middle classes, which was the subject matter painted by the popularly accepted painters of the day, their work caused a public sensation when it was shown in 1908 in the famous exhibition of the work of these artists and three friends, which has become known as the exhibition of The Eight.

The Utica picture is an excellent example of Sloan's approach to his city life subjects. The healthy vitality and camaraderie of the three scrubwomen, who are the focus of the painting, is clearly what had attracted Sloan and not the library itself. There is not the slightest trace of any social commentary or criticism on Sloan's part, just as there is none in most of his city life paintings. The lively and chattering scrubwomen violating the imposing silence and dignity of the library is characteristic of Sloan's delicately barbed wit, which frequently appears in his city life subjects.

Sloan's view of his subject is stated in his comment on the painting in his book, *Gist of Art,* where he wrote: "These jolly strong-arm women in the golden brown and musty surroundings of thousands of books aroused a strong urge to fix them on canvas. The result is very satisfactory to the painter."[1] Sloan had gone to the Astor Library at 425 Lafayette Street, near Astor Place (now the Public Theater), with his friend, the artist John Butler Yeats, on May 26, 1910,[2] where he saw the scene that he began to paint a week later. All of Sloan's city subjects were painted in the studio from memory or, occasionally, with reference to a sketch or two. He seems not to have made a sketch in the case of *Scrubwomen, Astor Library.* He worked on the painting from June 1 through June 4, 1910, and, on the 5th, noted in his diary: "A pleasant day of idleness, but since I have what I think is a pretty good picture, the result of the last three days work, I took the day off and felt right content."[3] However, the next year, when Sloan was selecting work to exhibit with a group of his colleagues at the Union League Club, he encountered some difficulties in reworking the painting, recording in his diary: "Fussed with the Library picture to no good purpose, spoilt one of the heads."[4] Obviously, he was able to save the situation as *Scrubwomen, Astor Library* is one of his most successful city paintings.

ROWLAND ELZEA

৯ 1910–11
Oil on canvas, 32 × 26″
Museum purchase 58.87

MAURICE PRENDERGAST (1858–1924)

Landscape with Figures
(with original Charles Prendergast frame)

AMONG THE SEVEN WORKS Maurice Prendergast entered in the 1913 International Exhibition of Modern Art, known as the Armory Show, was a large, impressive painting called *Landscape with Figures,*[1] which found an immediate buyer, Edward Wales Root.[2] Root's choice of a Prendergast for his major purchase from the Armory Show is not surprising, for we believe he met the artist and others of his group through editorial work on the New York *Evening Sun.* Through these associations, and partly to help support artists in need, Root came to a commitment to collect the work of his contemporaries, and he had already acquired a Venetian watercolor by Prendergast the year before the Armory Show.[3]

Prendergast lived in Boston when his work first attracted Root's attention and did not move to New York until 1914, but he was a frequent visitor to Manhattan and a noted exhibitor in the local galleries. He drew the attention of the New York critics because of his earlier appearance in exhibitions there; by 1908, when he showed at Macbeth Galleries with The Eight, Prendergast's work was judged the most radical of a group dominated by urban realists and was recognized by some critics as being closest to European modernism, especially to Matisse.[4] Prendergast's color and facture, singled out in 1908 for both praise and condemnation, again drew critical attention in 1913 when he appeared to be in step with European artists and one of the most avant-garde Americans in the Armory Show.

As one of a number of oils thought to represent Salem Willows, on the Massachusetts coast,[5] *Landscape with Figures* is distinguished by its predominantly yellow, high-keyed color and loose brushwork; paint drips from the trees are freely dabbed all over the canvas and dragged and smeared from one figure to another. The joy of applying paint and the holiday atmosphere of the promenading figures were not overlooked by contemporary critics, among them Frank Jewett Mather, Jr., who also noticed the strengths of Prendergast's naiveté: "Prendergast has had the odd fate to be a Neo-Impressionist and a Post-Impressionist without knowing it. He splits the world up into a coarse mosaic of the primaries and recombines it in brusque and animated suggestions. It is not an art for slow eyes. There is plenty of sunlight and joy of life in it, and enough keen observation of men and women in any one of his three big pictures to fit out an Academy show and leave a surplus."[6]

When Edward Root acquired *Landscape with Figures* for eight hundred dollars he paid an additional one hundred twenty-five dollars for an elaborately carved frame, one of the few with the maker's name burned and incised on the back of its upper member. The frame, by the artist's brother, Charles Prendergast,[7] is the only one known to have been made as two separate wooden moldings, one elevated on dowels about an inch above the surface of its support with robust carving and undulating forms, which must have appealed to Root.

A silent world of expressive gestures and movements, as silent perhaps as both the artist's and the patron's in their deafness, *Landscape with Figures* unifies Prendergast's observation of social life on the Massachusetts coast with his own intellectual and artistic experiments, and his devotion to modernism. It was a fitting contribution to the exhibition, which publicized the affinities between European modernism and American artists.

CAROL CLARK

ॐ c. 1910–12
Oil on canvas, 29³/₄ × 42³/₄"
Edward W. Root Bequest 57.212

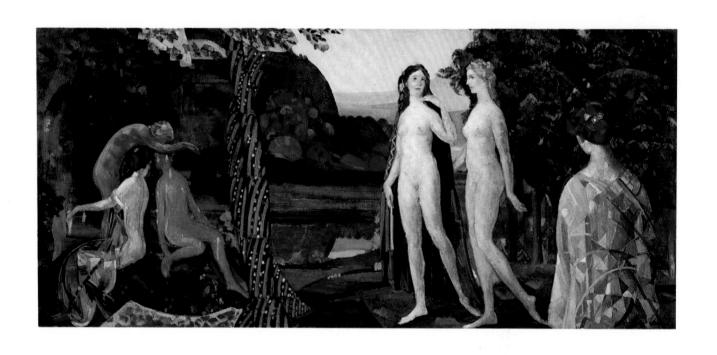

50

ARTHUR B. DAVIES (1862–1928)
Jewel-Bearing Tree of Amity

JEWEL-BEARING TREE OF AMITY was seen for the first time in *Thirty Paintings by Thirty Americans* at the Macbeth Gallery from November 14 to November 24, 1913.[1] It was the particular focus of attention because Arthur B. Davies had been a key organizer of the Armory Show, the event that had shocked American audiences in February of the same year with its introduction of art by the great innovators of European modernism. In his painting, Davies selected images—the capes of the women and the tree trunk encrusted with jewels—to cover with such decorative patterns as facets, lines, and dots painted in bright non-naturalistic colors. Critics were surprised at Davies's use of modernist conventions.[2] Their assumption that the new turn was the direct result of Davies's work on the Armory Show seems correct. However, it is difficult to say with certainty when the painting was completed; it is among the many works Davies did not date.[3]

Even though the painting provoked controversy, in subject and mood it remains securely within the Symbolist vein of Davies's pre-Armory Show work. Females grouped in two sets of three, with a third set suggested by tiny vertical strokes to the far left, move with graceful gestures. The twisted double trunk of the tree reflects the feeling of amity among the figures whose skin tones vary in coloration. However, no clear narrative is told. The women to the right call to mind the three graces in Botticelli's *Primavera* of c. 1478 (Uffizi Gallery), and the tree bears a generalized resemblance to those that magically relate to human life in James G. Frazer's *The Golden Bough,* an investigation of primitive myth that was a major source of inspiration for Davies. Particularly provocative, Frazer wrote of one tree decked with "strips of coloured cloth and sham bracelets and necklets of plaited straw."[4] However, in Symbolist fashion, Davies blended and personalized many sources, deliberately defying specific analysis in order to open possibilities for poetic evocation and reverie.

NANCY MILLER

c. 1912
Oil on canvas, 18 1/4 × 40 3/8"
Museum purchase 56.5

MORGAN RUSSELL (1886–1953)
Cosmic Synchromy

IN PARIS IN 1913, together with fellow American expatriate Stanton Macdonald-Wright, Morgan Russell founded the modernist movement they called Synchromism, meaning "with color."[1] They chose the term for its analogy with the word symphony to suggest their interest in color rhythms. Russell's explanation of his intentions, written for the catalog of the Synchromist exhibition at the Bernheim-Jeune Gallery in Paris, in October 1913, helps to explain the basis of *Cosmic Synchromy*:

These "color rhythms" somehow infuse a painting with the notion of time: they create the illusion that the picture develops, like a piece of music, within a span of time, while the old painting existed strictly in space, its every expression grasped by the spectator simultaneously and at a glance.[2]

Russell's *Cosmic Synchromy* contains repeated variations of the same spiral shape that he included in his earlier work, the monumental painting of 1913, *Synchromy in Deep Blue Violet* (Regis Collection, Minneapolis, Minnesota). In that picture the spiral derived from the contrapposto of Michelangelo's *Dying Slave* (Louvre). In the Utica picture, however, no such obvious pictorial source is evident.[3] Russell explained this when he exhibited this work in The Forum Exhibition of Modern American Painters in New York, in March 1916:

In my next step I was concerned with the elimination of the natural object and with the retention of color rhythms. An example of this period is the Cosmic Synchromy. *The principal idea in this canvas is a spiralic plunge into space, excited and quickened by appropriate color contrasts.*[4]

The importance Russell placed on *Cosmic Synchromy* is demonstrated by his exhibiting this canvas in the Forum Exhibition and discussing the work specifically in his text in the exhibition's catalog. For the reproduction of one of his works next to his essay, he also chose this painting among those he exhibited.

Macdonald-Wright had written to Russell and suggested that he include the *Cosmic Synchromy* among the works he sent to the Forum Exhibition, predicting that the picture was certain to sell: "Send by all means the Cosmic affair because as it has been advertised copiously it is a sure sale."[5] This recommendation may have been prompted by the work's having been reproduced a year earlier in *Modern Painting,* a book by the critic Willard Huntington Wright, Macdonald-Wright's brother and one of the Forum Exhibition's organizers.[6] Despite Macdonald-Wright's confidence and Willard Wright's promotion, Russell did not sell *Cosmic Synchromy*. When Willard Wright purchased one of his drawings from the Forum Exhibition, Russell generously gave him the *Cosmic Synchromy* and another painting, *Au Café* (location unknown), from the exhibition.

Today we can recognize *Cosmic Synchromy* as one of Russell's most important Synchromist paintings, produced at the moment when he had confidently developed his own original style, which would preserve his place in the history of modernist painting.

GAIL LEVIN

MAN RAY (1890–1976)
Hills

LIKE A HOST of other American painters of his generation, Man Ray was converted to modernism in the wake of the 1913 Armory Show, the first grand-scale exhibition of modern art to be held in this country. While the artist had already seen a number of important exhibitions of progressive European and American art at Alfred Stieglitz's 291 Gallery, it was the large paintings displayed at the Armory Show—particularly those by Picabia, Matisse, and Duchamp—that prompted Man Ray to begin work on a larger scale, while their abrupt departure from conventional painting only affirmed and encouraged the artist's modernist inclinations. The show's impact was so great that Man Ray claimed it overwhelmed him to the point of inactivity: "I did nothing for six months," he later told a reporter. "It took me that time to digest what I had seen."[1]

For the next two years, Man Ray would experiment with the most advanced of European art movements, fusing the bright colors of Fauvism with the broken planar structures of Analytical Cubism. His *Portrait of Alfred Stieglitz* (Yale University Art Gallery), for example—thought to be the first painting he made after seeing the Armory Show[2]—clearly reveals the impact of this new and revolutionary artistic movement, particularly in its similarity to works by Picasso and Braque that the artist would have seen in this important exhibition. But the severe planar fragmentation of Cubism was to occupy only a momentary interest in the artist's stylistic evolution during this period. In the spring of 1913, a few months after the Armory Show had closed, Man Ray moved out of his parents' home in Brooklyn and, upon the invitation of a friend, began sharing expenses on a sparsely furnished shack in Grantwood, New Jersey. The remote atmosphere of this small community, which was then still comparatively undeveloped, with only a few isolated houses situated along the heights overlooking the small town of Ridgefield, was exactly what the artist was looking for. Here, in this detached and relatively remote environment, Man Ray was free to pursue his artistic inclinations without inhibition, without the constant interference of relatives, teachers, and friends, many of whom had not always been in complete sympathy with his modernist inclinations.

The first paintings Man Ray executed in Ridgefield were scenic vistas of the surrounding terrain. Whereas a number of these landscapes betray the influence of Fauvism, and others reveal an inclination toward the structural simplification of Cubism, most are relatively faithful renderings of the Ridgefield countryside. Within a year, however, the artist's depiction of this same rural environment would, stylistically speaking, change dramatically. In the late summer of 1914, on the final afternoon of a three-day camping trip he had taken with his wife and two other couples to New York's Harriman State Park, Man Ray declared that he would no longer seek inspiration directly from nature. "In fact," he told one of his friends, "I decided that sitting in front of the subject might be a hindrance to really creative work."[3] Instead, he announced that upon his return to Ridgefield he would paint a series of "imaginary landscapes," the subjects of which would be derived from his recollection of events that had occurred during the course of this memorable excursion.

Hills is a painting that must have been among the first of these "imaginary landscapes." Behind the silhouetted, twisted branches of two barren trees positioned on flanking ends of a horizontally-oriented composition, a magnificent vista unfolds. Deep in the central foreground can be seen the far end of a rectangular field, portions of which are rendered as cultivated ground, for a series of black parallel lines were undoubtedly intended to depict freshly plowed furrows. Behind the field there appears a cluster of brown, semicircular shapes, possibly meant to represent a stringcourse of trees, the leaves browned by the encroaching frosts of autumn. And directly behind these shapes can be seen the most distinguishing feature of the landscape—a series of gently rolling hills—from which the painting derives its title. These majestic hills, separated from one another by a low-lying atmospheric mist, range in hue from a deep gray in the immediate foreground, through to a brilliant purple in the central range, to a milky gray at the distant horizon. Finally, in the upper reaches of the composition, prominent cloud formations appear to echo consciously the repetitive linear and circular patterns of the landscape below.

The basic components of this small landscape provide the essential background details in a much larger and more ambitious picture from this same period entitled *Departure of Summer* (1988, Middendorf Gallery, Washington, D.C.), wherein the artist has depicted three nude female figures bathing in a mountain stream, recalling a scene he had witnessed during the time of his outing in Harriman State Park. The flatness and lack of articulation given to these figures and the background landscape point in the direction of the artist's future work, and thus establishes the painting of *Hills* as an important intermediary step in the artist's evolution toward a more abstract, two-dimensional style.[4]

FRANCIS M. NAUMANN

ᡒᢙ 1914
Oil on canvas, 10¹/₈ × 12″
Museum purchase 86.1.2

53

PRESTON DICKINSON (1891–1930)
Fort George Hill

FORT GEORGE HILL, painted during the spring of 1915, is thematically, stylistically, and professionally significant for the development of the art of Preston Dickinson. Having only recently returned to his native New York City after a four-year sojourn in Paris, Dickinson had just established a long-term affiliation with the Daniel Gallery late in 1914 as well as begun his first series of drawings and paintings focusing on the terrain and architecture of the Harlem River Region of Upper Manhattan and the Bronx.[1] This painting is one of the few completed oils from this series and is a depiction of a well-known landmark, just north of High Bridge in Washington Heights, a residential area of Manhattan.

Like other American artists at this time, Dickinson was fascinated by the American urban scene; but unlike Robert Henri, John Sloan, and Jerome Myers, who dealt with the ongoing life of New York City, Dickinson did not concentrate on the city's inhabitants, nor was he socially critical. Rather, his inclination was primarily pictorial. In his images of New York City from 1914–16, as well as those from 1922–24, his emphasis was predominantly architectonic, but also dynamic, picturesque, and symbolic.

Although he is known primarily as a Precisionist, Dickinson created artworks that are more varied in style; his works are nontheoretical and combine aspects from a variety of modernist modes that he was attracted to while he was in Paris. Despite its simplified lighting effects and geometric shapes, *Fort George Hill* is very different from his early Precisionist drawing of about this time, *High Bridge* (Cleveland Museum of Art). Instead, Dickinson accentuated the energy inherent in the scene by simplifying the architectural details and color choices and by exaggerating the rhythmic curves and diagonals on the hillside. Due to the low vantage point, the apartment buildings on the crest of the hill gain grandeur and provide an effective counterpoint to the more intimately scaled building and billboards below them. If the simplified geometric shapes and flattened details are evocative of aspects of Cubist art and naive painting, the intense colors reveal the artist's growing interest in the art of the Fauves and the Synchromists and anticipate the colorful emphasis in his paintings of the later 1910s.[2] The brilliant greens and yellows of the park below the tenements are vitalized by the highly saturated reds on the billboards and by the thin band of ultramarine blue that hovers over the clouds in the sky.

Fort George Hill successfully conveys the freshness and energy of springtime light, color, and breezes. On another level, however, the contrast between the apartment buildings and the small white house below them is indicative of the city's continual growth. The house seems to be a relic from another era, while the brightly colored signs announce the future development of the area. A billboard at the lower right even serves as an advertisement for Dickinson's future by containing his signature. Coincidentally, this work, purchased by Edward W. Root in May 1915, was the first artwork by Dickinson to become part of a major private collection.

RICHARD RUBENFELD

JOHN MARIN (1870–1953)

Landscape

THE YEAR MARIN PAINTED *Landscape* was a time of great turmoil for himself, his friends, and the Western world. The start of World War I in 1914 worried and appalled Americans and brought to this country many European artists seeking to escape the devastation of the war. This latter fact intensified the involvement of Alfred Stieglitz and the circle (in which Marin was a major figure) at The Little Galleries of the Photo-Secession with the European avant-garde. At 291, as the gallery was usually called, there were exhibitions of Picasso, Braque, and African art. Francis Picabia had been in New York in 1913, and returned in 1915. Marcel Duchamp arrived in the summer of 1915, about the same time *Landscape* was executed. Going to Maine in the summer of 1915 was in part Marin's escape from the cacophony of theories being bandied around at the gallery.[1]

It was Marin's habit to spend the warm months of the year in the country, and in 1915 he returned to Maine for the second summer in succession. Revealingly, he wrote to Alfred Stieglitz from Maine, in 1915, that "a great man is a combination of deliberation and impulse."[2] While he was not referring to himself as a "great man," his formula for greatness—deliberation and impulse—could be taken as Marin's artistic credo. For him there was too much deliberation and not enough impulse going on at 291.[3]

Despite Marin's resistance to the Cubism of Picasso and Braque,[4] Cubist influences are evident in the paintings made in Maine during the summers of 1914 and 1915. The impact of Cubism is felt mostly in the degree of abstraction in many Maine paintings. Several watercolors from the summer of 1915 are among the most abstract work in Marin's oeuvre to that time. He appeared to be searching for a vocabulary of symbols that would encompass the landscape, but not solely by its ordinary appearance.

Perhaps the most extreme form of Marin's investigation of Cubism is a painting titled *Tree Forms, Autumn.*[5] Here Marin has stylized forms from nature into zigzags, curves, and, in other works, wavy lines to symbolize water. Some of this vocabulary finds its way into *Landscape.* The zigzag shapes on the foliage of the tree on the left side of this picture are virtually identical to those found in *Tree Forms, Autumn* (John C. Marin, Jr., New York).

No matter how abstract Marin's paintings became—with the exception of a very few experimental nonobjective works—he remained dedicated to the landscape itself. Even *Tree Forms, Autumn* is after all *tree* forms, not simply forms. In fact, from almost any phase of Marin's long career, there are paintings that by any measure are representational alongside others that are very abstract. Marin we recall put impulse as well as deliberation in his equation of greatness.

Stylistically, the Utica picture occupies a position between the two extremes explored by Marin. Indeed, most of his works belong in this intermediary category. It is always important to realize the depth of his commitment to nature. From Maine he wrote: "Good to have eyes to see / Ears to hear the roar of the waters. / Nostrils to take in the odor of the salt-sea and the firs."[6] John I.H. Baur explained it this way: "The truth is that Marin was old enough to be rooted in an American tradition that saw in nature an ultimate reality, and this militated against abstraction."[7] But Marin was younger than Matisse and only eleven years older than Picasso. When he painted *Landscape* Marin was forty-five and in a few years his art became more vigorously expressionistic. Yet in *Landscape* we have an excellent example of his exquisite balance between the modern movement and the softly lit world of Whistler.

SHELDON REICH

ॐ 1915
Watercolor on paper, 16 × 19¹/₂″
Gift of Mr. and Mrs. Edmund Munson
and Mr. and Mrs. Watson Lowery 82.45

CHARLES BURCHFIELD (1893–1967)
Childhood's Garden

CHILDHOOD'S GARDEN exemplifies Charles Burchfield's style from 1912 through the early part of 1919. Expressionistic distortions of space, color, and proportion common to these early paintings convey the intensity of remembered emotions. Burchfield wrote that the painter should "paint directly the emotion he feels, translating a given object or scene without detours."[1] In *Childhood's Garden,* Burchfield effects this translation, depicting the remembered emotion of the garden, not its physical realities.

If this is all Burchfield attempted to do in *Childhood's Garden,* the painting would be similar to many works of the late nineteenth and early twentieth centuries. Most artists of that time were motivated by the desire to depict emotional responses to nature, rather than more "objective" representations of scenes. But *Childhood's Garden*'s significance rests with Burchfield's fascination with sound.

As his journal reveals, when Burchfield remembered the past his memories were based more on sound than on vision. In 1915 he wrote of the coming of spring: "The sound of clashing street cars even has a sound of spring in it; at noon I heard a carpenter's saw — it brought spring."[2] Similarly, sound triggers the nightmarish image of Burchfield's childhood garden. The leaping, flame-like shapes are visual equivalents to the noises of insects hidden in the grass. The cottage is obscured by sound and even the small pansies in the foreground grimace as if the weight of these noises crushes them. A 1917 journal entry describes such an oppressive auditory experience, "the pulsating chorus of night insects commences swelling louder and louder until it resembles the heart beat of the interior of a black closet."[3]

Burchfield shared this synaesthetic proclivity with artists such as Dove, Munch, and Kandinsky. His desire to represent various sensory experiences in visual terms, and his belief that vision could not operate in a vacuum but rather was molded by these other experiences, places Burchfield among the modernists of his time. This contradicts the prevailing image of him as an isolated, idiosyncratic painter.[4]

This modernist temperament is seen in yet another aspect of *Childhood's Garden.* In the same year this work was painted, Burchfield created a series of twenty drawings, "Conventions for Abstract Thought." These abstract images were translations of states of mind such as melancholy and fascination with evil. The window of the cottage in *Childhood's Garden,* with its arched "eyebrow" and darkened lower half, resembles the convention Burchfield developed for dangerous brooding, a mood evoked by the rest of the painting. Burchfield's belief that an abstract visual image could stand for an emotion was shared by many modernists from Gauguin through Kandinsky.

The sources for Burchfield's "Conventions" have not been established. Precedents for such translations of feeling to form, however, do exist in the writing of the theosophists, a source of ideas plumbed by modernists such as Kandinsky, Mondrian, and William B. Yeats (whose plays were admired by Burchfield). The theosophist text *Thought-Forms* (a book readily available in the United States and included in the Cleveland Public Library collection when Burchfield was in school in that city) includes a series of reproductions of images created by specific thoughts.

Childhood's Garden, therefore, is a work typical of Burchfield's early style. More importantly, it demonstrates that during the 1912–19 period Burchfield shared concerns and goals with artists and theorists who were squarely within the modernist camp, repudiating interpretations of his work as divorced from mainstream twentieth-century aesthetic motivations.[5]

NANCY B. KETCHIFF

ह्ल 1917
Watercolor on paper, 27 × 18 15/16″
Edward W. Root Bequest 57.90

56

CHILDE HASSAM (1859–1935)

Amagansett, Long Island, New York

THE EASTERN END of Long Island, New York, notably that area on the South Fork surrounding the villages of "the Hamptons," has attracted artists since the late nineteenth century.[1] Childe Hassam joined the ranks of artists flocking to the area when he purchased a home on Egypt Lane in East Hampton in 1920. Although first introduced to the region some two decades before, in 1898, when he visited the home of fellow artist and friend G. Ruger Donoho (1857–1916), Hassam returned to the area only occasionally until he bought from Donoho's widow an eighteenth-century shingle cottage adjacent to the Donoho home. Over the next decade and a half, the sixty-year-old artist spent long summers in residence in East Hampton and, to a great extent, retired from the peripatetic lifestyle of his younger years. Consequently, much of his production during this period draws upon the native scenery and habitat of the East End—expansive beaches and sand dunes, the Atlantic Ocean and the adjoining bays, broad farmland and lush golf courses, and, of course, the houses, gardens, and streets of the local villages.

Amagansett, Long Island, New York of 1920 takes as its subject one of the local farms in the area, in a community several miles east of East Hampton. Across a wide field in which a lone horse is grazing are clustered the various outbuildings of a farm, nestled harmoniously among trees abundant with foliage. The natural, unadorned beauty and tranquility of the native landscape as depicted in this canvas are emblematic of a theme to which Hassam returns consistently in his late career. His paintings of eastern Long Island during the last decades of his life reveal an aging artist's increasing interest in producing an art dealing with themes of enduring importance, paintings that move to the overtly symbolic.[2] While Hassam continued to render on canvas impressionistic interpretations of his new environment, his artistic vision was profoundly colored by his concern with issues of symbolic message, as well as his interest in decorative pattern and design at the expense of naturalistic depiction. Although he adhered to the stylistic heritage of French Impressionism, perhaps more consistently than any other American Impressionist, a significant portion of his production from as early as 1900 suggests a persistent symbolic vein that ought not to be ignored. Hassam's late work of this vein has often been dismissed as incongruous to the artist's impressionist vision.

Amagansett, Long Island, New York is a painting that belongs in one sense with Hassam's more directly transcribed late landscapes in that it does not introduce extraordinary characters, yet it still may be considered within the context of the artist's growing anti-naturalism. Although Hassam was himself part of a wave of sophisticated urbanites whose gathering in East Hampton necessarily changed the old colonial community, he, in nostalgic yearning not atypical of the post-World War I era, glorified in paint, watercolor, and print the pastoral and arcadian beauty of the undeveloped area. His subjects of the period repeatedly extol American bounty and heritage: the simple grace of colonial architecture, the congenial atmosphere of the village streets, the beauty of the native flora, and the grandeur of the undeveloped landscape. *Amagansett, Long Island, New York* is one of a number of works by the artist that is devoted to the theme of farming or to the ritualistic cycle of planting and harvesting, suggesting Hassam's preoccupation with time and the essential cycles of life.[3]

Like many of Hassam's late landscapes, the painting is horizontally composed, thus emphasizing the broad panoramic reach of the land. The painting's rigid broken brushwork, its naively geometricized composition, its stylized treatment of the sky, grass, and trees, and the vivid, expressive use of pigment is characteristic of the artist's late style. Despite Hassam's avowed dislike for modern art and, in fact, in late life his almost jingoistic attitude toward European influences on American art, he was not untouched by the changes in art wrought by Cézanne and other modernists. His increasing concern with a controlled, manipulated composition, as evidenced here in the use of flattened planes receding parallel to the picture, as well as the emphasis on the surface design suggest not only Hassam's interest in pattern, but, in a larger sense, an artist's prerogative to render form in a manner besides naturalistic representation.

KATHLEEN M. BURNSIDE

1920
Oil on canvas, 20 1/8 × 30"
Museum purchase 58.7

Charles Demuth (1883–1935)
Nospmas. M. Egiap Nospmas. M.

Lancaster, Pennsylvania, was the lifelong home of Charles Demuth, a major early American modernist and Precisionist. Most of his works were painted here and many treat Lancaster subjects, ranging from vaudeville themes to still-life arrangements inspired by produce available at the local farm markets and his own flourishing garden—which he and his mother maintained in back of his house on East King Street—to views of the city's buildings.

Demuth's paintings inspired by Lancaster's architecture remain among the artist's strongest and most fascinating works.[1] He painted his first on this theme in 1919 and his last in 1933, although he continued to explore other subjects throughout this period. When they were first shown, his architectural scenes did not receive the favorable reception that greeted his more accessible vaudeville and still-life subjects, and the critics struggled to sort out their strongly formal characteristics and evocatively elusive meanings.[2]

Demuth painted about twenty works of Lancaster structures and almost all of them treat specifically identifiable sites within the city.[3] Probably none of his subjects is more familiar than the John W. Eshelman Feed Company's grain elevators, erected in 1919, which once stood at 244 North Queen Street, just a few blocks away from the artist's home near the city's center. This site, one of several local groups of buildings that served as the source for multiple paintings by the artist, possessed a rich personal resonance for him.[4] Not only did it inspire Demuth's most famous work, the powerfully iconic *My Egypt* of 1927, but also his *Buildings, Lancaster* of 1930 (both, Whitney Museum of American Art), which depicted other structures that were a part of the Eshelman complex.

Demuth gave unusual titles to these paintings and the strangest one surely is *Nospmas. M. Egiap Nospmas. M.,* a side view of the Eshelman grain elevators.[5] The quixotic title has long been problematic for Demuth scholars, and while several explanations have been proposed, none are conclusive, and it may never be satisfactorily deciphered. It has frequently been observed that, read backward, its letters form a seemingly recognizable name, "M. Sampson Paige M. Sampson." While this may indeed be significant, no similar name appears in Lancaster city directories of the period, nor has the identity of the "Monsieur Sampson"[6] suggested by Emily Farnham been discovered. One theory was that the title relates "page Sampson . . . tear these buildings down,"[7] yet it is not clear why Demuth would have favored the demolition of these structures. He frequently painted industrial images, regarding them as positive aspects of the Lancaster cityscape. Alvord L. Eiseman has proposed a link to the biblical Sampson,[8] but while the elevators may have retained an emblematic biblical connotation dating from Demuth's youth,[9] this explanation too provides little in the way of clarification. Other letters appear within the composition. Some are shortened from words such as "flour," but others are too cryptic to be decoded and the visual references, such as signs and billboards, which may have suggested them to the artist, have long since disappeared. They may also contain as yet undiscovered connections to the writings of his friends Gertrude Stein, William Carlos Williams, or Marcel Duchamp.

Demuth painted comparatively fewer works on architectural themes than he did of other subjects, and they represented major artistic statements to him. Begun at the beginning of a period of increasingly fragile health from the debilitating effects of the diabetes which eventually caused his death, they mark a shift in medium from watercolor to oil and tempera, as well as a distinct increase in scale. Although many of his Lancaster architectural paintings feature bold primary colors, the Utica picture was executed utilizing a more restrained palette of white, subtle pinks, muted reds, and grays. The first of Demuth's paintings to record the Eshelman buildings, it was executed in 1921, six years earlier than *My Egypt,* and thus assumes a pivotal importance in the artist's aesthetic explorations of local images.

When Demuth died in 1935, *Nospmas. M. Egiap Nospmas. M.* was one of a group of works he willed to Georgia O'Keeffe.[10] Sometime later it entered the possession of Edith Gregor Halpert's Downtown Gallery, which handled the work of Demuth and many of his contemporaries. In 1968 it was purchased from this gallery by the Munson-Williams-Proctor Institute Museum of Art.

Betsy Fahlman

ॐ 1921
Oil on canvas, 24 × 20¼″
Museum purchase 68.29

∼ 58

Willard Leroy Metcalf (1858–1925)
Nut Gathering

Metcalf painted *Nut Gathering* of c. 1922 from a vantage point high above the little village of Chester, Vermont. The landscape of New England had been his chosen subject for many years, but the tranquility that dwells in this painting and in all his other work masked a despair at the inroads being made, bit by bit, on the countryside by industrial civilization. He continued, however, to give the beauty of New England some permanence by relocating it in his consciousness, that is, in his craft, in his art.

As with many artists of his generation, he found the impressionist aesthetic compatible for it confirmed his bias toward depicting the pleasant in life and conveniently abjured the dramatic, sordid, shocking, or even the too inventive. But even without Impressionism's implied permission, he would have gone about his pursuit of the landscape, serene and undeterred.

He also shared with many of his colleagues an unsorted-out, tossed-around-in-conversation leaning toward pantheism and transcendentalism. But spiritualism was his received and firm faith. He accepted only certain aspects of this widely practiced religion of the nineteenth century, chief among these being a belief in the afterlife called "Summerland," in which correspondences with this world were to be found, a spinoff of the more esoteric tenets of Swedenborgianism. Metcalf habitually transformed bright scenes of nature into spiritualistic metaphors of death, which, incidentally, according to his wife Henriette, he contemplated with equanimity. The perfect days and nights on his canvases were a reflection of a journey toward a spiritualist "home" far removed from the imprisoned spiritual calm of the early American Luminists who knew the immanent presence of God.

Despite the painting's title, the townsfolk gathering nuts receive short shrift and are relegated by Metcalf to a few suggestive, enlivening brushstrokes. His real interest is the tree, or trees. These were unquestionably the artist's loving obsession.[1] His early sketchbooks, even prior to his apprenticeship under George Loring Brown in the 1870s, reveal drawings of trees consummately "understood," with no suspicion of textbook formulas.[2] They must have contributed to his reluctance to embrace fully the divisionist technique of the Impressionists for, once committed, it would wrest from him his devotion to closely approximating bark and limb and foliage on canvas. Nonetheless, the tree in *Nut Gathering* is identifiable as a hickory, despite the nondiscriminated leaves. (At about this time in his life his depiction of foliage was becoming broader, not so picked out and stitched, and would soon relax even further into somewhat blurred effects characteristic of his pictures painted before 1903.)

The recognition of the familiar in this landscape tends to work against an appreciation of Metcalf's compositional challenges. It is, after all, basically a depiction of two objects, a single, tall tree and its shadow on one side of the canvas, and the branches and shadow of a second on the other. They are potentially adversarial. Why did he not impose three, rather than one, gladiators on the hilltop? (Three objects are more readily composed.) He had chosen his scene after scrutinizing it carefully. Just how did he achieve the strength, clarity, and breadth of effect evident in this unassuming statement of natural beauty?

The intruding branches and their shadows on right canvas are painted in hues of burnt umber, russet, and violet that occur on the color wheel directly across from the warm orange-golds seen in the autumnal hickory tree. They are muted sufficiently to sound no discordant note, but offer a mild challenge to the dominance of the hilltop. Deft midtone touches of yellow ocher and the siennas within the shadows also invite a certain amount of attention. At the same time, relatively even divisions of alternating branch and shadow thrust out and upward, urging the eye to identify the true subject and discover as well that not only is the shape on the right side triangular, but the entity of hilltop and crowning tree is also. The climbing diagonal of the hill provides one side of this triangle and contains the painting's brightest light-value pattern, overlapped and emphasized by the dark shape on lower right. True, the apex of the light triangle is the hickory tree, whose top branches reach into a hazy blue sky, its lower ones, pendant and contorted, ignoring it. But it is the knoll, painted in high values of green and yellow, that anchors this shape. It is the set piece for its jewel, the tree; the nut gatherers in a way do self-effacing duty as decorative seed pearls, announcing to one and all that dominance belongs justly to the left. The flicks of extreme brightness hovering somewhat above the shadows' edges are also glow-heightening devices, but the contestants must still rely upon the hills in the middle ground and distance for a decisive assist. They contribute a coloristic unity that knits together the two large triangular shapes. Skillful accents appear rhythmically in the cool, dark greens of piney knobs, lending both contrast and the projection of, yes, that third important, humpy, but noncompeting triangle—a small hill, right in the center. Just where it should be.

Elizabeth de Veer

∼ c. 1922
Oil on canvas, 24 × 24¼″
Purchased with funds from the Charles E. Merrill Trust 73.160

Edwin Dickinson (1891–1978)
Bible Reading Aboard the Tegetthoff

BIBLE READING ABOARD THE TEGETTHOFF is the fifth of seven paintings by Edwin Dickinson relating to polar subjects, and the second of two works related to the 1870s arctic voyage of the Austrian vessel Tegetthoff.[1] It is hardly surprising that a maritime subject should be painted by an artist who as a youth had hoped to attend the U.S. Naval Academy and who later served in the navy as a radio operator. Such a topic becomes even more plausible given that Dickinson spent most of the 1920s in Provincetown, Massachusetts, relentlessly observing the changing drama of ocean and sky.

But this particular subject refers to the past, not to the artist's own sailing experience. *Bible Reading Aboard the Tegetthoff* reflects the artist's peculiar antiquarian interests and specifically to his own collection of over fifty books on polar topics. And though the subject of prayer reminds us that Dickinson was raised in a devout household presided over by his minister father, this depiction of faith is set in a foreign and imperiled realm, aboard a scientific exploration during which the ship became trapped in a huge ice floe that drifted for almost two years before the crew abandoned it and finally made their way back to civilization. Rendered with the faceless imprecision of a half-remembered dream, Dickinson's image of prayer becomes a psychologically charged meditation, combining personal preoccupations with a real historical event. The artist transforms an epic voyage of scientific discovery into a beleaguered spiritual quest, in which the story of man's search for facts is cast aside in favor of spiritual salvation. The reading of the Bible becomes a plea to God for deliverance from premature death.

The Utica painting is also a depiction of human beings gathered together for solace amid a hostile environment, but the image is hardly reassuring. The steeply angled perspective forces the viewer to peer down uneasily upon the deck. This device not only suggests the disorienting movement of a ship trapped in ice but also acts as a metaphor for instability. And in the tense, scattered placement of the figures lies a suggestion of the fragile supersession of community by isolation.

The sobriety of the scene, with its predominant grays and blacks, verges on the funereal. The sails draped over the deck to form a tent assume a shroud-like appearance, as if engulfing the figures rather than protecting them. Simultaneously, sail, mast, and the explorers themselves stretch upward, away from the constraints of earthly existence, as if to counter the fate of being swallowed by the ice. Dickinson's lifelong habit of repeated overpainting and his disregard for plausible spatial relationships appear to have left one supplicant enveloped by the gray canvas sail. Only feet and shadow protrude, leaving the disturbing impression of a body wrapped for sea burial. Is the artist suggesting that faith forestalls death, or could it be that the climate for faith has itself become endangered? Though the mournful mood of the painting appears to unite faith with death, the finality of "death" seems somehow too absolute a word for Dickinson's world. His lifelong quest was to visualize evanescence itself, the passing of time and the mutability of all things.

A glimmer of light offers a foil to the northern gloom of this noonday service. Is this a proverbial sign of hope indicating that the Tegetthoff's party was ultimately rescued, or is it Dickinson's reminder that the world is always one of shadows, where the clarity of day cannot reach to dispel the unknown?

MITCHELL D. KAHAN

❧ 1926
Oil on cardboard, 19⅞ × 23¹³/₁₆″
Gift of Mr. and Mrs. Ferdinand H. Davis 68.36

⤫ 60

STUART DAVIS (1894–1964)

Eggbeater No. 2

IN 1927–28 STUART DAVIS painted a series of pictures he called "Eggbeaters," which were the first truly abstract paintings to be made in America in nearly a decade. The series is not only a landmark in the history of American abstract art, but it also represents the culmination of Davis's efforts during the 1920s to make a mature modernist statement using the vocabulary of Synthetic Cubism.

The "Eggbeater" series consists of four oil paintings, *Eggbeaters Nos. 1–4*, and with each there is associated a smaller gouache version and a graphite drawing prepared with a grid. The dating and numbering of works in the series have been confused by contradictory inscriptions and statements by the artist, but titles and dates inscribed on the preparatory drawings by the artist himself—by all appearances at the time of the completion of the studies—permit a confident restoration of the original numbering system to the paintings.[1] All works in the series were executed during 1927 and early 1928. The Munson-Williams-Proctor Institute Museum of Art's "Eggbeater" is the gouache version of what has heretofore been referred to in the Davis literature as *Eggbeater No. 4*, but now may be definitively called *Eggbeater No. 2* of 1928 (Mr. and Mrs. James A. Fisher, Pittsburgh, Pennsylvania).[2]

Davis said that in 1927 he had nailed an eggbeater, a rubber glove, and an electric fan to a tabletop in his studio and focused on this subject matter for a year. Doing so, he said, enabled him to concentrate on handling the elements of pictorial construction in a logical manner so that he might transcend the associational properties of the subject matter.[3] In point of fact, it is virtually impossible to identify the original subjects in any of the "Eggbeaters." The artist wrote about these paintings:

In the first place my purpose is to make Realistic pictures. I insist upon this definition in spite of the fact that the type of work I am now doing is generally spoken of as Abstraction. The distinction is important in that it may lead people to realize that they are to look at what is there instead of hunting for symbolic suggestions. A picture is always a three-dimensional illusion regardless of subject matter. That is to say that the most illusionistic types of painting and modern so-called abstractions are identical in that they both represent an illusion of the three-dimensional space of our experience. They differ in subject which means that they choose a different character of space to represent.[4]

In *Eggbeater No. 2* Davis has located abstracted geometric forms in an interior architectural space. The gouache and the oil versions have quite distinct personalities in that the artist has employed stronger colors and light and shade contrasts in the former (for instance: the plane that describes the rear wall of the interior space in the gouache is black and in the oil it is lime green; the wall on the left in the gouache is orange and in the oil it is lavender). Also, the illumination of the space and the forms is entirely different in character, being clear, cool nocturnal light in the gouache, while the oil is subjected to strong, bleaching daylight.

Beginning in the 1940s, Davis returned to earlier compositions as the sources for new pictures, and *Eggbeater No. 2* provided the composition for *Hot Still-scape for 6 Colors—7th Avenue Style* of 1940 (Museum of Fine Arts, Boston, and William H. Lane Foundation). This painting, in which the architectural space and abstracted still-life forms of *Eggbeater No. 2* are used again, combined with hot, vibrant colors and a proliferation of energized decorative forms—emblematic of the New York urban scene—and brilliant blues and whites—representative of the water and sky of the New England coast—is another of the artist's most notable works.

JOHN R. LANE

⤫ 1928
Gouache on cardboard, 14 1/2 × 18"
Museum purchase 54.3

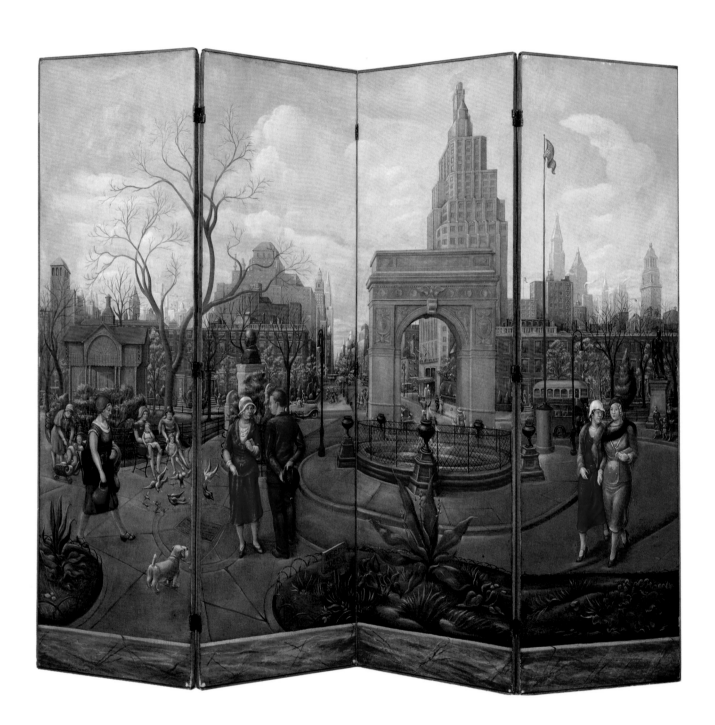

ᖷ 61

WILLIAM C. PALMER (1906–87)
Washington Square, New York

THIS FOLDING SCREEN was considered by the artist to be one of his most successful works. It was started in a mural class taught by Kenneth Hayes Miller at the Art Students League in 1928 or 1929. It was Palmer's second attempt at a screen. The earlier one, known only from a photograph, depicted Central Park.[1] After the completion of the Empire State Building in 1931, Palmer painted the new Manhattan landmark into his depiction of Washington Square. He kept this work in his studio until making a gift of it to the Munson-Williams-Proctor Institute in 1987. In an inventory of his studio taken after his recent death, it was noted that the last sketches in his sketchbook were for a new screen, a project he had discussed with Paul Schweizer.[2]

The influence of Miller in this screen has been seen in the treatment of the figures and buildings as well as the paint handling.[3] What remains to be explored is what the choice of this scene may have meant to the young artist and the dynamic relation of the images to the four angled panels of the screen as the artist intended it to be seen.

First there is the choice of the urban park, not surprising for a young man who comes to the excitement of the city after growing up in a more pastoral setting. Palmer was born and for the most part raised in Des Moines, Iowa. Other artists focused on more urban aspects of New York City: Robert Henri, its mean streets; Joseph Stella, its soaring Brooklyn Bridge; John Marin, its towering buildings; Reginald Marsh, its marquees and beaches. By contrast to these sorts of images Palmer's Washington Square has a characteristic relaxed pace and attentive decorum. In the scene, women and children have gathered to stroll or rest on park benches. The one man seen in profile on the second panel was identified by Palmer as a self-portrait.[4] He converses with a fashionably dressed woman who holds the leash of a small terrier. Palmer's delight in the urban variety of women's fashion is apparent in the attention he paid to details of costume, the fur pieces, and the women's variously styled hats. Palmer revealed that he did not paint these panels outdoors on the Square, but worked from memory and sketches. This lends weight to the conception of these panels as Palmer's ideal urban landscape—himself surrounded by fashionable women, a few animals, plants, and the triumphal arch which identifies the park as Washington Square.

This triumphal arch was for Palmer a souvenir of Paris, from which he had recently returned after a period of study with muralist M. Baudoin. Palmer's choice of site for this painting reveals his inclination toward the green earth and natural forms, yet the prominence of the Square's arch and detailing of costume also recall Palmer's love of the sophistication of city fashions and the urban historical monuments that Paris had herself borrowed from Rome.

The vantage on the arch permits a clear view of the setback arrangement of the tower of the hotel beyond. The dominance of the most famous American architectural form, the skyscraper, (reinforced by Palmer's celebration of the completion of the Empire State Building) suggests Palmer's ultimate loyalty. He includes the arch for its beauty, but the distinctively American skyscraper for its overpowering size and power. His sympathy lies with his American contemporaries excited by their new vision of the twentieth-century city.

Another aspect of the work of particular concern to the artist was the relation of the angled placement of the panels (enabling it to stand free) to the action within the painting. As arranged by the artist, the screen's outer panels should be angled toward the viewer. Thus the woman on the left could more easily walk by the couple standing in the second panel, instead of colliding with them as is suggested when the screen is flattened. Above this striding woman, the sinuous linear curves of a leafless tree knit the first panel to the second. Below her, the position of the terrier, the angle of its protective gaze, and the pattern in the paving relate the first panel to the complementary angle of the second panel.

As the second panel recedes from the viewer, so does the scene. The physical recession at the middle of the screen is matched by the most recessed part of the image: the deep perspectival rendering of the length of Fifth Avenue. The circular fountain, fence, and curb accented by the flowering plant in the foreground, as well as the height of the hotel in the background, bring the viewer forward away from the depth of the avenue. This circularity is accentuated at the right side by the angled path of the bus in the background and the two striding women in the foreground, whose path leads back into the scene. The axis created by the fountain almost acts like a carousel, relating the figures on the right and left in a dynamic unity.

JOHN R. SAWYER

ᖷ 1928/29–32
Oil on canvas, four panels, each 68½ × 20″
Gift of the artist 87.16

ALEXANDER BROOK (1898–1980)
The Yellow Fan

FROM 1925 to 1927 Alexander Brook was Assistant Director of the Whitney Studio Club. Through this organization Gertrude Vanderbilt Whitney fostered exhibitions and activities for the more progressive artists in the New York area. The core group of Whitney Studio Club artists, such as Peggy Bacon, Alexander Brook, Reginald Marsh, Henry Schnakenberg, and their teacher Kenneth Hayes Miller, came from the Art Students League and were oriented toward painting the human figure.[1] While Brook was dedicated to upholding the traditional artists' methods emphasized in the Art Students League, he was open to experimentation in composition and surface treatment. Although not a modernist, he had a moderately expressive brushstroke, which ranged from a vigorous to a delicate feathery touch, as well as a personal sense of color combined with an intelligent simplification of form.

During the mid-1920s, Brook established his reputation with studio pictures which seem to form a bridge with the preceding century. In the twentieth century the accouterments of the studio—still life and models themselves—and how they were painted became the major subject of art. However, in the nineteenth century the studio picture generally depicted the artist's work space and reflected aspects of his life. For example, in *The Artist's Studio* (Louvre) of 1854–55 by Courbet, the artist filled his space with models, friends, and people from different social and political levels of society in order to present an allegory on realism. On the other hand, in *The Artist's Studio* (National Gallery of Art, Washington) of 1860–70 by Corot, the artist isolated himself from any social relations. As his substitute, the model daydreams before the landscape on the artist's easel, thereby transporting herself from the daily world of the studio into the poetic landscape.

Brook's models are posed sitting, reading, sleeping, or daydreaming rather than caught in an active slice of life atmosphere in the studio. Although family and friends, his models remain anonymous and are rarely used for straightforward portraits. In his own self-portrait of 1926, *Sad But True* (location unknown), he seems to indicate his preference to suffuse his subjects with a romantic, moody spirit.[2]

In *The Yellow Fan* Brook has situated his model in a pearly pink half-slip with a muted yellow fan propped on her lap. In contrast to the earlier impastoed brushwork of paintings such as *Bouquet* (Munson-Williams-Proctor Institute Museum of Art) of 1928, he delicately applied his colors and softened his contours, drapery folds, and hairlines with a fuzzy gray-black line. Although certainly aware of the tradition of intimate scenes of women in the boudoirs, which began in the eighteenth century, Brook was influenced by the lounging semi-nude figures of Jules Pascin, a French artist active in the United States in the mid- to late 1920s. In the Utica picture Brook turned a potentially erotic subject—his wife Peggy Bacon—into a softly focused study of a figure resting at a table against a plain, medium-blue wall and staring blankly out into the spectator's space.

In 1929, a year before *The Yellow Fan,* the United States suffered the biggest financial upset in its history. During the 1930s the Depression was a major force in moving artists toward social comment. Yet at the same time some artists, such as Brook, eschewed specific reference to contemporary events and communicated their humanity in their private concerns and dreams. Brook withdrew into his studio away from a political role in society.

SARAH CLARK-LANGAGER

ॐ 1930
Oil on canvas, 30 × 36"
Edward W. Root Bequest 57.88

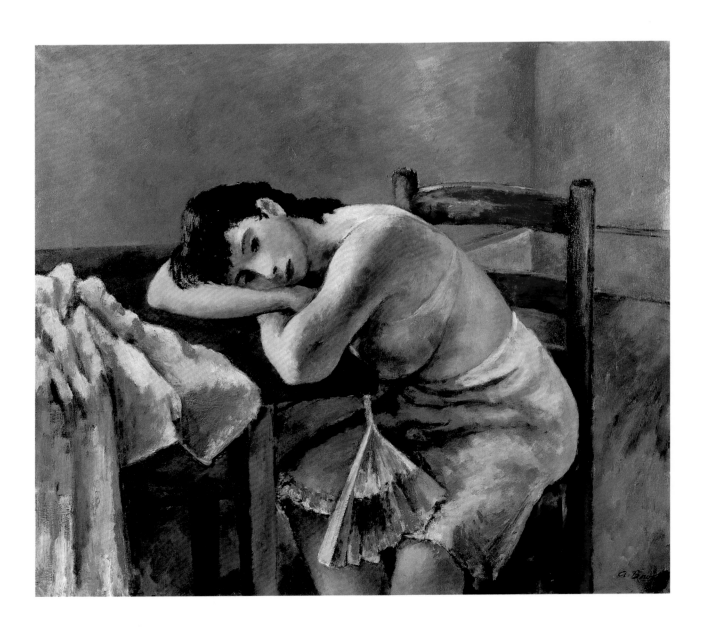

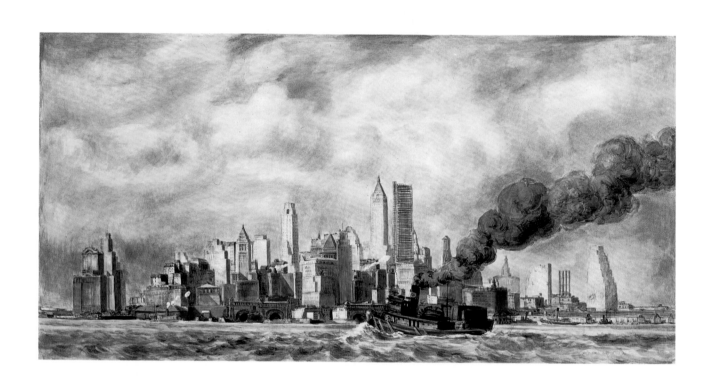

63

REGINALD MARSH (1898–1954)

Lower Manhattan

BY 1930, when Reginald Marsh painted *Lower Manhattan,*[1] the painter had reached the beginning of artistic maturity. His 1930 one-man exhibition at the Frank K.M. Rehn Gallery had established his reputation as a painter of New York City, of dance marathons and burlesque shows, of Coney Island and the Bowery. It was at that time that Marsh was adopted by his contemporary painters, the so-called Regionalists Thomas Hart Benton and John Steuart Curry, as one of their own. Marsh's fixation on the city (he rarely left New York) was viewed as an urban counterpart to Regionalism. While the Regionalists painted the barn dances, wheat harvests, and cornfields of the Midwest, Marsh painted the "talkies," breadlines, and shop windows of Manhattan. For Marsh a barn dance was a dance marathon, a landscape was the New York skyline. In either case the turn to American subject matter and representational styles of painting in the 1930s reflected the country's growing concern with itself. Paintings of America, whether urban or Western, illustrated a popular and chauvinistic tradition independent of Europe, and affirmed a national identity in the midst of economic Depression.

What constituted the particular success of Marsh's own painting style at the time, however, was his shift to egg tempera, the medium used in *Lower Manhattan.*[2] Marsh got the recipe for egg tempera, an old master medium, from Benton.[3] A draftsman above all, Marsh found that tempera allowed him a fluidity in painting that he missed when working in oil. Since tempera dried quickly he could paint over the surface rapidly, infusing the work with a linear intensity that matched the animated character he found in city life.

Throughout his career, Marsh made many paintings and prints of the New York skyline. All were based on sketches he made from the piers of Brooklyn or New Jersey. In some sense, the skyline is the obverse side of the artist's preoccupation with the public life of the city. Marsh filled his paintings with crowds of people rushing about in an urban environment replete with signs and advertisements. In paintings such as *Lower Manhattan* the artist focuses instead on the physical setting of the city seen from a distance.

Still, Marsh's skyline is not a static depiction of an island of massive skyscrapers. It is restless and alive. The excitement of the scene comes from incipient and actual activity—the billowing smoke of the tugboat as it pushes through the harbor waters, the choppy waves, the cloud-filled sky. An oncoming storm is made palpable in the yellow light thrown onto the sides of the buildings, causing them to pulsate against the steel-blue sky and the purple-green water. Marsh's skyline anticipates the city life within it. It is a turbulent, man-made drama of buildings, which nervously unfurl themselves against sea and sky. The skyline Marsh renders is as emblematic of urban America in the 1930s as the dance marathon or movie palace facade; it evokes a city and populace in perpetual motion.

MARILYN COHEN

1930
Egg tempera on linen on Masonite, 24 × 48"
Edward W. Root Bequest 57.195

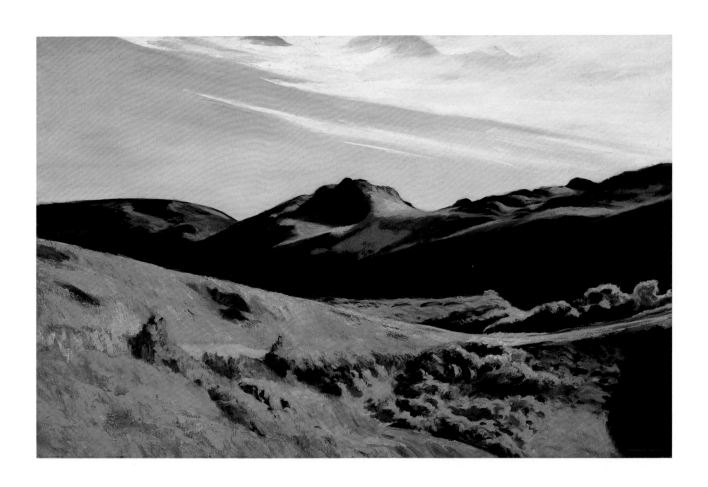

64

EDWARD HOPPER (1882–1967)

The Camel's Hump

ALTHOUGH CLOSELY IDENTIFIED with his many urban scenes, the realist Edward Hopper was very much involved with painting in rural New England.[1] He imbued his landscapes with a stark, intense quality, which often evokes in the spectator some of the same feelings of loneliness suggested by his empty city scenes or melancholy figures in interiors.

Hopper painted *The Camel's Hump* in South Truro on Cape Cod during the summer of 1931. This was the second year that he and his wife, Jo, summered on Cape Cod, where they were to build their own house in 1934. Hopper probably painted this canvas outdoors, as he and Jo stayed in a tiny place they called "Bird Cage Cottage." They gave their rented home this name because rain, wind, and even animals entered freely.

After enduring an especially rainy summer in 1933, they decided to build their own house in order to be able to paint indoors and avoid the changeable Cape Cod weather. Although Hopper initially complained about the barren quality of this area of Cape Cod, he eventually preferred spending his summers there, rather than Maine or Gloucester where he had previously gone. The weather on Cape Cod stayed warmer longer so that he was able to remain through much of the autumn.

The Utica picture depicts a bare, saddle-shaped dune located behind the South Truro Church, which Hopper had painted the previous summer. If one visualizes this striking topography as the back and hump of a camel, the rider's perch is shown as bare sand, singularly lacking any foliage. This area was known to be an old Indian campground. Hopper painted this scene in the late afternoon, when the hills in back were dramatically cast in shadow. Typically, he preferred to paint in the morning or late afternoon because the shadows were longer.

Hopper limited his palette in this canvas. He used a range of greens and blues, representing the foliage in the foreground and on the hills, as well as the blue of the sky beyond. The hillside is covered with bayberry bushes and timothy grass, both of which grow abundantly in the sandy Cape Cod soil. The grass, which is highlighted by the sunlight falling in the foreground, has begun to take on the rich golden tone of late summer.

The area Hopper painted in *The Camel's Hump* was already quite familiar to him. During the previous summer, he had painted the same landscape from a slightly different perspective in his canvas *Hills, South Truro* (Cleveland Museum of Art). Hopper continued to spend his summers in South Truro until the end of his life, but he became bored by his surroundings and felt compelled to travel elsewhere in search of inspiration. *The Camel's Hump* represents his early response to a locale that became central to his life.

GAIL LEVIN

1931
Oil on canvas, 32¼ × 50¼"
Edward W. Root Bequest 57.160

WALT KUHN (1877–1949)
The Camp Cook

IN 1940 WALT KUHN WROTE of this painting: "Despite the prominence of subject matter, a strong armature of design is ever-present."[1] And it does have most, if not all, of the abstract elements necessary to a complete artistic statement regardless of subject and surface style. Kuhn more than once said that three basic tones were all that were necessary to any painting. The three tones in *The Camp Cook* are the light one of the hat, shirt, and bowl; the middle tone is the tawny flesh of the face and arms, the potatoes, and a swag of some kind of drapery in the upper right; the dark tones are those of the background, with a climax in the work-apron, the same one the painter himself usually wore. It has a warmer quality than the neutral background. The whole painting escapes the threatened boredom of a monochrome by grace of the yellow hat with its flick of ribbon, and the friendly wood color of the bowl.

The Utica painting came from the good year, or rather half-year, of 1931. Kuhn had spent several spring months in Europe, looking with a new intensity at well-remembered masterpieces and new developments in the arts. He was back in New York by June, ready to produce several other notable paintings: *The Blue Clown* (Whitney Museum of American Art), *Clown with Red Wig* (Mrs. Eugene McDermott, Dallas, Texas), *Plumes* (Phillips Collection), *The Guide* (Sheldon Memorial Art Gallery, Lincoln, Nebraska), and *Trude* (Santa Barbara Museum of Art). *Trude* and *Plumes* are an early and most distinguished part of the chorus line of show girls for which he is best known to the general public, together with other show business types, clowns, and acrobats.

The model for *The Camp Cook* was, oddly enough, from show business too. He was George Fitzgerald, a farm boy from Eden, Wisconsin, who drifted to New York where he signed up with Lillies, a producing and booking agency. "He is a loyal admirer of art and artists," wrote the painter, "and enjoys posing for such reflective pictures," as he did for at least two others: *The Man from Eden* (Albright-Knox Art Gallery) and *Wisconsin* (National Gallery of Art). He introduced several useful models to the artist.[2]

In 1931 Kuhn also painted *Miss A.* (Colby College Museum of Art), a half-draped nude figure of a Martha Graham dancer. Walt Kuhn did very few such paintings, having a Spanish reticence in these matters. After all, he was half Spanish and began his 1931 European odyssey in Spain, "My mother's country."[3] There is an unmistakable Spanish reserve, in spite of its engaging subject, in *The Camp Cook.*

Curiously enough he painted only one small still life in 1931, unless the potatoes, paring knife, and bowl of *The Camp Cook* should be considered one, as it might well be. After all, his later still lifes are among his major accomplishments, as important as his better known show business subjects.

Most significantly, *The Camp Cook* is one of the early important confirmations of the principle that the artist had laboriously discovered and from 1931 on was to demonstrate with a master's authority—that the central theme of Western art is the single human figure, simply posed.

PHILIP RHYS ADAMS

દ્ 1931
Oil on canvas, 40 × 30¼"
Museum purchase 57.307

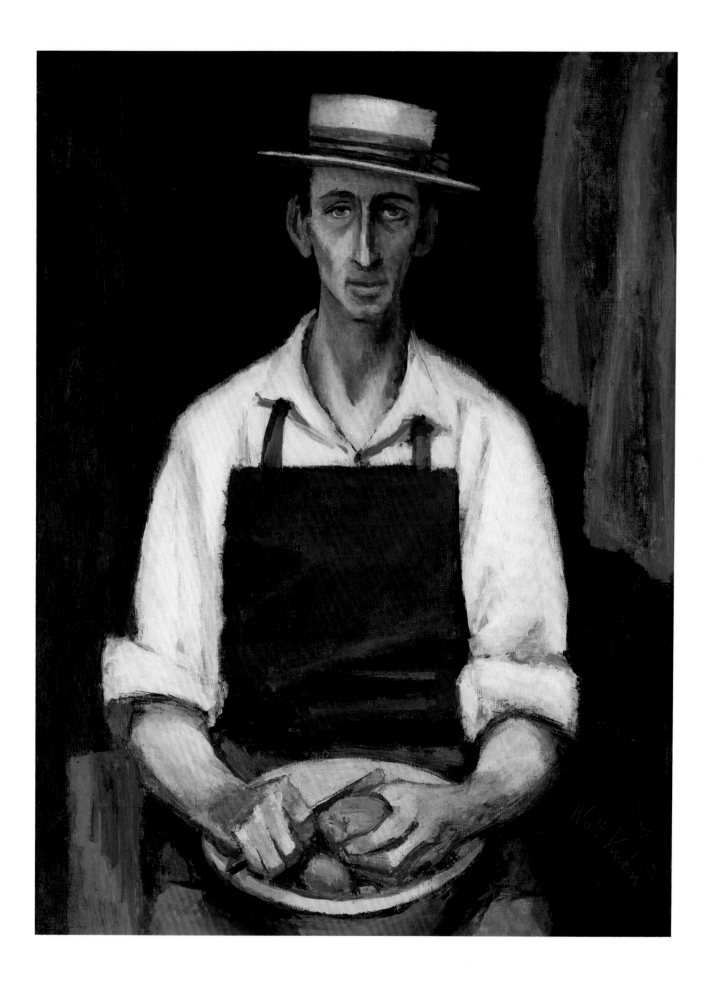

JOHN KANE (1860–1934)
Morewood Heights

IT IS MORE THAN FIFTY YEARS since John Kane's death and in that half century Pittsburgh has changed dramatically. Yet, there is nothing of the past about Kane's cityscapes: they bear the stamp of the essential Pittsburgh. Kane's vision is our vision; it is of our day.

Of the 160 or so paintings attributed to John Kane, fully a third represent Pittsburgh or its immediate environs, a rich testimony to the artist's affection for his adopted city and the compatibility he enjoyed with its hills and valleys, its bridges and railroads. There are even those who accuse Kane of creating Pittsburgh in his own image.

At the left of *Morewood Heights* we overlook a section of Carnegie-Mellon University; to the right are the stately old residences of the neighborhood for which the picture was named. Consciously or unconsciously, Kane often included Pittsburgh's Catholic churches in his city portraits—in this instance St. Paul's Cathedral at the far left. Still another thematic recurrence are the plumes of smoke issuing from building chimneys and factory stacks. Here, the white wintry smoke belies the lush foliage and wild flowers that abound in the foreground.

Kane relished painting roller-coaster hills with strong horizontal planes of lights and darks to provide depth and visual movement. His heavy, dark-undersided clouds parallel the terrain below to further accentuate the horizontality of the composition. In this painting the paler foliage contrasts with the darker lines of shadow and again with the light areas of mowed fields. Kane, who never attended an art class, developed his own expressive techniques. For a naïf, he was an acutely sophisticated observer!

Emigrating from Scotland in 1879, Kane participated in America's vast industrial expansion. An unskilled laborer, he worked at any trade that would pay him a wage, and worked unceasingly except for imposed layoffs during periods of economic depressions. He was always poor. A strong, proud and hard-drinking man, Kane had an intense love for America, its cities and countryside, its traditions and work ethic. He admired George Washington and Abraham Lincoln; both were self-educated, self-motivated men with whom he could identify. He worked ten to twelve hours a day, six days a week. Why he turned to painting when he was forty is difficult to understand. Sunday, after Mass, was his only time for himself, and this he set aside as his time to paint. It is impossible to date most of his works; however, the majority were painted in the last seven years of his life, especially in the final four when he was able to sit almost daily before his easel.

Kane's autobiography, *Sky Hooks,* as related to Marie McSwigan, a Pittsburgh newspaper woman, is a remarkable achievement for a barely educated man. It is a moving, lively tale, told with warmth and humor, and completely devoid of self-pity or self-concern. "It is in the main a simple story but like my paintings it contains many details, too."[1] He found "beauty everywhere"—in America's burgeoning industrial scene, in its landscapes, and in the routines of daily life. And that is the essential nature of John Kane's art.

LEON A. ARKUS

෫⤴ c. 1931–33
Oil on canvas, 23 × 28″
Gift of Mrs. James Lowery 82.51

JOE JONES (1909–63)
Portrait of the Artist's Father

THE DECADE OF THE 1930s was a period of catastrophic economic distress, which fostered a social and cultural climate marked by fervent political activism, factionalized ideological debate, and aesthetic controversy. Never before in this country had artists participated on such a scale in an economic and political struggle, or focused their creative energy on subjects born of their contemporary situation. Federal support of thousands of artists under the auspices of the Public Works of Art Project, the Federal Art Project, and the Treasury Relief Art Project directly contributed to the development of groups of artists working primarily in representational styles more precisely defined as Regionalism, Social Realism, Urban Realism, and Social Surrealism.

Joe Jones's interest in the industrial urban landscape and the social injustices of the racially and economically oppressed, alongside his paintings of more traditionally regionalistic subjects of farmers laboring in the drought-stricken Midwest, encompasses a broad range of the iconographic and stylistic interests developed during this period. When his first one-man exhibition opened in May 1935, at the ACA Galleries in New York City, Jones was critically acclaimed as establishing social content as a dominant factor in the contemporary art scene.[1] Soon after, Lewis Mumford wrote: "Coming at the close of the season, Jones's exhibition brings it to an end not with a whimper but with a bang," and he proclaimed Jones the year's most promising young artist.[2]

Portrait of the Artist's Father was painted in 1932, at a time when Jones was first gaining recognition in his native St. Louis for his outspoken attitudes about art and for paintings with socially potent subjects, innovative uses of color, and unorthodox compositions. Self-taught as an artist, Jones studied the paintings of the old masters in reproductions and at the St. Louis Art Museum. Pablo Picasso and George Grosz were the contemporary artists he most admired, as well as the Mexican muralists José Clemente Orozco and Diego Rivera.[3] Painting for Jones was both an opportunity to present contemporary social ills—to "paint things that will knock holes in the walls"[4]—and an exploration of formal and aesthetic issues. In *Portrait of the Artist's Father,* tensions created by the subject are played against the formal beauty of the painting.

In a St. Louis newspaper interview about this and two other family portraits, Jones emphasized his desire to present the personality of the sitter through pose and setting, relying less on likeness.[5] The image of his father is most striking for its unorthodox positioning of the man with his back to the viewer, selected so as not to reveal a missing right arm. The result of this arrangement is an anonymity of subject that suggests the universal. Jones's father, resting head in hand beside an empty gin bottle and glass, facing an empty corner, transcends the everyday to symbolize the isolation, struggle, and emptiness of the individual during a period of crisis.

The Cubist paintings of Picasso and Braque are stylistic sources for Jones's handling of form and painting technique. The subject itself, of a half portrait seated at a table with still-life accessories, had been investigated two decades before by the Cubists. While Jones quotes early modernist European painting (itself a subject of controversy at this time), his exploration of color and form evolve into a personal style that does not dominate his subject, but rather adds an expressive depth to it. In this painting, Jones's careful placement of the red baseboard and the circular composition that the artist himself considered "violent"[6] further amplify the underlying tensions of the image.

ROBERT G. WORKMAN

෫෬ 1932
Oil on canvas, 30 × 36"
Museum purchase 83.13

RAPHAEL SOYER (1899–1987)
Study for "Sentimental Girl"

FORTY YEARS AFTER *Study for "Sentimental Girl"* was completed, Raphael Soyer remembered the model as a "vivacious young dancer" named Sylvia.[1] The same woman also posed for the artist's 1933–34 lithograph, *Sylvia,* and for a painting of a young woman's head titled *Portrait of an Agitator* (location unknown), which Soyer executed in 1938 for the cover of *Scribner's Magazine.* The cover's caption filled out Sylvia Gold's biography, stating that she was neither "agitator nor model" but a "young garment worker, married, fairly active in her union and mainly interested in interpretive dancing."[2]

For his images of working-class women in the 1930s, Soyer usually chose women he knew, rather than professional models. They posed for the street scenes showing office workers and shop girls on their way home from work or for scenes that treated the model posed in studio interiors with what one critic described as a "sensitive drabness."[3] The artist met some of his models at meetings of the Communist John Reed Club, which he regularly attended. Many came from an immigrant background similar to his own and shared his leftist political views. Like Sylvia, some of Soyer's other models were struggling dancers, writers, or artists. While many held the kinds of low-paying jobs that had once helped Soyer contribute to his family's income, others were unemployed. By the middle of the Depression, when Soyer and his schoolteacher wife Rebecca were finally earning enough money to make ends meet, the artist remembered earlier hardships and opened his studio to his unemployed models who had nowhere else to sleep.

Soyer's images of partially clothed models belong to the artistic tradition of the studio picture, but they are never simply about figure painting for its own sake. Influenced by Degas and Eakins, the works are penetrating psychological studies which depend on subtleties of pose, gesture, glance, and effects of light and setting to convey the sitter's character and mood. In *Study for "Sentimental Girl,"* for example, Soyer suggested Sylvia's "vivaciousness" by casting a glowing light on her arms, upper torso, and especially her face. Her flushed cheeks and full red lips heighten the gentle sensuousness created by her partially clad figure, and the red from her lips is picked up in the expressive red brushwork that enlivens the otherwise dreary background to the right of the figure. Although Sylvia's forearms and hands rest quietly on her knees, the rest of her body is animated. She leans forward in an anticipatory pose, her serious gaze directed at something outside the picture.

Soyer, like many socially committed artists in the 1930s, wanted to make his art responsive to contemporary issues without making pictures that were overtly propagandistic. Thus, apart from being individualized portraits, the artist's paintings of studio models are more generalized types whose rumpled appearance, somber moods, disconsolate poses, and lack of purposeful activity embody the hardships and the accompanying resignation experienced by many working-class women during the Depression. By 1934, twenty-three percent of New York's female workers had lost their jobs, but little publicity was given to their cause.[4] Though men received attention as the principal victims of the economic situation, unemployment was as much a threat to women. There were no large-scale institutions for women's relief; they seldom joined breadlines, and, when totally destitute, many took the last resort and approached men who would take them in.[5] Observed in this Depression era context, *Study for "Sentimental Girl,"* and other pictures of women waiting patiently in studio interiors, record these unacknowledged victims of the Depression. By modifying the traditional conventions of the studio picture, Soyer took these lower-class women, who were out of public view, and gave them a sympathetic place of recognition in his art.

ELLEN WILEY TODD

ઠ** 1934
Oil on canvas, 20 × 24"
Edward W. Root Bequest 57.236

CLYFFORD STILL (1904–80)

Brown Study

CLYFFORD STILL's *Brown Study,* painted in the fall of 1935, is an important early work, combining Still's interest in Cézanne, Nietzsche, and Native American art and thought.[1]

In 1935, while an M.A. student at Washington State College (now University), Still wrote a thesis on Cézanne whom he described as a provincial "primitive" whose work rhythmically co-ordinated form and color. Still's identification with this concept of Cézanne informs the style of *Brown Study.* The painting incorporates stylistic features from two different periods of Cézanne. The loose, rambling forms of the right shoulder and arm are taken from Cézanne's early, violent, and more painterly style of the 1860s, before his absorption of Impressionism, while the small diagonal strokes throughout and the continuous flow of planes from the head to the lower central area reflect Cézanne's Post-Impressionist *passage.* By limiting his color to a single brown tone, Still attempted to unify these forms and thus to establish a continuity and extension of figure and color to the very edges of the canvas. This transformation, by which form becomes extended color, and extended color becomes form, is fundamental and characteristic of Still's later style of expansive color fields.

While the style reflects his understanding of Cézanne, the image in *Brown Study* is pure Still. It consists of a semi-abstract figure, whose massive, stone-like head, articulated only by deep eye-sockets, rises vertically above a more loosely defined torso. To the left is an outsized hand, dropped from the bent wrist in a vertical parallel to the head. This large and emphatically vertical head-figure becomes a constant in Still's work as it increasingly incorporates ideas adapted from his contacts with Nietzschean thought and with Native American life.

Still spent part of 1934–35 at Yaddo, the artist colony in Saratoga Springs, New York. There he came into contact with the growing interest in Nietzsche among American artists and writers. Nietzschean attitudes and purposes immediately shaped Still's art and thought. In his writings, Nietzsche conceived a new type of human being who, through the cultivation of his ancient and natural powers, would contest modern civilization and scientific man. Such a figure was a primitive force unto himself. This Nietzschean image suited Still's forceful personality and his growing sense of the artist's power and transformative role. Then, while teaching on the reservations of the Plateau Native Americans near Pullman, Washington, during the summers of 1937 and 1939, Still observed Native American life and art. From Native American ceremonies in particular, he learned how to attain their so-called primitive magical power and their communication with natural spirits.

Brown Study is among the first paintings by Still that synthesizes these seemingly divergent sources with his own concerns. The painting can be described as the symbolic representation of a nature-figure, whose form was probably inspired by Native American stone and wood carvings. The figure looms before us as a natural, primitive, expanding force. Identifying and projecting himself as such a "primitive power," Still set forth to engage and contest the modern culture that he was so famous for denouncing.

STEPHEN POLCARI

ॐ 1935
Oil on canvas, 29^{15}/$_{16}$ × 20^{1}/$_{4}$"
Purchased with funds from the Katzenbach Foundation 75.65

RALSTON CRAWFORD (1906–78)

Buildings

BUILDINGS epitomizes the boldly simplified geometric style and industrial subject matter with which Ralston Crawford's early career is identified. Executed during the 1930s, when American scene painting dominated American art, it represented an aesthetic posture dramatically at odds with prevailing tastes and revealed Crawford's allegiance to an art of order, discipline, and purity.[1] Its sharply demarcated forms and smooth paint handling link it to Precisionism, which had pioneered in the 1920s under such artists as Charles Sheeler and Charles Demuth. Yet while the choice of architectural subjects and the concentration on sharp-edged, geometric forms had unquestionably been inaugurated a full decade before Crawford's experimentation with these issues, his embrace of them grew less out of the example of these older colleagues than out of his independent study of Cézanne. Moreover, perhaps because Crawford's style developed after Precisionism had already been fully launched, his vocabulary was far more aggressively simplified and his forms more broadly handled than those of the other Precisionists. Yet, however much Crawford simplified his forms into flat color shapes, tightly fit together in shallow-spaced compositions, he never strayed from the subject's visual appearance. Characteristic of his work during the 1930s is the silhouetting of brown, rust-red, or gray forms against a clear blue sky. As in *Buildings,* his elimination of detail and reduction of forms to smooth, uninflected areas of single hues created a visual interlocking of flat color planes reminiscent of Synthetic Cubism. This conjunction of an abstract, structural art with an accessible subject matter distinctly related to the American experience caused his work to be universally acclaimed when it was first exhibited.

While Crawford exploited the inherent geometry of the American industrial landscape as a means of approximating the abstract forms and flattened space of Cubism, his choice of subject went beyond formalist considerations. For Crawford, industrial structures embodied a stable and assured civilization; they stood as affirmative symbols of the emancipation that was possible with technological achievement. The calm monumentality of *Buildings* bespeaks Crawford's unswerving faith in the industrial future. By 1945 Crawford's work had moved beyond the Precisionist style of *Buildings* to a more radically abstract treatment of space, shape, and color. While pictorially successful, this latter style did not generate the notoriety of his earlier mode and Crawford remained identified in the public's mind with Precisionism until after his death in 1978.

BARBARA HASKELL

ટ♥ 1936
Oil on canvas, 40 × 32″
Anonymous gift 77.140

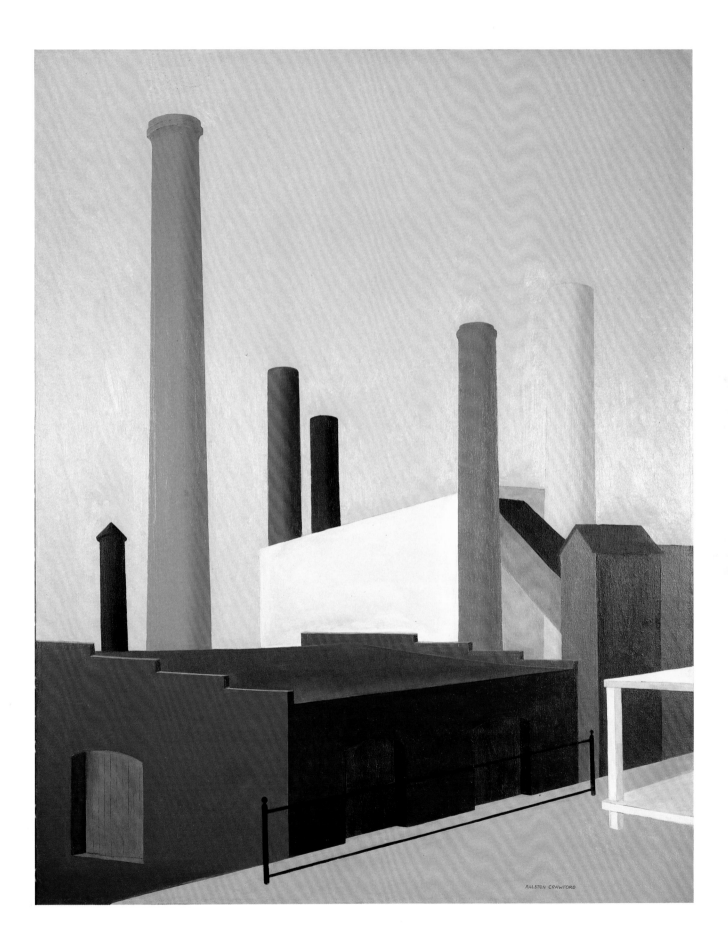

ᕫ 71

ARTHUR DOVE (1880–1946)

Summer Orchard

ARTHUR DOVE MADE HIS MARK in early twentieth-century American art through his resolute commitment to abstraction. He was one of the first painters of our century, whether European or American, to commit himself so avidly and so brilliantly to the promise of abstract art. But unlike so many painters who chose this direction in the second decade of the twentieth century, and then gave up abstraction, Dove pursued this mode of painting until his death. True, he occasionally produced works that are representational or that merely hint at subject matter, but his great contribution was in the realm of abstract painting.

Dove started as an illustrator, but during a trip to France in 1908–9, he gave himself completely to painting. In France, he acquainted himself with modern developments, which he incorporated into his own emerging style. Upon returning to New York, he became part of the circle of Alfred Stieglitz, the distinguished photographer and promoter of modern art, and through Stieglitz's encouragement and influence Dove blossomed as an abstract artist. In 1910 (or possibly 1910–11) Dove created a remarkable set of six abstractions, in oil, that show him to be a pathfinder in the realm of abstract art. These paintings reflect European influences, to be sure, but they display an inventiveness in handling abstract form that cannot be traced to one European source or another.

In 1911–12 Dove produced an even more adventurous series of paintings, some of them so abstract that subject matter is virtually undetectable. These were called the "Ten Commandments" and were shown in New York and Chicago in 1912. This series, like the group of six that preceded them, placed Dove at the forefront of international abstract painting.

Dove's paintings were often far ahead of their time and, as a result, he enjoyed few sales. Yet he persistently clung to the promise of abstraction and worked along in his own way, in spite of economic deprivation. He moved about from one place to another, trying both to paint and earn a living by means outside of painting. By 1937, the date of *Summer Orchard,* the United States was still reeling from the Depression and all its attendant economic hardships. Dove, too, was struggling to stay alive; yet from a painting like this one would hardly guess at his personal difficulties.

Summer Orchard is a lively, affirmative work, filled with the energies of nature, to which Dove remained close throughout his career. Characteristically, Dove's shapes are organic, pulsing with life, hinting of the mysterious powers of growth. The painting, of course, is a translation of his experience of nature in abstract terms, using forms that are painted with confidence and fluidity, the mark of an artist who was completely experienced and confident in his medium.

Dove's basing of an abstract painting on organic shapes, as in *Summer Orchard,* forecasts in a very special way the biomorphic paintings of the Abstract Expressionists, particularly Baziotes and Stamos. The similarities between the biomorphic abstractions of this later generation and those by Dove in the 1930s are not accidental. As Robert Goldwater has pointed out, certain of the Abstract Expressionists looked to Dove, more than any other abstract painter of the preceding generation, as a model and source.[1] Understandably, the work of the later artists is different from Dove's in certain important respects, but there is a similar devotion to energetic amoeba-like forms softly interacting with each other.

As an original member of the Stieglitz circle, Dove was one of the few artists of his generation who kept abstraction alive from the 1920s through the 1940s. He never lost faith in the appropriateness of his style and continued to paint with unflagging dedication. *Summer Orchard* is an excellent example, and a typical one, of Dove's mature capabilities as an abstract artist. It shows him at the height of his power and skill as a painter who could capture the vital impulses of nature in a visual language that is satisfying to return to again and again.

WILLIAM INNES HOMER

ᕫ 1937
Oil and wax emulsion on canvas, 15 × 20¹⁵/₁₆″
Edward W. Root Bequest 57.135

Kenneth Hayes Miller (1876–1952)
The Morning Paper

In the early 1920s, Kenneth Hayes Miller shifted away from the landscape and mythological imagery that had preoccupied him for much of his twenty-year career and turned to the contemporary scene. The American home-maker in both her public and private roles became Miller's primary subject. Many of his works depict the lower- and middle-class shoppers he saw outdoors near his Four-teenth Street studio in the heart of New York's bargain shopping district. Their counterparts were women por-trayed in simple settings at home—with children, making music, paying social calls, or at their toilettes. *The Morn-ing Paper,* one of the most informal of these domestic scenes, shows a typically full-figured Miller matron. Having finished her coffee and opened her mail, she turns her attention to the *New York Times.*[1] In the upper right-hand corner of the painting, a picture of an older woman decorates the room and is an example of Miller's frequent placement of young and old women together to meditate on the passage of time and its effects on female beauty.

With his interest in showing the contemporary scene, Miller followed fashion trends and most of his women are up-to-date in both demeanor and dress. Unlike the reflec-tive or daydreaming woman reader who was frequently imaged in late nineteenth-century art, the woman in *The Morning Paper* is fully absorbed in a serious urban news-paper. Late 1930s fashion magazines displayed the type of V-neck dress she wears here more than any other style. And, a 1938 *McCalls* beauty feature pictured hair worn higher, curled, and "rolled" off the face exactly as it ap-pears on the woman in the painting.[2]

After women gained the franchise in 1920, commenta-tors continued the debates about proper roles for the mod-ern woman. In spite of superficial accommodations to modern fashion, the woman in *The Morning Paper* em-bodies what was still the widely held middle-class ideal of womanhood—the nurturing figure whose proper place was at home as a wife and mother. Even as the so-called

"new women" were moving into the workplace, testing new roles and relationships in and outside the family, Miller never depicted working women. Moreover, his women rarely appear with men, remaining instead within their own separate spheres of domestic activity. In terms of body imagery, post-World War I changes in fashion had created new preferences in body type that were reflected in both figurative art and popular stereotypes. The sleek and boyish Flapper, for example, became the model for artist Guy Pène du Bois's contemporary woman, while the blond bombshell of thirties' movies helped to create Regi-nald Marsh's female types. A generation older, Miller ignored these models and returned instead to the full-figured classical body type that had been both the popular and the artistic ideal of female beauty during his years of training with academic artists Kenyon Cox and H. Sid-dons Mowbray at the turn of the century. His women, who were painted from memory rather than from models, were based on prototypes from the Venetian Renaissance (Ti-tian being his favorite) and from Renoir's late nudes.

Miller's image of modern womanhood reached the height of its popularity in the Depression when its endur-ing qualities helped to counteract both the fragmentation of modern society and economic chaos. Contemporary art critics praised the Miller woman's ample proportions and suggested that her plain features evoked the nobility of the average American.[3] Describing her as a woman both "ma-ternal and companionable,"[4] these critics reflected the attitudes of many Americans who ultimately placed a high value on a woman's more traditional role.

Ellen Wiley Todd

ॐ 1938
Oil on canvas, 30 × 25 1/8″
Museum purchase 53.211

Marsden Hartley (1877–1943)
Summer—Sea Window No. 1

Summer—Sea Window No. 1 is among the paintings Marsden Hartley executed after his return to his native Maine in 1937 following a career of peripatetic wandering in Europe and America. As with all of his work, notwithstanding its frequent shifts in style and subject matter, the painting exudes a strong emotional content arising from Hartley's color and expressive paint handling. This sensuous presentation of paint had sustained his work throughout his career, insuring the success of his production even through less thematically convincing periods. By the time *Summer—Sea Window No. 1* was executed, Hartley's exploitation of rich, thick-bodied paint had reached an apotheosis. As he neared the end of his life, the physical act of painting became paramount for Hartley. He disavowed any interest in subject matter and openly claimed to want "the whole body, the whole flesh, in painting."[1]

At the same time, the deep resonant color of *Summer—Sea Window No. 1* imbues it with an intense spiritual grandeur reflective of Hartley's emotional reconnection with the landscape of his childhood and his return to his early appreciation of spiritual concerns. Using thinly impastoed, fuzzy brushstrokes, he modulated his low-keyed palette of purples, maroons, and reds to create luminous color harmonies. Even the still-life motif, once considered by Hartley a means of escaping into moodless simplicity, assumes here a dignified gravity. Too, the image of a lone ship, which Hartley had employed earlier as a metaphor of the violence and unforgiving power of the sea, gives way here to a calm tranquility, a reconciliation between man and nature.

Hartley's conjunction in *Summer—Sea Window No. 1* of landscape and still-life motifs utilized a format he had experimented with as early as 1917 on a trip to Bermuda, when he had painted floral still lifes in front of an open window overlooking the sea. He briefly resuscitated the device in 1934–35 in a small group of paintings of Gloucester and, again, of Bermuda. But by 1940 his use of the motif had become frequent. Deriving from Matisse, it allowed him both to assert the two-dimensionality of the picture plane and to indulge in the sweep of perspective space visible through the window "baffles." In *Summer—Sea Window No. 1* the contrast established between the geometric severity of the foreground elements—the window and table—with the organic landscape of the background gives the composition a particularly effective structural dynamic. This painting, along with others from Hartley's late period, unequivocally establishes him as one of America's foremost expressionist painters.

Barbara Haskell

ફ્ 1939–40
Oil on cardboard, 28 × 22"
Museum purchase 72.37

Surf reflected upon higher glass

MORRIS GRAVES (b. 1910)
Surf Reflected Upon Higher Space

SURF REFLECTED UPON HIGHER SPACE is a relatively austere and abstracted work. Its delineation appears brittle, crystalline, and transparent. Color is restricted to the interaction of delicate white lines with the crackled brown paper. The painting is one of a small group of important Morris Graves's works referring to sea and surf, from 1943–44. Others include *Sea, Fish, and Constellation* (Seattle Art Museum), *Sea and the Morning Redness* (Art Institute of Chicago), and *Black Waves* (Albright-Knox Art Gallery). Each combines a pervasive rhythmic energy with the cosmic suggestiveness of water imagery. They differ from Graves's more numerous works in which animals, birds, or objects are a focus of being and consciousness. An exhibition at the Museum of Modern Art in 1942 made Graves popular with a wide audience as the painter of *Bird in the Moonlight* (Nancy Wilson Ross, Old Westbury, New York), *Blind Bird* and *Little Known Bird of the Inner Eye* (both Museum of Modern Art). In a brief statement then, Graves mentioned "our mysterious capacities which direct us toward ultimate reality." His creatures seemed the vicarious embodiments of those capacities. But he also wrote that he painted "to rest from the phenomena of the external world—to pronounce it—and to make notations of its essences."[1] The water images seem directed at that.

Surf Reflected Upon Higher Space relates to Graves's reading of Jacob Böhme and Meister Eckhart, and to works of his close friends in Seattle including Guy Anderson, Kenneth Callahan, and Mark Tobey, who were seeking visual metaphors for universal immaterial energies. Tobey, like Graves, often worked on paper with waterbase media; and both used pale linear configurations on a darker ground (often called "white writing") to suggest a dematerialized transparency. For example, in *White Night* of 1942 (Seattle Art Museum), Tobey almost filled the surface with networks of brittle angular lines. Similar to Graves, Tobey wrote in 1946: "The multiple space bounded by involved white lines symbolizes higher states of consciousness."[2] Later Graves noted that his own *Beach Under Gloom* of 1943 (Fort Wayne Museum of Art) was probably a response to "the way the Japanese formalized sea water" and to Tobey's *Modal Tide* of 1940 (Seattle Art Museum), "the way the waves are delineated. . . . He had so quieted the forms and yet so emphasized the energy and vitality."[3] The broad patterns of *Modal Tide* are even closer to the sober brown coloration and all-over structure of *Surf Reflected Upon Higher Space*.

Surf Reflected Upon Higher Space followed two extraordinary crises in Graves's life. The first was the great ambivalence he experienced after his unprecedented success through the Museum of Modern Art exhibition. Following immediately, he had serious difficulties over his registration as a conscientious objector, and he was incarcerated by the army through much of 1942. This conjunction of opportunity and confinement lay behind his succeeding paintings in which wounded birds alternated with ocean surfaces. Graves wrote in a letter: "Perhaps I could decode the sea and heavens as a communication with you—but not for exhibition."[4] Expansion, release, and a joining to the cosmic emerge through *Surf Reflected Upon Higher Space*.

MARTHA KINGSBURY

❧ 75

Yasuo Kuniyoshi (1893–1953)
Empty Town in the Desert

ONE OF THE LEADING ARTISTS of his day, Yasuo Kuniyoshi fused three discrete traditions—early American folk art, European modernism, and traditional Japanese painting. Images of spare landscapes, children, casually attired women, and circus themes re-emerged throughout his career, even as his style evolved from the naïve works of the 1920s, toward naturalism in the 1930s, and, ultimately, to nearly abstract compositions in the late 1940s and early 1950s.

While his early landscapes recall Ogonquit, Maine, where he summered, Kuniyoshi's two trips to the Southwest, in 1935 and 1941, deeply affected him. The vast and primitive terrains of Arizona, Nevada, New Mexico, Colorado, Utah, and Wyoming inspired a series of paintings which *Empty Town in the Desert* typifies. In his diary, Kuniyoshi compared this type of landscape to Maine: "I thought it is more of a beginning of creation of earth. . . . I like those ghost towns, deserted places. Buildings still standing of 1870s. Their bigness of sky and earth react so much different than Eastern states."[1]

The events of World War II initiated a period of political awareness that influenced his work throughout the 1940s. The barren ruins of *Empty Town in the Desert* reflect his melancholy over world affairs. An avid patriot, Kuniyoshi denounced Japan and was outspoken in his support of the United States involvement. In his art, Kuniyoshi looked to the stark drama of the Western landscape as a symbol of America. "Somehow I feel that if ever a real American painting is produced, it must come from these sources. . . . After all, I think we must have an expression that will grow from the soil of this country."[2]

SUSAN LUBOWSKY

❧ 1943
Oil on canvas, 20 × 36¹/₄"
Edward W. Root Bequest 57.170

GEORGIA O'KEEFFE (1887–1986)

Pelvis with Pedernal

PELVIS WITH PEDERNAL is one of a series of seven pelvis paintings shown at Alfred Stieglitz's gallery, An American Place, early in 1944. The exhibition also included twelve works depicting enlarged flowers and views of the New Mexico landscape.[1]

Desert mountains and cleansed, whitewashed bones had been part of O'Keeffe's oeuvre since 1930, when she first stayed in New Mexico. Years later she recalled that summer sojourn:

I have wanted to paint the desert and I haven't known how. I always think that I cannot stay with it long enough. So I brought home the bleached bones as my symbols of the desert. To me they are as beautiful as anything I know. To me they are strangely more living than the animals walking around—hair, eyes and all with their tails switching. The bones seem to cut sharply to the center of something that is keenly alive on the desert even tho' it is vast and empty and untouchable—and knows no kindness with all its beauty.[2]

In these paintings the bones, mostly skulls, are shown head on; in contrast, the pelvises are seen from various viewpoints, in such a way as to bring forth a strong and tense relationship between the main image and background.

In *Pelvis with Pedernal* tensions are created through color contrasts between blues and siennas, and by a strong diagonal that leads the eye from the enlarged pelvis to the distant mountain.

The Pedernal, the flat-topped mesa in the background of the painting, first appeared in O'Keeffe's work of 1936. She painted it many times with hills, flowers, the moon, and the stars against the blue or gray sky.[3] At one time she joked: "It's my private mountain. It belongs to me. God told me if I painted it enough, I could have it."[4] For her 1944 exhibition O'Keeffe wrote:

A pelvis bone has always been useful to any animal that has it—quite as useful as a head I suppose. For years in the country the pelvis bones lay about the house indoors and out—always underfoot—seen and not seen as such things can be—seen in many different ways. I do not remember picking up the first one but I remember from when I first noticed them always knowing I would one day be painting them. . . .

So probably—not having changed much—when I started painting the pelvis bones I was most interested in the holes in the bones—what I saw through them—particularly the blue from holding them up in the sun against the sky as one is apt to do when one seems to have more sky than earth in one's world—

They were most wonderful against the Blue—that Blue that will always be there as it is now after all man's destruction is finished.

I have tried to paint the Bones and the Blue[5]

O'Keeffe's symbolism consisted of using a part to represent the whole: bones indicating life; pedernal representing death.[6] Thus in this painting by simply juxtaposing two images she not only referred to World War II then in progress, but also to the past as well as to the future, and in the long run to man's insignificant place in the "blue" universe.

ILEANA B. LEAVENS

ℰ 77

MILTON AVERY (1893–1965)

Pink Tablecloth

THE UNEQUIVOCAL RICHNESS and beauty of *Pink Table-cloth* lies in Milton Avery's spectacular ability as a colorist. As one of the first and most accomplished American exponents of color and its structural implications, Avery paved the way for later generations of American color practitioners. Although today many artists use color as their primary structural and emotional focus, for an American of Avery's era such an aesthetic was unique. His technique of applying thin washes of diluted paint to individual shapes within the composition resulted in chromatic harmonies of striking delicacy and invention. In *Pink Table-cloth,* for example, what appears as even-toned areas of pink, orange, and lavender are actually multiple layers of closely valued hues. Yet what insures the success of this soft lyricism is the painting's rigorous pictorial structure. Avery has locked his simplified, spare forms into a composition so finely balanced that to change one shape or color saturation would destroy the equilibrium of the whole.

Avery developed his vanguard style during the 1920s and 1930s, when modernism was retrenching, and a concern with realism and subject matter was ascendant. His early paintings wedded the formal technique of European artists such as Henri Matisse and Pablo Picasso to the genre subject matter popular with the Social Realists and American scene painters. By 1940 Avery's palette had brightened and he had already dispensed with illusionistically modeled shapes in favor of simplified forms and flat colors.

The year 1944—the date of *Pink Tablecloth*—saw a further maturation in Avery's style as he abandoned the anecdotal detailing and brushy paint application that had marked his earlier endeavors. In their place he introduced dense, more evenly modulated areas of flattened color contained within crisply delineated forms. These simplified, seemingly flat shapes created a remarkable parity between the abstract and recognizable components of his paintings. Although his pigments would eventually become more diluted, these characteristics heralded the arrival of his mature style. Typical of his work from 1944 is the shallow pictorial space, articulated by steep perspective and tilted planes, that characterizes *Pink Tablecloth*.[1]

Landscapes and figures comprised the majority of Avery's subject matter; still lifes were less frequent. In all categories, however, he imbued his subjects with a mood of gentleness and composure. This celebration of harmony combines with Avery's ineffable color harmonies and structural clarity to endow canvases such as *Pink Table-cloth* with a power to remain compelling and fresh with each successive viewing.

BARBARA HASKELL

ℰ 1944
Oil on canvas, 32 1/8 × 48 1/8″
Gift of Mr. and Mrs. Roy R. Neuberger 53.439

THEODOROS STAMOS (b. 1922)
Cosmological Battle

STAMOS'S EARLY WORK embodies his personal memories of nature, his admiration for American artists whose works express a pantheistic unity with their surroundings, and his knowledge of books and museums dealing with the natural sciences. He synthesized these interests and experiences into a personal abstract expression of his total communion with nature.

In his first one-man exhibition in 1943, he exhibited semi-figurative oils and pastels of seaforms, shells, and rocks from the Atlantic Ocean. Reflecting on these works in 1957, he stated that his objective was "to free the mystery of the stone's inner life."[1] In order to communicate the mysteries of nature, he had to first find and then participate in the inner life of natural phenomena. One place to study nature's secrets was the Museum of Natural History in New York City. There Stamos saw scientific displays of the natural world and how earlier cultures related to their dramatic natural surroundings. He could also study early man's propitiation of nature and discover how he himself fit in with all living things.

In his early work Stamos moved from a simple penetration into the geologic layers of the earth—similar to delving into the levels of human consciousness—to a contact with nature's cycles of birth and death, analogous to the motions and emotions of man. His personal discoveries in *Blue Fish* of 1944 and *Seedling* of 1945 (both Munson-Williams-Proctor Institute Museum of Art) seem to culminate in *Cosmological Battle* of 1945. In *Blue Fish* Stamos focused on a strip of beach where a fish skeleton and conch shell lay side by side. Encircling these two forms is a heavy line as if drawn in the sand. In this painting Stamos has cropped the space so as to suggest that the shell and skeleton may also be embedded in the sandy floor of the ocean. His evocation of two levels of space, one above the horizon and one below sea level, corresponded to the outward and inward directions of the human mind. When he painted *Seedling* the following year, he indicated a concern for the natural powers of regeneration. Superimposed on a fish-like skeleton is a circular form, orb, or embryo, quivering with wavy lines and encompassing a nucleus, which suggests an animal or plant form spiraling from the deep toward the crust of the earth. By the time he painted *Cosmological Battle* in 1945, he allowed the land and marine creatures to share the same space-time relationships. Whether emerging from the eroded surfaces of a moonlit cave, adrift in the murky atmosphere, or floating along the muddied shoreline, the two central orbs (one with interlocking conch shell, hook-beaked bird, and embryo juxtaposed with a three-pronged insect or crayfish; and the other with a single imprint of a large four-toed creature) abut and overlap each other in a potential eruption. He used primordial forms suggesting both the birth and death cycles of nature. Stamos originally called this painting *Formling*. Between the time he painted this work, perhaps in the late spring of 1945, and its display in a group show at the Betty Parsons Gallery in September of 1946, someone, perhaps Stamos, changed the title to *Cosmological Battle*.[2] Betty Parsons had opened her new gallery, which featured the work of Stamos along with such artists as Pollock, Newman, Rothko, and Still. Two of these artists, Mark Rothko and Adolph Gottlieb, had clearly stated in a 1943 WNYC radio interview that they felt they could express the violent conditions of their age, the world at war, in a universal language rather than through social realist-styled painting. "All primitive expression reveals the constant awareness of powerful forces, the immediate presence of terror and fear, a recognition and acceptance of the brutality of the natural world."[3] In August 1945, the most potent source of power in the modern world was unleashed and labeled by the press as "the cosmic bomb."[4] In renaming his painting, Stamos may have been influenced by the awesome power and brutal aspects of nature's atomic forces.

SARAH CLARK-LANGAGER

꧁ 1945
Oil on Masonite, 30 × 24"
Edward W. Root Bequest 57.244

MARK TOBEY (1890–1976)
Partitions of the City

MARK TOBEY'S *Partitions of the City* comes from the 1940s, the decade in which he formulated the major themes of his work and an abstract pictorial language to express them. While the subject matter of Tobey's early work encompassed still life as well as the figure, landscape as well as cityscape, it is in his paintings of the city that we see the main thrust of his development. This was a subject that he pursued throughout his life as an artist and one that seemed to embody a distillation of his artistic concerns.[1]

Tobey's desire to convey the experience of city life prompted his first use of a calligraphic linear style. In the mid-1930s, soon after a crucial visit to the Orient where he studied calligraphy, Tobey painted a series of paintings of San Francisco's Chinatown and New York's Broadway.[2] Inspired by the dense humanity and brilliant lights of the city, he achieved a breakthrough in his development with a painting called *Broadway* of 1935 (Metropolitan Museum of Art), in which the crowds and traffic on the avenue are conveyed in the frenetic and agitated activity of the artist's brush.

When Tobey resumed the theme of the city in the 1940s, he further developed the dichotomy between an abstract, calligraphic treatment of the surface and a perspectival illusion of depth. His contemporaneous exploration of Cubism and multiple perspective led to a shallow pictorial space with many points of recession, which he unified by an over-all gestural brushstroke. *Partitions of the City,* one of the most densely worked paintings of this period, exhibits a steep diagonal path of recession by means of the artist's use of white in the central portion of the composition. The sense of depth is strongly contradicted by the vigorous use of brushstroke, which varies from wet brush to dry, thick strokes to thin, in a breadth of handling that continued to characterize the artist's mature

style. While figures are more specifically defined in Tobey's city paintings of the two preceding years, in the Utica picture only a few may be identified with certainty, including a bearded figure in the lower left corner of the composition, which could be the artist himself. Other figures or faces are suggested but subsumed into the general matrix of linear abstraction. In this respect *Partitions of the City* looks forward to Tobey's more abstract works of the 1950s and 1960s, in which line suggests rather than describes the subject of the work. In forcing us to contemplate the image in order to perceive its subject, Tobey succeeds in his desire to create paintings that not only arrest but detain the viewer.

Tobey viewed the city as a microcosm of the entire world effectively shrinking due to the impact of modern technology. His approach to this theme gradually shifted, both pictorially and philosophically, from descriptive to abstract, from a specific city to a universal one. Tobey's intense response to the subject and his goal of investing it with larger meaning are revealed in this painting, which marks a pivotal point in his artistic evolution.

ELIZA E. RATHBONE

๛ 1945
Opaque watercolor on Masonite, 30¼ × 23¾"
Edward W. Root Bequest 57.264

Arshile Gorky (1904–48)
Making the Calendar

A work that allows us to savor Arshile Gorky's gigantic talents as a painter, *Making the Calendar* occupies a melancholy place in the history of modern American art. Its direct predecessor, *The Calendars* of 1946, was incinerated in 1961 (when, during Nelson Rockefeller's incumbency, it burned at the Governor's Mansion in Albany). This loss added another miserable coda to Gorky's career—his life had long since ended by suicide in 1948. In the absence of its direct ancestor, *Making the Calendar* can be compared to a full-scale preparatory drawing (Fogg Art Museum) and to a series of small sketches (one in oil, the others in pen and ink, and crayon) in which he essayed his ideas for this composition.[1] Once Gorky arrived at his design for this theme he did not alter it, but over time reused the composition in several works, of which *Making the Calendar* is now foremost.

Beneath floating washes of oil paint, *Making the Calendar* displays the underlying drawing of the "Calendars" series. This drawing defined the space and the portrayed characters—Gorky's family seated in their Connecticut home. Specific color cues in the Utica picture identify Gorky's original subjects by referring back to *The Calendars*.[2] The lost painting presented discrete areas of color, where *Making the Calendar* uses mere touches of hue, but these colors derive from naturalistic representation. Two reddish-brown marks in the lower center inform us of the location of a dog's ears in the foreground. A dark, roughly triangular mark, that hovers within a circle above the dog at the painting's center, identifies the fireplace; adjacent to the upper edge, a rectangle at the left locates the eponymous calendar; and a bit of red at the right directs us to Agnes Gorky's (the artist's wife) blouse. All of *The Calendars'* coloring has been retained, but in an abbreviated form whereby the merest samples of a hue sustain original

features and references. These small samples of naturalistic color would have been lost (or at least unrecognizable as references to a "real world") were it not for Gorky's retention of his gorgeous drawing beneath the Matta-like oil washes; these glazes thicken to a cloud-like consistency in some places, elsewhere paint thins to admit our entrance to the picture's deeper spaces.

Thus, starting with a cozy family view that seems as complacent as an Ingres (and which includes the father/artist reading his newspaper, a baby in a cradle, an older daughter gazing out a window into the surrounding countryside, a dog seated on a rug, etc.), Gorky distilled the essence of his scene into a linear composition derived from Miro's style of drawing. Above this design he layered filmy oil glazes that almost certainly were learned after close contact with Matta, and Gorky ornamented the loose surface with a colorful network of dripped accents that he first saw in Picasso's painting. Together, this combination of massively informed abstraction based on personal emblems forged the components of the best painting of the New York School, for which Gorky was the prototype.

Harry Rand

໒ 1947
Oil on canvas, 34 × 41″
Edward W. Root Bequest 57.153

81

PHILIP GUSTON (1913–80)

Porch No. 2

PHILIP GUSTON TOOK A LEAVE OF ABSENCE from Washington University, in St. Louis, in the spring of 1947, bringing away with him an unfinished canvas—*Porch No. 2*. During the two academic years Guston had spent in St. Louis, he had distanced himself from the softened, lyrical style that had won him recent acclaim and had addressed once again his old preoccupation with the tragic. As early as 1930 he had stated his social indignation in strong terms. His representations of the Ku Klux Klan, broadened to suggest the nefarious history of the Inquisition, were powerful indictments. Stylistically, they drew upon the monumental figures of de Chirico and the expressionistic mural style of Siqueiros. Memories of Renaissance murals were implicit in Guston's use of architectural details flanking the composition of tormentors that recalled the many scenes of violent torture and punishment in Italian art history.

By 1947 Guston had deepened his painting culture and was posing difficult questions to himself. Immediately after World War II, the most grisly news from Europe arrived in St. Louis, making a profound impression. Guston recalled his conversations with other painters after they saw films of the concentration camps. "Much of our talk was about the holocaust and how to allegorize it." He himself was searching "for the plastic condition, where the compressed forms and spaces themselves expressed my feeling about the holocaust."[1] His oeuvre between 1945 and 1947 included many scenes of punishment by quartering, crucifixion, and flaying, echoing sources in both Northern and Southern Renaissance painting. These were augmented, in 1947, by a renewed interest in Picasso's Cubism and in the work of the painter Max Beckmann, whom Guston had first encountered in a 1938 exhibition and whose catalog he had carefully studied. Beckmann interested Guston because of the way he "loaded" his compositions, filling up the picture plane with intricately woven objects and figures, leaving almost no free space. Picasso, on the other hand, had sharpened his interest in planar composition in which overlaps are eloquent. Guston produced several paintings in 1947 in which performers similar to Beckmann's mummers were pressed into uneasy propinquity, and in which faces were rendered as tragic masks strongly resembling the emaciated faces and huge eye-sockets of the survivors of the camps.

By the time Guston painted *Porch No. 2*, a watershed painting, he had digested and refined his various sources. The stylized figures press up against the picture plane, which is divided into cruciform symbolism. A blackish ground pushes flat forms forward, and, as in Cubist compositions, the shapes dilate from a cluster of forms on a vertical axis. The performers, with drumsticks and horns, seem to be performing a tragic ritual. The feeling of violence is muted but unmistakable: the upside-down figure could be a tumbler, but, given the insistence of the cruciform shapes, suggests, rather, ancient punishments, perhaps even of St. Peter himself. The claustrophobic environment is explicitly stated in the barred window of the flat red building behind the five figures—a building that, as in earlier works, suggests theatrical flats, reminding the viewer of the allegorical rather than specific motifs in Guston's work. The uneasiness of the painting is emphasized by the sharp, high colors—scarlets, oranges, and greens—breaking the continuity of the narrow planes and the horizontal-vertical rhythms, and by the explicitness of certain shapes, such as the shoe that presses its sole against the picture plane—an augur of paintings to come and a sinister reminder of the events that inspired Guston's tragic vision.

DORE ASHTON

1947
Oil on canvas, 62½ × 43″
Museum purchase 48.26

175

ISABEL BISHOP (1902–88)
Double Date Delayed No. 1

ISABEL BISHOP'S WOMEN UNDERSTAND EACH OTHER. In *Double Date Delayed No. 1* they are engrossed in conversation (reassuring each other perhaps?) as to the reason for the tardiness of the second man. The rather stoic man pictured here plays no part in the action and, in effect, removes himself from the conversation as the two women assess the situation and decide on strategy.

Bishop's women are the shop girls of Union Square, portrayed in everyday life situations by the artist who spent over fifty years of her life recording men and women with painstaking care and empathy. These women may be the daughters of poor immigrants, but they are portrayed as independent, self-assured people whose horizons are limited only by their pluck and talents. In reference to her often expressed search for mobility in her work, Bishop has said: "I want to show that these young women *can* move, not just physically but also in their own lives. I have seen them do it."[1]

Bishop's two main concerns are movement and mobility, and she cites Rubens, Rembrandt, and Fragonard as among her favorite artists. She says: "I try to limit content in order to get down to something in my work." Her method is slow and painstaking, with only a few works completed within a year. She usually proceeds from drawings to etchings to paintings, asking at each stage: "Is it so?" By this statement she is questioning whether or not the image holds true to the initial impression which had first attracted her attention. The work must answer back to her at each stage before she continues to explore its potential.

Isabel Bishop's goal is that the entire painting create a "seamless web," a fusion of figure and ground. She achieves this not only through composition and carefully built-up forms, but also through her shimmery light and transparent color, which allows part of the white ground to show through. Color in *Double Date Delayed No. 1* is typically subdued, as she blends hazy blues, greens, and earth tones, and then refocuses the viewer's attention on key areas by the impeccable craftsmanship of her sure line. She allows only a suggestion of architectural background, keeping her subjects close to the viewer. Typically, Bishop gives us an unsentimentalized, unidealized portrayal of her figures.

The daughter of scholars, Isabel Bishop came to New York in 1918 and studied at the Art Students League with Kenneth Hayes Miller. Her close friends were Reginald Marsh and Guy Pène du Bois. By 1927 she left Miller to begin her own personal search for what she considers the essential and universal in art. She began a happy and lifelong relationship with Midtown Galleries in New York City with her first solo exhibition in 1933. Her paintings and graphics are owned by museums, colleges, universities, and private collectors throughout the world. She has received many awards and won much recognition from the public and among her peers, including being nominated the first woman officer of the National Institute of Arts and Letters.

MARY SWEENEY ELLETT

ళ 1948
Oil on Masonite, 22³/₁₆ × 18³/₁₆″
Museum purchase 50.14

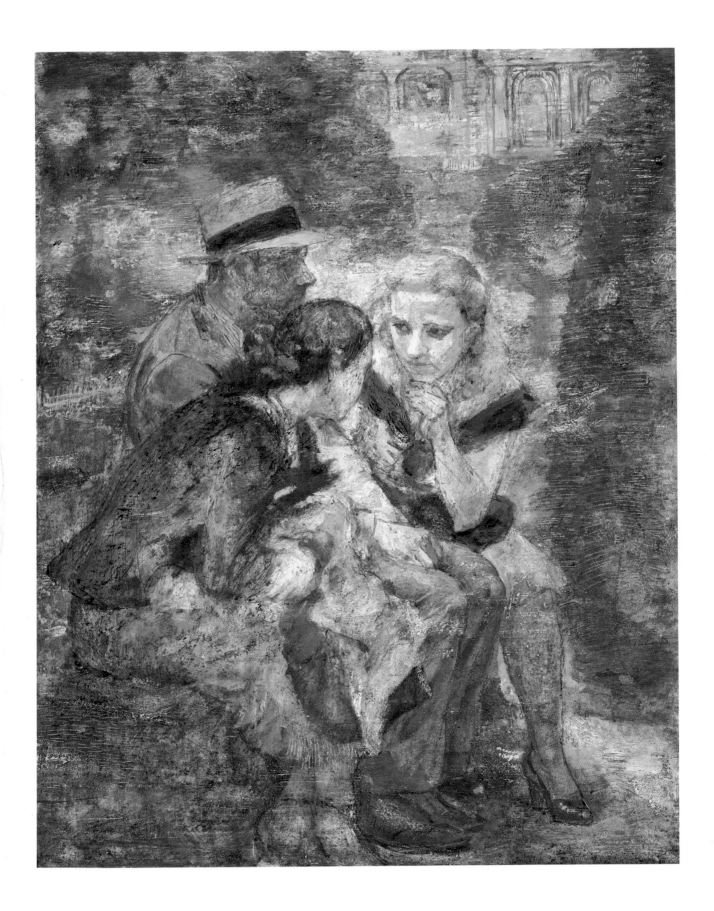

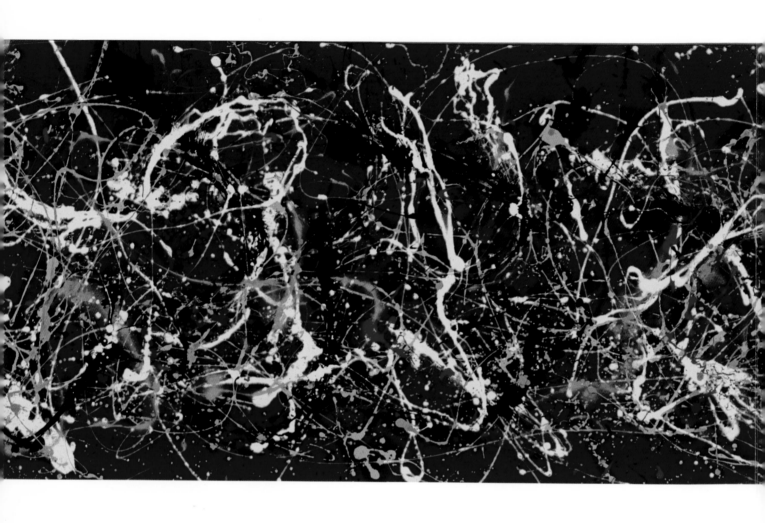

JACKSON POLLOCK (1912–56)

Number 2, 1949

JACKSON POLLOCK's *Number 2, 1949* is a forceful example of his pouring technique.[1] Its large, oblong size—nearly sixteen feet wide—immediately arrests vision, as does the striking contrast of black and white arabesques of paint against dark Indian red, which carry its vital aura across great distances. While its aesthetic impact from afar is immediate, and the tracing of its painted intricacies up close overwhelming, the viewer may well ask how such a painting, created with such apparent speed and representing nothing other than itself, can be meaningful. The answer is as complex as the painting itself.

We can, in general, know three things about an art object: what we feel encountering it visually, what information we can deduce from it through inspection, and what we can learn about the history of its creator and creation. How a painting *affects* us depends on what we bring to it subjectively, and that in turn depends on what we are able to see, and what we know about what we see. If, looking at *Number 2, 1949* for the first time, all we feel is annoyance at what appears to be spilt paint, that is one thing; if we feel thrilled by its beauty, or the energy it conveys, that is another. Both are valid subjective reactions. But we are still left to explain how this nonobjective work, perceivable as both a threat to common sense or a turn-on, affects us at all. And that entails bringing to our consciousness a visual recreation of the work and some historical knowledge.

Let us suppose that we do not know anything about Jackson Pollock, that we have just come upon *Number 2, 1949*, have all day to study it—and shall do so: first closely in itself and then in terms of what we can learn about its artist.

Looking objectively at the surface of *Number 2, 1949*, we see that it is made of poured lines and small drops of paint on a dark red fabric ground. The colors seem to have been applied in the following sequence: thin gray and white lines, bold black curves, an overall intertwining of white, and then delicate pourings and touches of yellow, silver, scarlet, and Indian red. A closer inspection will reveal that oil from the larger concentrations of black and white paint bled into the porous fabric, creating shadow-like areas of a darker red. Pollock exploited this aleatory phenomenon by carefully placing drops of Indian red paint, the same color as the ground fabric, within these darker red areas, thus creating a "repoussoir" effect that gives a lively dimensionality to what would otherwise have

appeared a drab mistake. But the fact that he did this makes us immediately aware that Pollock was not arbitrarily spilling paint, but was concerned about, and carefully controlling, his painterly effects for maximum affect.

If we could look at the back of *Number 2, 1949* (see enlarged detail), we would see something that would confirm this quite dramatically (and it might be a good idea to display this work as double-sided so this could be seen all the time). Because Pollock painted on a piece of relatively sheer, commercially dyed fabric and not on heavy artist's canvas,[2] it is possible to trace upon the back the first elements of the curvilinear design he set down when he began the work. Now it is very clear that soaked-through linear elements which appear on the back as if, say, a white line were under a black, appear on the front of the painting with the white line on top. And we find that the front reveals that Pollock very carefully filled in a part of that white line so that the overall balance of light and dark elements in his composition would, as he liked to say, "work." So we discover that this painting has been carefully thought through in its details and meticulously retouched to create an aesthetically balanced whole. And that suggests that we might want to think through some of its other elements.

For instance, if we look attentively at just the black and white lineations, and think of how a brush loaded with paint releases its liquid in terms of our handling it, it will be apparent that the black elements of the composition all feel right if our hand had slapped them down from left to right. But then, looking at the white elements that dominate the design, we find a certain tension which contradicts our kinesthetic intuitions about how we might have more slowly poured *them* out. They look in themselves vaguely wrong—like a famous Impressionist painting projected backward. Only in this absolutely nonobjective situation, devoid of representational cues, the problem our visual/kinesthetic instincts poses is solved when we realize that the whites were mostly set down from the other edge of the fabric—or, from our point of view, upside down; from Pollock's (who painted on the floor), it was just a matter of working along both of its long sides. If we turn the painting (or a reproduction of it) topsy-turvy, it would be apparent that the whites flow from our putative hand as freely and logically as do the blacks. This reveals one of the "signature" characteristics of most large-scale Pollocks:

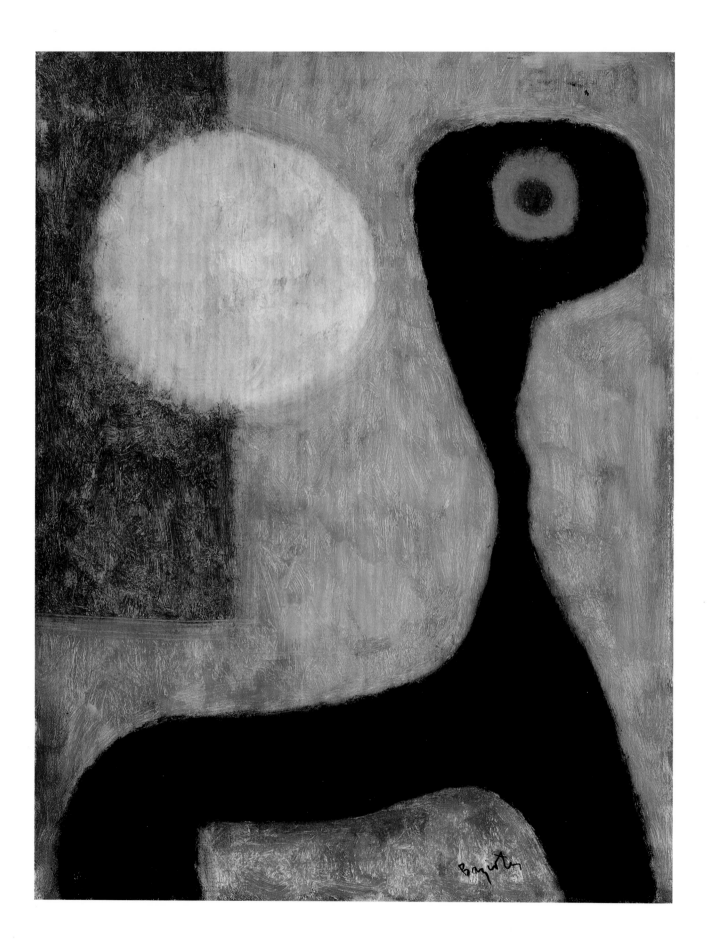

Number 2, 1949: detail of the center of the back.

the major design elements always flow from left to right, as if written out in longhand. The left edge of the work, whichever side Pollock is working from, is always addressed with an elegant pirouette of paint, which then dances in infinite variations across the length of the canvas until it reaches the terminal right edge, where a sudden vertical or unresolved element signifies the artist's frustration that his subjective infinity is limited by the objective length of his ground. In the case of *Number 2, 1949*, after thinking through the overall coherence of its composition from both sides, Pollock felt it "worked" better if the tension in the upside-down whites was retained against the freer black elements underneath. This was typical of his way of thinking: things ought not be too facile, too pretty—but more akin to the wildness of nature—though with its nonetheless intrinsic tendency to overall order and interconnectedness.

If we now turn to what we can know about Pollock, some of these details of facture take on even more significance. Let us begin with the rather odd shape of the work—about five times as wide as it is high. Such a long format, of course, served his tendency to "write out" his paintings—it kept that right edge as far away as possible. But it can also be related to the fact that Pollock was very interested during these years in painting murals—something he was never able to do when he worked on the WPA Federal Art Project during the 1930s. The oblong shape is typical of the shape of a mural. But it probably also goes even deeper into Pollock's experience: if we look at the Pollock family photographs of the dining room in the house in which he was born at Cody, Wyoming, in 1912, we find oblong oleolithographs of flowers on the wall—the exact shape and even look of many of his poured paintings such as *Number 2, 1949*.[3]

Another detail that relates to Pollock's interest in the mural is the row of black elements across the length of the work. When Pollock came to New York in 1930, he studied with Thomas Hart Benton, who was just beginning to establish a reputation as a muralist. Benton had written a series of technical articles on composition, and in one of them he advised artists to organize the large space of a mural with a series of stable vertical elements around which more free-flowing forms could be arranged. Pollock often used this device in his work—most famously, of course, in his *Blue Poles: Number 11, 1952*[4]—and he uses it in *Number 2, 1949*, countering the whites around the curved black uprights in a way that measures out the rhythms of the composition in a clear, satisfying, frieze-like manner.

Finally, let us consider Pollock's habit of painting on the floor, from all four sides of his ground. He associated this with Native American sandpainting, which he knew about from his boyhood in the West and would have seen in 1941 at an exhibit of Indian art.[5] Native Americans were impressed with the symbolic power of the four directions, and almost all their sandpaintings are so oriented. While Pollock does not do this, he did feel very deeply the analogy of his multi-directional method with that of the Indian artists. Implicit is also something else: namely the fact that his works only represent the vital process that created them. And that process, as we have seen, is dedicated to depicting something both natural and controlled—almost as if he is trying to emulate the processes of nature, which, however wild, have their innate environmental laws.

We can therefore look at *Number 2, 1949* as a very personal ecosystem—a unity composed of a balance of tensions, which engages our physical as well as our visual involvement, and which illustrates our transaction with it as much as it does the processes of an artist who could say, at the very start of his mature career, "I am nature."[6]

Francis V. O'Connor

1949
Oil, enamel, and aluminum paint on dyed fabric, 38¹/₈ × 189¹/₂"
Museum purchase 54.38

WILLIAM BAZIOTES (1912–63)
Toy

IN BAZIOTES'S APARTMENT two toy soldiers guarded the entrance way to the living room where a collection of dolls was carefully displayed in the corner. Central among them was a porcelain doll, described by his wife as a type of memory jug, sporting an assortment of coins, shells, and other memorabilia. Like the photograph of Proust that hung on their wall in the 1950s, this jar was a reminder of the key role childhood and memories played in Baziotes's art.

A lifelong admirer of Baudelaire, Baziotes would have agreed with the poet's concept that genius was childhood recovered at will and perhaps also with his discussions of toys as "the child's earliest initiation to art . . . and when mature age comes, the perfected examples will not give his mind the same feelings of warmth, nor the same enthusiasms, nor the same sense of conviction."[1] Indeed, Baziotes's notes call for the artist to "see as a child."[2] It is not surprising that during the 1940s and 1950s Baziotes was inspired by this theme and frequently used the word "toy" in his titles.

"Chance, difficulty, and danger" permeate a child's treasures, "and serve him not just as fetishes and good-luck pieces. They spirit him away to the world of adventure and distances. . . ." Like the magical objects of mythology, the toy can have a power that "enables you to go beyond what is normally possible: it permits you to disappear at will, to paralyze from a distance, to subdue without a struggle, to read thoughts, and to be carried in an instant wherever you want to go."[3] These words reveal a Surrealist attitude that may lie closest to Baziotes's own. Indeed, Baziotes, who was known to approach a trance-like state while painting, imbued his painting *Toy* with an aura of mystery.

In this work a large biped with multilayered meanings, a familiar form in Baziotes's art at this time, stares silently at the viewer, its limbs immobilized, caught by the edge of the canvas. The mesmerizing effect of the creature's gaze is reinforced by the picture's slowly painted scumbled surface and muted colors. By the late 1940s when *Toy* was painted, Baziotes's art had moved in the direction of a few forms subtly distributed within the canvas and in relation to the edges. They appear trapped in a viscous matrix. In the Utica picture the only shape free of the edges, the circle, is embedded in the left rectangle. Baziotes liked the quality of slow deliberation, which is evident here and came to characterize his version of Abstract Expressionism. He was later to say that he wanted his forms to take effect slowly, to haunt and to obsess.[4]

Baziotes painted intuitively and, like the Surrealists, remained receptive to memories, metaphors, and associations. The subject, he asserted, revealed itself to him as he worked or afterward. At some point in the process the strange and richly evocative world of toys with its many associations inspired the title for this suggestive, fettered, staring "toy." As Harold Rosenberg wrote in a poem dedicated to a painting by Baziotes, with the best toys "the shut heart balloons like a light turned on."[5]

MONA HADLER

ॐ 1949
Oil on canvas, 18 × 14⅛"
Edward W. Root Bequest 57.72

MARK ROTHKO (1903–70)
Number 18

MARK ROTHKO's *Number 18* of 1951 marks the emergence of his mature imagery and form. In the painting, orange, purple-red, and white rectangles at the top and a large white rectangle below float on a pink field, their indefinite edges making them seem to emerge from and fade into the field.

The forms of *Number 18* were abstracted from the more recognizable imagery of Rothko's earlier works. Here, as in other mature works, Rothko eliminated specific representational references in an effort to arrive at more evocative signs and metaphoric suggestions of his underlying subjects. For example, the very configuration of large and extended narrow shapes can be traced back to the seated and reclining figures of earlier semi-abstract, biomorphic paintings such as that in *The Entombment* c. 1946 (Edith Ferber, New York City). In 1952 Rothko remarked to William Seitz that in his mature work he had "substituted" color shapes for figurative ones.[1]

Rothko loved what he considered the root cultures of Western civilization, the Greco-Roman and Christian Renaissance. In the early works, many figure-like forms and architectonic fragments were adapted from Greco-Roman art in the Metropolitan Museum of Art. In his youth, he had studied ancient culture and custom by absorbing the then-popular studies of ancient traditions, *The Golden Bough* and *Babel and Bible.* His favorite book, Nietzsche's *The Birth of Tragedy,* gave him an understanding of Greek tragedy. These interests led to his frequent choice of classical subjects as is evident in works such as *Sacrifice of Iphigenia* of 1942 (private collection) and *Tiresias* of 1944 (Estate of Mary Alice Rothko). In similar fashion, Rothko admired and drew from Christian ritual and tragedy in such works as *Gethsemane* of 1945 (private collection) and the numerous "Entombments." As these latter sources and subjects suggest, he was fascinated with antiquity and the Renaissance tradition not simply because of the aesthetic qualities of their visual forms, which, in any case, he progressively modified and abstracted. Rather, it was because the subjects as well as forms served to evoke, he thought, the inwardly archaic—the psychic, cultural, and emotional roots of the West.

To these allusions to the cultural past Rothko added references to humanity's natural history. Many early works consist of compositions of emergent biological forms in horizontal sequences that reflect scientific diagrams of paleontological and geological time scales. In mature works such as *Number 18*, Rothko alludes to such evolutionary and natural process by softly brushing the top edge of the orange and the bottom edge of the white rectangular forms so that they begin to fluctuate and expand as in natural agitation and movement.

Number 18 is a configuration of fluctuant, summary, rectangular shapes packed with allusions. It is a compound of vestiges of his earlier figural, cultural, and natural forms, a heightened emblem charged with Rothko's concepts of human origins. *Number 18* fuses his lifelong themes of the ancient, traditional, and natural roots of humankind's evolving inner life.

STEPHEN POLCARI

ξ❦ 1951
Oil on canvas, 81³/₄ × 67″
Museum purchase 53.216

ᏋᎦ 86

CHARLES SHEELER (1883–1965)
New York No. 2.

IN 1919 CHARLES SHEELER left his native Philadelphia and moved to New York. Like many artists of his generation, he was immediately captivated by the city's energy and modernity, and upon his arrival he put aside the still lifes and views of rural architecture that had been his focus to produce a remarkable series of paintings, drawings, photographs, and a film depicting the skyscrapers of Manhattan. Then just as suddenly, his interest in New York's buildings waned and he turned to other subjects—domestic interiors, still lifes, and the industrial landscapes that made him famous. Although he maintained a studio in New York through the 1930s, he would not again focus his artistic eye on the city's buildings until the 1950s, the last decade of his career.

Sheeler's first images of New York during this period were made with the camera. Beginning in 1950, he photographed the city's new landmarks—the RCA Building, the United Nations complex, and the Lever Building. Subsequently, he depicted these buildings in a series of modest-sized canvases. But as he suggested by their generalized titles—*Skyline* of 1950 (Wichita Art Museum), *Convergence* of 1952 (Mr. and Mrs. George Greenspan, New York), *Windows* of 1951 (1987, Hirschl & Adler Galleries, New York), and *New York No. 2*[1]—he did not intend these paintings as portraits of celebrated structures, but rather as tributes to the abstract, formal grandeur of New York City.

As was his custom, Sheeler did preliminary research for *New York No. 2* with his camera. A photograph (private collection) of the building at 15 Park Row in lower Manhattan (the headquarters, for a time, of several of the city's newspapers)[2] records the principal elements he showed in the painting: a narrow central structure with triple windows; the recessed facade of an abutting building with a single line of windows articulating its ascent in a brittle staccato rhythm; and at right, the nearly blank face of a building seen at so violent an angle that it seems to rise on a diagonal. The hulking shadow creeping up the central building is also recorded in the photograph. In translating his photographic image into paint, Sheeler simplified many architectural details (for example, the balconies punctuating the center building's facade were eliminated

to create a sleeker surface) and extended the tonal range. The photograph's medium grays become sharply contrasting near-white and deep maroon, with a range of creams, lavenders, and slate blues between them. Superimposed on these structures is a group of prismatic shapes, also reminiscent of architecture, which were suggested by a second photograph. In the Utica picture Sheeler was using a compositional procedure he would perfect in the 1950s: he sandwiched together and manipulated several photographic negatives in order to generate an abstract and evocative design.

The result, in *New York No. 2*, is a magical vision in which shadows appear to have as much substance as concrete structures, in which the multiplication of shapes produces a dizzying pattern of architectural profiles, and in which buildings begin well below the viewer's vantage point and soar beyond his field of vision. Some of these devices go back to Sheeler's famous *Skyscrapers* of 1922 (Phillips Collection), which also depicts the Park Row building: the use of a worm's eye perspective, and the choice of an anonymous generalized facade (rather than a readily identifiable one), recall his 1927 lithograph *Delmonico Building*. Yet in *New York No. 2*, the buildings are more massive, almost overbearing. They are blocky structures, looming upward, pressing forward, multiplying to fill the picture space and nearly obliterating the sky; they are rendered in fantastic, improbable colors, which add to the air of unreality. New York for Sheeler was no less exhilarating in the 1950s than it had been in the 1920s, but the delicate beauty of buildings in the earlier pictures gave way to more iconic, powerful, thrusting forms, which are thrilling but not without a disturbing undercurrent.

CAROL TROYEN

ᏋᎦ 1951
Oil on canvas, 27 × 18¼″
Museum purchase 51.35

WILLEM DE KOONING (b. 1904)

Abstract Drawing

WILLEM DE KOONING'S PREOCCUPATION with black and white during the years following World War II was shared by other Abstract Expressionists. They, as well as contemporary European artists, were drawn to the reductive economy and the message-making properties inherent in this simplification of the palette.[1] The Utica drawing is one of about twenty by de Kooning from the period 1949 to 1951. In this group of works he resumes and clarifies the themes of his more abstract black-and-white paintings of the previous several years, often using the same black enamel.[2]

There is drama in de Kooning's paint application, with its mixture of slapdash freedom and precise care. He has used visibly liquid paint with a special sign-painter's brush, chosen for its flexibility of touch and the heavy charge of paint its long bristles can hold. The eloquent lines have been elaborated by swiping, possibly with a palette knife, to create large, dragged passages and flame-like forms.[3]

Speedy linear filaments first appeared in de Kooning's white-on-black works about 1946, perhaps in dialogue with Gorky's use of the liner brush. By 1948 the conversation included Pollock's poured skeins of paint. The enamel drawings bear closest resemblance to Pollock's black paintings of 1951.[4] Both artists present imagery that resists full comprehension and use a dazzlingly free execution that energizes the entire surface.

The image that asserts itself within the welter of de Kooning's forms may be read as a reclining nude in the foreground of a large architectural space.[5] As such, it is part of a long tradition, from Titian to Matisse. The tiny window, tangent to the figure, creates a deep space by its abrupt diminution in scale. The diagonal lines of the receding ceiling above it ingeniously echo the window shape and the top contour of the figure, thus locking organic and geometric forms, near and far, into a taut surface design.

Among the paintings of the period, the Utica work is nearest in imagery to *Warehouse Manikins* of 1949 (Bagley Wright, Seattle), *Yellow Boudoir* of 1949 (private collection), and *Woman, Wind, and Window I* of 1950 (Warner Communications, Inc., New York). The female forms of the paintings, however, are more nubbly, lacking the lithe abandon evoked here. The Utica form, with its short, splayed appendages, has a surprising shape-analogue in a painting by Soutine, one of de Kooning's favorite artists. It is the *Carcass of Beef* of c. 1925 (Albright-Knox Art Gallery), exhibited at the Museum of Modern Art in 1950. Whether the likeness emerged spontaneously or intentionally, the image is one de Kooning knew well, as he also knew, through reproduction, the painting that inspired it, Rembrandt's *Slaughtered Ox* (Louvre).[6]

Such a conflation of woman and butchered flesh startles, invoking both John Graham's wounded ladies and Surrealist precepts of imaging one's darkest fantasies. Also pertinent to the combination is the sense of grief and outrage at wartime atrocities, as conveyed in Picasso's *Charnel House* of 1945 (Museum of Modern Art). With its intelligence and urgency, this drawing can bear such content, although the indeterminate image, by its very nature, permits other readings.

JUDITH WOLFE

c. 1951
Enamel on cardboard, 24$^{1}/_{4}$ × 30$^{7}/_{16}$″
Edward W. Root Bequest 57.128

Ilya Bolotowsky (1907–81)
Diamond Shape

Russian-born Ilya Bolotowsky came to the United States in 1923 as a young man of sixteen. In 1936 he took an active role in founding the American Abstract Artists group which drew together a generation of abstract and nonobjective painters and sculptors; many of them lived in New York City and worked on various divisions of the WPA Federal Art Project.[1] Bolotowsky's earliest abstract paintings derive from Russian Constructivism combined with biomorphic Surrealist elements, and they are characterized by a unique and complex use of color.

During Bolotowsky's more than forty-year career as one of America's most distinguished nonobjective painters his style was often identified with that of the modern European master Piet Mondrian. While several other gifted American artists, among these Charles Biederman, Burgoyne Diller, Fritz Glarner, and Harry Holtzman, continued to work within and expand the visual vocabulary of Neoplasticism, Bolotowsky understood the art of Mondrian as a starting point for his own carefully considered sometimes dramatic deviations.

Bolotowsky's *Diamond Shape* of 1952 is related in form and spirit to Mondrian's innovative compositions of 1940–44 painted in New York City. Mondrian's last and unfinished painting, *Victory Boogie-Woogie* (1944), was created within a diamond format, which is a symmetrical variant of the square, retaining a ninety-degree horizontal and vertical orientation within its boundaries. The diamond format combines the twin virtues of stability and dynamism, hallmarks of the Neoplastic program.[2]

In Bolotowsky's *Diamond Shape,* alternating open and broad, then tightly integrated passages create a dramatic counterpoint. His unusual secondary colors, tones of greenish-tan, blue-gray, and mauve exist at the edges of the composition, while areas of vivid highly saturated red and sharply defined black act as architectonic supports and focal points for stability and dramatic emphasis. Partly sensuous although primarily architectonic, Bolotowsky's paintings of the 1950s are among his most admired and original. They exhibit the calm and broadly defined openness that he found in Neoplasticism, yet they also surprise and delight through their unusual rhythms of shape, interval, and color.

The Utica picture, painted in 1952, was created during a highly productive period in Bolotowsky's career. Following a two-year tenure as Instructor of painting and then Acting Head of the Art Department at Black Mountain College in North Carolina from 1946 to 1948, Bolotowsky and his family moved to Laramie, Wyoming, where he served as Associate Professor of Art from 1948 to 1957. Living and working far from the New York art world he had known as a young man, Bolotowsky's art became more distinctive and personal as he probed the structural and expressive possibilities of Neoplasticism. Vacation periods were generally spent in New York and his work continued to be seen and exhibited there on a regular basis. Bolotowsky's hard-edged, nonobjective style of the 1950s stood in sharp contrast to the art of the Abstract Expressionists, but he was recognized as an American predecessor of Minimalism when he returned to live in the New York area in 1957. He was honored with a retrospective exhibition at the Guggenheim Museum in New York, in 1974, and his long and productive career continued unabated until his death in 1981.

Susan C. Larsen

ॐ 1952
Oil on canvas, 42¼ × 42¼"
Museum purchase 53.440

JACK LEVINE (b. 1915)

The Golden Anatomy Lesson

THE GOLDEN ANATOMY LESSON was painted in 1952, shortly after Jack Levine's return from his second Guggenheim-sponsored trip to Europe. After his first sojourn, he had come back charmed enough with some Cubist ideas to experiment with colors and the flattening of the picture plane. His second exposure to the old masters as seen in Europe, particularly Caravaggio and Rembrandt, convinced him, however, that for him the most fascinating challenge was to follow in their footsteps and to paint volumes in light and shade.

Jack Levine grew up in Boston, where he early experienced disillusionment with the segment of society that set and maintained its rules. The disdain he developed for police, politicians, and businessmen as a result of their wheeling and dealing has really never left him. Nevertheless, on the way to maturity he found ample opportunities to grow and assert himself in his chosen field.

In 1952, Harry S. Truman was President of the United States and as such was not a favorite of Levine's. The artist was well aware of the 1945 Potsdam Conference, attended by Truman, where the principal Allies of World War II met to implement the agreements that had been reached at Yalta, agreements that later failed because of disagreements between the Soviet Union and the Western Powers.

In *The Golden Anatomy Lesson* we see four figures gathered around a globe in a setting reminiscent of the Pantheon in Rome, resulting in an aura of grandeur. The artist kept his colors somewhat subdued, deep tones of gray, brown, gold, and green, in order to enhance the sculptural fullness of the characters. Certain Cubist elements remain from Levine's earlier experimentation, such as in the highlights employed to facet the picture surface. The figures obliterate the middle ground, accentuating the recession of the distant coffered ceiling and pedimented niches.

As artists through the ages have turned to the giants of the past for their inspiration, so we see Levine turning to his idol, Rembrandt, in the title's allusion to *The Anatomy Lesson of Professor Nicolaes Tulp* (Mauritshuis, The Hague), and in the golden helmet as part of his iconography. But the characters are contemporary, and it is not flesh but the world that concerns them. President Truman, helmeted, occupies the center and reaches out to touch the globe. Hovering near him is James Forrestal, Secretary of Defense from 1947 to 1949 and, before that, Secretary of the Navy under President Roosevelt. To the left is Henry Wallace, Secretary of Commerce from 1945 to 1946, and at the right is a character from Levine's imagination, who, with but minor variations, has played an important role in several of his major works. The cravat, boutonnière, and flashy finger ring are the attributes of a dishonest businessman or politician in Levine's repertoire of characters.

When questioned about the content of this painting, Levine ventured: "I think I had some dim idea that the American ruling class was conquering the world and dividing it up."[1] Hence Truman is presented as a Midas-like American imperialist. One must, however, not take these thoughts too seriously. Levine is foremost interested in the art of painting. The subject matter is a device around which the artist has organized his masterful brushwork, layering of paints and glazes, and balanced his colors, opaque and translucent. (Here he experimented with adding wax to the oil paint in order to increase its permanence.) Known for his satire, which by no means is the total extent of his focus, Levine amuses himself in the loneliness of his studio with the content of his paintings. He would be bored were he to turn to total abstraction.

With renewed interest in the technique of the old masters, particularly in Europe, where some of the young artists are trying to emulate their skills, the thought that Levine may one day be considered a forerunner of this new breed is intriguing; that, to Jack Levine, would indeed be sweet irony, having suffered neglect in the heyday of abstraction and disregard for traditional artistic skills.

KENNETH W. PRESCOTT

BRADLEY WALKER TOMLIN (1899–1953)

Number 10

NUMBER 10 is one of the largest, greatest, and last paintings by Bradley Walker Tomlin, the elder member of the New York School of Abstract Expressionism. As Barnett Newman stated, the group did not represent a movement in the conventional sense of a style, but a collection of individual voices.[1] What these artists shared were cultural and aesthetic values, a common ideological background. After an academic training begun at Syracuse University in 1917 and continued in Paris during the 1920s, and years of both figurative and abstract painting in New York City and Woodstock, New York, Tomlin relinquished his Cubist-Surrealist mode of the early 1940s and in 1945 turned to the nonobjective, expressive automatism of the avant-garde to which he was introduced by Adolph Gottlieb. After experimenting with psychic improvisation, which itself was an outgrowth of Surrealism and dependent upon the dominant role of the subconscious, he finally achieved his mature style, a synthesis between spontaneity and control, energy and order. The results are "a heroic but gentle Mozartian kind of quality."[2]

Some of Tomlin's finest paintings were created during the last five years of his life. Number 10 is one of these. It consists of horizontal and vertical bars, produced with a flat, square brush and dragged stroke with dryer added to the paint. There is a new stability which has replaced the free surface drawing of his previous mode. Simultaneously, the identifying number, typical of the New York School during the 1950s, has now been substituted for the more poetic titles of the 1940s. This grid-like composition, which was invented either by Tomlin himself or by Gottlieb, precedes those of Tomlin's subsequent and final "petal paintings" with their adjacent spots of delicate color, an approach reminiscent of Impressionism at close range. Tomlin's late paintings have collectively been called "eye-music"[3] with soft and hard, high and low notes according to Betty Parsons,[4] whose gallery he joined during the late 1940s. Although sometimes referred to as a calligrapher,[5] Tomlin was, above all else, a colorist and, according to the sculptor Herbert Ferber, the only member of the group who really knew how to mix colors.[6] Despite a general consensus by the New York School to maintain the integrity of the two-dimensional plane, the blues and blacks of Number 10, while forming an "all-over" grid, vibrate back and forth amid the accents of oranges, yellows, pinks, and ochers, creating a tension between the three-dimensional space and the picture plane. "Colored disks are superimposed in many places on squares of contrasting hue, causing an optical flicker not explored again in American art until the ellipse paintings of Larry Poons."[7] The result is not just a decorative pattern but a radiant structure that is both organic and geometric. Its expression ranges from mystical to whimsical. One writer described such paintings as "deeply playful."[8] In Tomlin we see a juxtaposition not only of color but of seeming opposites such as freedom and discipline, sobriety and humor, as well as fusion of the cerebral and spiritual. Although not primarily a decorative artist, despite occasional references to "prettiness" by those who do not understand his painting, Tomlin "unlike many artists of this time . . . did not mistrust beauty."[9] Throughout his career Tomlin's paintings display subtlety, elegance, and sensitivity, which were also characteristic of the man himself.

Respected and admired by the other Abstract Expressionists, Tomlin was a "painter's painter."[10] Never personally aggressive, a fact that may have contributed to his relative obscurity as compared to the other members of the New York School, he always manifested a calm authority when it came to painting and it is this combination of sensitivity and assurance that is evident in his best works. The impact that Tomlin's personality had on his contemporaries is apparent from the comment made by the sculptor Raoul Hague: "Everything came to me out of looking at things and out of long walks and talks with Gorky or Tomlin, and through countless arguments over new developments."[11] In the statement he made for the catalog of the Museum of Modern Art's 12 Americans exhibition in 1956, Hague was even more complimentary about Tomlin's influence: "In the last thirty years, of all the artists I have known, there have been only three whose eyes I could trust—Gorky, Tomlin, and Guston—and I have used them in my own development."[12]

Tomlin considered himself to be very much part of the group, challenging the Metropolitan Museum of Art along with the other members of the "Irascible 18" in 1951, participating in the school called Subject of the Artist (later Studio 35), and having long discussions at the Cedar Bar in Greenwich Village with Jackson Pollock and the others. He died in 1953 at the age of fifty-three. Mark Rothko gave a toast at the funeral dinner "to the first of our family to leave us."[13] Robert Motherwell declared Tomlin an "élan into light . . . one of the rare, joyous spirits in the Abstract Expressionist Group."[14]

JEANNE CHENAULT PORTER

ॐ 1952–53
Oil on canvas, 72 × 102½"
Museum purchase 53.217

ꝫ 91

ROBERT MOTHERWELL (b. 1915)

The Tomb of Captain Ahab

MANY ABSTRACT EXPRESSIONISTS regarded Herman Melville's *Moby Dick* as the American equivalent of James Joyce's *Ulysses*. For them it was a symbolic journey to the unconscious. These artists followed the Surrealists in being interested in psychology and the writings of Sigmund Freud. In addition, they were fascinated with Carl Jung's concept of the archetype as a genetically encoded predisposition to a universal concept.

The Abstract Expressionists practiced a free-associational technique which the Surrealists had termed "psychic automatism" and Robert Motherwell called "plastic automatism." Motherwell was well-read in French symbolist poetry and transformed Stephane Mallarmé's dictum, that poems are made with words not ideas, into a belief that paintings are made with paint, not ideas.

The Tomb of Captain Ahab is a small sketch based on Motherwell's ideas about the role of the unconscious in art and the use of plastic automatism as an initiatory technique. The painting is a variation on his "Elegy to the Spanish Republic" series with an important difference: the free-form amoebic shapes are not caught between implacable verticals—all the black forms are set in a sea of white paint that seems to be at the point of engulfing them. This active white background, which looks like a white wall in most of the "Elegies," is an important clue to the painting's title and gives form to the following statement made by Motherwell in 1950 about the way he regards black-and-white pigments:

The chemistry of the pigments is interesting: ivory black, like bone black, is made from charred bones or horns, carbon black is the result of burnt gas, and the most common whites—apart from cold, slimy zinc oxide and recent bright titanium dioxide—are made from lead, and are extremely poisonous on contact with the body. Being soot, black is light and fluffy, weighing a twelfth of the average pigment; it needs much oil to become a painter's paste, and dries slowly. Sometimes I wonder, laying in a great black stripe on a canvas, what animal's bones (or horns) are making the furrows of my picture. . . . Black does not reflect, but absorbs all light; that is its essential nature; while that of white is to reflect all light. . . . For the rest, there is a chapter in Moby Dick *that evokes white's qualities as no painter could, except in his medium.*[1]

Despite being one of the most literate Abstract Expressionists, Motherwell avoids storytelling and works to let paint and his way of applying it connote the feeling of his painting. Titles are only clues to the feelings manifested by these resolutely abstract works.

ROBERT C. HOBBS

ꝫ 1953
Oil on canvasboard, 8 × 10³/₁₆″
Museum purchase 59.14

FRANZ KLINE (1910–62)
The Bridge

FIRST EXHIBITED IN FRANZ KLINE'S one-man show at the Sidney Janis Gallery in March 1956, *The Bridge* is a major example of the artist's fully developed black-and-white style. At the same time it is one of his first attempts to incorporate color—a warm, earth brown—into a large-scale abstraction. In this light the painting and its title acquire a metaphorical overtone. By the mid-1950s Kline sought to extend his well-known, monumental black-and-white idiom into color. The Utica painting stands, then, as a "bridge" between both modes.

While the picture's initial impact is largely generated by the looming configuration, close looking reveals a markedly rich surface and a repartee of black, white, and brown. Kline sets up an interplay not only among the three "colors," but between areas of sized unpainted canvas and the range of whites and blacks. A thinly painted zone, such as the upper left corner, fluctuates when seen against more thickly painted whites elsewhere, some scumbled with black toward gray while others are brushed on more heavily. Indeed, direct correspondence between white strokes or areas and their counterparts in black are prevalent throughout. Moreover, it is significant that few white areas in *The Bridge* are opaque. Black drips and runs, as well as more substantially painted black details, are visible beneath the white overpainting. This, along with a comparable layering of blacks and the use of brown creates a sharply felt planar tension. Of particular note is the way a wide light brown stroke near center left locks into the black configuration. Pulling white along with it, this muscular stroke amplifies the dynamic horizontal thrust spanning the painting's midsection and, just as emphatically, opens the lower left quadrant spatially.

In little time *The Bridge* affirms its strong sculptural presence. Perhaps Kline's homage to the indomitable Neogothic towers of the Brooklyn Bridge—a New York landmark he admired—this painting also becomes in historical context a counterpart to aspects of American sculpture of the late 1940s and 1950s. The resiliency and tensile strength of the composition, both expanding and contracting plastically, bring to mind David Smith's sculpture of forged and welded metal.

Since high-school days in Lehighton, Pennsylvania (1927–31), Kline had been drawn to bridges and their realization of structural stress. He included Lehighton's Central Railroad Bridge as a prominent feature in a mural commissioned in 1946 for the town's American Legion Post.[1] And a 1959–60 black-and-white canvas with blue/green underpainting, *Lehigh V Span* (San Francisco Museum of Modern Art), is Kline's abstract reiteration of thrusts and counterthrusts which he felt correspond to those in the Lehighton bridge.[2] While less specific in pictorial equivalence, the Utica painting offers provocative figural associations. Kline's major abstractions rarely conjure up a single visual metaphor, and *The Bridge* may ultimately be as much displaced being as solid structure.

The Bridge was one of ten Klines in the landmark exhibition 12 Americans, which took place at the Museum of Modern Art in 1956. Organized by Dorothy Miller as a group of simultaneous one-person shows, it also included works by James Brooks, Sam Francis, Philip Guston, Grace Hartigan, and Seymour Lipton. This was Kline's first important exhibition at a New York museum.

HARRY F. GAUGH

ॐ c. 1955
Oil on canvas, 80 × 52³/₄"
Museum purchase 56.40

ᏕᏙ 93

Ben Shahn (1898–1969)
The Parable

Ben Shahn had an extraordinary genius for weaving his ideas and emotions into lines and configurations, which, after first conceived, were reborn and regrouped in different contexts and media to contemplate, celebrate, or castigate whatever was in the artist's mind at the time. Thus, when we look at this partially submerged and seemingly desperate figure, similar images rush by in a mental review. There is the imposing figure in the 1963 serigraph, *Maximus of Tyre,* imploring mankind to forget their differences in worship of "God Himself, the Father and Fashioner of all that is."[1] He appears again in the wash drawing *The Drowning Hero* (Meyer P. Potamkin, Philadelphia), with which the Utica painting perhaps has the closest affinity.[2] In Shahn's *Haggadah for Passover,* the image of an outstretched arm and powerful hand is found repeatedly throughout the illustrations and has been referred to as a "leitmotif."[3]

Shahn painted *The Parable* in 1958, soon after he had completed a series of lectures at Harvard as the Charles Eliot Norton Professor of Poetry. The essence of these lectures has come down to us in his fascinating little book, *The Shape of Content* (Harvard University Press, 1957), in which he exhibits an unusual discipline and acuity in analyzing the making of art, its meaning, its context, its form, and its place in history. Stylistically, Shahn had arrived at a mature expression, where the graphic line, jagged much of the time, is combined with an exceedingly painterly application of colors—colors that refuse to be bound by contours. Shahn, while remaining a figurative painter at a time when abstract art was the dominant interest of the art world, incorporated much of what was abstract and expressive in his painting. The hues of the sky in this painting, mostly in shades of lavender, pink, and light blue, are reflected in the face of the man. By their appearance both in back and in front of the upstretched arm, they deny the background any traditional depth and anchor the image firmly to the two-dimensional surface. The ultramarine blue and black foreground, in which the figure is immersed, is enlivened by movements of the water, indicated by black, calligraphic swirls, which, as well as the intricate curls of the black beard, reveal the artist's joy in graphic details in startling contrast to his broad-brush application of colors. The troubled brow registers fear or despair, and the intersecting lines of the arm imbue it with life. The large, brooding eyes will look at us again in many future paintings. Shahn's graphic line, seemingly naive, is based on consummate drawing skills.

The meaning of this painting is enigmatic. The title does not clarify the intent of the artist. But then, Shahn by this time had rejected the forthright message of his earlier Social Realism paintings and his later interest in what he himself referred to as a more personal realism, that is "personal observation of the way of people, the mood of life and places."[4] He was reaching for symbols that would have a universal quality, and it is in this category that we must place *The Parable.* We see a man in need of rescue. Is he in fact physically threatened and reaching for help from God or man? Or is it *Homo sapiens* who needs rescuing from himself? Has science taken man to a point of no return? If we are puzzled, it is because Shahn wanted it so. His intent, if we dare to conjecture, was not to illustrate a specific parable, but to move us to think, to feel.

This work joins many others, painted by Ben Shahn about this time, which bear witness to his deep concern with contemporary society's overwhelming reliance on science and its skepticism with its negative effect on traditional beliefs. Shahn maintained that man must have some beliefs "to which he may attach his affections,"[5] and he was convinced that "if we are to have values, a spiritual life, a culture, these things must find their imagery and their interpretation through the arts."[6]

Kenneth W. Prescott

ᏕᏙ 1958
Tempera on cardboard, 47³/₄ × 37³/₄"
Museum purchase 58.272

HELEN FRANKENTHALER (b. 1928)

Two Moons

ONE OF HELEN FRANKENTHALER'S PRIMARY, revitalizing sources is nature, but her paintings do not depict specific scenes. Her abstract projections can be related to sensations she has found there. To her, nature is a catalyst for spontaneous feeling. *Two Moons* was painted during the year Frankenthaler established her first summer studio at Provincetown, Massachusetts. This painting comes nine years after the well-known *Mountains and Sea* of 1952 (collection of the artist). In the mid-1960s, when Frankenthaler returned to a more restrained rectilinear composition, she reflected on this seminal work and stated, "I know the landscapes were in my arms as I did it."[1] Alluding to the interrelationship of sky, sea, and land, *Two Moons* may be seen as a return to the airy ambience of *Mountains and Sea.*

Although *Mountains and Sea* was created after a summer of painting and sketching landscapes in Nova Scotia and Cape Breton, this early abstraction was primarily a work that attacked a formal problem: how to build upon the work of such Abstract Expressionists of the 1940s as Gorky, Hofmann, de Kooning, and Pollock. In order to extend the achievements of these artists, particularly the fluid, biomorphic line and translucent color of Gorky and the radical gestural technique of Pollock, Frankenthaler tried a new method of applying paint in works such as *Mountains and Sea.* She thinned her oil pigments with turpentine in order to spread the color and to make it soak into the weave of the unprimed canvas. With poured lines and watery stains pulled together into a faintly drawn Cubist structure on the bare ground of the canvas, she created a new sensation of light and space.[2]

Before the use of her staining technique the nuances of pictorial space had generally progressed in three steps: the scumbling and drybrush techniques of standard, Western easel painting; the Cubist light-and-dark value structuring of interrelated planes, which, for example, de Kooning used in a heavily laden manner; or Pollock's pulverization of three-dimensional form through a web of thick, colored lines poured, dripped, and manipulated all over his canvas. Pollock's lines of color built up a luminous, optical space, but also a hard reality on the surface of the canvas. Frankenthaler was aware of Pollock's own use of the staining technique, as in his *No. 2, 1949* (Munson-Williams-Proctor Institute Museum of Art), but she allowed her spilled lines of color to flow and enclose more area.[3] Diluted lines of color and lines becoming planar shapes pulsate at the surface, but do not separate themselves from the ground. Her technique simultaneously emphasizes the literal and illusory space of the flat canvas.

Throughout the 1950s Frankenthaler chose to adhere to the Abstract Expressionists' image, while avoiding their use of myth and their use of the canvas as a personal arena. Although reducing facture, she aggressively layered colors and denied the stained pools their purity through thick drawing and splattered paint. Only in 1957 did she begin to restore the more open quality of *Mountains and Sea.* The Utica painting shares its subtle, open landscape-type arrangement.

Yet with its spare imagery organized around two arcs, *Two Moons* exemplifies a dramatic change to a centered format and a greater attention to large areas of exposed canvas. In this painting Frankenthaler seems to set up a dialogue with the more orderly approach to composition and economy of means characteristic of art of the 1960s. While her reduction of visual incidents around a geometric core might reveal the influence of Kenneth Noland's early "Target" series, and her focus on a centrally expansive, gravity-defying image might parallel Morris Louis's "Floral" series, she reasserts her handmade marks and her interiorization of the forces of nature. In *Two Moons* Frankenthaler indicates her future interest in joining a minimum number of shapes to construct a dynamic space without de-emphasizing free luminous areas of saturated, yet subtle, colors.[4]

SARAH CLARK-LANGAGER

꤮ 1961
Oil on canvas, 32¼ × 52"
Museum purchase 83.24

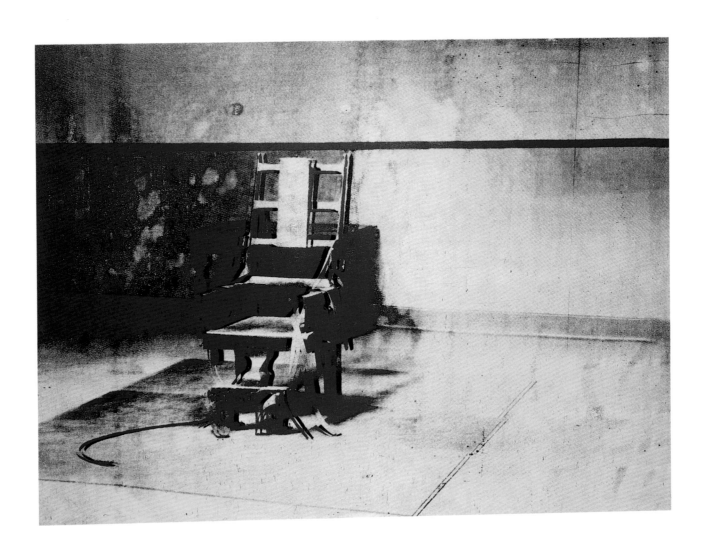

Andy Warhol (1930–87)
Big Electric Chair

The *Big Electric Chair* of Andy Warhol, depicting the most prominent tool of capital punishment in a highly industrialized society, carries a meaningful significance as almost no other object of public interest. Together with Warhol's *Atomic Bomb* (Hubert Peeters, Bruges), "Car Crashes," "Race Riots," and others, this image functions as an ideographic sign and, for that reason, was depicted by Warhol beginning in 1963 from a file of newspaper photographs and photographic police records. The technique of representation has an integral and reciprocal correlation to the image itself, generating content and meaning: silkscreen reproduction, on a cool gray/blue background, requires no manual involvement in creating the result, as the electrocution of a human being by an electric chair was conceived as "the best method [sic!] of carrying out the provisions of the law."[1] With the *Big Electric Chair* Warhol intends to demonstrate the ultimate expression of internal state sovereignty in dealing with its enemies; with the *Atomic Bomb* its ultimate expression in dealing with other nations.

In September 1945, just fifteen years old, Warhol registered at the art school of Carnegie Institute of Technology in Pittsburgh, choosing a career in the Fine Arts! What a remarkable choice, considering the artist's background. In awe of almost everything, two years below the average student's age, Warhol was raised in typical working class circumstances — coal-mining, minimum wages — and worked to pay his way through school. At the end of World War II, in Europe as well as in the South Pacific, the colleges and universities were flooded with veterans. These aged and experienced men with their rough macho-army behavior, and their exotic and brutal experiences, made a lasting impression on the then-teenaged fellow student.

After two years of more or less successful assimilation, from 1947 to 1949, Warhol was confronted with a highly sophisticated program in Pictorial Design, as the course at the Carnegie Institute was called. It stressed and required of the visual artist a keen sense of observation and of understanding for formal projections of meaningful experience, which were to be understood as "the *social flux* in a social setting with ever changing interrelations of the individual and its community."[2] The program for the 1948 Pictorial Design course shows that it was meant to be a formal study of what was called the *social flux*, of the community and its individuals: "this includes formal elements of neighborhood, of housing (in which people spend more than a third of their time), of human behavior as reflected by masters of short stories and novels," and it stressed "clothing as a sign giving process of social status and personal taste."[3]

It is mainly this last aspect that reminds us of the inner dichotomy of socially formed code systems and the individually shaped transformation of experienced social structure into memory. Thus, this course was — as Warhol's art is — about the alteration of "primary data"[4] into adequate graphic signs, which transforms information into art.

Rainer Crone

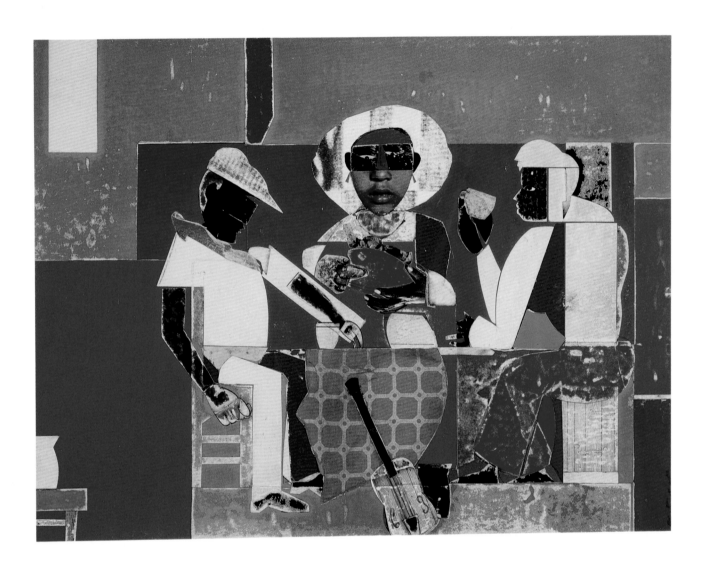

96

ROMARE BEARDEN (1914–88)

Before the Dark

THE SUBJECT MATTER OF ROMARE BEARDEN'S COLLAGE, *Before the Dark,* recurs frequently in his oeuvre. The painting is a celebration of the rituals of the Black family.[1] The members of a family are seated around a table having a meal, dinner perhaps, before the sun sets—"before the dark." Deceptively simple in its narrative content, the scene depicts the patriarch seated at the head of the table. A woman has brought a bowl of food and is about to place it on the neatly patterned tablecloth. He imperiously points to a place for the bowl. Seated across from him is another woman, who holds a coffee cup in her hand. A guitar leans against the table. In the bottom left-hand corner, a pitcher sits on a stool. Above it, light streams in through a window.

Bearden has composed a scene of domestic clarity and order. He has depicted one of those routine, mundane rituals that gives structure to day-to-day life. As he has fashioned the scene, however, the routine, the mundane becomes charged with the mysteries of ancient rituals and ceremonies.[2] He achieves this metamorphosis by establishing a taut balance between a literal almost storybook realism and a highly formalized stylization. For example, the rendering of the face of the woman who serves is spliced; the lower half is realistic, composed of photographic fragments of a Black woman's face, whereas the top half, masked as if to conceal her identity (ethnic or otherwise), presents an aura of disguise and mystery. The faces of both the man at the left and the woman seated across from him are silhouettes, stiff and unarticulated, giving the appearance of wall paintings. The contrast between realism and stylization continues in the background, which has been reduced to large rectangles of color against which the narrative details of table, chairs, guitar, and food are placed.[3] The reality of time and place is undercut by the decorativeness of the background. Even the title, *Before the Dark,* conveys a sense of mystery lurking behind the realism of this domestic scene. Though modest in size, this picture is a fine example of Romare Bearden's early collages.

Born in 1914 in Charlotte, North Carolina, Bearden grew up in Harlem and Pittsburgh. After studying with George Grosz at the Art Students League, he began to paint scenes of Black life in a Social Realist style patterned after such Mexican artists as Diego Rivera and Jose Orozco.

After World War II he turned away from Social Realism and adopted an abstract figurative style, painting watercolors and oils on literary themes. His paintings became increasingly abstract in the late 1950s and early 1960s until, abruptly, at the height of the civil rights movement, he abandoned abstract art, adopted collage as his medium, and began to re-create deeply ritualistic images of his past. Since the 1960s Bearden has produced one series after another based on jazz music, the Caribbean island of St. Martin, his autobiography and the like that reflect aspects of Black life as he remembers it, or as he imagines it to have been; from Storyville in New Orleans to his Black interpretation of the *Odyssey.*

Before the Dark is as vital an image of American life as a painting by Edward Hopper or Robert Rauschenberg. As such, it is an important part of the canon of images of American experience.

MARY SCHMIDT CAMPBELL

1971
Collage on cardboard, 18 × 24"
Museum purchase 72.8

❧ 97

Malcolm Morley (b. 1931)
Kodak Castle

Malcolm Morley left his native England in 1957 when Pop art was emerging as a central force in England and America. At that particular moment Morley was more interested in the American Pop artist's predecessors, the Abstract Expressionists. His first exhibition in New York in 1964 featured paintings of horizontal bands overlaid with abstract marks resembling waves and clouds. In these works he sought to investigate diverse ways of painting these elements—waves and clouds—rather than allowing the surface of his canvases to be an Expressionist's interpretation of those elements. He soon amplified this exploration of art's own modes of representation by shifting to other types of conventional signs for images. Similar to the Pop and Minimal artists of the 1960s, he turned to society's ready-made forms.

The Pop artists imitated the commercial signs and media techniques found in our modern environment in television, newspapers, and advertisements. With their interest in recognizable subject matter, they commented on the stereotyped and secondhand reality generated through the media. Not only did they challenge the idealistic content of earlier modern art, but they also diffused in a deadpan manner the potency of modernism by combining the techniques of commercial media with the formalism of fine art. The Minimalists also shared the Pop artist's interest in duplication. They chose industrially prefabricated shapes as their ready-made images, and investigated the literal properties of their art by focusing on such pre-established qualities as overall shape, units of shape, and surface. Crucial to the Minimalists' aesthetic was their conceptualization of the artistic process.

Instead of attempting to encompass all facets of advertisements, Morley singled out the photograph or postcard as his subject, and in 1965 he became the first artist to produce paintings that were virtually indistinguishable from the photographic process. He framed his highly illusionistic scenes, such as *Rhine Château* of 1969 (private collection, Paris), with a white canvas field or border to further enhance the illusion that the painting was a postcard or tourist poster. The subject of Morley's paintings was Pop art's mechanically reproduced image as image, in which he avoided any emotional involvement by ordering them over the telephone according to color, and by painting his compositions upside down with minutely ordered abstract strokes. Like the Minimalists he also utilized the grid when painting because the device enabled him to emphasize process. He invented his own way of covering the ground without being involved in a subjective arrangement of parts, the hierarchy of figure and ground, or the emotional influence of colors. By synthesizing Pop subject matter with conceptual ideology and realist illusionism, Morley became a pivotal figure in the evolution of the Photo-Realist style. He differed from the Photo-Realists, however, because he never used a spray gun or a projector to enlarge subjects. In fact, when he painted the highly illusionistic poster scene of a South African race track in 1970 (Neue Galerie, Aachen), he canceled it with a mono-printing of a painterly red *x,* which referred to the political situation, but, more importantly, alluded to his changing attitudes about the techniques of the Photo-Realists.[1]

In *Kodak Castle,* of 1971, Morley depicted a turreted French château beside a river flocked by white swans. As in *Rhine Château,* however, the subject is not the sun-drenched tranquil landscape, but rather its Kodachrome copy. Its high-keyed color depicts a typical European scene filtered through the cliché of a photograph, postcard, or poster. To reinforce this second reading, Morley painted the yellow and red trademark name, Kodak, in the upper right corner of the composition. The Utica painting is different from *Rhine Château* in that it was painted in oil rather than acrylic, with brushstrokes that erupt from the surface of the support and in its lack of a white border. *Kodak Castle* is a major work of the early 1970s, which embodies Morley's evolving ideas about the making of art from a reproducible source and the making of a picture with its own unique aura.

Sarah Clark-Langager

❧ 1971
Oil on Masonite, 36 × 48″
Museum purchase 82.6

FRANK STELLA (b. 1936)
Olkienniki No. 1

FRANK STELLA's "Polish Village" series of 1970–73 explores space through abstract means. This series was seen by critics as opening up new possibilities for his art, as well as for modernist painting in general. What was new in those works was their avoidance of a strict serial effect, and their sense of disjunctive depth and texture on a two-dimensional surface.[1]

In Stella's abstract paintings of the early 1960s, the internal surface pattern of stripes paralleled the framing edge or shape of the canvas. By the late 1960s he had developed another basic shape—the half circle—into a highly involved series of compositions. Throughout this period he used a wide range of paints—metalic, Day-Glo, acrylic, enamel, and fluorescent—to vary the color and texture of his paintings. At this time he also experimented with a series of irregular polygon paintings, dominated by two or three large, impacted shapes. These paintings introduced a degree of spatial ambiguity into the flat picture plane of modernism.

In the "Polish Village" series Stella allowed the interior geometric shapes to move freely within the bounding edge. Like his irregular polygons of 1965–66, he designed compositions that forsook the absolute identity of surface pattern and canvas shape that was so characteristic of his early work. He created illusionistic spaces without clear *gestalts*. In *Olkienniki No. 1*, for example, there are separate perceptions of space and time within the work. The color bars—shades of red, green, and yellow—float free in the lower region, interlock in the center and top left, and then penetrate and activate pockets of small spaces created by the major interlocking shapes.

In the early 1970s Stella had read a book on the destroyed Polish synagogues of the seventeenth through nineteenth centuries.[2] He particularly admired the materials and carpentry techniques of this wood architecture. In his "Polish Village" series Stella reflected upon these conditions, but did not attempt to represent the individual synagogues. With a two-dimensional medium he expands our vision of space and heightens our tactile sensations through the use of diverse materials, collage techniques, and relief effects. He dared to renew modernist painting with allusions to vernacular architecture, to the structural complexity of Cubism and its legacy, and to the bold, linear gestures of some of his immediate predecessors, the Abstract Expressionists.

In developing the "Polish Village" series, Stella first executed over forty different drawings. In the first full-scale development of the drawings numbered 1 through 13, he painted and collaged flat materials—felt, paper, and layers of painted canvas—on stretched canvas. Because of technical problems, he switched to canvas glued to heavy cardboard (KachinaBoard) which was then secured to a strainer support. In the second group of drawings, numbered 14 through 42, of which *Olkienniki No. 1* is a part, he also used light cardboard as one of the collage materials. He then executed two other versions of each configuration in which components of the design are raised and tilted in space.[3]

SARAH CLARK-LANGAGER

❧ 99

SUSAN ROTHENBERG (b. 1945)
Untitled (Night Head)

SINCE THE EARLY 1970s, Susan Rothenberg has been engaged in a set of problems related to the representation of figures. Like a number of her contemporaries, Rothenberg based her art upon the rich legacy of Minimalism and Conceptualism, as well as on Abstract Expressionism, rather than upon the resources of traditional realist art. In her first paintings of horses she used this animal as a surrogate; it enabled her to create figurative images without conjuring up the burdensome associations inherent in the human figure. Placed in flat profile and divided by abstract lines, the horses were used to extend the possibilities of Minimalist painting by establishing a dialog between its shape and the monochromatic field of background color, the edges of the canvas, and its parts to the whole. In these paintings her use of the horse enabled her to emphasize the nebulous boundary that can exist between figurative and abstract meaning.

By 1979 Rothenberg began to reinforce the earlier residual associations stimulated by her use of this animal. She fragmented the horse and selected certain parts— head, leg, bone—to stand for its whole image. In her use of these primal shapes she suggested the analogy between animal and human beings. Moreover, through the manipulation of scale, and the isolation and/or disjunctive placement of these body shapes, she also referred to physical and psychological states. As Rothenberg began to become aware of her subject matter, she also began to realize the potency of color. For example, she found that "red and black are hellish, devil colors, about wanting the painting to have a lot of heat." In her urgent search for new directions, she began to make "a lot of little crayon drawings of heads and hands. I was thinking that all I have is a head and a hand to paint with, and eyes in my head. (You don't need a nose and mouth for painting and you really only need one eye.) That's the justification I gave myself for those images, which carried over into big paintings."[1] In contrast to the four other predominantly blue, black, and white paintings in this series, the Utica work of 1980–81 has more spectral colors—orange-red, green, and white set against a black field. Rothenberg has called it her "night painting."[2]

Not only the colors but also the primal imagery of the Utica painting suggest the childhood game of shadows played in the dark. The outline of a five-pronged shape intersects three irregular circles. With this drastic reduction of forms, the artist forces the viewer to rely more upon his memory than upon any learned associations for the content of the painting. The painting's schematic structure is equally important. Simple, yet strange, the centralized imagery seems to represent a white head and hand emerging from a dark background, hovering in space, and circled by a green and orange-red light. Also lurking in the fissures of the paint and in the imprint of the large hand is the profile of an animal. In the interlocking shapes fused with the dark painterly field, the viewer might perceive the dominance of one shape, the human or animal, over the other, both physically and metaphorically. Or, he might acknowledge the union between the human hand and head, which reflects the relationship between the sense of touch and the sense of sight, feeling and intuition with perspective and knowledge. The artist and the viewer engage in games of tracing the hand or shadow plays, as well as discovering themselves in the multilayered imagery.

While this focus on mind and body states is similar to aspects of Conceptual art (where the artist uses the raw material of his body as his subject), Rothenberg also focused on the Abstract Expressionists' involvement with the materiality of the paint itself and with its metaphorical possibilities. She opted for their variegated surfaces and overall field rich with content, rather than the formalists' homogenized surface seeking identity with its support. With her centralized illusion of heads, Rothenberg transformed the emphatic frontality and physicality so important to abstract painting since the 1950s. She merged highly charged subject matter with an investigation of different formal structures, thus reinvigorating the expressionist aesthetic.

SARAH CLARK-LANGAGER

❧ 1980–81
Acrylic and Flashe on canvas, 104 × 114"
Museum purchase 82.22

215

David True (b. 1942)
Void of Course

In an essay on his own work for the catalog that accompanied the Whitney Museum's *New Image Painting* exhibition (1978–79), David True narrated how he was visited by a spirit ten years earlier. He discovered this "translucent figure" with minimal features sitting "on a stack of four-by-fours" in his studio. After a soulful conversation, the spirit disappeared into True's body. Four or five years later, the artist began to adopt a more introspective viewpoint, fueling his ideas about the physical world with his powers of imagination.[1] Thus David True, who was formerly a Minimalist sculptor and painter in the mid-1970s, reintroduced figurative imagery in an abstract context. Although engaging in these new formal issues of representation and pure form, he sought to combine a stylized, naturalistic mode and speculative content into personal allegorical visions.

One of the critical issues of Minimalist sculpture is the literal, perceptual, and physical relationships that exist between the object and spectator in the same environment. In *Void of Course* of 1984, a leaping deer and overturned automobile appear in a verdant forest with massive stone outcroppings. True's first concern was to compress the space in order to set up a theatrical relationship between the painted figures and the spectator. He recently stated, "I realized by putting a row of rocks in the foreground and allowing just a lip to exist for the figures that I could make a kind of proscenium. The spectator enters the picture and stands within that very shallow foreground, with the background becoming kind of a stage backdrop."[2] In the Utica painting True avoided making the backdrop simply the space that comes behind foreground and middle ground. Instead, he eliminated the middle ground and allowed the backdrop or sky to play a key role in establishing the conditions of the drama. "In the painting the sky is somewhat geometric in construction, presenting seemingly natural cloud formations in configurations which are not natural. By doing the sky in this way I could infuse it with unexpected implications and exercise an abstract geometric order, that reinforced the geometry of the boulders and auto."[3]

In astrology the stars and planets determine human affairs. In his choice of a title for the Utica painting True chose to evoke a particular phrase in astrology. As he explained, " 'Void of Course' is a phrase in astrology defining the period of time when the moon is not in a specific sign while it passes from one sign to another. Starting something new, especially something dealing with the material world, is discouraged during a 'Void'."[4] His use of this phrase in his title could mean that there is no new sign to lead the way. Also, if one inflects the title so that there is pause between the word "Void" and the phrase "of Course," True could be stating that this painting is empty.

In a sense this is actually the case. The artist presented the moment when the deer exits the stage opposite the side of the overturned driverless car. The vacancy of the resultant scene sets up a strong sensation of tension, characteristic of many of his works. And, in his choice of title, he ironically avoided the rational state governing the sky, landscape, and figures. In his exploration of the static moment before the climax of a story, True also presented the passage from one place or state of consciousness to another. Rather than defining solutions for the present, he allowed *Void of Course* to refer to such deep thoughts and anxieties as our sense of continuity, transitoriness, and loss of utopian desires. In his use of the landscape to express ideas and emotions, True uncovered a new world of possibilities. In this fertile, almost primeval landscape, the perverted potential of technology, as exemplified by the car, contrasts with the new freedom of the hunted animal.

Sarah Clark-Langager

৯ৣ 1984
Oil on canvas, 84 × 114"
Museum purchase 84.25

Notes

A History of the Collection

1. Henry T. Tuckerman, *Book of the Artists* (New York: 1867; repr., New York: James F. Carr, Publisher, 1967), p. 628.
2. Christopher Bensch, *Fountain Elms* (Utica, N.Y.: Munson-Williams-Proctor Institute, 1986), pp. 3–4.
3. Barbara Franco, "New York Furniture Bought for Fountain Elms by James Watson Williams," *Antiques,* vol. 104 (September 1973), pp. 462–67.
4. The Williams family portraits by Darby and Spencer are now in the collection of the Munson-Williams-Proctor Institute Museum of Art. For Palmer and Moffitt, see J. Carson Webster, *Erastus D. Palmer* (Newark, Del.: University of Delaware Press, 1983), p. 188.
5. James L. Yarnall and William H. Gerdts, comps., *Index to American Art Exhibition Catalogues* (Boston: G.K. Hall & Co., 1986), vol. 1, pp. 19–20, 35–36.
6. Receipt from George W. Adams, President of the Utica Art Association to Mrs. James W. Williams, March 2, 1878. Hereafter, unless otherwise noted, all unpublished materials are drawn from the curatorial files of the Munson-Williams-Proctor Institute Museum of Art.
7. Johnson to Adams, March 18, 1878.
8. Invoice from the Utica Art Association to Mrs. J. Watson Williams, March 7, 1879.
9. "Art in Utica," *New York Post,* March 25, 1879, p. 3. The authors are grateful to Franklin Kelly for bringing this reference to their attention. For the amount that Mrs. Williams paid for Church's painting, see n. 8.
10. The size of Mrs. Williams's painting collection at this time, which contained around thirty-four American and European paintings, is documented in an inventory dated March 3, 1888, Oneida County Historical Society, Utica, N.Y.
11. Ferdinand T. Haschka, *The Thomas R. Proctor Collection of Antique Watches* (New York: privately printed, 1907). Also, Christopher Bensch, *Watches: The Proctor Collection* (Utica, N.Y.: Munson-Williams-Proctor Institute, 1986).
12. *The Frederick Towne Proctor Collection of Antique Watches and Time Clocks* (Utica, N.Y.: privately printed, 1913).
13. Boughton to Proctor, February 22, 1904.
14. The University of the State of New York. Provisional Charter of the Proctor-Williams-Munson Institute [sic], September 17–18, 1919, Institute archives.
15. Abigail Camp Dimon, "Munson-Williams-Proctor Institute," unpublished typescript [1946], pp. 1120, 1294–95, 1392–93, Institute archives.
16. "Philip Guston Visits the Institute," *Bulletin* (Munson-Williams-Proctor Institute), November 1947, p. 1.
17. Prior to Rudd, November 28, 1947.
18. Gruskin to Prior, March 4, 1948.
19. Ibid., March 15, 1948.
20. "Works by Visiting Artists Purchased by Institute," *Bulletin* (Munson-Williams-Proctor Institute), May 1948, p. 1.
21. *Thompkins* [sic] *H. Matteson, 1813–1884,* exhibition brochure (Sherburne, N.Y.: Sherburne Art Society, 1949).
22. Prior to Palmiter, March 12, 1949.
23. Sellers to Prior, May 27, 1953.
24. Halpert to Prior, June 10, 1953.
25. Aline B. Saarinen, *The Proud Possessors* (New York: Random House, 1958), pp. 250–55, 258–68.

Also *Edward Wales Root, 1884–1956: An American Collector,* exhibition catalog (Utica, N.Y.: Munson-Williams-Proctor Institute, 1957); Harris K. Prior, "Edward Root—Talent Scout," *Art in America,* vol. 50, no. 1 (1962), pp. 70–73; *Edward W. Root: Collector and Teacher,* exhibition catalog (Clinton, N.Y.: Fred L. Emerson Gallery, Hamilton College, 1982).
26. Prior to Root, November 17, 1949.
27. Root to Prior, November 19, 1949.
28. Ibid., November 27, 1949.
29. Prior to Root, February 7, 1950.
30. Ibid.
31. Root to Prior, February 5, 1950.
32. *The Edward Root Collection,* exhibition brochure (New York: Metropolitan Museum of Art, 1953). Also, Saarinen, pp. 265–66. For two reviews of this exhibition, see Aline B. Louchheim, "A Collector with Personal Vision," *New York Times,* February 15, 1953, p. 11; Henry McBride, "Patriotism and Art," *ARTnews,* vol. 52 (March 1953), p. 40.
33. Rand Carter, *Philip Johnson. Museum of Art Building: An Anniversary Exhibition,* exhibition brochure (Utica, N.Y.: Munson-Williams-Proctor Institute, 1986), p. 2.
34. Sturgis to Prior, September 21, 1955.
35. Prior to Sturgis, September 26, 1955.
36. Prior to Murray, November 1, 1955.
37. Prior to Sturgis, November 10, 1955.
38. Prior to Murray, May 14, 1956.
39. Prior to Maynard Walker, May 13, 1949.
40. McLanathan to Murray, December 9, 1957.
41. Louisa Dresser to McLanathan, December 12, 1957.
42. *Catalogue Of The Sixth Exhibition Of Paintings, Now Open By The Utica Art Association (Incorporated January, 1866) At Carton Hall, 173 Genesee St., Utica, N.Y.* (Ellis H. Roberts & Co., Printers, 1878), p. 11, no. 236.
43. Diego Suarez, comp., *The Collection of Portraits of American Celebrities and Other Paintings Belonging to The Brook* (New York: privately printed, 1962), pp. 50–51.
44. Dwight to Davidson, November 26 and December 3, 1963.
45. John I.H. Baur, *John Quidor,* exhibition catalog (Utica, N.Y.: Munson-Williams-Proctor Institute, 1965), p. 5.
46. William C. Murray to Robert F. Stein, September 1, 1961.
47. Frankenstein to Dwight, March 26, 1965.
48. Dwight to Mrs. Richard L. Simon, November 10, 1969.
49. Peter H. Davidson to Dwight, April 13, 1978.
50. Ibid.
51. Dwight to Davidson, April 18, 1978.
52. In conversation with Paul D. Schweizer during the week of May 3, 1987.

1.

1. Gerrit Symonse Veeder was born in Schenectady, New York, in about 1670, the son of Simon Wolkertse Veeder (alias de Bakker). Gerrit was married in Albany on August 3, 1690, to Tryntje, daughter of Helmer Otten, and died between 1747 (when he made his will) and 1755 (when it was proved). See Jonathan Pearson, *Contributions for the Genealogies of the Descendents of the First Settlers of the Patent and City of Schenectady from 1662 to 1800* (Albany: Joel Munsell, 1873), p. 264. Also George R. Howell and W.W. Munsell, *History of the County of Schenectady* (New York: W.W. Munsell, 1886), p. 31.

2. Ona Curran, "The Early Veeder Family," *Schenectady County Historical Society Bulletin,* vol. 7, no. 1 (September 1967), unpaged.
3. The "son" is likely to have been Veeder's son-in-law Daniel Van Antwerpen. Caleb Beck Account Book (November 30, 1718), Sleepy Hollow Restorations, Inc., Tarrytown, N.Y.
4. Mary Black, "Contributions Toward a History of Early Eighteenth-Century New York Portraiture: The Identification of the Aetatis Suae and Wendell Limners," *American Art Journal,* vol. 12, no. 4 (Autumn 1980), pp. 4–31.
5. John R. Totten, *Christophers Genealogy* (New York: New York Genealogical Society, 1922), unpaged.

2.

1. See Karin Calvert, "Children in American Family Portraiture, 1670–1810," *William and Mary Quarterly,* vol. 39 (January 1982), pp. 87–113. Alice Morse Earle, *Child Life in Colonial Days* (New York: Macmillan Co., 1899), p. 52. The painting descended through Coffin's only daughter, who remained in Massachusetts and in 1817 married Edward Hutchinson Robbins. It was left to their daughter, Miss Anne S. Robbins, then passed within the family to Mrs. C. Wharton Smith, who sold it to the Munson-Williams-Proctor Institute Museum of Art through Childs Gallery of Boston.
2. See Jules David Prown, *John Singleton Copley* (Cambridge: Harvard University Press, 1966), vol. 1, p. 32. The plant at the bottom right of the painting may possibly be a large species of philodendron.

3.

1. The two main references for Earl are William Sawitzky, *Ralph Earl, 1751–1801,* exhibition catalog (New York: Whitney Museum of American Art, 1945), and Laurence B. Goodrich, *Ralph Earl: Recorder of an Era* (Albany: State University of New York, 1967).
2. Dorinda Evans, *Benjamin West and His American Students* (Washington, D.C.: Smithsonian Institution Press, for the National Portrait Gallery, 1980), pp. 60–66.
3. John Wilmerding, *American Art* (New York: Penguin Books, 1976), p. 52.
4. Edgar P. Richardson, *Painting in America: The Story of 450 Years* (New York: Thomas Y. Crowell, 1956), p. 123.

4.

1. Elizabeth Melville, the author's wife, in an undated notebook entry reported "our portrait of Gen. Gansevoort is a copy from Stuart's by Joseph Ames [1816–72]." Merton M. Sealts, Jr., *The Early Lives of Melville* (Madison: University of Wisconsin Press, 1974), p. 176.
2. Herman Melville, *Pierre; or, The Ambiguities,* vol. 9 of *The Works of Herman Melville* (New York: Russell & Russell, 1963), p. 40.
3. Newton Arvin, *Herman Melville* (New York: Viking Press, 1957), p. 9.

5.

1. Two views of the Hudson River, *Morning* and *Evening,* are at Mount Vernon. A third painting, *Falls of the Genesee,* one of two landscapes purchased by George Washington in 1794, is in the collection of the National Museum of American History, Smithsonian Institution. Only two other works are known: a pair of small landscapes in a private collection.

2. The basic information on Winstanley's life can be found in William Dunlap, *History of the Rise and Progress of the Arts of Design in the United States* (New York: 1834; new ed., New York: Benjamin Blom, Inc., 1965), vol. 1, pp. 164, 234–37; vol. 2, pp. 77–78. See also J. Hall Pleasants, *Four Late Eighteenth-Century Anglo-American Landscape Painters* (Worcester: 1942; repr., Worcester: American Antiquarian Society, 1943).

3. Pleasants, p. 119.

4. Winstanley returned to Washington in 1800 when he was befriended by Dr. William Thornton, the architect of the Capitol, and his wife. It is to this period that the infamous story, related in Dunlap, concerning Winstanley's unauthorized copies after Stuart's portraits, dates.

5. Thomas Jefferson, *The Life and Selected Writings*, ed. by Adrienne Koch and William Peden (New York: 1944; repr., New York: Random House, 1972), pp. 192, 193.

6. Edmund Burke, *A Philosophical Enquiry Into the Origin of Our Ideas of the Sublime and Beautiful*, ed. by James T. Boulton (London: 1757; repr., Notre Dame, Ind.: University of Notre Dame Press, 1968).

7. For a discussion of Claude's influence on British art and thought, see Elizabeth Wheeler Manwaring, *Italian Landscape in Eighteenth Century England* (New York: 1925; repr., New York: Russell, 1965). For Gaspard, see *Gaspard Dughet called Gaspar Poussin 1625–75*, exhibition catalog (London: The Iveagh Bequest, Kenwood, 1980).

8. For a discussion of Vernet and his popularity in England, see Philip Conisbee, *Claude-Joseph Vernet 1714–1789*, exhibition catalog (London: The Iveagh Bequest, Kenwood, 1976). The Utica painting is particularly close in tone and composition to *Calm: Sunset* (Conisbee, no. 44), purchased by Lord Clive in 1773 and engraved by Daniel Lerpinière in 1782 for John Boydell.

6.

1. For a near-contemporary American evaluation of the hierarchy of artistic genres, see Daniel Fanshaw, "The Exhibition of the National Academy of Design, 1827," *The United States Review and Literary Gazette*, vol. 2 (July 1827), pp. 241–63.

2. The present author is at work on an examination of Peale's life and career, with emphasis on his still-life painting; given the infancy of American art criticism at that time, Peale was not ignored. Such major collectors as Robert Gilmor of Baltimore, Charles Graff of Philadelphia, James J. Fullerton of Boston, and John Ashe Alston of South Carolina, among others, all included examples of Peale's still lifes in their collections.

3. Charles Willson Peale's references to Raphaelle's artistic abilities and priorities (as well as his constant nattering at him for his profligate ways!) are innumerable in both letters to his son and references to other members of the family. To cite just one, see Charles Willson's letter to Raphaelle of November 15, 1817: "Your pictures of still life are acknowledged to be, even by the painters here, far exceeding all other works of that kind—and you have often heard me say that, with such talents of exact imitation, your portraits ought to be more excellent. My dear Raphaelle, why will you neglect yourself? Why not govern every unruly passion? Why not act the man. . . ." Charles Willson Peale Papers, American Philosophical Society, Philadelphia, now available on microfiche, see Lillian B. Miller, ed. *The Collected Papers of Charles Willson Peale and His Family* (Millwood, N.Y.: KTO Microform, 1980).

4. "Peale's Museum . . .," *Poulson's American Daily Advertiser*, vol. 46 (March 4, 1817), p. 1.

5. It is likely that this picture remained, in fact, in the collection of the Peale Museum in Philadelphia, for it is probably identical with item no. 257, *Cutlet and Vegetables* (no artist specified), which was on view in Cincinnati in 1852, in an attempt to transfer the contents of the Peale Museum to that city. See *Catalogue of National Portrait and Historical Gallery, Illustrative of American History* (Cincinnati: Gazette Company Print, 1852), p. 24.

6. For the most recent discussion of the work of Sánchez Cotan, and particularly of the appearance of his work in this country in the 1810s, see the essay by William B. Jordan in *Spanish Still Life in the Golden Age*, exhibition catalog (Fort Worth, Tex.: Kimbell Art Museum, 1985), pp. 58–60. As Jordan suggests, it is also possible that Mrs. Richard Worsam Meade owned the two Sánchez Cotan still lifes and lent them to the Pennsylvania Academy in 1818; although it appears more likely to the present author that the pictures were in Bonaparte's collection rather than Meade's, they might well have been available to Peale prior to their exhibition in either case.

7. Henry Smith Mount, brother of the artists William Sidney and Shepard Alonzo Mount, is the least studied of the three Mount artist-brothers. In 1824 he entered into partnership with the painter William Inslee in New York City; the firm of Inslee & Mount did sign and ornamental painting.

7.

1. A collection of seven letters at the Virginia Museum of Fine Arts, Richmond (Gift of T. Kenneth Ellis), dated between October 1822 and May 1823, from Alvan Fisher to Charles Henry Hall, discusses the commission and reveals the artist's interest in thoroughbred subjects. In a letter to Hall on October 1, 1822, Fisher stated: "The paintings which you employ'd me to execute are finished."

2. As early as 1665 the British colonial governor of New York introduced horse racing to this country on Long Island at Salisbury Plain, a two-mile course. It was not until the early nineteenth century, however, that thoroughbred races and breeding became popular in the United States. See David Hedges, *Horses and Courses* (New York: The Viking Press, 1972), pp. 113–14.

3. Cornelius W. Van Ranst, *An Authentic History of the Celebrated Horse American Eclipse, Containing an Account of His Pedigree and Performances . . .* (New York: E. Conrad, 1823), pp. 17–18.

4. Ibid., p. 18. His granddam was the English mare Pot 80's, who was sired by Eclipse, the renowned British thoroughbred. At five months old, American Eclipse was given his name, which clearly pays homage to his English ancestry.

5. "Memoir of American Eclipse," *American Turf Register and Sporting Magazine*, vol. 1 (February 1830), p. 270. The article relies strongly on information first published by Van Ranst, pp. 19–20.

6. [Cadwallader R. Colden], "The Great Match Race between Eclipse and Sir Henry," *American Turf Register and Sporting Magazine*, vol. 2 (September 1830), p. 6. The taller measurement appeared in Van Ranst, p. 17.

7. Van Ranst, p. 18.

8. Ibid., p. 20.

9. Ibid., pp. 21–27.

10. [Colden], p. 3. This editorial note preceded Colden's text.

11. Fisher to Hall, May 5, 1823, Virginia Museum of Fine Arts, Richmond (Gift of T. Kenneth Ellis).

12. Van Ranst, p. 27. See also [Colden], p. 5, in which the author claimed to be an eyewitness and recalled, "The throng of pedestrians surpassed all belief—*not less than sixty thousand spectators were computed to be in the field.*" In a letter to Hall on May 15, 1823, Fisher stated, "I am now engaged on a portrait of Eclipse for Mr. Vanranst [sic] which I shall carry with me when I come on to the races. . . . I shall be in Newyork [sic] on Thursday next."

13. Van Ranst, p. 27.

14. In addition to *Eclipse, with Race Track*, the Munson-Williams-Proctor Institute Museum of Art owns *Eclipse, with Owner* (1823, oil on canvas, 25 × 30 in.). There are three other portraits of Eclipse at the Virginia Museum of Fine Arts, Richmond; one at the National Museum of Racing, Saratoga Springs, New York; one at the National Sporting Library, Middleburg, Virginia; and another in a private collection. Four prints of Eclipse, based on different paintings by Fisher, were published by several engravers including Asher B. Durand between 1823 and c. 1857.

15. Fisher to Hall, May 5, 1823.

16. Union Course opened near Brooklyn in 1821 with the result that it "placed racing on a more elevated and permanent footing." (Henry W. Herbert, *Frank Forester's Horse and Horsemanship of the United States and British Provinces of North America* [New York: Stringer & Townsend, 1857], vol. 1, p. 153.) It was at the Union track that Eclipse won numerous races, including the famous North-South Match. In the Utica painting the distant track with its stockade-like observation towers is most likely the Union Course.

17. *New-York Mirror, and Ladies' Literary Gazette*, June 2, 1827, p. 354.

8.

1. The palette, surface, and objects of the still life by James Peale at the Worcester Art Museum are reminiscent of this work. In both paintings the same container as well as the highlights and shadowing throughout the fruit are virtually identical. Within Peale's still-life oeuvre further similarities with the Utica painting appear in three other paintings by James Peale: in the Pennsylvania Academy of the Fine Arts, the Fine Arts Museum of San Francisco, and the April 1981 sale at Christie's in New York (sale cat. no. 5049, lot 32). All share the same arrangement of grapes, peaches, apples, and pears in a pierced porcelain container.

2. The study of still-life paintings by James Peale presents a difficult problem since most previous attention has been focused on his miniature portraits. Many of James's children, Anna Claypoole (1791–1878), Margaretta (1795–1882), Sarah Miriam (1800–1885), and his nephew Rubens (1784–1865), as well as his great nieces, Anna Sellers (1824–1905) and Mary Jane Peale (1827–1902), painted copies of his still-life paintings. Rubens, alone, noted that he had copied fourteen of James's still-life paintings. See Charles Coleman Sellers, "Rubens Peale: A Painter's Decade," *Art Quarterly*, vol. 23 (1960), pp. 139–52.

Eleven copies of the Utica painting are recorded, some of which are unlocated. All the replicas and copies differ from the Munson-Williams-Proctor Institute Museum of Art's painting in the same respect: the apple at the left center is not fully rotten, and there is an apple in the background at left center between the two bunches of dark grapes. This distinction suggests that the copies were made from another version of this composition, rather than directly from the Utica panel. That lost painting is thought to be a work that is known today only from a black-and-white photograph in the James Peale file in the archives of the Corcoran Gallery of Art. No owner is recorded, but the photograph was annotated on the back: "26½ × 19 [width given first]/ Fruit/James Peale."

3. For a discussion of the Peale family members and their contributions to the development of this genre, see John I.H. Baur, "The Peales and the Development of American Still Life," *Art Quarterly*, vol. 3, no. 1 (Winter 1940), pp. 81–92; Edward H. Dwight, "Still Life Paintings by the Peale Family," in Charles Elam, ed., *The Peale Family: Three Generations of American Artists*, exhibition catalog (Detroit, Mich.: Detroit Institute of Arts, 1967), pp. 35–38, 118–19; William H. Gerdts and

Russell Burke, *American Still-Life Painting* (New York: Praeger Publishers, 1971), pp. 24–40.

4. James exhibited one painting and Raphaelle exhibited eight paintings. Subsequently both contributed still-life paintings to the annual exhibitions held regularly from 1811 on at the Pennsylvania Academy of the Fine Arts. Raphaelle exhibited sixty-three still-life paintings between 1812 and his death in 1825. From 1824 until his death in 1831 James exhibited thirty-four still-life paintings. See Anna W. Rutledge, ed., *Cumulative Record of Exhibition Catalogues: The Pennsylvania Academy of the Fine Arts* (Philadelphia: The American Philosophical Society, 1955), pp. 164–67.

To date twenty-one signed still-life paintings by James Peale, dating from 1821 to 1831, have been located. Many of these (fifteen different compositions) are also known to have been copied by other family members or replicated by James. Additional works have been attributed to him, bringing the number of still-life paintings currently under study to over sixty works.

5. Gerdts and Burke, p. 31.

9.

1. Howard Corning, ed., *Letters of John James Audubon, 1826–1840* (Boston: 1930; repr., New York: Kraus Reprint Co., 1969), vol. 1, p. 7.
2. Edward H. Dwight, "Audubon's Oils," *Art in America*, vol. 51 (1963), pp. 76–79.
3. Corning, vol. 1, p. 12.
4. Alice Ford, ed., *The 1826 Journal of John James Audubon* (Norman: University of Oklahoma Press, 1967), p. 276.
5. Ibid., p. 290.
6. Ibid., p. 295.
7. Ibid.

10.

1. Henry T. Tuckerman, *Book of the Artists* (New York: 1867; repr. New York: James F. Carr, Publisher, 1967). For a full account of West's life and art see Estill C. Pennington, *William Edward West, 1788–1857: Kentucky Painter,* exhibition catalog (Washington, D.C.: National Portrait Gallery, 1985). Also, Estill C. Pennington, "Painting Lord Byron: An Account by William Edward West," *Archives of American Art Journal*, vol. 24 (1984), pp. 16–21.
2. This engraving is illustrated as fig. 2 in Paul D. Schweizer, "Washington Irving's Friendship with William Edward West and the Impact of His *History of New-York* on John Quidor," *American Art Journal*, vol. 17 (Spring 1985), p. 74.
3. Ibid., p. 77.
4. William Dunlap, *History of the Rise and Progress of the Arts of Design in the United States* (New York: 1834; new ed., New York: Benjamin Blom, Inc., 1965), vol. 3, p. 41.
5. Tuckerman, p. 202.
6. Nellie P. Dunn, "An Artist of the Past: William Edward West and His Friends at Home and Abroad," *Putnam's Monthly Magazine*, vol. 2 (September 1907), p. 665.

11.

1. See Dorinda Evans, *Benjamin West and His American Students,* exhibition catalog (Washington, D.C.: National Portrait Gallery, 1980), p. 147, fig. 111, for an illustration of the Corcoran painting.
2. Illustrated in Ellis Waterhouse, *Painting in Britain, 1530–1790* (Baltimore: 1953; rev. ed., Harmondsworth: Penguin Books Ltd., 1978), p. 219, fig. 169.
3. The Utica painting may be compared to Turner's *Dido and Aeneas* of 1814 (Tate Gallery), illustrated in Martin Butlin and Evelyn Joll, *The Paintings of J.M.W. Turner* (New Haven and London: Yale University Press, 1984), vol. 2, plate 129.

4. Shaw's designs for *Picturesque Views of American Scenery* were engraved by John Hill, and the nineteen colorplates were published by M. Carey & Son in Philadelphia in 1820, the same year that William Guy Wall's *Hudson River Portfolio* first appeared.
5. Virgil, *The Aeneid,* translated by H. Rushton Fairclough (Cambridge, Mass.: Harvard University Press, 1978), 4,129–42.
6. Washington Allston's *Dido and Anna* of 1813–15 (Lowe Art Museum, University of Miami), shows the grieving Dido and her compassionate sister, Anna, as Aeneas steals away to join his men aboard a ship that awaits him in the harbor. This painting is illustrated in William H. Gerdts and Theodore E. Stebbins, Jr., *"A Man of Genius:" The Art of Washington Allston (1779–1843),* exhibition catalog (Boston: Museum of Fine Arts, 1979), p. 45, fig. 26.
7. Shaw's *Fantasy with Classical Ruins* of 1851 (oil on canvas, 33 × 48 in., Kennedy Galleries, Inc., New York, inventory no. 13687) shows that the artist was still absorbed with the pastoral, historiated landscape late in his career.

12.

1. For studies of Quidor as a literary painter, see John I.H. Baur, *John Quidor: 1801–1881,* exhibition catalog (New York: Brooklyn Museum, 1942); Celia L. Ruder, "John Quidor and Washington Irving: The Outcast and the Hero," (M.A. thesis, University of Wisconsin, 1966); David Sokol, *John Quidor: Painter of American Legend,* exhibition catalog (Wichita, Kans.: Wichita Museum of Art, 1973).
2. Washington Irving, *A History of New-York from the Beginning of the World to the End of the Dutch Dynasty* by Diedrich Knickerbocker (New York: G.P. Putnam, 1848), pp. 265–66.
3. For the fullest discussion of this painting-within-a-painting, see Paul D. Schweizer, "Washington Irving's Friendship with William Edward West and the Impact of His *History of New-York* on John Quidor," *American Art Journal*, vol. 17 (Spring 1985), pp. 82–86.
4. The lintel relief is discussed at length in Christopher K. Wilson, "The Life and Work of John Quidor," (Ph.D. dissertation, Yale University, 1982), pp. 122–24.
5. The literature on sexual allusions and punning is substantial and all of the recent writers on Quidor have discussed aspects of this question. It has been somewhat of a preoccupation of Bryan J. Wolf in *Romantic Re-Vision* (Chicago: University of Chicago Press, 1982).
6. Recent infrared photographs of the Utica painting have revealed the never before noted drawings. Careful examination indicates changes in both figure placement and facial expressions from the drawing to the completed painting.

13.

1. On March 25, 1839, Cole made a copy for himself of "the description which I gave to Mr. Ward . . . at the time he gave me the commission. The subject had been on my mind for several years and was conceived at the time my pictures of 'The Course of Empire' were exhibited . . . a few months after the death of Mr. Reed" (Thomas Cole Papers, Archives of American Art, Smithsonian Institution, Washington, D.C., reel D-6, frame 269). Yet even before Reed's death, in such poems by Cole as his 1833 "Lines Written after a Walk on [a] Beautiful Morning in November" (Marshall B. Tymn, ed., *Thomas Cole's Poetry* [York, Penn.: Liberty Cap Books], pp. 62–65), Cole used the idea of the river as a metaphor for life. A year or two before this—probably around 1837—he wrote down in relatively quick succession the three preliminary descriptions of *The Voyage of Life* that appear in a sketchbook

which he had begun using in 1827. ("Thomas Cole's List: 'Subjects for Pictures,'" with comments by Howard S. Merritt, *Baltimore Museum of Art Annual*, vol. 2: *Studies on Thomas Cole, An American Romanticist* [Baltimore: Baltimore Museum of Art, 1967], pp. 90–92.)
2. For an illustration of an installation of *The Course of Empire* that approximates Cole's original intention, see Ellwood C. Parry III, "A Cast of Thousands," *ARTnews,* vol. 82 (October 1983), p. 110.
3. The universal themes embodied in Cole's series are discussed in Joy S. Kasson, "*The Voyage of Life*: Thomas Cole and Romantic Disillusionment," *American Quarterly*, vol. 27 (March 1975), pp. 42–56; Alan Wallach, "*The Voyage of Life* as Popular Art," *Art Bulletin*, vol. 59 (June 1977), pp. 234–41; Michael Kammen, "Changing Perceptions of the Life Cycle in American Thought and Culture," *Proceedings of the Massachusetts Historical Society*, vol. 91 (1979), pp. 35–66.
4. Cole's early attempts at figure painting are discussed by Ellwood C. Parry III in "Thomas Cole and the Problem of Figure Painting," *American Art Journal*, vol. 4 (Spring 1972), pp. 66–86.
5. See figs. 3 and 5 in *"The Voyage of Life" by Thomas Cole: Paintings, Drawings and Prints,* exhibition catalog, with essays by Ellwood C. Parry III, Paul D. Schweizer, and Dan A. Kushel (Utica: Munson-Williams-Proctor Institute, 1985).

14.

1. See fig. 7 in *"The Voyage of Life" by Thomas Cole: Paintings, Drawings and Prints,* exhibition catalog, with essays by Ellwood C. Parry III, Paul D. Schweizer, and Dan A. Kushel (Utica: Munson-Williams-Proctor Institute, 1985).
2. Elliot S. Vesell, ed., *The Life and Works of Thomas Cole by Louis Legrand Noble* (Cambridge: The Belknap Press of Harvard University Press, 1964), pp. 210–11. The holograph version of this letter is among the Thomas Cole Papers at the New York State Library in Albany.
3. The exterior of Ward's mansion and its appended art gallery are depicted in an undated watercolor by Abraham Hosier, which is reproduced as fig. 2 in *"The Voyage of Life" by Thomas Cole: Paintings, Drawings and Prints.* No view or description of the interior of Ward's picture gallery is known to exist.
4. Cole's drawing for the installation of *The Course of Empire* in Luman Reed's gallery is reproduced in Ellwood C. Parry III, "Thomas Cole's 'The Course of Empire,' A Study in Serial Imagery" (Ph.D. dissertation, Yale University, 1970), fig. 74.
5. The compositional pairing that Cole achieved by reversing the course of the river in *Youth* and *Old Age* was pointed out by Ellwood C. Parry III on p. 4 of his essay in *"The Voyage of Life" by Thomas Cole: Paintings, Drawings and Prints.* Additional evidence that Cole planned the four pictures to be seen as two sets of interdependent pairs, and that he knew where they would hang in Ward's gallery, is apparent from the sources of light he painted into the series, which in the first two pictures enters from the right, and in the second two pictures enters from the left. If Ward's picture gallery had windows along the east wall—which is the only wall according to Hosier's watercolor (see n. 2) where there could plausibly be any—the lighting in the paintings suggests that *Childhood* and *Youth* were hung on the north wall to the left of the windows, and *Manhood* and *Old Age* hung opposite them on the south wall to the right of the windows. When installed in this way, the natural light that entered Ward's gallery through the windows along the east wall would reinforce the artificial light that Cole painted in each work. When planning *The Course of Empire,* Cole took pains to assure that the internal lighting of the paintings in that series was consistent with the natu-

ral lighting of Reed's gallery (Parry, "Thomas Cole's 'The Course of Empire,'" pp. 60–61), so it certainly seems likely that he would strive to achieve the same effect with *The Voyage of Life.*
6. For Cole's relationship with Ithiel Town, see Ellwood C. Parry III, "Thomas Cole's Imagination at Work in *The Architect's Dream,*" *American Art Journal,* vol. 12 (Winter 1980), pp. 41–59. William Dunlap noted that Town's library was "truly magnificent, and unrivalled by anything of the kind in America, perhaps no private library in Europe is its equal." *A History of the Rise and Progress of the Arts of Design* (Boston: C.E. Goodspeed & Co., 1918), vol. 3, p. 77. For a recent survey of the type of prints that Cole could have studied in Town's library, see Thomas P. Bruhn, *A Journey to Hindoostan: Graphic Art of British India, 1780–1860,* exhibition catalog, with an essay by Mildred Archer (Storrs, Conn.: The William Benton Museum of Art, 1987).
7. Cole made this statement when he wrote to his wife from Rome on February 12, 1842, in a letter he began six days earlier, which is at the Museum of Fine Arts, Boston.

15.
1. See fig. 12 in *"The Voyage of Life" by Thomas Cole: Paintings, Drawings and Prints,* exhibition catalog, with essays by Ellwood C. Parry III, Paul D. Schweizer, and Dan A. Kushel (Utica: Munson-Williams-Proctor Institute, 1985).
2. "Thomas Cole's List: 'Subjects for Pictures,'" with comments by Howard S. Merritt, *Baltimore Museum of Art Annual,* vol. 2: *Studies on Thomas Cole, An American Romanticist* (Baltimore: Baltimore Museum of Art, 1967), p. 92.
3. *Thomas Cole,* introduction and catalog by Howard S. Merritt (Rochester: Memorial Art Gallery of the University of Rochester, 1969), p. 36.
4. This point was made by Alan Wallach, "The *Voyage of Life* as Popular Art," *Art Bulletin,* vol. 59 (June 1977), p. 240. Joy S. Kasson has also noted that *Manhood* is the emotional turning point of the series ("*The Voyage of Life:* Thomas Cole and Romantic Disillusionment," *American Quarterly,* vol. 27 [March 1975], pp. 50–51); however, in contrast to Wallach, who sees the religious awakening that takes place in this picture as the prerequisite for the religious salvation of *Old Age,* Kasson believes that *Manhood* marks the beginning of the voyager's doubt and disillusionment.

16.
1. *"The Voyage of Life" by Thomas Cole: Paintings, Drawings and Prints,* exhibition catalog, with essays by Ellwood C. Parry III, Paul D. Schweizer, and Dan A. Kushel (Utica: Munson-Williams-Proctor Institute, 1985), pp. 16, 18.
2. See fig. 17 in *"The Voyage of Life" by Thomas Cole: Paintings, Drawings and Prints.*
3. Ellwood C. Parry III, "Thomas Cole and the Problem of Figure Painting," *American Art Journal,* vol. 4 (Spring 1972), p. 79.
4. Both Walter N. Nathan ("Thomas Cole and the Romantic Landscape," *Romanticism in America* [New York: Russell & Russell, 1961], p. 54) and Joy S. Kasson ("*The Voyage of Life:* Thomas Cole and Romantic Disillusionment," *American Quarterly,* vol. 27 [March 1975], pp. 50–51) feel that the basic message of the series is joyless and disheartening. This reading seems incorrect, given the optimistic interpretation Cole himself provided for *Old Age* in both his published description of the last picture (*Thomas Cole,* introduction and catalog by Howard S. Merritt [Rochester: Memorial Art Gallery of the University of Rochester, 1969], p. 37) and in the concluding stanzas of his 1844 poem "The Voyage of Life" (Marshall B. Tymn, ed., *Thomas Cole's Poetry* [York, Penn.: Liberty Cap Books, 1972] pp. 159–60).

17.
1. William Dunlap, *History of the Rise and Progress of the Arts of Design in the United States* (New York: 1834; new ed., New York: Benjamin Blom, Inc., 1965), vol. 3, pp. 137–38.
2. William H. Gerdts, "Henry Inman, Genre Painter," *American Art Journal,* vol. 9 (May 1977), pp. 26–48.
3. Thomas Picton, "Old Time Disciples of Rod and Gun," *The Rod and Gun,* vol. 7 (February 12, 1876), p. 313. Picton notes that among the favorite areas chosen by Fosdick, Inman, and their companions in Sullivan County for trout fishing were Beaver Kill and the Willowwhemack (now Willowemac) rivers in the northeast corner of the county. It is very possible that the topography of Inman's painting can be documented to that region.
4. "The Fine Arts. National Academy of Design. First Notice," *New-York Mirror,* vol. 19 (May 15, 1841), p. 159; "National Academy of Design. Sixteenth Annual Exhibition," *New York Express,* May 18, 1841 [p. 2]; "The Fine Arts. Exhibition of the Academy," *Arcturus,* vol. 2 (June 1841), pp. 60–61; "Editor's Table. The Fine Arts," *Knickerbocker,* vol. 18 (July 1841), p. 87.
5. "Fine Arts. Inman Gallery," *Anglo-American,* vol. 6 (February 14, 1846), p. 403; "The Inman Gallery," *Littell's Living Age,* vol. 9 (April 1846), p. 19.

18.
1. David B. Lawall, *Asher B. Durand: A Documentary Catalogue of the Narrative and Landscape Paintings* (New York: Garland Publishing, Inc., 1978), p. 171, no. 328.
2. Asher B. Durand, "Letters on Landscape Painting VIII," *The Crayon,* vol. 1 (June 6, 1855), p. 354.
3. Henry T. Tuckerman, *Book of the Artists* (New York: 1867; repr., New York: James F. Carr, Publisher, 1967), p. 193.
4. See, for example, Richard Koke et al., *American Landscape and Genre Paintings in the New-York Historical Society* (New York: The New-York Historical Society, 1982), vol. 1, pp. 322–23, nos. 628 and 632 for similar "portraits" of trees on canvases of similar size. I am indebted to my colleague Paul D. Schweizer for calling these similarities to my attention.
5. John Durand, *The Life and Times of A.B. Durand* (New York: 1894; repr., New York: Da Capo Press, 1970), p. 188.
6. *Catalogue Of A Collection of Bric-a-Brac, Paintings, Office Furniture, Etc. From The Estate Of The Late Charles Lanman ... To Be Sold At Auction Thursday and Friday Afternoons February 18th and 19th, 1915 ... At The Merwin Galleries, 16 East 40th Street, New York,* (New York, 1915) p. 22, no. 191.

19.
1. Charles Dickens, *American Notes for General Circulation* (London: Chapman and Hall, 1842), vol. 2, p. 297. Also see Michael Slater, ed., *Dickens on America and the Americans* (Hassocks, Sussex: Harvester Press, 1979), p. 19.
2. For more on these particular pictures, see Patricia Hills, *The Painter's America: Rural and Urban Life, 1810–1910* (New York: Praeger Publishers, 1974), pp. 12, 21, and 52–53, figs. 18 and 63–65. Also see Barbara Groseclose, "Politics and American Genre Painting of the Nineteenth Century," *The Magazine Antiques,* vol. 120, no. 5 (November 1981), pp. 1210–17.
3. In his book, *Mirror to the American Past; A Survey of American Genre Painting, 1750–1900* (Greenwich, Conn.: New York Graphic Society, 1973), p. 96, Herman Warner Williams, Jr., observed that "while he was capable of an unsentimen-

tal realism, more often than not Clonney strained for a chuckle."
4. Dickens, *American Notes,* vol. 2, p. 77.
5. *The Happy Moment* and *Mexican News* are reproduced side by side in Lucretia H. Giese, "James Goodwin Clonney (1812–1867): American Genre Painter," *American Art Journal,* vol. 11, no. 4 (Autumn 1979), pp. 22–23, figs. 21 and 22. What may be the same model from the neighborhood of New Rochelle, N.Y., where Clonney was living at this time, appears on a much smaller scale in a boat in the foreground of Clonney's *Fishing Party on Long Island Sound Off New Rochelle,* also painted in 1847. See Barbara Novak, *The Thyssen-Bornemisza Collection: Nineteenth-century American Painting* (New York: Vendome Press, 1986), p. 107.
6. The lithographs entitled *Ancient and Modern Republics, Miss Clarissa and Mr. Smith* and *Ex Pede Herculem,* executed by Auguste Jean Jacques Hervieu as illustrations for Mrs. Trollope's *Domestic Manners,* show related examples of how poorly American men sat on chairs.
7. The Munson-Williams-Proctor Institute Museum of Art owns a sheet of paper (9 5/16 × 11 7/8 in., accession no. 68.4) with sketches for *Mexican News* on both sides. The more complete compositional study is reproduced by David Sellin, *American Art in the Making,* exhibition catalog (Washington, D.C.: Smithsonian Institution Press, 1976, p. 35, fig. 45, cat. no. 29).
8. When it came to the issue of finding at least some degree of humor in American character types, even Charles Dickens had to admit that "in shrewdness of remark, and a certain cast-iron quaintness, the Yankees, or people of New England, unquestionably take the lead" (*American Notes,* vol. 2, p. 297). For a more complete discussion of these types in both art and literature, see Joshua C. Taylor's delightful survey, *America as Art* (Washington, D.C.: Smithsonian Institution Press, 1976), in which an entire chapter (pp. 37–94) is devoted to the concept of "The American Cousin."

20.
1. Barbara Novak, *American Painting of the Nineteenth Century: Realism, Idealism and the American Experience* (New York: Praeger Publishers, 1969), pp. 213–14.

21.
1. Williams S. Talbot, *Jasper F. Cropsey 1823–1900* (New York: Garland Publishing, Inc., 1977), pp. 47ff, 70ff.
2. Pencil on paper, 1848, Talbot, p. 344, no. 30.
3. Oil on canvas, 1848, ibid., p. 351, no. 41.
4. Pencil and wash, 1849, ibid., p. 354, no. 45.
5. In 1855 Cropsey sold *Chepstow Castle,* and in the 1856 sale there was a picture titled *Chepstow Castle,* 18 × 27" (Talbot, pp. 314, 488). Given the habit of citing window (image) dimensions rather than full canvas size, it is tempting to identify it as the Utica picture. There is, however, no resemblance between the actual ruins of Chepstow and the architecture of the castle in the Utica painting.
6. Talbot, p. 365, no. 60.
7. Ibid., p. 372, no. 70.

22.
1. Theodore Winthrop, *Life in the Open Air, and Other Papers* (Boston: Ticknor and Fields, 1863), p. 9.
2. The drawing is owned by Olana (OL 1980.1448). "Second twilight" occurs after the sun has passed below the horizon, and it is then that some of the most intense sunset colors are seen. I am grateful to John Wilmerding for his help in identifying the site depicted in the drawing.
3. The oil study is also owned by Olana (OL 1981.72).

4. Church's interest in such coastal Maine views had been strong earlier in the 1850s, but it waned during 1854–55, as he turned his attention to painting South American subjects.
5. David Huntington first suggested the connection between *Sunset* and this trip in his *The Landscapes of Frederic Edwin Church: Vision of an American Era* (New York: George Braziller, 1966), pp. 73–78. As is the case with every student of Church's work, I am much indebted to Huntington's insightful analysis of the artist.
6. Winthrop, p. 50.
7. Ibid., p. 75.
8. A more complete discussion of *Sunset* may be found in this writer's *Frederic Edwin Church and the National Landscape* (Washington D.C.: Smithsonian Institution Press, 1988), pp. 86–94. The earliest recorded exhibition in which *Sunset* appears was the Utica Art Association's seventh exhibition in 1879. The painting was listed for sale, with a price of two thousand dollars. This strongly suggests that Church retained the painting for over twenty years—an unusual occurrence for a man whose work was much in demand. Additional evidence is provided by the frame, which is certainly original. Unlike the simpler moldings Church favored in the 1850s, *Sunset* has a more complex, decorated profile perfectly in keeping with the style of the 1870s. It is thus possible that the painting had never been framed before and that when Church sent it to the Utica exhibition he simply framed it in the current style.

23.

1. For biographical information on Ranney, see Francis Grubar, *William Ranney: Painter of the Early West* (New York: Clarkson N. Potter, 1962), and Linda Ayres, "William Ranney," in *American Frontier Life: Early Western Painting and Prints* (New York: Abbeville Press, 1987), pp. 78–107. The Revolutionary War paintings, in addition to the Utica picture, are: *Battle of Cowpens* of 1845 (private collection); *First News of the Battle of Lexington* of 1847 (North Carolina Museum of Art); *Washington Rallying the Americans at the Battle of Princeton* of 1848 (The Art Museum, Princeton University); *Marion Crossing the Pedee* of 1850 (Amon Carter Museum); *Revolutionary Soldier,* not dated and location unknown; *Washington at the Battle of Princeton,* not dated (Thomas Gilcrease Institute of American History and Art); and *The Tory Escort* of 1857 (location unknown).
2. Interest in the Revolution was evident not only in the paintings of the late 1840s, but also in the range of newly published biographies and popular tales relating to the war. See Michael Kammen, *A Season of Youth: The American Revolution and the Historical Imagination* (New York: Oxford University Press, 1978). Emanuel Leutze painted about eleven Revolutionary War scenes. Peter F. Rothermel, Junius B. Stearns, and Dennis Malone Carter, to name but a few, also painted this subject in the late 1840s and 1850s.
3. *Encyclopaedia of American History,* ed. by Richard Morris, 3rd rev. ed., s.v. "The War with Mexico, 1846–48."
4. Michael Quick has pointed out that paintings of the Düsseldorf School, much in vogue in America in the late 1840s and early 1850s, frequently included women in passive roles, often relatives of historical figures, "reacting to the central action with visible emotion," and that Emanuel Leutze depicted "wives and daughters dramatizing the human interest of historical events." Ranney employs women for such roles in the Utica painting. See Michael Quick, "A Bicentennial Gift: *Mrs. Schuyler Burning Her Wheat Fields on the Approach of the British* by Emanuel Leutze," *Los Angeles County Museum of Art Bulletin,* vol. 23 (1977), p. 31.
5. The Ranney Fund Sale, held at the National

Academy of Design, raised some seven thousand dollars, which was invested for the artist's children. Of the 212 works sold, 108 were by Ranney. Ninety-five artists, including Asher Durand, Albert Bierstadt, Frederic Church, John F. Kensett, and George Inness, donated their works for sale. This highly successful event led to the formation of the Artist's Fund Society. The Munson-Williams-Proctor Institute painting was most likely no. 75, "Enlisting during the Revolutionary War," which sold to "Brady" for one hundred dollars. This was probably the Honorable James T. Brady, who gave a public lecture on American art prior to the Fund Sale, the proceeds from which defrayed exhibition expenses at the Academy. For information on the Ranney Fund Sale, see Grubar, *William Ranney,* pp. 11–12 and 57–59; and *The Crayon,* vol. 6 (February 1859), part 2, p. 58.
6. On Blauvelt, see Richard J. Koke et al., *American Landscape and Genre Paintings in the New-York Historical Society* (New York: The New-York Historical Society, 1982), vol. 1, pp. 61–64, nos. 167–68. Blauvelt donated a painting entitled *The Lesson* to the Ranney Fund Sale. At least three other Ranney paintings were completed after his death by other artists: *Rail Shooting* (Terra Museum of American Art) and *The Pipe of Friendship* (Newark Museum) both by William S. Mount, and *The Freshet* (location unknown) possibly by Otto Sommer.

24.

1. David Tatham, "Thomas Hicks at Trenton Falls," *American Art Journal,* vol. 15, no. 4 (1983), pp. 4–20.
2. Ibid. See also N. Parker Willis, ed., *Trenton Falls, Picturesque and Descriptive* (New York: G. P. Putnam, 1851).

25.

1. For a general discussion of Blythe's political and social attitudes, see Bruce W. Chambers, *The World of David Gilmour Blythe,* exhibition catalog (Washington, D.C.: National Collection of Fine Arts, 1980).
2. I would like to acknowledge the assistance of Elizabeth Johns in exploring the theme of women at work in nineteenth-century American genre painting.
3. On the caged bird as a Pre-Raphaelite motif, see Elaine Shefer, "Deverall, Rossetti, Siddal, and the Bird in the Cage," *Art Bulletin,* vol. 67 (September 1985), pp. 437–48.
4. The painting bears an old label from J.J. Gillespie & Company, Blythe's Pittsburgh dealer. The existence of this label does not preclude Blythe's having sold the painting in Baltimore. On the other hand, all of the evidence that Blythe worked in Baltimore and Philadelphia in 1858–59 is circumstantial.

26.

1. Henry T. Tuckerman, *Book of the Artists* (New York: 1867; repr., New York: James F. Carr, Publisher, 1967), p. 434.
2. "A Fine Painting," *Waterville Times,* February 20, 1863 [p. 3]. A notice in the same newspaper eleven months earlier ("Portrait Painter in Town," March 7, 1862 [p. 3]) announced Matteson's arrival in Waterville. I am grateful to Philippa S. Brown of the Waterville Historical Society for bringing these references to my attention. A photograph that shows the Utica painting hanging in the parlor of Frog Park, the Conger home in Waterville, N.Y. is in the collection of the Munson-Williams-Proctor Institute Museum of Art.
3. "Hops: Harvesting the Pernicious Weed," *Heritage* (New York State Historical Association), vol. 2 (September-October, 1985), unpaged.
4. A sketchbook owned by Matteson is in the col-

lection of the New York Historical Association, Cooperstown, N.Y. On page 40 is a preliminary sketch for the figures standing around a hop box at the right of the Utica painting. On the following page is a sketch for the horse and buggy in the middleground at the extreme right. I am grateful to Harriet Groeschel for bringing this sketchbook to my attention.
5. Linda S. Ferber and William H. Gerdts, *The New Path: Ruskin and the American Pre-Raphaelites,* exhibition catalog (New York: Brooklyn Museum, 1985).
6. Christopher K. Wilson, "Winslow Homer's *The Veteran in a New Field:* A Study of the Harvest Metaphor and Popular Culture," *American Art Journal,* vol. 17 (Autumn 1985), pp. 3–27.
7. The Arkansas painting ($22\frac{1}{4} \times 33\frac{1}{4}$"), is briefly mentioned in Harriet H. Groeschel, "A Study of the Life and Work of the Nineteenth-Century Genre Artist Tompkins Harrison Matteson," M.A. thesis, Syracuse University, 1985, p. 80, n. 37. It is cited in James L. Yarnall and William H. Gerdts, comps., *Index to American Art Exhibition Catalogues* (Boston: G.K. Hall & Co., 1986), vol. 4, p. 2330. The cluster of barns at the left of the Arkansas painting appears at the right of the Utica painting, but is shown from a slightly different vantage point.

27.

1. Hugh W. Coleman, "Passing of a Famous Artist, Edward Moran," *Brush and Pencil,* vol. 8 (July 1901), p. 191.
2. For example, there is no mention of Edward Moran in Samuel Isham's *History of American Painting* (1905), nor is he discussed to any great length in Charles Caffin's *Story of American Painting* (1907).
3. The Philadelphia Museum of Art's *Shipwreck* is illustrated on the cover of Paul D. Schweizer, *Edward Moran 1829–1901: American Marine and Landscape Painter,* exhibition catalog (Wilmington: Delaware Art Museum, 1979). A replica of this work was sold in New York City by the Kenneth Lux Gallery in 1979.
4. John Ruskin, *The Harbors of England,* in *The Complete Works of John Ruskin,* ed. by E.T. Cook and Alexander Wedderburn (London: George Allen, 1904), pp. 13–49.
5. Susan P. Casteras, "The 1857–58 Exhibition of English Art in America: Critical Responses to Pre-Raphaelitism," in Linda S. Ferber and William H. Gerdts, *The New Path: Ruskin and the American Pre-Raphaelites,* exhibition catalog (New York: Brooklyn Museum, 1985), pp. 109–33.
6. Schweizer, p. 22. For a list of the titles of the paintings Moran exhibited at the Academy in Philadelphia in 1862, see Anna W. Rutledge, ed., *Cumulative Record of Exhibition Catalogues: The Pennsylvania Academy of the Fine Arts* (Philadelphia: The American Philosophical Society, 1955), p. 49.
7. Two other paintings Moran exhibited during and shortly after 1862, one of which may be the correct title for the Utica painting, are *St. John's near Halifax,* exhibited in Buffalo and Rochester in 1862 and later, and *Bay of Fundy,* which was shown in 1864 at the Great Central Fair in Philadelphia. See James L. Yarnall and William H. Gerdts, comps., *Index to American Art Exhibition Catalogues* (Boston: G.K. Hall & Co., 1986), vol. 4, pp. 2461–62.

28.

1. For a full account of Tait's life and work, see Warder H. Cadbury, *Arthur Fitzwilliam Tait, Artist in the Adirondacks* (Newark: University of Delaware Press, 1986).
2. A useful reference is Arthur R. Harding, *Deadfalls and Snares* (Columbus, Ohio: A.R. Harding

Publishing Co., 1907). William Sidney Mount painted two boys with a different sort of trap in 1844. See Christie's New York auction catalog for December 9, 1983, lot no. 31, pp. 40–41.
3. The definitive account is in Richard Gerstell, *The Steel Trap in North America* (Harrisburg, Pa.: Stackpole Books, 1985).
4. Winslow Homer's *Trapping in the Adirondacks,* which shows a steel trap, appeared in *Every Saturday* (Dec. 24, 1870), p. 849.

29.
1. The painting was originally exhibited as *Negro Life at the South.* For this title and much of the preceding biographical information, I have drawn upon Patricia Hills, *Eastman Johnson,* exhibition catalog (New York: Whitney Museum of American Art, 1972). I am also grateful to Dr. Hills for personally suggesting several improvements to this entry.
2. Henry T. Tuckerman, *Book of the Artists* (New York: 1867; repr., New York: James F. Carr, Publisher, 1967), p. 467.
3. Oil on canvas, 16⅝ × 13⅛″, signed lower left: E. Johnson. Gift of Mrs. Francis P. Garvan, 1962. An apparent study for *The Chimney Corner* is listed in John I.H. Baur, *Eastman Johnson, 1824–1906,* exhibition catalog (New York: Brooklyn Museum, 1940), p. 90.
4. Tuckerman, p. 624.
5. Another painting by Johnson, *Sunday Morning* of c. 1866 (New-York Historical Society), incorporates the same setting.

30.
1. The primary study of Silva is John I.H. Baur, "Francis A. Silva, Beyond Luminism," *Antiques,* vol. 118 (November 1980), pp. 1018–31.
2. On Colman, see Wayne Craven, "Samuel Colman (1832–1920): Rediscovered Painter of Far-Away Places," *American Art Journal,* vol. 8 (May 1976), pp. 16–37.
3. Recently, another version of the Utica painting came to light in a private collection in Arizona. The disposition of the clouds is slightly different, as is the face of the breaking wave. In size (39¾ × 19½″), it is somewhat larger than the Utica painting and in addition to the artist's signature has the date "1873."

31.
1. William S. Talbot, *Jasper F. Cropsey 1823–1900* (New York: Garland Publishing, Inc., 1977), p. 71.
2. An 1849 painting of Haines Falls (private collection) has an inscription on the back that reads: "My first Study from Nature—/made in company with J.F. Kensett &/J.W. Casilear." See John I.H. Baur, " 'the exact brushwork of Mr. David Johnson,' an American Landscape Painter, 1827–1908," *American Art Journal,* vol. 12 (Autumn 1980), figs. 2, 3, and 33.
3. David Johnson letter to George W. Adams, March 18, 1878, Munson-Williams-Proctor Institute.
4. Johnson to Adams. Johnson's interest in Corot can be seen in one of his sketchbooks, where there is a copy of one of the Barbizon master's paintings. See Baur, figs. 11 and 38.
5. Johnson to Adams.

32.
1. Peter Bermingham, *American Art in the Barbizon Mood,* exhibition catalog (Washington, D.C.: National Collection of Fine Arts, 1975).
2. The results of the Ichabod T. Williams sale were reported in the *New York Times,* February 4, 1915, p. 9; February 5, 1915, p. 11.

33.
1. Alfred L. Baldry, "G.H. Boughton: His Life and Work," *Art Journal Christmas Annual,* vol. 29 (1904), p. 8. Baldry's monograph remains the most complete discussion of the artist and his work. Rudolph de Cordova's interview with Boughton ("Mr. George Henry Boughton," *Strand Magazine,* vol. 20, no. 115 [August 1900], pp. 3–15) is a valuable reminiscence of the artist on his early career. See also the reminiscences of one of Boughton's fellow Albany artists, Charles Calverley, "Recollections of George H. Boughton," undated typescript in the McKinney Library, Albany Institute of History and Art.
2. *Catalogue of Work in Many Media by Men of the Tile Club,* New London, Connecticut, 1945.
3. As if to emphasize the hardships the Puritans willingly suffered, Boughton depicted them on more than one occasion in snowy winter landscapes. The *Puritan Maiden* is especially akin to the slightly later *Priscilla,* in which a pretty young woman braves the elements alone.
4. Boughton abandoned his usual historical accuracy of detail in the *Puritan Maiden.* The subject's costume is a curious pastiche of elements proper to contemporary as well as historic dress and may well have resulted from an expedient use of studio props. Similar ribbon-trimmed hats are worn by the pretty subjects of contemporary costume pieces by Boughton entitled *Winter* and *A Winter Ramble* (locations unknown, both illustrated in "Paintings by G.H. Boughton, Reproductions," mounted and bound by the New York Public Library, vol. 4 [1936]). The subjects of the latter carry fur-edged muffs virtually identical to that in the Utica painting.

34.
1. It is no. 691 (*The Galleries of the Stelvio, Lago di Como,* dated 1878, 24 × 30″, coll. of Mrs. James Watson Williams, Utica, N.Y.) in *A Memorial Catalogue of the Paintings of Sanford Robinson Gifford, N.A., with a Biographical and Critical Essay by Prof. John F. Weir of the Yale School of Fine Arts* (New York: 1881; repr., New York: Olana Gallery, 1974). For a more detailed discussion of this painting and related works, see Ila Weiss, *Poetic Landscape: The Art and Experience of Sanford R. Gifford* (Newark, Del.: University of Delaware Press, 1987).
2. "There are a great many galleries and tunnels to protect the road from avalanches." Sanford R. Gifford, "European Letters," Archives of American Art, Smithsonian Institution, Washington, D.C., vol. 2 (July 28, 1857), pp. 177–78.
3. "Delightfully cool they were, like wells, going into them from the hot sun." Ibid., vol. 3, p. 27.
4. Gifford sketchbook, "Maggiore, Como, Sicily, Rome, Genoa, 1868," pp. 46–47, 4¾ × 9″, on deposit at the Brooklyn Museum of Art, N.Y. The tonal study is inscribed "Galleries of the Stelvio Rd. Lake Como Aug '68." See Ila Weiss, "Sanford R. Gifford in Europe: A Sketchbook of 1868," *American Art Journal,* vol. 9 (November 1977), pp. 94–96.
5. *Stelvio Road by Lake Como,* August 6, 1868, oil on canvas, 9⅞ × 8⅛″, Thyssen-Bornemisza collection, Lugano, Switzerland (*Memorial Catalogue,* no. 506). It is inscribed "Stelvio Road Aug 6 1868 Como," and illustrated in Barbara Novak, *The Thyssen-Bornemisza Collection: Nineteenth-Century American Painting* (New York: The Vendome Press, 1986), p. 147, and in Weiss, *Poetic Landscape,* p. 314.
6. Two years later he painted an unlocated midsized version (*Memorial Catalogue,* no. 563), with the dimensions given as 20 × 26″. The proportions indicate that this was a related vertically formatted picture with its printed dimensions reversed (as were those of no. 691 in the same publication).

35.
1. LeRoy Ireland, *The Works of George Inness* (Austin, London: University of Texas Press, 1965), p. 216, no. 867. The painting was acquired by the Munson-Williams-Proctor Institute Museum of Art in 1954 as *In the Berkshires;* in 1965 Edward H. Dwight, director of the museum, changed the title to *The Coming Storm,* in time to have it published with the alternate title in Ireland's catalog.
2. Ireland, p. 289, no. 1166.
3. The suggestion is by Kathryn Gamble, the former director of the Montclair Art Museum, in a letter to Edward H. Dwight, March 3, 1964, on deposit in the Inness curatorial file at the Munson-Williams-Proctor Institute.
 Montclair, New Jersey is the title the Cleveland painting was given in the catalog of the 1904 executor's sale of the estate of Mrs. Elizabeth Inness. Like most of the works in that sale, however, this painting—and hence its title—have, in my opinion (but for reasons that cannot be argued here), a very uncertain claim to authority.
4. Ireland, p. 175, no. 712; p. 182, no. 741; and p. 192, no. 775 respectively.
5. "The Arts," *Appleton's Journal,* vol. 14 (September 18, 1875), p. 376.
6. Ibid.

36.
1. This may, in fact, be the painting discussed in a newspaper clipping in the Blemly scrapbook which, according to a penciled note, was printed in the Munich *Neueste Nachrichten* in August 1882. It reads: "News from the Kunstverein. The exhibition at present is in the usual midsummer doldrums; thanks to this situation, a 'still life' takes first place this week. A fairly large picture by W. Harnett, *Table with Books, Sheet Music and Musical Instruments,* must be called a masterpiece of this type. It is scarcely possible to paint these objects with greater truth to nature and in a more pleasing manner. The partly yellowed music-sheets and the cracked flute worked in precious ivory provide more food for thought than any of your wooden, badly executed human figures." Alfred Frankenstein, *After the Hunt: William Harnett and Other American Still Life Painters 1870–1900* (Berkeley and Los Angeles: 1953; rev. ed., Berkeley, Los Angeles, London: University of California Press, 1975), p. 62, no. 34. The work illustrated as fig. 56 in Frankenstein's book is not the painting in Utica for it lacks the tobacco case that is next to the stein in the center of the Institute's painting.
2. In earlier pictures Harnett revealed an overt interest in the theme of *vanitas;* for example, three times during the late 1870s he painted *memento mori,* which included such forthright reminders of death as a skull. Small wonder, for Harnett had ready access to seventeenth-century still lifes in New York in the 1870s (including a *Vanitas* by Edwaert Collier in the newly established Metropolitan Museum of Art), and the influence of Dutch painting was to deepen during his residence in Europe in the 1880s.
 Harnett's strong interest in the *vanitas* theme has been the subject of two recent studies: Barbara S. Groseclose presented a paper on "Vanity and the Artist: Some Still-Life Paintings of William Michael Harnett," at the Munson-Williams-Proctor Institute in November 1983 and published her comments under the same title in the *American Art Journal,* vol. 19, no. 1 (1987), pp. 51–59. The author delivered a paper entitled "William Michael Harnett's *The Old Cupboard: An Iconographic Interpretation*" at the annual meeting of the College Art Association, Los Angeles, 1985. A revised version of this paper was published in the *American Art Journal,* vol. 18, no. 3 (1986), pp. 51–62.
3. For a summary of the three groups of objects

that constitute the *vanitas* still life (symbols of earthly existence, transience, and resurrection), see Ingvar Bergström, *Dutch Still-Life Painting in the Seventeenth Century,* translated by Christina Hedström and Gerald Taylor (New York: Thomas Yoseloff Inc., 1956), p. 154.

4. See Larry Freeman, *Light on Old Lamps* (Watkins Glen, N.Y.: Century House, 1946), chapter 6; and *Lamps & Other Lighting Devices 1850–1906,* comp., The Editors of Pyne Press (Princeton, N.J.: The Pyne Press, 1972), p. 15.

5. For a discussion of the beetle as a symbol of earth and winter, see Leonard J. Slatkes, "Caravaggio's *Boy Bitten by a Lizard,*" *Print Review,* vol. 5 (1976), p. 151.

The beetles' associations with the winter season and decay continued into Harnett's time. For example, according to Lantz's *Acme Cyclopedia and Dictionary:* "Beetles feed on decaying substances, either animal or vegetable, and are often called the 'scavengers of nature. . . .' Beetles live but one season and die before winter, leaving nothing but their eggs to continue their species." M.S. Lantz, *The Acme Cyclopedia and Dictionary: A Practical Compendium of Useful Information and Book of References for Everybody* (Philadelphia: Globe Publishing Co., 1884), p. 82.

6. Boieldieu's *La Dame Blanche* was well-known in the late nineteenth century; between 1875 and 1914 the opera was performed close to seventeen hundred times (Nicolas Slonimsky, ed., *Baker's Biographical Dictionary of Musicians* [New York: G. Schirmer, 1958], p. 174).

7. Miguel de Cervantes Saavedra, *Adventures of Don Quixote de la Mancha,* translated by Charles Jarvis (New York: John Wurtele Lovell, Publisher, 1880), book 4, chap. 53, p. 691.

37.

1. Henry James, "Duveneck and Copley, 1875," in *The Painter's Eye: Notes and Essays on the Pictorial Arts by Henry James,* ed. by John L. Sweeney (London: Rupert Hart-Davis, 1956), p. 105.
2. Quoted from John Douglas Hale, "The Life and Creative Development of John H. Twachtman," (Ph.D. dissertation, Ohio State University, 1957), vol. 1, pp. 47–48.
3. "A Study of the Pictures: Second View of the Watercolor Exhibit," the *New York Times,* February 6, 1882, p. 5.

38.

1. Samuel G.W. Benjamin, *Art in America: A Critical and Historical Sketch* (New York: Harper and Brothers, 1880), p. 75.
2. Linda S. Ferber, *William Trost Richards (1833–1905): American Landscape and Marine Painter* (New York: Garland Publishing, Inc., 1980), pp. 356–58.
3. The Corcoran curator William MacLeod wrote to the artist on May 14, 1883: "It gives me pleasure to state that your picture gives entire satisfaction to the Committee, to the Trustees & Mr. Corcoran; and no picture has been brought here, more admired by the public. It is now on exhibition." William T. Richards Papers, Archives of American Art, Smithsonian Institution, Washington, D.C., as quoted in Ferber, *Richards,* p. 383, n. 41.

39.

1. This title appears on a Macbeth Gallery label originally attached to the painting, which is now in the curatorial files of the Munson-Williams-Proctor Institute Museum of Art. It is the fervent hope of this author that this label was placed on the painting at the time of Macbeth's December 1904 exhibition of Wyant's paintings. Unfortunately, a catalog for this exhibition has yet to be found. The Utica painting is illustrated in Eliot C. Clark, *Sixty Paintings*

by Alexander H. Wyant (New York: privately printed, 1920), no. 12, f.p. 32 as *Adirondack Ledge* in the collection of George S. Palmer. The picture can be dated to approximately 1884 on the basis of its very strong similarity in style, subject, and size to *A Mountain Brook, Adirondacks* (present location unknown), formerly in the collection of the Albright-Knox Art Gallery, and which was acquired in 1884. (Letter from Susan Krane, Albright-Knox Art Gallery, to the author, April 1, 1986.) A photograph of the former Buffalo painting is on file at the Frick Art Reference Library, no. 118–22/F.
2. Robert S. Olpin, *Alexander Helwig Wyant, 1836–1892,* exhibition catalog (Salt Lake City: The University of Utah, 1968). In addition to offering major biographic information on Wyant, Dr. Olpin included the Utica painting in his "Register of Alexander H. Wyant Paintings in American Public Collections," unpaged.
3. Letter from Peggy O'Brien (author of "Capturing the great North Woods . . . Alexander Wyant 1836–1892," *Adirondack Life,* vol. 3 [Spring 1972], pp. 38–41) to the author, April 28, 1986, confirms that "it could be any number of places."
4. See Wanda M. Corn, *The Color of Mood: American Tonalism, 1880–1910,* exhibition catalog (San Francisco: M.H. de Young Memorial Museum and California Palace of the Legion of Honor, 1972). Dr. Corn included Wyant in her exhibition and essay.
5. Macbeth Gallery Scrapbook, 1902–10, Archives of American Art, Smithsonian Institution, Washington, D.C., reel NMC1, frame 54. The Utica picture, which is likely the one mentioned in the Macbeth Gallery's December 1904 exhibition, was sold by Macbeth to George D. Pratt on May 10, 1905, for six thousand dollars. (Letter from Gwendolyn Owens, H.F. Johnson Museum of Art, to Paul D. Schweizer, Munson-Williams-Proctor Institute Museum of Art, March 29, 1985.) The source of Ms. Owens's information is the as yet to be microfilmed Macbeth Gallery account books. (Letter from Ms. Owens to the author, May 2, 1986.)
6. James L. Yarnall, "John Henry Twachtman," in Patricia C.F. Mandel, *Selection VII: American Paintings from the Museum's Collection, c. 1800–1930* (Providence: Rhode Island School of Design, 1977), no. 28, pp. 72–74.
7. "Alexander Wyant," in *American Art and American Art Collections,* ed. by Walter Montgomery (Boston: E.W. Walker and Company, 1889), pp. 967–68.

40.

1. William M. Chase, "The Import of Art: An Interview with Walter Pach," *The Outlook,* vol. 95 (June 25, 1910), p. 442.
2. The original title, *Memories,* appeared in an article which described the work: "The William M. Chase Exhibition," *Art Amateur,* vol. 16, no. 5 (April 1887), p. 100.
3. Kenyon Cox, "William M. Chase, Painter," *Harper's New Monthly Magazine,* vol. 78 (March 1889), p. 556.
4. "The Chase Exhibition," *American Art Illustrator* (December 1886), p. 99.
5. Ibid.
6. "A Boston Estimate of a New York Painter," *The Art Interchange,* vol. 17 (December 4, 1886), p. 179.

41.

1. These were in turn inspired by mid-nineteenth-century photographs of game still lifes taken by the German photographer Adolphe Braun (1811–77).
2. For other versions of the "Fish House Door" series, see John Wilmerding, *Important Information Inside: The Art of John F. Peto and the Idea of Still-Life Painting in Nineteenth-Century America,* exhibition catalog (Washington, D.C.: National Gal-

lery of Art, 1983), pp. 157–58, and figs. 140 and 142.
3. Even the Utica painting's plain green frame is almost certainly Peto's own, probably made from old boards similar to those he painted—a final imaginative gesture at the juncture, like a hinge, between art and reality.

42.

1. See William H. Gerdts and Russell Burke, *American Still-Life Painting* (New York: Praeger Publishers, 1971), pp. 101–11.
2. See Anthony F. Janson, "The Paintings of Worthington Whittredge" (Ph.D. dissertation, Harvard University, 1975), pp. 88–89, 128.
3. Edward H. Dwight in discussion with the author.
4. Edward H. Dwight, *Worthington Whittredge, 1820–1910: A Retrospective Exhibition of an American Artist,* exhibition catalog (Utica: Munson-Williams-Proctor Institute, 1969), p. 57, no. 34.
5. Illustrated in ibid., p. 63, no. 40.

43.

1. Conversation with Everett Shinn, September 12, 1952, as reported in Bennard B. Perlman, *The Immortal Eight: American Painting from Eakins to the Armory Show* (New York: 1962; rev. ed., Westport, Conn.: North Light Publishers, 1979), p. 79.
2. The term "Ashcan School" did not appear in print until 1934, when Holger Cahill and Alfred H. Barr, Jr., employed it in their book, *Art in America: A Complete Survey* (New York: Reynal & Hitchcock, 1934).
3. Conversation with Shinn (as in n. 1).

44.

1. Reprinted from *William Glackens and the Eight: The Artists Who Freed American Art* by Ira Glackens, published by Horizon Press, New York, copyright 1983, pp. 67–72.
2. Ibid., pp. 69–70.
3. The others are *Luxembourg Gardens* (Corcoran Gallery of Art), *Luxembourg Gardens* (Wichita Art Museum), *Flying Kites, Montmartre* (Museum of Fine Arts, Boston), *Café de la Paix* (private collection), *Château-Thierry* (Huntington Library and Art Gallery, San Marino, California), and *Beach at Dieppe* (Barnes Foundation, Merion, Pennsylvania). The Huntington Library also has a small oil sketch (*pochade*) for the painting of Château-Thierry. In addition, Glackens made at least four drypoint etchings, all in editions of three or less, which are related to this series of paintings. One of these, *The Luxembourg Gardens,* an etching with color, signed in the plate "W. Glackens 06 Paris" (Philadelphia Museum of Art), closely resembles the motifs in the Wichita canvas. This print is reproduced in "Recent Art Books," *Arts and Decoration,* vol. 6 (May 1916), p. 349 and in Forbes Watson, *William Glackens* (New York: The Arts Monographs Duffield and Company, 1923), plate 3.
4. The jury for this exhibition included Thomas Eakins and Robert Henri.
5. There exists a preliminary sketch of the composition, done on the spot in Paris, and differing only in detail from the finished painting. This drawing is reproduced with the title *In the Bois,* from an unidentified source, in the clipping scrapbook of the Mallet Library of Art Reproductions on deposit in the library of the National Museum of American Art/National Portrait Gallery, Smithsonian Institution, Washington, D.C.
6. Françoise Cachin, Charles S. Moffett, and Michel Melot, *Manet: 1832–1883,* exhibition catalog (New York: Metropolitan Museum of Art, 1983), pp. 122–26, 537.
7. *In the Buen Retiro,* painted in Madrid, was the only canvas from the 1906 trip that was included in

the exhibition at the Macbeth Gallery in February 1908 (no. 57 "Bues [sic] Retiro, Madrid"). See also Richard J. Wattenmaker, "William Glackens's Beach Scenes at Bellport, *Smithsonian Studies in American Art,* vol. 2, no. 2 (Spring 1988), pp. 75, 86 and n. 23.

45.
1. For an account of Henri's art and life in Holland in 1907, see my *Robert Henri and His Circle* (Ithaca: Cornell University Press, 1969), pp. 133–36, 241.

46.
1. James Huneker, "The Seven Arts," *Puck,* vol. 75 (May 23, 1914), p. 21.

47.
1. An extended discussion of the history of the Harlem River bridges can be found in Sharon Reier, *The Bridges of New York* (New York: Quadrant Press, 1977).
2. The question of the identity of the bridge in the Utica painting was initially raised by Henry D. Blumberg of Little Falls, N.Y., in correspondence with the Munson-Williams-Proctor Institute Museum of Art in October of 1985. At that time the museum identified the painting as a view of High Bridge. Mr. Blumberg, noting the steel arch in the painting, rightly stated that, if it was a view of High Bridge, it would have to date after 1927. However, as a painting of Washington Bridge—its correct identification—it could date to any year after 1888, which is to say, to c. 1910, the date originally supplied by Edward Root. The problem of identifying the bridges in Lawson's paintings was first raised in a footnote in Adeline L. Karpiscak, *Ernest Lawson, 1873–1929,* exhibition catalog (Tucson: University of Arizona Museum of Art, 1979), p. 33, n. 8.

48.
1. John Sloan, *Gist of Art* (New York: American Artists Group, 1939), p. 223.
2. Bruce St. John, ed., *John Sloan's New York Scene* (New York: Harper and Row, 1965), p. 426.
3. Ibid., pp. 429–30.
4. Ibid., p. 518.

49.
1. I am indebted to Charles Parkhurst, Milton W. Brown, Nancy M. Mathews, Gwendolyn Owens, and Carol Derby, my colleagues on the Prendergast project, Williams College Museum of Art, for their contribution to our continuing study of Maurice and Charles Prendergast.
2. Root withdrew the picture from the traveling show and consequently it was not seen in either Chicago or Boston.
3. This work is *Canal* and is now in the collection of the Munson-Williams-Proctor Institute Museum of Art.
4. "Exhibitions Now On," *American Art News,* vol. 6 (April 11, 1908), p. 6.
5. It is most closely related to *The Holiday* (Fine Arts Museums of San Francisco), *On the Beach No. 3* (Cleveland Museum of Art), and *The Promenade* (Columbus Museum of Fine Arts).
6. F.J.M. [Frank Jewett Mather, Jr.], "The Armory Exhibition—II," *The Nation,* vol. 93 (March 13, 1913), p. 267.
7. The use of only their last name suggests the possible collaboration of the brothers in the conception and execution of the frame.

50.
1. Macbeth Gallery Papers, Archives of American Art, Smithsonian Institution, Washington, D.C., reel NMc2, frame 167.
2. Ibid., frames 169–72. Also, *Vanity Fair,* n.s., vol. 1 (January 1914), p. 40.

3. Two letters at the Archives of American Art (Max Weber Papers, reel N69–83, frame 62, and Walt Kuhn Papers, reel D240, frames 390–91) reveal Davies's frustration at not being able to work while organizing the Armory Show, a pressure that was complicated by other personal problems. Nevertheless, the Macbeth Gallery's *Art Notes* reported in its January 1913 number that "In spite of hard work in connection with the coming exhibition in the Sixty-ninth Armory, Mr. Davies has been able to finish a few canvases now being privately shown here."
4. James G. Frazer, *The Golden Bough (Adonis, Attis, Osiris)* (London: Macmillan and Co., Ltd., 1914), vol. 1, p. 240.

51.
1. For a detailed analysis of this movement and Russell's development, see Gail Levin, *Synchromism and American Color Abstraction, 1910–1925* (New York: George Braziller, 1978).
2. For the entire text of this catalog and other Synchromist texts, see Levin, *Synchromism,* p. 130.
3. For a discussion of the sculptural basis of many Synchromist abstractions, see Gail Levin, "The Tradition of the Heroic Figure in Synchromist Abstractions," *Arts Magazine,* vol. 51 (June 1977), pp. 138–42.
4. *The Forum Exhibition of Modern American Painters,* exhibition catalog (New York: Anderson Galleries, March 13–25, 1916), unpaged. In this catalog, the title of *Cosmic Synchromy* is given in English only.
5. Stanton Macdonald-Wright to Morgan Russell, referred to in Levin, *Synchromism,* p. 30; quoted in full in William C. Agee, "Willard Huntington Wright and the Synchromists: Notes on the Forum Exhibition," *Archives of American Art Journal,* vol. 24 (1984), p. 11.
6. Willard Huntington Wright, *Modern Painting: Its Tendency and Meaning* (New York: John Lane Company, 1915), p. 294, as *Synchromie Cosmique.*

52.
1. Quoted in C. Lewis Hind, "Wanted a Name," *The Christian Science Monitor* (c. November-December 1919), undated clipping preserved in the scrapbooks of Katherine Dreier, Collection of the Société Anonyme, Beinecke Library, Yale University, New Haven), reprinted in Hind, *Art and I* (New York: John Lane, 1920), pp. 180–85. Despite the early date of this statement—made only five years after the event referred to—it is unlikely that the artist totally ceased artistic production for a period of six months simply because he needed time to contemplate what he had seen at the Armory Show. It is at best an exaggeration, meant only to emphasize the importance of this event.
2. As suggested by Arturo Schwarz, *Man Ray: The Rigour of Imagination* (New York: Rizzoli International Publications, 1977), p. 30.
3. Unless otherwise noted, all biographical references contained in this entry are derived from the artist's autobiography, *Self Portrait* (New York and London: Andre Deutsch, 1963); this quotation from p. 54.
4. On this phase of the artist's work, see Francis M. Naumann, "Man Ray: Early Paintings 1913–1916, Theory and Practice in the Art of Two Dimensions," *Artforum,* vol. 20 (May 1982), pp. 37–46. This subject shall form the basis of a forthcoming monograph on the artist tentatively entitled "Man Ray in America: The New York and Ridgefield Years 1910–1921" (currently in preparation).

53.
1. For additional biographical information on Dickinson, see Louis Bouche, "Preston Dickin-

son," *Living American Artist Bulletin* (October 1939), pp. 2–4; *Dictionary of American Biography* (Supplement 1), s.v. "Dickinson, Preston." See also Ruth Cloudman, *Preston Dickinson 1889–1930,* exhibition catalog (Lincoln, Nebr.: Sheldon Memorial Art Gallery, 1979), and Richard Rubenfeld, "Preston Dickinson: An American Modernist, with a Catalogue of Selected Works" (Ph.D. dissertation, Ohio State University, 1985).
2. For Dickinson's interest in brilliant, non-associative color, see Thomas Hart Benton, *An American in Art* (Lawrence: University of Kansas Press, 1969), p. 53. Benton, a colleague of Dickinson, wrote that about 1916 the two artists were experimenting with Synchromism. The Utica picture reveals this tendency in Dickinson's art a year earlier (Rubenfeld, 1985, pp. 106–8). A full analysis of *Fort George Hill* can be found on pp. 337–38 of Rubenfeld.

54.
1. Letter to Alfred Stieglitz from Small Point, Maine, August 1, 1915, in Dorothy Norman, ed., *The Selected Writings of John Marin* (New York: Pellegrini and Cudahy, 1949), p. 20.
2. Ibid., September 19 and 26, 1915, p. 27.
3. Ibid., p. 20.
4. Ibid.
5. *Tree Forms, Autumn* (John Marin, Jr., New York), in Sheldon Reich, *John Marin: A Catalogue Raisonné* (Tucson: University of Arizona Press, 1970), p. 413, fig. 15.56.
6. John I.H. Baur, *Watercolors by Charles Burchfield and John Marin* (New York: Kennedy Galleries, Inc., 1985), unpaged.
7. John I.H. Baur, *John Marin's New York* (New York: Kennedy Galleries, Inc., 1981), unpaged.

55.
1. Ernst Watson, *Color and Method in Painting* (New York: Watson-Guptill Publications, Inc., 1942), p. 5. A pencil inscription by the artist on the back of this watercolor reads: "a memory of childhood—an attempt to recreate the way a flower gardens [sic] looks to a child."
2. Charles Burchfield, March 1915, Charles Burchfield Papers, Burchfield Art Center, State University College at Buffalo, New York.
3. Ibid., 1917. In this journal entry Burchfield described the theme of his 1917 painting, *The August North* (William C. Janss, Sun Valley, Idaho).
4. This image of Burchfield is seen in John I.H. Baur's 1956 monograph, *Charles Burchfield* (New York: Macmillan Co., 1956). It also appears in *Charles Burchfield: The Charles Rand Penny Collection,* exhibition catalog, with essays by Charles R. Penny, Bruce Chambers, and Joseph S. Czestochowski (Rochester: Memorial Art Gallery of the University of Rochester, 1978). Czestochowski takes an approach that differs from Bauer and Chambers in that he connects Burchfield with the vision of nineteenth-century American landscapists, a legitimate connection in that he concentrates on the artist's later watercolors from 1946 until his death in 1967.
5. Ibid.

56.
1. A considerable amount has been written on the art history of Long Island, most notably by Ronald G. Pisano, whose recent publication, *Long Island Landscape Painting 1820–1920* (Boston: New York Graphic Society, 1985), is an excellent survey of the subject.
2. In the winter of 1924–25 the artist had an important one-man exhibition of his recent work of eastern Long Island subjects at the galleries of William Macbeth in New York City. The exhibition, titled *Montauk* after the easternmost town on

Long Island, consisted of twenty paintings which the artist had executed over the past few years. Most of the works included in the show, unlike the Utica painting, were paintings that directly revealed the artist's interest in classical and mythical themes as if he were aligning his art with a grand tradition. In works such as his *Adam and Eve Walking Out on Montauk in Early Spring* (Guild Hall Museum, East Hampton, New York), or his *Nine Muses Celebrating the Indian Corn in Flower* (location unknown), he inserted mythical characters into a landscape that only draws its inspiration from the actual locale. This exhibition drew mixed reviews, mystifying some enthusiasts of Hassam's work. Subsequently, these allegorical works have been largely ignored.
3. Other works along this theme include his 1923 *Jonathan Baker Farm* (location unknown), his 1923 *Spring Planting* (Delaware Art Museum), his 1926 *Spring at Easthampton* (private collection), and his 1932 *Long Island Husbandry* (private collection).

57.

1. See Betsy Fahlman, *Pennsylvania Modern: Charles Demuth of Lancaster*, exhibition catalog (Philadelphia: Philadelphia Museum of Art, 1983), for the most recent discussion of these paintings.
2. The earliest known exhibition of the Utica picture was in December 1922, when it was shown at New York's Daniel Gallery, where the artist had his first one-man show in 1914.
3. Several of his depictions of Gloucester and Provincetown architecture record known structures. His Bermuda paintings, begun during the winter of 1916–17, however, were not site specific.
4. See Karal Ann Marling, "*My Egypt:* The Irony of the American Dream," *Winterthur Portfolio*, vol. 15 (Spring 1980), pp. 25–39.
5. I am grateful to Robert LeMin of Lancaster, whose photograph of the grain elevators, taken several years before their demolition in July 1977, enabled me to conclusively identify the painting's subject. See fig. 10 of my "Charles Demuth's Paintings of Lancaster Architecture: New Discoveries and Observations," *Arts Magazine*, vol. 61 (March 1987), p. 26.
6. Emily Farnham, *Charles Demuth, Behind a Laughing Mask* (Norman: University of Oklahoma Press, 1971), p. 184.
7. Letter from Mary E. Marshall to the Downtown Gallery, August 22, 1950, curatorial files, Munson-Williams-Proctor Institute Museum of Art.
8. Alvord L. Eiseman, "A Study of the Development of an Artist: Charles Demuth" (Ph.D. dissertation, New York University, 1976, p. 362).
9. One local resident recalled that while Demuth was a student in Lancaster one of his teachers related the story of how Augusta, in giving Biblical instruction to her young son Charles, used the grain elevators as a local illustration to the story (Gen. 41) of how Joseph could have stored corn for the seven lean years in Egypt.
10. Robert Locher inherited Demuth's drawings and watercolors; O'Keeffe was left the remainder of his paintings.

58.

1. Despite his having produced a number of treeless landscapes of the New England shore in the American impressionist manner, Metcalf wrote Charles Woodbury in 1912 regarding a summer rental at Ogunquit, Maine, specifying that the cottage must have trees close by for subject matter. Woodbury must not have been able to comply, for Metcalf spent the season at Kittery Point (Woodbury letters, Keeper of the Prints Archive, Boston Public Library).
2. Metcalf Papers, Archives of American Art, Smithsonian Institution, Washington, D.C., reel N70/13, frames 330, 333, 344, 380, 385, and 387; also reel D-105, frame 895.

59.

1. My gratitude is extended to Frances F. Dickinson, the artist's widow, for her generosity in providing information about Dickinson's polar subjects.

60.

1. Telephone conversation with William C. Agee, director of the Stuart Davis catalog raisonné project, September 22, 1986.
2. The Fisher painting is an oil on canvas, $29^{1}/_{4} \times 36^{1}/_{4}$ in. The information on the Downtown Gallery label attached to the verso of the Utica gouache does identify it as *Eggbeater No. 2*, but the 1927 date on this label cannot be considered reliable. It antedates by nearly twenty years the making of the work of art in that the address on the label is 32 East 51st Street, New York, a location to which dealer Edith Gregor Halpert did not move the gallery until the mid-1940s. It was probably attached on the occasion of the gallery's *Stuart Davis Retrospective*, held January 29–February 16, 1946, at which time all the gouache versions of all the "Eggbeaters" were shown. Moreover, the inscription on the preparatory drawing for the Utica work, dated "January 8–10, 1928" (Estate of Stuart Davis), strongly suggests 1928 as the date for the gouache as well. In referring to the medium of the small versions of the "Eggbeaters," Davis used the terms "gouache" and "tempera" interchangeably.
3. Stuart Davis, *Stuart Davis* (New York: American Artists Group, 1945), unpaged.
4. Stuart Davis to Edith Halpert, August 11, 1927, Edith Gregor Halpert Papers, Archives of American Art, Smithsonian Institution, Washington, D.C.

61.

1. An illustration of this screen is in the William C. Palmer papers in the archives of the Daniel Burke Library, Hamilton College, Clinton, N.Y.
2. This inventory is in the curatorial files of the Munson-Williams-Proctor Institute Museum of Art. Also found in his studio were Janet W. Adams's book *Decorative Folding Screens* (New York: Viking Press, 1982), and vol. 17, no. 2 of the *American Art Journal*, which featured on the cover a photograph of Thomas W. Dewing's screen, *Morning Glories*, 1900 (Museum of Art, Carnegie Institute).
3. Howard D. Spencer, *William Palmer: A Retrospective*, exhibition catalog (Wichita, Kans.: Wichita Art Museum, 1986), p. 6.
4. Conversation with the author, July 1987.

62.

1. For a discussion of the Whitney Studio Club, see Patricia Hills and Roberta K. Tarbell, *The Figurative Tradition and the Whitney Museum of American Art*, exhibition catalog (New York: Whitney Museum of American Art, 1980), pp. 14–17.
2. For an illustration of this work, see *A Retrospective Exhibition of Paintings by Alexander Brook*, exhibition catalog (New York: Salander-O'Reilly Galleries, Inc., 1980), no. 9. In 1945 Brook stated that "any good portrait is a self-portrait, not the physical likeness of the painter of course, but an identifiable reflection of his preference." *Alexander Brook* (New York: American Artists Group, Inc., 1945), unpaged.

63.

1. In a 1939 letter to Edward W. Root, the original purchaser of *Lower Manhattan*, Marsh referred to the painting as "New York Skyline 1930." (This letter is in the possession of the Munson-Williams-Proctor Institute.) Root purchased the painting in January of 1931 from the Rehn Gallery in New York City.
2. In the letter cited above, Marsh described how he repaired this painting nine years after it was first executed using egg tempera and varnish.
3. Marsh copied the recipe for egg tempera into a notebook which he devoted to methods of painting and printmaking, now with his papers at the Archives of American Art, Smithsonian Institution, Washington, D.C.

64.

1. For a discussion of the locations that Hopper painted, see Gail Levin, *Hopper's Places* (New York: Alfred A. Knopf, 1985).

65.

1. Philip R. Adams, *Walt Kuhn, Painter: His Life and Work* (Columbus: Ohio State University, 1978), p. 136.
2. Ibid., p. 129.
3. Ibid., p. 132.

66.

1. Leon A. Arkus, comp., *John Kane, Painter* (Pittsburgh: University of Pittsburgh Press, 1971), p. 102.

67.

1. Herman Baron, "History of the ACA Galleries," Herman Baron Papers, Archives of American Art, Smithsonian Institution, Washington, D.C., reel D304, frame 600.
2. Lewis Mumford, "At the Galleries, In Capitulation," *The New Yorker*, vol. 11 (June 1, 1935), p. 57.
3. John Selby, *St. Louis Daily Globe-Democrat*, September 11, 1938, p. 4a.
4. "Joe Jones Tries to 'Knock Holes in Walls'," *Art Digest*, vol. 7 (February 15, 1933), p. 9.
5. "A St. Louis Artist Discusses His Family on Canvas," *St. Louis Post-Dispatch Sunday Magazine*, undated clipping, artist's scrapbook, courtesy of D. Wigmore Fine Arts, Inc., New York.
6. Ibid.

68.

1. Letter from the artist to Joseph S. Trovato, March 29, 1975, in the curatorial files of the Munson-Williams-Proctor Institute Museum of Art. Soyer wrote that the title of the painting was chosen by his dealer, Valentine Dudensing, because Sylvia was posed like the model in another painting from the same period, called *Sentimental Girl* (Bella and Sol Fishko).
2. *Scribner's Magazine*, vol. 104 (November 1938), p. 4.
3. "Social Commentaries Mark the Pennsylvania Academy's Annual," *Art Digest*, vol. 8 (February 15, 1934), pp. 5–7.
4. Lorine Pruette, ed., *Women Workers through the Depression: A Study of White Collar Employment Made by the American Woman's Association* (New York: Macmillan & Co., 1934), p. 20.
5. Meridel Lesuer, "Women on the Breadlines," *The New Masses*, vol. 7 (January 1932), pp. 5–7.

69.

1. A full discussion of Still's development will appear in my forthcoming book, *Resurrection: Abstract Expressionism and the Modern Experience*.

70.

1. Similar paintings from this period appear in Barbara Haskell, *Ralston Crawford*, exhibition catalog (New York: Whitney Museum of American Art, 1985), figs. 20, 32, 36, and 37.

71.

1. Robert Goldwater, "Arthur Dove, A Pioneer of Abstract Expressionism in American Art," *Perspectives USA*, no. 2 (Winter 1953), pp. 78–88.

72.

1. The only legible word on the paper is "The," carefully delineated in the gothic script of the *New York Times* masthead.
2. "Hair is on the Up and Up," *McCalls* (June 1938), p. 89.
3. Lloyd Goodrich, *Kenneth Hayes Miller* (New York: The Arts Publishing Corporation, 1930), pp. 11–12.
4. Walter Gutman, "Kenneth Hayes Miller," *Art in America,* vol. 18 (February 1930), p. 92.

73.

1. Barbara Haskell, *Marsden Hartley,* exhibition catalog (New York: Whitney Museum of American Art, 1980), p. 124.

74.

1. Dorothy C. Miller, ed., *Americans 1942: 18 Artists from 9 States,* exhibition catalog (New York: Museum of Modern Art, 1942), p. 51.
2. Mark Tobey, "Mark Tobey Writes of his Painting on the Cover," *ARTnews,* vol. 44 (January 1–14, 1946), p. 22.
3. Eda E. Rubin, ed., *The Drawings of Morris Graves* (Boston: New York Graphic Society, 1974), p. 54.
4. Morris Graves in a letter to Marian Willard, October 22, 1942, in Ray Kass, *Morris Graves, Vision of the Inner Eye* (New York: George Braziller and the Phillips Collection, 1983), p. 37.

75.

1. Kuniyoshi Diary, August 20, 1944 (Yasuo Kuniyoshi Biographical Notes and Diaries, Sara Kuniyoshi, Woodstock, New York).
2. Ibid., November 18, 1944.

76.

1. Daniel Catton Rich, "The New O'Keeffes," *Magazine of Art,* vol. 37 (March 1944), pp. 110–11.
2. Katherine Hoffman, *An Enduring Spirit: The Art of Georgia O'Keeffe* (New York: The Scarecrow Press, Inc., 1984), p. 78. By home, O'Keeffe meant Stieglitz's country house at Lake George, New York.
3. Laurie Lisle, *Portrait of an Artist: A Biography of Georgia O'Keeffe* (New York: Seaview Books, 1980), p. 235.
4. Ibid.
5. Georgia O'Keeffe, in Anita Pollitzer, *A Woman on Paper: Georgia O'Keefe* (New York: Touchstone/Simon Schuster, 1988), p. 239.
6. Pedernal is the Spanish word for flint. Lisle in *Portrait of an Artist,* p. 235, notes that this particular mountain contained a flint deposit the Indians used for arrowheads, and that it was the proverbial birthplace of the Navaho's "Changing Woman," a goddess of the rites of passage, especially those of women.

77.

1. For an extended discussion of this period of Avery's career see Barbara Haskell, *Milton Avery,* exhibition catalog (New York: Whitney Museum of American Art, 1982), pp. 77–92.

78.

1. Barbara Cavaliere, "Theodoros Stamos in Perspective," *Arts,* vol. 52, no. 4 (December 1977), p. 105. Barbara Cavaliere has written extensively on Stamos.
2. From the gallery labeling on several related works described here, it is clear that the title was changed. First, written in crayon on the back of the painting (as are the titles on almost all of the seventeen paintings by Stamos in the collection of the Munson-Williams-Proctor Institute Museum of Art's collection) is the inscription "Formling / Theodoros Stamos / 146 5 Ave. / N.Y.C. / 1945."

The Betty Parsons Gallery label has the title *Hibernation* crossed out (see below). Mr. Edward Root's characteristic red and white label has "0–60 / *Cosmological Battle.*" In 1945 Stamos was in a group exhibition at the Mortimer Brandt Gallery and again in a two-man show in April of 1946. Betty Parsons was in charge of the contemporary section of the Mortimer Brandt Gallery, but by September of 1946 she had opened her own gallery with a group exhibition that included the work of Stamos. In 1946 Mr. Edward Root, Munson-Williams-Proctor Institute's benefactor and Stamos's patron, purchased *Blue Fish* of 1944; *Movement of Plants,* dated September 1945; and *Cosmological Battle* of 1945 from Betty Parsons (all Munson-Williams-Proctor Institute Museum of Art). It is likely that *Cosmological Battle* was in the Mortimer Brandt Gallery before being transferred to the newly-founded Betty Parsons Gallery. It is clearly evident that some titles were changed at the Brandt Gallery. For example, the title *Formling* is similar to another work called *Seedling* of 1945 (Munson-Williams-Proctor Institute Museum of Art), which has a Mortimer Brandt Gallery label with the title *Vortex and Spiral.* Root purchased *Seedling* in 1949 from Betty Parsons, but his own label on the back of the painting lists the title of the work as *The Embryo.* The title *Hibernation,* which was crossed out on the Betty Parsons label on *Cosmological Battle,* was used on another work of 1947, which is now at the Addison Gallery of American Art, Andover, Mass. The label on the back of the Addison painting reads: "*Hibernation* / 1947 / Theodorus Stamos / 237 W. 26th / N.Y.C." It has part of a Mortimer Brandt Gallery label with the title *Cosmological Battle,* as well as two Root labels: one with only "0–60 / *Cosmo*" and one with "0–84 / *Hibernation.*" It would appear that around 1945–46 the titles *Cosmological Battle* and *Hibernation* were both in use. In addition to Stamos, Parsons, and Root, another person who may have played a role in the proposed link of title changes was Mark Rothko. In April of 1946 Rothko exhibited watercolors at the Mortimer Brandt Gallery using titles that referred to myths and Jungian psychology.
3. Jeffrey Weiss, along with such other scholars as Stephen Polcari, has discussed the relationship of science and primitivism in Abstract Expressionism. For Rothko and Gottlieb's statement, see Jeffrey Weiss, "Science and Primitivism: A Fearful Symmetry in the Early New York School," *Arts,* vol. 57, no. 7 (March 1983), p. 85.
4. Ibid. Weiss discusses *Cosmological Battle* in relation to the atomic bomb.

79.

1. Eliza E. Rathbone, *Mark Tobey: City Paintings,* exhibition catalog (Washington, D.C.: National Gallery of Art, 1984).
2. Ibid., pp. 25–32.

80.

1. Harry Rand, "The Calendars of Arshile Gorky," *Arts Magazine,* vol. 50 (March 1976), pp. 70–80.
2. For a complete description of the subject matter of this work, see Harry Rand, *Arshile Gorky: The Implication of Symbols* (Montclair, N.J.: Allanheld & Schram, 1981; Berkeley, Los Angeles, New York, London: University of California Press, 1989), pp. 131–32.

81.

1. Dore Ashton, *Yes, but . . . A Critical Study of Philip Guston* (New York: The Viking Press, 1976), p. 74.

82.

1. All statements by Isabel Bishop are from interviews conducted by the author on February 2, 1985,

January 24, 1986, as well as in telephone conversations with the artist.

83.

1. See Francis V. O'Connor and Eugene V. Thaw, *Jackson Pollock: A Catalogue Raisonné of Paintings, Drawings, and Other Works* (New Haven & London: Yale University Press, 1978), vol. 2, pp. vii–viii, for a detailed discussion of why the word "drip" is not accurate in describing Pollock's essentially linear painting method.
2. According to Lee Krasner Pollock, her husband painted only one other work on this commercially dyed fabric, *Number 13A 1948: Arabesque* (Richard Brown Baker, loan to Yale University Art Gallery). When he was commissioned in 1950 to paint *Mural* (Teheran Museum of Modern Art, Iran) with a similar red ground, Pollock painted the canvas to match the fabric he had used in the two earlier works. See O'Connor and Thaw, vol. 2, p. 38, no. 217, and p. 80, no. 259.
3. O'Connor and Thaw, vol. 4, p. 204, fig. 4. The complex flower patterns in these commercial prints, very much reduced in the photograph, look surprisingly like Pollock's compositions such as *Number 2, 1949.* Pollock knew these photographs, since motifs from others in the same group appear in his early landscapes.
4. For details about Benton's methods and *Blue Poles* (Australian National Gallery, Canberra), see O'Connor and Thaw, vol. 2, pp. 193–98, no. 367. Also Stephen Polcari, "Jackson Pollock and Thomas Hart Benton," *Arts Magazine* (March 1979), pp. 120–24.
5. Pollock almost certainly would have seen the Museum of Modern Art's exhibition "Indian Art in the United States," January 22–April 27, 1941, during which Indians demonstrated sandpainting. In 1947 he stated: "On the floor I am more at ease. I feel nearer, more a part of the painting, since this way I can walk around it, work from the four sides and literally be *in* the painting. This is akin to the method of the Indian sand painters of the West." Quoted in O'Connor and Thaw, vol. 4, p. 241.
6. His reply to Lee Krasner's teacher, Hans Hofmann, in 1942, who had suggested he work from nature. Quoted in O'Connor and Thaw, vol. 4, p. 226.

84.

1. Charles Baudelaire, "A Philosophy of Toys," *The Painter of Modern Life and Other Essays,* ed. by Johnathan Mayne (New York: Phaidon Press, 1965), p. 199. For a general discussion of Baziotes's art, see Michael Preble, *William Baziotes: A Retrospective Exhibition,* exhibition catalog, with essays by Barbara Cavaliere and Mona Hadler (Newport Beach, Calif.: Newport Harbor Art Museum, 1978).
2. William Baziotes's undated Hunter College teaching notes, Archives of American Art, Smithsonian Institution, Washington, D.C. Baziotes taught at Hunter College from 1952 to 1962.
3. Roger Caillois, "The Myth of Secret Treasures of Childhood," *VVV,* vol. 1, no. 1 (June 1942), pp. 5–6.
4. William Baziotes, "Notes on Painting," *It Is,* no. 4 (Autumn 1959), p. 11.
5. Harold Rosenberg, "Reminder to the Growing," *Tiger's Eye,* no. 7 (March 1949), p. 82.

85.

1. Rothko, interview with William Seitz, January 22, 1952, on file at the Archives of American Art, Smithsonian Institution, Washington, D.C.. Bonnie Clearwater, "Selected Statements by Rothko," in Alan Bowness, *Mark Rothko 1903–1970,* exhibition catalog (London: The Tate Gallery, 1987), p. 73, noted that the artist said: "It was not that the figure had been removed, not that the figures had

been swept away, but the symbols for the figures, and in turn the shapes in the later canvases were new substitutions for the figures."

86.

1. The designation of the Utica painting as *No. 2* serves to distinguish it from another painting Sheeler called *New York* (Regis Collection, Minneapolis, Minnesota), painted the previous year, which is horizontal and shows a view of the city's skyline. A small 1951 tempera version of *New York No. 2* (location unknown) records all the elements of the composition and was made by Sheeler after the oil, possibly as a record of the picture for his own use.
2. I thank Erica Hirshler for this information.

87.

1. See Lawrence Alloway, "Sign and Surface: Notes on Black and White Painting in New York," *Quadrum,* no. 9 (1960), pp. 49–62, 191.
2. Thomas B. Hess, *Drawings of Willem de Kooning* (Greenwich, Conn.: New York Graphic Society, 1972), pp. 13, 34–35. This work may have been exhibited in de Kooning's second one-man exhibition at the Charles Egan Gallery, New York, in the spring of 1951.
3. Hess, p. 35, discusses the technique of this work, which is reproduced as plate 29. The technique for the group of drawings is also discussed by Paul Cummings, "The Drawings of Willem de Kooning," *Willem de Kooning,* exhibition catalog (New York: Whitney Museum of American Art, 1983), p. 16; and William C. Seitz, *Abstract Expressionist Painting in America* (Cambridge, Mass.: Harvard University Press, 1983), p. 20.
Within this black-and-white work are several touches of color: red in the upper left and slight amounts of orange at the far right, creating accents analogous to those in contemporaneous paintings such as *Excavation* of 1950 (Art Institute of Chicago). Near the center of the drawing, part of an arcing line has been edited with a cover of white paint, perhaps to encourage a reading of the large shape as a torso, certainly to eliminate the only slack form.
4. It was de Kooning who introduced Gorky to sign-painters' brushes (Seitz, p. 17). Pollock's poured works were first exhibited at the Betty Parsons Gallery in January of 1948. De Kooning's enamel drawings were exhibited in April of 1951. It is possible that Pollock's black paintings, under way by June 7, 1951, when the artist mentioned them in a letter, were a response to de Kooning's enamel drawings (Hess, pp. 37–38). The text of the Pollock letter is given in Francis V. O'Connor and Eugene V. Thaw, *Jackson Pollock: A Catalogue Raisonné of Paintings, Drawings, and Other Works* (New Haven & London: Yale University Press, 1978), vol. 4, p. 261, D99.
5. Hess, p. 35, sees "an empty leotard or stocking" and "a cross, acting as a window frame." Other drawings of the group have both crosses and windows. The imagery of some of these drawings is discussed by Sally Yard, *Willem de Kooning: The First Twenty-Six Years in New York* (New York: Garland Press, 1986), pp. 173–75.
6. The medium, of course, is unlike Soutine's oil impasto. For de Kooning's comments on Soutine, see Margaret Staats and Lucas Matthiessen, "The Genetics of Art," *Quest,* vol. 1, no. 1 (1977), p. 70.

88.

1. For the founding of the American Abstract Artists group see Susan C. Larsen, "The Quest for an American Abstract Tradition, 1927–1944," *Abstract Painting and Sculpture in America, 1927–1944,* exhibition catalog, ed. by John R. Lane and Susan C. Larsen (Pittsburgh: Museum of Art, Carnegie Institute, 1983), pp. 36–37.
2. Further insights on Bolotowsky's use of a diamond format appear in Adelyn D. Breeskin, *Ilya Bolotowsky,* exhibition catalog (New York: Solomon R. Guggenheim Museum, 1974), p. 10.

89.

1. Kenneth W. Prescott, *Jack Levine, Retrospective Exhibition: Paintings, Drawings, Graphics,* exhibition catalog (New York: The Jewish Museum, 1978), p. 17.

90.

1. Barbara Rose, *American Art Since 1900, A Critical History* (New York: Frederick A. Praeger, Inc., 1967), p. 189.
2. Christopher B. Crosman and Nancy E. Miller, "Speaking of Tomlin," *Art Journal,* vol. 39 (Winter 1979–80), p. 107.
3. Henry McBride, "Abstract Report for April," *ARTnews,* vol. 52 (April 1963), p. 15.
4. Crosman and Miller, p. 115.
5. George Flanagan, *Understand and Enjoy Modern Art* (New York: 1951; rev. ed., New York: Crowell, 1962), p. 318.
6. Crosman and Miller, p. 108.
7. David Bourdon, "In Praise of Bradley Walker Tomlin," *Art In America,* vol. 63 (September 1975), p. 56.
8. Letter of George Dennison, December 8, 1970. Jeanne Chenault, "Bradley Walker Tomlin," Ph.D. dissertation, University of Michigan, 1971, pp. 76, 119, nn. 319 and 321. Tomlin was pleased with the term "rational joy" in reference to his painting.
9. Mary Burke, "Twisted Pine Branches: Recollections of a Collector," *Apollo,* vol. 121 (February 1985), p. 79.
10. Jeanne Chenault, *Bradley Walker Tomlin: A Retrospective View,* exhibition catalog (Buffalo: Albright-Knox Gallery, 1975), p. 7.
11. Gerald Nordland, "The Slow Emergence of Star Sculpture," *ARTnews,* vol. 63 (October 1964), p. 32.
12. Dorothy Miller, ed., *12 Americans,* exhibition catalog (New York: Museum of Modern Art, 1956), p. 44.
13. Chenault, p. 28. This account of the funeral dinner was provided by an interview with Gwen Davies, September 10, 1970.
14. Ibid., p. 28. This statement was made during a telephone conversation with John I.H. Baur and is recorded in the Artists' Files at the Whitney Museum of American Art.

91.

1. As quoted in Stephanie Terenzio, *Robert Motherwell and Black,* exhibition catalog (Storrs, Conn.: William Benton Museum of Art, 1980), p. 94.

92.

1. Illustrated in Harry F. Gaugh, *The Vital Gesture: Franz Kline,* (Cincinnati: Cincinnati Art Museum and Abbeville Press, New York, 1985), fig. 55.
2. Ibid., fig. 119.

93.

1. Kenneth W. Prescott, *The Complete Graphic Works of Ben Shahn* (New York: Quadrangle/New York Times Book Co., 1973), p. 54.
2. Bernarda Bryson Shahn, *Ben Shahn* (New York: Harry N. Abrams, Inc., 1972), p. 200.
3. Ben Shahn, *Haggadah for Passover,* with translation, introduction, and notes by Cecil Roth (Boston: Little, Brown and Company, 1965), p. viii.
4. Ben Shahn, *The Biography of a Painting* (New York: Paragraphic Books, 1956), p. 51.

5. Ben Shahn, *Paragraphs on Art* (Roosevelt, N.J.: privately printed, 1952), p. 4.
6. Ibid.

94.

1. Henry Geldzahler, "An Interview with Helen Frankenthaler," *Artforum,* vol. 4, no. 2 (October 1965), p. 36. Frankenthaler's feelings about art and nature must have been reinforced by her study with Hans Hofmann in Provincetown, Massachusetts, during the summer of 1950. He believed that there were universal laws governing art and nature, and that each student, after directly observing nature, should translate his sensations in accordance with the two-dimensional character of the canvas.
2. Irving Sandler has stated that James Brooks adapted Pollock's staining method around 1949. He has also stated that Frankenthaler's earliest stained canvases were preceded by a group of watercolors executed on Cape Cod during the summer of 1956. *The New York School* (New York: Harper and Row, 1978), pp. 67, 88, n. 3.
In her study of modern art, Frankenthaler looked to the Abstract Expressionists, as well as to Kandinsky, Dove, and Marin. Eugene Goossen sees a relationship between Frankenthaler's early works and John Marin's vignetted compositions. In Frankenthaler's *Two Moons* there are clusters of shapes, as well as a residual "framed" space on the right. *Helen Frankenthaler,* exhibition catalog (New York: Whitney Museum of American Art, 1967), p. 9.
3. Frankenthaler first saw Pollock's work at the Betty Parsons Gallery in the fall of 1950. She was in the *Ninth Street Show* with him and other Abstract Expressionists in 1951. While Pollock's *Number 2, 1949* (Munson-Williams-Proctor Institute Museum of Art) was purchased from an earlier exhibition and would not have been known to her, there are numerous instances throughout the canvas where the oil in the enamel paints bled into the fabric support and created darker stained areas. Pollock's technique of allowing thinned-down pigment to soak into the canvas was most prominent in his black Duco enamel paintings of 1951–52.
4. In 1959 and 1960 Morris Louis exhibited his "Veils" and "Florals" at French and Co. in New York where Clement Greenberg worked. In 1959 Kenneth Noland exhibited his "Target" series at the same gallery for the first time. One of the paintings in the exhibition was *Lunar Episode* (Charles Gilman, Jr., New York). Greenberg, a long-time admirer of Frankenthaler's paintings, wrote his first major article on these two artists in the spring of 1960. The new simplification in Frankenthaler's *Two Moons* can be seen in other works of 1961: *Three Moons* (Arthur Stern, Rochester, New York), *Swan Lake No. 2* (Anthony Caro, Frognal, London), *Vessel* (collection of the artist), *Blue Caterpillar* (private collection), *Yellow Caterpillar* (Henry Geldzahler, New York), *May Scene* (collection of the artist), and *Arden* (Whitney Museum of American Art). In 1960 Frankenthaler began to experiment with primed canvas to harden the edges of her shapes. In 1962 she began using the brighter, nonfading, flatter acrylic paints that Louis and Noland used. The Utica painting is not tied to either of these two technical developments. For a discussion of these issues, see Barbara Rose, *Frankenthaler* (New York: Harry N. Abrams, Inc., 1971), pp. 90–92 and 100.

95.

1. *Encyclopaedia Britannica,* 14th rev. ed., s.v. "Electrocution."
2. Robert Lepper, Professor of Art at the Carnegie Institute of Technology, in his outline for the course Pictorial Design, given in the junior and senior

years, as published in Rainer Crone, *Das Bildnerische Werk Andy Warhols* (Berlin: Wasmuth, 1976), pp. 243–52.

3. Ibid., p. 244.

4. Ibid., p. 245.

96.

1. For a comprehensive examination of the art and life of Romare Bearden, see Mary Schmidt Campbell, "Romare Bearden: Towards an American Mythology" (Ph.D. dissertation, Syracuse University, 1982).

2. For an excellent explanation of the concepts of ritual in Bearden's work, see Ralph Ellison, *Romare Bearden: Paintings and Projections,* exhibition catalog (Albany: The University Art Gallery, State University of New York at Albany, 1968).

3. His working process is outlined in a letter to the author, September 22, 1973. Bearden included a diagram to explain the way in which he constructs his basic rectangular grid. He considered the process of construction as having several distinct phases, moving from the purely relational and sche-

matic to the more definitely pictorial and metaphorical. See also Bearden, "Rectangular Structure in my Montage Painting," *Leonardo,* vol. 2 (1969), pp. 11–19.

97.

1. Michael Compton, *Malcolm Morley: Paintings 1965–82,* exhibition catalog (London: Whitechapel Art Gallery, 1983), pp. 10–11.

98.

1. For two critics' views of the significance of the "Polish Village" series for Stella's art, see Rosalind Krauss, "Stella's New Work and the Problem of Series," *Artforum,* vol. 10 (December 1971), pp. 39–44; and Louis Finkelstein, "Seeing Stella," *Artforum,* vol. 11 (June 1973), pp. 67–70.

2. Carolyn Cohen, *Frank Stella, Polish Wooden Synagogues: Constructions from the 1970s,* exhibition catalog (New York: The Jewish Museum, 1983), p. 4.

3. For a discussion of the technical aspects of this series, see Philip Leider, *Stella Since 1970,* exhibi-

tion catalog (Fort Worth: The Fort Worth Art Museum, 1978), pp. 10–12.

99.

1. Peter Schjeldahl, "Putting Painting Back on Its Feet," *Vanity Fair,* vol. 46, no. 6 (August 1983), p. 85.

2. Marge Goldwater, "Susan Rothenberg," *Images and Impressions: Painters Who Print,* exhibition catalog (Minneapolis: Walker Art Center, 1984), p. 46.

100.

1. Richard Marshall, *New Image Painting,* exhibition catalog (New York: Whitney Museum of American Art, 1979), p. 62.

2. Frederick R. Brandt, *David True: Paintings 1977–1984,* exhibition catalog (Richmond: Virginia Museum of Fine Arts, 1984), p. 14.

3. David True in a letter to the author January 28, 1986.

4. Ibid.

Index

Pages on which illustrations appear
are in *italics*

Glackens, William, 10, 99, 100, 108; *Chez Mouquin,* 100; *In the Buen Retiro,* 100; *Under the Trees, Luxembourg Gardens,* 100, *101*
Goldwater, Robert, 155
Goodrich, Lloyd, 11
Gorky, Arshile, 11, 172, 191, 196, 204; *Calendars, The,* 172; *Making the Caldendar,* 172, *173*
Gottlieb, Adolph, 168, 196
Graham, John, 191
Graves, Morris, 6, 9, 11, 161; *Beach Under Gloom,* 161; *Bird in the Moonlight,* 161; *Black Waves,* 161; *Blind Bird,* 161; *Little Known Bird of the Inner Eye,* 161; *Sea, Fish, and Constellation,* 161; *Sea and the Morning Redness,* 161; *Surf Reflected Upon Higher Space,* 160, 161
Grosz, George, 146, 209
Guggenheim Museum, 192, 195
Guston, Philip, 8, 9, 10, 175, 196, 201; *Performers, The,* 8; *Porch No. 2,* 8, *174,* 175

Hague, Raoul, 196
Halpert, Edith Gregor, 8–9, 127
Hals, Frans, 86, 103, 105
Harnett, William Michael, 11, 12, 13, 84; *After the Hunt,* 94; *Study Table, A,* 84, *85*
Hartley, Marsden, 6, 9, 13, 158; *Summer—Sea Window No. 1,* 158, *159*
Hassam, Childe, 125; *Amagansett, Long Island, New York,* 12, *124,* 125
Heade, Martin John, 6, 73, 96
Henri, Robert, 103, 105, 108, 119, 135; *Dutch Soldier,* 12, *102,* 103
Hirschl & Adler Galleries, New York, 11, 188
Hofmann, Hans, 6, 204
Homer, Winslow, 10, 70; *Veteran in a New Field, The,* 65
Hopper, Edward, 9, 11, 141, 209; *Camel's Hump, The,* *140,* 141; *Hills, South Truro,* 141
Hudson River School, 35, 48, 73, 96

Impressionism, 73, 99, 125, 129, 151, 178, 196
Inman, Henry, 6, 46; *Dismissal from School on an October Afternoon,* 46; *Lake of the Dismal Swamp,* 46; *Newsboy, The,* 46; *Trout Fishing in Sullivan County, New York,* 13, 46, 47
Inness, George, 10, 61, 83; *Approaching Storm,* 83; *Coming Storm, The,* *82,* 83; *Montclair, New Jersey,* 83; *Saco Ford: Conway Meadows,* 83; *Saco River Valley,* 83
Irving, Washington, 33, 36

James, Henry, 86
Janis, Sidney, gallery, 201
Jarvis, John Wesley, 6
Jefferson, Thomas, 23
Johnson, David, 7, 75; *Brook Study at Warwick,* 7, *74,* 75; *Forest Rocks,* 75
Johnson, Eastman, 6, 70; *Chimney Corner, The,* 12, 70, *71; Life in the Old South* (later *Old Kentucky Home*), 70; *Lord Is My Shepherd, The,* 70; *New England Kitchen,* 70

Jones, Joe, 146; *Portrait of the Artist's Father,* 13, 146, *147*
Joyce, James, 199

Kandinsky, Wassily, 123
Kane, John, 145; *Morewood Heights,* 13, *144,* 145
Kantor, Morris, 6, 9
Kennedy Galleries, New York, 12
Kensett, John, F., 73, 75
Kline, Franz, 10, 201; *Bridge, The,* 10, *200,* 201; *Lehigh V Span,* 201
Knoedler & Co., New York, 12, 13, 77
Kraushaar Gallery, New York, 105
Kuhn, Walt, 6, 142; *Blue Clown, The,* 142; *Camp Cook, The,* 11, 142, *143; Clown with Red Wig,* 142; *Guide, The,* 142; *Man from Eden,* 142; *Miss A.,* 142; *Plumes,* 142; *Trude,* 142; *Wisconsin,* 142
Kuniyoshi, Yasuo, 6, 9, 11, 163; *Empty Town in the Desert,* *162,* 163

Lanman, Charles, 48
Lawson, Ernest, 6, 107; *Washington Bridge,* 12, *106,* 107
Leibl, William, 86
Leslie, Charles, 33
Levi, Julian, 6
Levine, Jack, 10, 195; *Golden Anatomy Lesson, The,* *194,* 195
Longfellow, Henry Wadsworth, 79, 86
Lorrain, Claude, 23, 35
Louis, Morris, "Floral" series, 204
Louvre, 115, 136, 191
Luks, George, 10, 99, 105, 108; *Man with Dyed Mustachios,* 105; *Roundhouse at High Bridge,* *104,* 105
Luminism, 99, 129

Macbeth Gallery, New York, 91, 103, 105, 110, 113
Macdonald-Wright, Stanton, 115
Manet, Edouard, *Music in the Tuileries,* 100
Marin, John, 6, 9, 13, 120, 135; *Landscape,* 120, *121; Tree Forms, Autumn,* 120
Marsh, Reginald, 6, 10, 11, 135, 136, 139, 157, 176; *Lower Manhattan,* *138,* 139
Martin, John, 45
Matisse, Henri, 110, 117, 120, 158, 167, 191
Matteson, Tompkins H., 6, 8, 62, 65; *Hop-Pickers,* 65; *Hop Picking,* 8, *64,* 65
Mauritshuis, The Hague, 195
May, Edouard, 79
Melville, Herman, 20, 199
Metcalf, Willard Leroy, 13, 129; *Nut Gathering,* *128,* 129
Metropolitan Museum of Art, 8, 10, 19, 48, 65, 92, 171, 186, 196
Michelangelo Buonarroti, *Dying Slave,* 115
Middendorf Gallery, Washington, D.C., 117
Midtown Gallery, New York, 8, 176
Miller, Kenneth Hayes, 10, 135, 136, 157, 176; *Morning Paper, The,* 10, *156,* 157
Minimalism, 192, 210, 215, 216

Miró, Joan, 172
Mondrian, Piet; 123, 192; *Victory Boogie-Woogie,* 192
Moran, Edward, 67; *Coast Scene near New Brunswick,* 67; *Shipwreck,* 13, *66,* 67; *Shipwreck, The,* 67
Morley, Malcolm, 13, 210; *Kodak Castle,* 210, *211; Rhine Château,* 210
Morse, Samuel F. B., 10, 46
Motherwell, Robert, 196, 199; "Elegy to the Spanish Republic" series, 199; *Tomb of Captain Ahab, The,* 12, *198,* 199
Mount, Henry Smith, 6, 10, 25; *Beef and Dead Game,* 25
Mount Holyoke College Art Museum, 83
Mowbray, H. Siddons, 157
Mumford, Lewis, 146
Munich School, 86
Museum of Fine Arts, Boston, 16, 46, 51, 96, 132
Museum of Modern Art, New York, 13, 161, 191, 196, 201
Museum of Natural History, New York, 168

National Academy of Design, New York, 33, 45, 51, 73, 75, 79; exhibitions, 27, 35, 46, 59, 68, 73, 75, 79, 105
National Gallery, London, 67, 100
National Gallery of Art, Washington, D.C., 39, 41, 43, 45, 54, 136, 142
National Museum of American Art, 70
Neoclassicism, 24, 25, 29
Neo-Impressionism, 110
Neoplasticism, 192
Neue Galerie, Aachen, 210
Newman, Barnett, 168, 196
New-York Historical Society, 39, 41, 48, 70, 79
New York Public Library, 48, 79
New York Realists, 99
New York School, 172, 196
New York State Historical Association, Cooperstown, 51
Nietzsche, Friedrich, 151, 186
Noland, Kenneth, "Target" series, 204
North Carolina Museum of Art, 62

O'Keeffe, Georgia, 9, 10, 127, 165; *Pelvis with Pedernal,* *164,* 165
Orozco, José Clemente, 146, 209

Palmer, William C., 6, 8, 10, 135; *Washington Square, New York,* 13, *134,* 135
Paris Salon (1877), 75
Parsons, Betty, 196; gallery of, 168, 196
Partridge, Nehemiah, 6, 15; *Gerrit Symonse Veeder* (attrib.), 12, *14,* 15
Pascin, Jules, 136
Peale, Charles Willson, 24, 29
Peale, James, 29; *Still Life: Apples, Pears, Grapes,* 13, *28,* 29
Peale, Raphaelle, 6, 24–25, 29; *Ribs of Raw Beef,* 25; *Still Life with Celery and Wine,* 25; *Still Life with Steak,* 8, 24–25, *25*